The Temptation of Despair

WERNER SOLLORS

The Temptation
of Despair

Tales of the 1940s

The Belknap Press of Harvard University Press

Cambridge, Massachusetts, and London, England ▪ *2014*

Library of Congress Cataloging-in-Publication Data

Sollors, Werner.

The temptation of despair : tales of the 1940s / Werner Sollors.

pages cm

Includes bibliographical references and index.

ISBN 978-0-674-05243-7 (alk. paper)

1. Reconstruction (1939–1951)—Germany. 2. Denazification.
3. Social psychology—Germany. 4. World War, 1939–1945—
Influence. 5. World War, 1939–1945—Art and the war. 6. World War,
1939–1945—Literature and the war 7. World War, 1939–1945—
Motion pictures and the war. I. Title.

D829.G3S56 2014

940.55'4—dc23 2013037693

For Sara, my daughter,
and in memory of my mother

When I think back, I am certain that not even the darkest pessimist could have imagined then [in 1933] what has now become reality.

—Alfred Döblin, "What Germany Looks Like in 1946"

This is a political age. War, Fascism, concentration camps, rubber truncheons, atomic bombs, etc. are what we write about, even when we do not name them openly. We cannot help this. When you are on a sinking ship, your thoughts will be about sinking ships.

—George Orwell, "Writers and Leviathan" (1948)

A new movement should be launched by European intellectuals, "the movement of despair, the rebellion of the hopeless ones."

—Klaus Mann, "Europe's Search for a New Credo" (1949), quoting a philosophy student at Uppsala

Contents

Introduction

Before Success

The American occupation of Germany after World War II: these words evoke a mythic chapter in twentieth-century history on both sides of the Atlantic, bringing to mind haunting visual images of liberated concentration camps and ruined cities; the sounds of rattling tanks, heavy trucks, and bouncing jeeps racing through the German landscape, of politicians' agitated, loudspeaker-amplified voices, and of swing music playing on tinny-sounding radios; the taste of cinnamon and spearmint chewing gum, sweet Hershey bars, and chlorine-saturated water; the scent of the stale air of abandoned bunkers, of pungent cigarettes, even more pungent cigarette butts, of acid-stock comic books and cheap paperbacks; and with the feel of soft nylons and rough army fatigues. One thinks of crowds everywhere, of refugee treks and packed trains, of endless food lines and swarming prisoners-of-war and Displaced Persons, of large groups of G.I.s milling around medieval villages and around rubble in cities. This epoch was publicly documented not only in thousands of photographs and film clips—one even *thinks* of this time period in black and white at first, not in color—but also in sound recordings, radio programs, newsreels, and newspaper accounts; public opinion surveys; countless pages marked "SECRET" or "geheim"; as well as in private letters, diaries, and dreams; in questionnaires and curricula vitae on which the very heading, *Lebenslauf!* might be followed by an emphatic exclamation mark. The story of this intense cultural moment inspired painters, poets, playwrights, and novelists, and a work's dedication—as in *Für Albert Camus!*—could also appear in the exclamatory mode.

Our way of remembering this period is shaped by the aesthetic techniques and styles that were then in fashion, be they strong images of previously taboo subject matter that were now being thrust at the viewer, or hard-boiled prose that one could read on grainy, fast-yellowing paper, dialogues full of quick and snappy wisecracks that seemed to be not just comic exercises but far more than that, attempts at talking back to a world of existentialist meaninglessness. Yet it is not the arts of the second half of the 1940s and of the very early 1950s that first come to mind when the period is evoked. It is rather the political tale of the American occupation of West Germany, in particular, as a legendary story of bringing a country ruled by a ruthless dictatorship back into the fold of democracy through a process that was not yet very often called nation building, but that included, after the conclusion of military operations, curtailed sovereignty and prolonged military government, political trials of selected leaders by the novel form of an international military tribunal, and enforced democratic reeducation of the populace, with an at first harmonious and then more and more uneasy inter-Allied cooperation that turned into the full-blown Cold War by the time of the 1948 Berlin blockade.[1] It is, in public memory, then, the prototypical tale of a mission accomplished and a story that has become the explicit model for later military occupations for which it seemed to set a standard, even though they live in our minds in different media, in bright desert colors or with simulcast bomb attacks on green-grey computer screens. Invoking the old and mythic story has raised the expectation that such new ventures would be as inevitably crowned by success as, it is now widely believed, the Allied occupation of West Germany was.

But was it experienced as such? The retrospective view seems clear: German democracy did indeed prevail in the Western zones of occupation. No German right-wing party could celebrate any noteworthy national electoral success in more than six decades after the war, and from the mid-1950s on, the "economic miracle" helped make West Germany remarkably prosperous. No civil war, no large-scale unrest destabilized the reconstruction of cities destroyed by heavy bombing. The "Werwolf" units—an armed guerrilla resistance movement that Himmler created in 1944 to menace the victorious occupiers and their German collaborators—never amounted to much, and foreign armies stayed on German soil in significant numbers for decades after the war, without any trouble to speak of.[2] Millions of German refugees and expellees who had been driven out of

their homes, their towns, cities, and provinces, often violently, as the Yalta and Potsdam agreements redrew the map of Germany, never organized a political movement with the aim of changing back militarily the newly drawn political boundaries. Though they were at times accused of being "revanchist" in their often-expressed hope that Germany would be restored to its borders from before the time the Nazis took power, the refugees did not threaten the long-term peaceful accommodation Germany ultimately was able to reach with all its neighbors in the postwar era.[3]

From hindsight we can imagine the outline of a success story that began to take shape in the 1940s and that ultimately continued through the unification process with the former Soviet zone of occupation, the German Democratic Republic. Yet sources of the period itself—private diaries and published briefs, photographs, journalistic reportage, essays, and the fuller aesthetic representations in fiction or film of the postwar years—portray a much murkier world, more given to looking backward than to envisioning a long-range future, let alone the hopeful mapping out of such a future. The orientation toward the past meant first of all dealing with the fresh memory of one of the bloodiest periods in human history. In the years from 1939 to 1945 more than 50 million civilians and soldiers had died in World War II, and another 13 million, among them the 6 million Jews who were murdered in the Holocaust, or Shoah, had been victims of intentional mass killings, planned starvation, and other war crimes.[4] The news in the wake of World War II confronted those who had survived it with unimaginably large numbers of human victims. And not all suffering ended with the war, as the new postwar order was established at the cost of additional human lives.

How fragile life is, how thin the line that separates life from death, is something we all know and try generally not to think about too much but are reminded of when we face illnesses or accidents. Fortunately, the times are rare when large numbers of people are made to feel that the line between life and death does not seem to matter much or when death may seem to hold more promise than life for them. The 1940s clearly were such a period in Europe, which can be seen in the strong undercurrent of melancholy and despair in many forms of expression from that time.

Looking backward in the second half of the 1940s meant thinking of lost relatives and friends and wishing to avoid a repetition of the story that led

from the aftermath of World War I through the rise of National Socialism to the war years. Yet how? Deep pessimism and serious skepticism prevailed in much of the planning and the experience of the occupation in the postwar years. Some witnesses of the period simply turned to despair or to sarcasm rather than toward assuming a hopeful and forward-looking, let alone a triumphalist, braggingly self-assured pose. This seems true for the victors, the defeated, and the surviving victims of the defeated. They may have imagined the time they were living in as transitory or felt that they had been thrust into a confusingly timeless limbo, but they were rather uncertain of what the ultimate outcome of this moment might turn out to be. They told themselves and each other countless stories of life under the occupation, but the success story of the occupation as the route toward democracy in West Germany was simply not yet prominent in their repertoire.

The occupation was, of course, an Allied effort that included four powers. Yet the Americans and the Russians were the heavyweights in this arrangement, and only the Americans approached it from the background of a country that itself had never experienced major German military attacks (as had the three other occupying powers) or a German occupation (as had France and Russia). The United States "held and still holds a position in Germany that no other occupying power holds," an American observer commented in 1947, and some of the mythic tales about the American occupation came about precisely through its contrast with those of the other occupying powers, and most especially that of the Soviet Union.[5] It is not surprising when one considers the mass rapes of German women by Russian soldiers at the end of World War II that the Soviet Union would not enjoy much popularity as an occupying power, but G.I.s were also more appreciated than French or British soldiers.[6] A military government opinion survey from 1947 was known as OMG–76. [*The voice command on my computer reads out this abbreviation as "oh my God," as if it came from a text message of the twenty-first century, and we may take this opportunity to note the period's remarkable love for acronyms. The American occupation might be seen as the displacement of one set of inscrutable acronyms by another: HJ and BdM by GYA; OKW by SHAEF and USAREUR, and so forth.*][7] That Office of the Military Government survey showed that 84 percent of German respondents said they would have chosen to live under American rather than any other occupying power had they known in 1945 what they knew at the time of the survey, with only 4 percent preferring the British; 68

percent said "that, if they had a son, they would want him to live in the U.S. zone," while 5 percent chose the British zone; very large majorities thought that "economic conditions were better" under the Americans "than under the British (67 percent), French (76 percent), or Soviets (77 percent)."[8] [*My own anecdotal memories of relatives discussing and comparing the merits and shortcomings of the four occupying powers have family opinion similarly veering toward the Americans.*]

Such relative popularity would be hard to anticipate from the first official declarations of the occupation's goals that were formulated before unconditional surrender. The American blueprint for the occupation embodied in the April 28, 1945, Joint Chiefs of Staff directive to General Eisenhower (JCS-1067) chose an emphatically stern and punitive tone in defining the basic goals of the military government: "Germany will not be occupied for the purpose of liberation but as a defeated enemy nation," and "The principal Allied objective is to prevent Germany from ever again becoming a threat to the peace of the world."[9] The process was to include the imposition of economic control, denazification, demilitarization, deindustrialization, and the payment of reparations—political goals that all four powers endorsed in 1945. For a good while the American military was anxious to accede to all Soviet demands, including to the redrawing of European borders and the repatriation, at times against their will, of Displaced Persons into the Soviet sphere of influence. As mapped out in the JCS-1067, German sovereignty was abolished, and the American military government's "supreme legislative, executive, and judicial authority" was "broadly construed" and provided, without any euphemistic language, for "information control" and political censorship of the press as well as of private correspondence: the censorship of free speech extended to bans of any criticism of the Russians, including references to the rapes, even in private letters. The one vague glimmer of hope that such punitive measures were to serve as "the preparation for an eventual reconstruction of German political life on a democratic basis"—to be brought about through reeducation—was thoroughly overshadowed by the great detail with which the imposition of a system without checks and balances was described. More than one contemporary observer was struck by the absurdity of the idea that it was military forces who were to drive militarism out of Germany and prepare German political life on a democratic basis by military rule. Only in the retrospective glow of the success story is it therefore

surprising that the grim 1940s produced a good number of gloomy and pessimistic comments all around, with themes of burnout, suicide, destruction, absurdity, and nihilism. The temptation of despair was omnipresent and exerted quite a powerful pull.

The Temptation of Despair

Despair (*accidia* or *acedia*) was one of the Christian capital sins, a dangerous one unless it was repented and addressed with a mix of fear and hope.[10] According to Giorgio Agamben, there was a tradition that made it out to be the most lethal of vices, and an unpardonable one.[11] It was particularly associated with old age, and the later notion of the temptation of despair specifically referred to the fear at the moment of dying that our sins and failings are so overwhelming that our souls are lost and that eternal damnation seems inevitable. A fifteenth-century illustrated manuscript, and popular woodcuts and engravings derived from it, represented "The Temptation of Despair" by six devils surrounding the bed of a dying man and holding up the catalog of his capital sins, in one version identifying his various indictments with inscriptions in banderoles that the most horrifying-looking devils hold. In view of the long list of his serious failings, how can a dying man still have any hope for God's forgiveness? Yet after the lures of heresy, impatience, pride, and longing for earthly treasures, the temptation of despair may be only one of the last tricks the devil plays on us in order to get hold of our souls as they get ready to leave our bodies. The only remedy for the dying sinner to achieve "Triumph over Despair" was to have faith in God's tender mercy, and indeed, the image parallel to the temptation of despair shows the dying man guided by an angel who reminds him that God forgave such sinners as Peter who had denied Christ; Mary Magdalene, long believed to have been a prostitute; the nameless thief who was crucified next to Jesus; and Saul who had persecuted Christians before he converted to Christianity on the road to Damascus and changed his name to Paul. The *ars moriendi*, the art of dying, shows that with the affirmation of the sinner's hope for God's mercy, the devils of despair would run away or hide under the bed.[12]

Only where was that angel of hope and forgiveness in the mid-twentieth century? The danger posed by the temptation of despair was not only that it made dying people doubt that their souls could be saved. It also could

create among the living a sense that going on with their lives was futile and that a wish to die was more appropriate, that, in fact, even suicide was more than justified.[13] The French Catholic writer Georges Bernanos developed the notion of "temptation of despair" in his haunting 1926 novel *Sous le soleil de Satan* (Under Satan's Sun), which opens with the story of the pregnant Germaine Malorthy, who kills one of her suitors, gives birth to a still-born child, and ultimately commits suicide. The main part, which carries the title "La Tentation du désespoir," is about Abbé Donissan's desperately self-chastising battle with sin, though he must learn to recognize, in long philosophical conversations with Abbé Menou-Segrais, that his despair had only led him from blind hatred of sin to a fierce contempt of himself as a sinner. In giving up hope, he had merely fallen for one of Satan's tricks and yielded to the temptation of despair. In the 1940s, Bernanos's vivid, perhaps even lurid representation of despair seemed to capture the spirit of the time, and his death in 1948 led to a renewed discussion and a wider circulation of his work. *Die Sonne Satans*, the German translation of Bernanos's novel, appeared in a mass market paperback edition in 1950 and sold fifty thousand copies in the first week.[14]

Voices from the 1940s

On March 29, 1945, the journalist Lili Hahn, who had been prohibited by the Nazis from exercising her profession, wrote in her diary upon the arrival of the Americans in Frankfurt: "The Nazis are gone and have taken my youth, having stolen twelve years of my life, ruined my health, and made a very different person of me from the one I should probably have become originally. I personally have won the war but lost the peace, for I can imagine no future, do not know what I should be looking forward to with joy. I have no destination and I am burnt out."[15] The film director Billy Wilder, among the first Americans to enter Soviet-occupied Berlin in August 1945, talked with a German war widow who was clearing the rubble on Kurfürstendamm and thought of their conversation as the inspiration for a new film. When the woman expressed happiness that the Americans had arrived and would help repair the gas lines, Wilder interjected, "I suppose it will be nice to get a warm meal again." The woman, however, went on to say: "It's not to cook," and after a long pause: "We will turn it on, but we won't light it. Don't you see? It is just to breathe it

in, deep."[16] In fact, a wave of suicides did sweep Germany in 1945.[17] One of these sets of suicides, that of Leipzig deputy mayor and treasurer Dr. Kurt Lisso, his wife, and his daughter on April 18, 1945, was captured by Margaret Bourke-White, Lee Miller, and by army photographers in hauntingly gruesome images, all the more so when one has to realize that several photographers who were present in a room with the corpses of people who had just killed themselves had apparently rearranged things as props in order to take pictures from various angles in their different styles.[18] Zelda Popkin's novel, *Small Victory* (1947), represented a murder-suicide as the *Liebestod* conclusion of a fraternization subplot between a Jewish-American officer and his German secretary. William Gardner Smith's novel, *Last of the Conquerors* (1948), mentions the double death of the black soldier Mosley and his German girlfriend: here the girl killed the soldier and then herself because she could not stand the idea of a permanent separation when Mosley was to be shipped back. Suicides were frequent, but they were only one indication of the general atmosphere of hopelessness.

Thomas Dodd, having arrived in Nürnberg to work as an American legal counsel in the upcoming war crimes trials, expressed little hope for the future in Europe when he wrote his wife on August 18, 1945:

> Grace, I am afraid of what has happened here. The awful destruction—the terrible losses of all kind—they may hate us for one thousand years. I am sorry too because I know now from eyesight and from the lips of our own men in arms that all the atrocities, all the sinning, was not on one side. I am sorry because I know some of these things. It is not that I fear German hatred, or because I am forgetting their terrible deeds, their unspeakable horrors and cruelties and indecencies—for which they must be made to suffer and to pay. Rather that there is no sure sign of a better day in Europe or in the world because I have learned that all who carried our righteous banner did not live in its righteous way. Many did. Some did not. It is very depressing to see all this ruin, want, suffering, injury and pain and not really be hopeful for the future. Europe is a mess. I do not think it will be cleaned up for a long time.[19]

In his quirky book *The German Talks Back*, published in September 1945, Heinrich Hauser expressed his conviction that Germans desperately

needed a new dream to keep them from falling "into the nihilism of despair" and perishing "in spiritual and physical suicide."[20] Christianity could no longer play that role, Hauser believed, but he also ruled out democracy, for it "has been tried in living memory and it failed," as well as monarchy, for it "is too modest a dream to justify the nation's decimation and its utter ruin" (111). Hence he feared that communism might become the new German national dream but supported as an alternative the creation of a new exclusively agriculture-based Germany: "It will be a hard uphill fight, and we cannot hope to win it in our lifetime," and "life will be essentially the same as it was a thousand years ago: felling of trees, hewing of stones, plowing of fields; straw for a bed and a vegetable diet for food" (213).[21]

An editorial in the *Stuttgarter Zeitung* of October 24, 1945, summarized the mood in Germany with the metaphor of illness: "We Germans are very ill. Sometimes we seem to be closer to death than to any hope of recovery. We are in danger of succumbing to a gnawing rot. The horsemen of the apocalypse have descended upon us. Their hoofbeats are still thundering in our ears. Now we are tired, want calmness, rest, security, forgetting."[22]

As Dachau survivor Zalman Grinberg put it in a November 1945 meeting of the Central Committee of Liberated Jews in München, Jewish survivors in Displaced Persons' camps also faced, and most especially so, "the bitter yesterday, the bad to-day and the hopeless to-morrow."[23]

Losing the Victory

Although the Austrian-born émigré political scientist William Ebenstein, a former student of Hans Kelsen, approached the question of Germany's future from a completely different point of view, he, like Hauser and Henry Morgenthau Jr., viewed the removal of Germany's industrial resources as more important in 1945 than the establishment of democracy for the future maintenance of peace, though he also proposed a program of antiracist reeducation.[24] In Ebenstein's view, it was simply "not true that nondemocratic forms of government are *ipso facto* militaristic and expansionist," as the examples of so many Latin American countries as well as of Portugal and Turkey showed. A nondemocratic Germany would represent no threat as long as "the Germans will voluntarily give up the collective mania of the Herrenvolk complex, and—just as important—if the Germans do not

possess the industrial resources to make war" (307). Hence: "If we build our long-term policy with regard to Germany on the wish that she must be democratic very soon, we are doomed to fail" (308). This was not to exclude the long-range possibility of democracy slowly emerging, for "to deny that the Germans can change their ways is to accept the very essence of Germanism, is to think in terms of tight historical entities determined by national characteristics and peculiar qualities" (308).

The general mood did not turn cheery anytime soon. John Dos Passos contributed a photo-essay to *Life* (January 7, 1946) titled "Americans Are Losing the Victory in Europe." Dos Passos reported the "sobering experience" that "Europeans, friends and foes alike, look you accusingly in the face and tell you how bitterly they are disappointed in you as an American," with the word *liberation* having become synonymous with looting. Americans get blamed for the "fumbling timidity" in negotiation with Russians, for the handling of the Displaced Persons, for the black markets, for mechanical and counterproductive denazification procedures, and for the illusionary gesture at Nürnberg of prohibiting wars of aggression by international law. "We have swept away Hitlerism," Dos Passos wrote provocatively, "but a great many Europeans feel that the cure has been worse than the disease."[25] Drew Middleton wrote a feature on the occupation in *Collier's* (February 9, 1946) with the equally telling title "Failure in Germany." The military government had failed, the illustrated article with somber captions and section titles argued, in its top-down effort to instill a democratic spirit in Germany. Middleton predicted that the Germans' dislike of Americans would turn to hatred with the result that "when a people become united in hate against their conquerors, the balance of the people become the allies and protectors of any underground movement." "We have won the war with Germany," the article ends. "Have we lost the peace?"[26] Ann O'Hare McCormick wrote in the *New York Times* on November 18, 1946: "All the peoples of Europe are suffering in ways the United States, despite its grave internal problems, cannot possibly envisage. The misery and despair prevailing over large areas of this continent are beyond American experience or imagination. Conditions are worse than last year, even when they appear better, as in France and the Low Countries, because there is less hope. The prolonged emergency tells everybody that the basic elements of recovery and peace are lacking."[27]

Also in 1946, the émigré legal theoretician Karl Loewenstein, a liberal who had in the 1930s analyzed the growth of European fascist movements as the para-political expression of "the vast army of the unemployed and the youth of all classes, despairing of the future in the over-crowded countries" and as "the hope of the despairing, the refuge of those outwitted by the burden of daily life," and who was now advising the military government, wrote: "No German government, and no government of any subdivision of prewar Germany, should be tolerated for a long time to come. Rather, politically trustworthy Germans should be permitted to build up, on the municipal, local or regional level, nuclei of purely administrative character whose effectiveness would be enhanced by their complete abstention from governmental responsibility."[28]

The leftist émigré political scientist Franz Neumann published an article in 1947 in which he found that "it is becoming evident that our occupation is likely to fail in its objectives. It will not achieve de-militarization; it has failed in the destruction of Nazism; and it is doubtful that a viable democracy can arise from the conditions prepared between 1945 and 1947." Neumann blamed the existence of a military government rather than a military occupation "with merely advisory and veto powers vis-à-vis the indigenous government" of a sovereign Germany for the failure.[29]

A character called "the Professor" in William Gardner Smith's novel *Last of the Conquerors* talks about the occupation "failing miserably." When asked what he means, he explains: "We have not succeeded in interesting the German people in such democratic institutions as elections, political parties, and the like. We have not to any noticeable extent changed their way of thinking. They are still the same people they were when our troops first crossed the Elbe."[30]

And as late as 1950, Hannah Arendt published "The Aftermath of Nazi Rule: Report from Germany" in *Commentary*. She tells somewhat resignedly what she herself calls "the melancholy story of post-war Germany," a story that raises a twofold question: "What could one reasonably expect from a people after twelve years of totalitarian rule? What could one reasonably expect from an occupation confronted with the impossible task of putting back on its feet a people that had lost the ground from under it?" She sees the real political problem in the consequences of totalitarianism rather than the "so-called German problem," believes that it could be solved only in a federated Europe, but thinks that this "solution seems of

little relevance in view of the imminent political crisis of these coming years" and that Germany is not "likely to play a great role in it," creating the sense of "the ultimate futility of any [German] political initiative."[31] Many more pessimistic comments could be cited from the second half of the 1940s, a period that has remained an interregnum between World War II and the creation of the two German states as the result of the onset of the Cold War.

This Book

It is the task of this book to retrace stories and reexamine images of the end of the war and the early years of the military occupation, stories that were then believed to be plausible attempts at capturing a strange and unfamiliar reality, but that have meanwhile been largely replaced by the mythic success story that seems to have swallowed up most others in public memory. These stories can be found in letters, often written in very small handwriting and up to the very edge of each page so as to get the most words onto the precious sheets of paper, and at times marked by censors' deletions; in diaries that may include strange pieces of evidence collected in apparent disbelief—diaries that were also at times altered and adjusted in later years; in official, mimeographed communications, reports, studies, and orders that remind us that this was the age of the manual typewriter, the carbon copy, and the mimeograph; in newsreel footage accompanied by blaring marchlike musical introductions and the then-so-popular agitated shouting voices of announcers; in "unabridged" or "uncensored abridged" mass media paperbacks with lurid covers and improbably exaggerated blurbs; in newspapers and illustrated magazines; and in many of the other media that were then available.

In many cases, these tales point to shared themes and experiences, to moments that seemed particularly noteworthy, aspects that were so haunting or enticing or amusing as to be present in many sources, even if viewed from rather different angles. I have made an effort to hover over some such moments, describing different reactions they provoked and the dialogues some of them inspired, or could have inspired. Some of the stories are fully told, others are only implied; they may be verbal or visual; they may be romances or gothic horror tales, elegiac or defiant, sentimental plots or tough stories of revenge; they may be religious or secular in ori-

entation, reactionary, conservative, liberal, or left-wing dramas. Yet they would seem to add up to a chorus of voices that articulated tales of the postwar 1940s in which people then recognized themselves.

Who were the artists, the writers, photographers, and filmmakers who responded to what they saw and tried to record it or to turn it into art? Both established and less well-known figures were among them. The writers included an anonymous German diarist who published the immensely popular book *A Woman in Berlin;* the radical American short story writer Kay Boyle; the Swedish avant-garde novelist and reporter Stig Dagerman; the German Jewish modernist Alfred Döblin who returned to Germany after the war; the American experimentalist John Dos Passos; the Swiss playwright Max Frisch; the American novelist and journalist Martha Gellhorn; the returning émigré journalist Hans Habe; the German religious novelist Kurt Ihlenfeld; the novelist Ernst Jünger; Erich Kästner, best known as a German children's book author with complex and contradictory experiences in Nazi Germany; the Polish Jewish survivor Anna Kaletska; the Berlin cultural journalist and diarist Ursula von Kardorff; the skeptical German postwar experimentalist Wolfgang Koeppen; the German émigré legal scholar Karl Loewenstein; the German fiction writer Gerhart Pohl; the Jewish American detective writer Zelda Popkin; the political theorist Carl Schmitt; the African American draftee, *Pittsburgh Courier* journalist, and novelist William Gardner Smith; the German teacher Ernst Schneider; the American expatriate and mother of modernism Gertrude Stein who visited Germany in the year before she died; and the novelist writer Kurt Vonnegut, here represented with an early short story. Some other diarists and letter writers of the period are referred to more briefly.

Oscar-winning Billy Wilder and the seasoned Robert A. Stemmle were among the film directors. The professional photographers Margaret Bourke-White, Lee Miller, and George Rodger provided memorable images of the war and postwar years for *Life* and *Vogue,* and the Hungarian-born Robert Capa, after covering the Spanish Civil War and World War II from the London blitz to the liberation of Paris, took more than two hundred photographs of Berlin in the summer of 1945. There was also the young Italian American Tony Vaccaro, drafted as a G.I. but equipped with his own Argus C-3 camera, and so affected by what he witnessed that he stayed on in Germany, working for *Stars and Stripes* and taking thousands

of photographs of the occupation; later he became a fashion and celebrity photographer, was admitted to the Légion d'honneur, and received the Knight's Cross of the Order of Merit of the Federal Republic of Germany. The German photographer Fred Kochmann captured the eerie postwar world of ruined Frankfurt in more than twenty-six hundred photographs, the majority of them taken in 1946 and 1947. The Polish-born Ephraim Robinson, who survived the war in the Soviet Union documented the years 1945–48 that he spent in a Displaced Persons' camp near Frankfurt in a brief documentary film and in many photographs, about two hundred of which he selected for an album he made after emigrating to the United States; Cecilia "Zippy" Orlin produced an album of Jewish Displaced Persons who lived in the postwar Bergen-Belsen camp from 1945 to 1950. Ray D'Addario took official photographs of the Nürnberg trials in black and white but privately explored the nightmarish ruinscape of the city, capturing it incongruously in gloriously vivid color photographs.

The experience of the postwar world was strong enough to inspire some established artists to enter new periods in their own creative careers. Werner Bischof, for example, who was trained as a professional photographer in Switzerland and specialized in nature photography for scientific purposes, was so shaken by a tour through postwar Germany in 1945 that, after taking a series of deeply upsetting pictures, some of which have hence become classics, he never returned to nature photography but became an artist who focused on scenes of human suffering around the world. Gerhard Gronefeld, a German photographer for the *Neue Berliner Illustrierte*, captured Berlin's misery from 1945 to 1947 before he turned toward nature and animal photography in 1950. Providence-born and Yale-educated, William Grosvenor Congdon joined the American Field Service in World War II and moved with the military campaign from North Africa to Germany, doing a series of drawings of the scenes he witnessed in the liberated concentration camp at Bergen-Belsen. Deeply affected, he returned to New York and became involved in action painting, beginning with "New York Explosion, 1949." The Czech-born visual artist William Pachner who had specialized in landscapes, colorful commercial art for advertisements, and comic cartoons started illustrating eyewitness accounts of German death camps in grim new grey-tones. Pachner did not go back to postwar Europe, but the cultural moment inspired a considerable number of Europeans who had escaped from the Nazis to America to

return to Europe, some for a while, some for good, and create works in response to the postwar world and the war stories that it generated. Postwar returnees like the Hungarian-born Hans Habe and the Polish-born Billy Wilder have already been mentioned, but there were many others, among them the Latvian-born psychologist David P. Boder who went back to Europe to make and evaluate wire recordings of testimonies by survivors of Nazi-inflicted and other war-related trauma. There were other scholars whose work became part of the culture of the occupation, for example, in devising the denazification questionnaire that then became omnipresent in tales of the 1940s.[32] And there were professors and students in disciplines ranging from anthropology to political science who researched many aspects of the occupation while it was going on and arrived at varied conclusions and recommendations that were also often formulated in terms of the same story lines that artists were developing more freely. And of course there were many ordinary soldiers and civilians, workers and housewives, amateur photographers and family letter writers who contributed to the rich sources that make up the cultural history of the period.

The search for appropriate story lines and images led artists to draw on long traditions of representing human suffering and requiems for the dead as well as on a novel sense of living at a moment when surrealistic nightmares and nonrepresentational modernist art more generally seemed to have become a physical reality and made up a good part of the observable world. Some were attracted by the storehouse of literature and art to understand the postwar setting—with such predictable notions as that of the Deluge or the Apocalypse but also developing unexpected maritime metaphors and drawing analogies to doll's houses—while others gave voice to a weird sense of humor inspired by the seemingly unprecedented incongruities that surrounded them. This book is intended to retrace some of the story lines that were advanced and images that circulated in the period.

[*Although I was only a small child and was not conscious of it then, I did live in some of the stories of the 1940s, the first decade of my life, and therefore I've felt occasionally inspired to include parenthetical asides in this book, drawing on my own recollections and experiences. Perhaps because I was a child in the period, stories of children in the 1940s may particularly have caught my attention and will appear in several sections of this book, but child protagonists and fairy tale*

motifs do indeed appear in a great number of sources. Meditating on the grim story of race relations in Europe and America of the 1940s also meant discovering some early sources of my own interest in the history of genocide and racial segregation, and specific stories of European Jews and African Americans are also present in several sections of this book.]

In putting together various readings of cultural work of the 1940s, I have loosely followed the model of *A New Literary History of America* in devising chapters that have a date as their point of departure. The dates range from 1945 to 1948, but each chapter may move backward and forward from these moments in time. Inside the book each chapter also has a longer heading associated with the date that serves as trigger for the exploration of its more general topic. Some chapters focus on a single work (a photograph, a film) others range more broadly across a variety of texts, issues, or cultural productions. I have attempted to include not only works published in English but also a good number of interesting German texts, some of which have not yet been translated into English. As far as possible, I have relied on sources from the period itself, noting occasionally how the impressions of that time were altered and adjusted later on, how such postwar stories underwent telling changes and revisions in subsequent years. In some cases, pursuing these often revealing revisions I have consulted manuscripts in various archives. I have also taken advantage of the possibility of researching the period with the help of digitized historical newspapers and thus found a surprisingly rich coverage of postwar population expulsions in American dailies and of the situation of black soldiers in the African American weeklies. I imagine a general reader for this book, not a scholar specialized in the postwar years.

The temporality of textual and visual sources is apparent in Chapter One, "Between the No Longer and the Not Yet: Peace Breaks Out Gradually in Central Europe," which presents several accounts and two photographs by Tony Vaccaro of the moment military action ceased and suggests the heterogeneous ways the end of World War II was experienced, with a partial focus on instances of diaries from 1945 that were changed in later years. Thus Ursula von Kardorff's *Berliner Aufzeichnungen aus den Jahren 1942 bis 1945* (Berlin Notes from the Years 1942 to 1945) and Erich Kästner's *Notabene 1945* were diaries that were dramatically revised for their publication in the early 1960s. The 1945 diary of an anonymous *Woman in Berlin* (first published in English in 1954) has some

telling variants in its republication and has been enmeshed in controversy about its authorship and authenticity.

In Chapter Two, "Malevolent Rectangles of Spectral Horror: A Photographer and His Subject," a striking, frequently reproduced photograph by George Rodger of a scene from a few days after the liberation of the concentration camp Bergen-Belsen, taken on April 20, 1945, and first published in *Life* magazine on May 7, 1945, is approached as a carefully composed image that is both shocking and eerily beautiful, then seen in its historical, cultural, and biographical contexts, with the different captions and interpretations it has received. Reading this photograph involves interpretive challenges and detective work and also raises ethical questions.

What followed the end of the war was also the dramatic time of "After Dachau: Of Private Vengeance, Collective Guilt, Life in Ruins, Population Transfers, and Displaced Persons," the subject of Chapter Three. Martha Gellhorn followed her 1945 reportage on the liberated camp of Dachau with a novel in which she imagined a private revenge plot against random members of a people deemed guilty collectively. James Stern described the posting of "guilt placards" in postwar Germany in a report he composed on the basis of his United States Strategic Bombing Survey. He contributed vivid metaphors to suggest the appearance of bombed cities, as did numerous other writers in the 1940s, among them John Dos Passos, Alfred Döblin, Max Frisch, and Gertrude Stein, while photographers from Tony Vaccaro to Robert Capa also highlighted particular motifs repeatedly. The Swedish writer Stig Dagerman and the British publisher Victor Gollancz were particularly effective in observing the miserable conditions prevailing in postwar Germany. As the military occupation regime began, at least 5 million people from many countries who had been uprooted by the Nazi slave labor machinery and an estimated 13 million East Germans who had fled the Red Army or were driven out from their homes were on the road and in camps, waiting for a political resolution of their situation while being held, relocated, prohibited to return to their residence, or repatriated. These topics were covered extensively in the British and American press, and the publication of eyewitness reports (by Robert Jungk and others) led to protests by the World Council of Churches and the Committee against Mass Expulsion. The little-known fiction writers Kurt Ihlenfeld and Gerhart Pohl attempted to represent stories of German refugees and expellees in fiction, whereas Zelda Popkin

focused on the fate of Jewish survivors in a Displaced Persons' camp near Frankfurt. The stories about just a few individual cases are read against the background of contemporary newspaper reportage on what may have been one of the largest migratory movements in human history.

At the center of Chapter Four, "Dilemmas of Reeducation: Karl Loewenstein, Carl Schmitt, Military Occupation, and Militant Democracy," is a confrontation between two political theorists, triggered by Loewenstein's request on October 4, 1945, to have Schmitt's library confiscated by the American occupation authorities so as to permit a full review of Schmitt's writings as a Nazi apologist. A theorist now often quoted by critics on the Left for his comment on the state of exception and his theory of space, Schmitt in his enthusiastic and perhaps opportunistic endorsement of the Nazi government apparently failed to recognize that Hitler was set on governing on the basis of the state of siege alone rather than of a new National Socialist constitution. What is the responsibility of an intellectual who is interested in what he describes as scientific theory but who lives and teaches in a tyranny?

In World War II, a racist dictatorship was conquered by a foreign army that had as one of its goals the eradication of racism among the defeated; yet the victorious army itself was racially segregated. In Chapter Five, "Are You Occupied Territory? Black G.I.s in Fiction of the American Occupation of Germany after World War II," novels by William Gardner Smith (who served in the U.S. Army), Hans Habe (who returned to Germany with the occupying forces), and Wolfgang Koeppen (who was exempted from military service in Nazi Germany because he worked as a scriptwriter), as well as short stories by Kay Boyle and Kurt Vonnegut, are read against the background of contemporary journalism (especially in the Negro press) and academic work. Differing postwar versions of fraternization, mixed-race babies, and the possible future of democracy emerge.

Chapter Six, "The Race Problem in the House on Lilac Road: Occupation Children and the Film *Toxi*," offers a close reading of the popular German film *Toxi*, about the daughter of a black G.I. and a German woman, that serves as point of departure for an examination of the way memories of the Nazi past intrude on liberal and antiracist sentiments in postwar Germany and how African American media wrestled with the issue of *Besatzungskinder*. The birthday of Elfie Fiegert, the actress who starred as Toxi, serves as the date from which this chapter unfolds, while the date of

the film's release takes the reader to the early 1950s and a feeling of the impending end of the American occupation.

"Heil, Johnny: Billy Wilder's *A Foreign Affair*; or, The Denazification of Erika von Schlütow," the seventh and last chapter, offers a close reading of an unusual, and unusually funny, postwar comedy. Working with a comedy plot Paramount had earlier acquired, Billy Wilder not only managed to create a surprisingly funny comedy against the background of ruins and denazification, starring Jean Arthur and Marlene Dietrich, but also an amazingly balanced film. While *A Foreign Affair* was released in America on August 20, 1948, the Information Control Division of the American Military Government vetoed its release in Germany so that it was exhibited there only in 1977. The brief Coda continues to explore the role of postwar humor and reviews a few examples of it, and the Afterword reviews some of the findings that surprised me in undertaking this study.

It should be obvious from these introductory remarks that this book does not aim for a comprehensive account of the period but for an inward understanding of a cultural moment through a close focus on a few particularly striking examples.

People's reaction on first seeing the G.I.s entering their town. Barby, April 12, 1945. *Photo by Tony Vaccaro/AKG images, File AKG_200158, picture reference 9-1945-4-18-A2.*

March 29, 1945

A village girl greets American tanks with a bouquet of flowers.

Between the No Longer and the Not Yet

Peace Breaks Out Gradually in Central Europe

> What we call the beginning is often the end
> And to make an end is to make a beginning.
> The end is where we start from. . . .
> Every phrase and every sentence is an end and a beginning,
> Every poem an epitaph.
>
> —T. S. Eliot, "Little Gidding" (1942)

When we speak of the end of World War II in Europe we tend to think of a fixed date, although people in different countries may be thinking of different dates.[1] On May 7, all German troops surrendered unconditionally, hence this day is celebrated as the end of the war in Commonwealth countries. Because the surrender took effect only on May 8 at 11:00 p.m. in Central Europe, this is the date remembered in Germany, Western Europe, and the United States. But since the late hour was already May 9, Moscow time, much of Eastern Europe considered this day the end of the war, all the more so since Stalin gave his victory speech then. Of course, the ambiguity as to which date is meant by "the end of World War II" extends further than just to the period from May 7 to May 9, for the war also ended at different times in many different places in Germany. In the West, Aachen was the first German city to surrender to the Americans on October 21, 1944; in the East, the concentration camp Auschwitz and the industrial killing center Auschwitz-Birkenau were liberated by the Russians on January 27, 1945; and well after May 9, there were still isolated

military actions in Holland and in Slovenia. Peace thus broke out gradually, and the famous "zero hour" (*Stunde Null*) actually extended over the course of more than half a year. It is not only the date that is unstable, but the end of the war was also experienced less uniformly than one might imagine. If our first association with "the end of World War II" is a photograph of the VE Day celebration in New York, we need to acknowledge the many different meanings that the phrase "peace breaks out" could have elsewhere in 1945. Witnesses at the time may indeed have experienced the moment as the final, long-awaited liberation from a concentration camp, from physical enslavement, or from living under a dictatorial regime, but it may also have appeared to others as a time of great uncertainty, as the frighteningly total collapse of a country that had already seen its cities destroyed by heavy bombing, or as nothing but the beginning of a new cycle of violence.[2] Still others may have been overwhelmed by the new suffering brought about by mass expulsions and the establishment of communist rule in East Germany and Central Europe. Whole collections of diary entries and letters of the war and the immediate postwar moment have appeared in print, including Walter Kempowski's massive *Echolot*, and numerous archives hold even more documents that have never been published.[3] Many show the complexity of the war-ending moment.

Liberation

Ernst Schneider, a grade school teacher in the Hessian village of Schönberg, kept a diary through the war and postwar years. He witnessed some pretty terrible scenes near the end of the war—treks of thousands of enslaved laborers who could barely walk anymore, a train that seemed to be armed with a secret weapon sitting in the Kronberg station, the departure of the village's thirteen-to-fourteen-year-old boys as the last *Volkssturm* reserve for the army, occasional bombings, the fearful expectation of final military actions, and life without electricity or gas. But Easter week 1945 brought an end to much of that, and he wrote in his diary: "Maundy Thursday, afternoon, the first Amer. troops (some tanks) arrive in Oberhöchstadt, shoot along the street with machine guns. Priest [Richard] Keuyk walks toward them in his robe, assures them that they will not be met by any hostilities, goes to the school square with them, and already the villagers come forth. . . . On the same day, the first Americans (*Tanks*

[he uses the English word]) appear in Kronberg. A German girl greets them with a bouquet of flowers." On Good Friday and on Saturday the teacher still hears gunshots (SS troops have hidden in the forest), but on Easter Sunday, April 1, 1945, everything is peaceful. "A mass is held again. A true resurrection celebration" ("Ein echtes Auferstehungsfest!").[4]

The full weight of that same moment that separated war from peace in the village becomes more apparent in Priest Keuyk's undated but clearly retrospective memoir. He describes the encounter with two German-speaking G.I.s who come toward him, submachine guns in their hands. One tells him, "For German soldiers the war is over." ("Für den deutschen Soldaten ist der Krieg zu Ende.") The priest adds that, even from his retrospective vantage, he can still hear the sound of the words *zu Ende*—it seemed so unbelievable after all those war years. But the situation gets tense when the soldiers ask whether there might be snipers in the village and threaten that if one single shot were to be fired the whole village would be mowed down. Fortunately, everything remains peaceful, and the priest writes, relieved:

I believed I felt the breath of liberation from an unbearable yoke. When I looked out over the growing crowd of villagers, I saw white cloth being hung up in many windows as a sign of surrender. The Americans were no longer our enemies but our liberators.

The crew of a newly arrived tank "entered a conversation with the population. They were German-Americans whose fathers had come from the area around Frankfurt and had emigrated to America. Some soldiers inquired about the homeland of their fathers, and the priest had to pose repeatedly for photographs. . . . For German soldiers the war was over, the American soldier had explained to the priest. For the town of Oberhöchstadt the war was over on March 29, 1945."[5] It was appropriate for a Christian teacher and a Catholic priest to merge the Easter week celebration of Christ's resurrection with the sense of political liberation that the arrival of American troops brought to a village. And it was a village that saw the transition take place in a nonviolent, downright peaceful way.

A very full sense of liberation was experienced by victims of National Socialism. Thus on April 1, 1945, Anna Kaletska, a Jewish woman from Poland who had survived Auschwitz working as a slave laborer, was on an

SS-ordered march to Bergen-Belsen and had just been driven out of Lippstadt. Then she heard the rumbling of American tanks and shooting, as she reported her experience to the Latvian-American psychologist David P. Boder, who recorded the stories of more than a hundred Displaced Persons in 1946 on wire recordings that still exist and have since been digitized.

Anna: Shooting, [*with joy in her voice*] Americans! They are shooting at us, and here we are, together with the SS men, lying under the trees. The bullets whistled. [*She uses the expression - bullets burned.*] And we laughed—crazy of us. The SS men stood around. They were no heroes anymore. They don't know where to run. Only five minutes before, they wouldn't run away. They could not leave us alone. They still believed in the Führer. And now they were standing with their arms down. They were still ordering to go to the "shops," but nobody went. We remained lying down right there. The Americans fired three times, and then a silence came over us. An aeroplane came down at low altitude, and a white flag [*here she sobs . . .*] was spread out.

Boder: What do you mean, a white flag?

Anna: The Germans raised a white flag. The name of the town is Kaunitz, in Westphalia near Lippstadt, twenty-seven kilometers from Lippstadt. And here we were, almost crazy. We haven't a strip of a white thing. Somebody had a bandage around a wounded leg, and that bandage was raised at an approaching American tank, and the women prostrated themselves on the ground, kissing the wheels. The Americans thought it was a house of the insane. They looked at us. . . . And how we looked! All in tatters. [*Her words are barely audible.*] And speaking—nobody could. We were all speechless. And then he understood, and two tears rolled down his face. [*. . . the text is not clear, she is very upset.*] And until the others arrived, he wept with us. Not a Jew—a Christian. And then they began to arrive, the tanks. It was Passover. The last day of it. And matzos fell from the tanks. . . . And chocolate and cigarettes. And they would jump off the tanks and they were kissing us. Us dirty and lousy ones. "Do not weep," they would say. But we wept more and again.

And incessantly the tears ran. The Ninth Army had not seen any Jews in Germany, and we thought that we were the only Jewish survivors, and we did not want to live. But they consoled us. They were telling us that there were many other armies that have reached other camps which were liberated. That was liberation.[6]

Anna Kaletska thus describes an extraordinarily high point of liberation, from years of living on the brink of death, and it takes place during the Passover holiday, with matzos falling from American tanks. Yet at this moment, believing her group to be the only Jewish survivors, she also expresses the wish not to live anymore. The interview was held in the rehabilitated synagogue in Wiesbaden on September 26, 1946, on Rosh Hashanah, and she ends her conversation with somber reflections on the nature of holidays by a lonely survivor: "Where are all mine, who used to celebrate the holidays with me? . . . my own people are no more. I am alone." David Boder made that last sentence the heading under which he published the interview in 1949.

The Eternal German Dilemma

The moment of the first arrival of an American tank in German towns was photographed by Tony Vaccaro near Paderborn on April 5, 1945, the white flags in clear view in a couple of windows, and about twenty G.I.s atop their tank in impressively casual poses, a few of them with cigarettes dangling from their mouths. They seem to be carefree, and only a couple of them are bothering to look up at the windows, out of one of which an old woman is watching the tank, holding a white sheet, towel, or pillow case in her right hand. The gasoline flowing out of the fuel-cap-less tank seems to provide a coincidental demonstration of the superior supplies of the U.S. Army.

In another photograph of the moment of dramatic change in a town near Magdeburg, taken on April 12, 1945, the focus is on four persons standing in a doorway and looking out at the (unseen) Americans, three partly obscured women and a fully visible man who is wearing a striped suit and a hat and holding what looks like a white flag wrapped around his hand or fist (see the photograph facing the opening page of this chapter).

U.S. troops capturing a German town during the advance in the direction of the Elbe. A tank rolls down a street where residents have hung white towels out of the windows. Near Paderborn, April 5, 1945. *Photo by Tony Vaccaro/AKG images, File AKG_308741, picture reference 9-1945-4-0-A13-1.*

Should he unfurl the white flag or not, he may be asking himself. Vaccaro commented: "This is the look of Germans upon seeing Americans for the first time, taking their village. They just opened the door as I clicked. And that's the look: 'My God. They are here!'"[7] Whereas the three figures standing in the door opening are staring to the right, from where the Americans must be arriving, a young woman behind the window grate in the doorframe appears to be looking straight at the camera. Her gaze identifies the photographer as a participant rather than as merely an unseen witness or observer, but it is now also eerily directed at *us* as viewers of the photograph. Tony Vaccaro was wearing an American uniform at the time he took the picture. A young, orphaned Italian-American soldier with pacifist leanings, who had been maligned as an American in a school in Italy, then called a fascist in an American school, Vaccaro took thousands of photographs of the end of the war and of the occupation. He represents what is literally a threshold moment, and the fact that the Americans who are taking the town are not visible makes the situation's open-endedness all the more apparent. One can only guess from the tense expressions on their faces what these Germans' reactions to that moment might have been.

There were many causes for Germans to worry. Might a period of conflicting formal and informal rules or of unpredictable lawlessness, of anomie, be following?[8] Did the arrival of troops really mean the end of the war, the end of danger, or was it just a temporary and treacherous interruption of things?[9] Showing a white flag too early could be terribly dangerous. Thus one account of the end of the war in München mentions a pensioner, Franz H., who put out a white flag and was picked up in his apartment by Werwolf members and hanged on a traffic sign by the belt of some window blinds; the louver belt broke, however, and so he survived.[10]

Scenes of such perilous uncertainty repeated themselves. Thus on Tuesday, April 24, 1945, at 5:00 p.m., in Jettingen (not far from Augsburg), the journalist Ursula von Kardorff saw a woman hurrying into her garden who said, "They are already at the station, and the white flag is waving on the church." She ran up to the attic with neighbors and also hoisted a bed sheet, and there was universal joy in the village—when the neighbor reappeared with different tidings: "Too early the rejoicing! The flags must be taken down again." The reason was that the SS had arrested and detained the mayor, the head of the police, the head of the party, and the priest, who had all favored surrender. "The SS is now the worst enemy, more threatening than the Americans who are conquering us," Kardorff confides to her diary and adds that she heard that the SS accused the mayor of cowardice and at first wanted to shoot him immediately, but then decided to take all four prisoners to the next village. "When they learned that the American tanks were really arriving, they let their prisoners go who were white as chalk, having escaped death by a hair's breadth."[11] A little later an Allied announcement threatened that anyone who resists will be shot. "I find that completely justified, but it is still depressing," Kardorff commented, and she also noted a French soldier furthermore mocking her for belonging to the "grand nation that hoists the white flag" (311).

Kardorff's vivid diary records the end of World War II, as experienced in the small village where she had sought refuge from Berlin. During the Nazi years, she worked as a cultural journalist for the *Deutsche Allgemeine Zeitung*, but was also close to the German resistance movement and the plotters of July 20, 1944, who attempted to assassinate Hitler; reportedly, she was interrogated twice by the Gestapo.[12] After the war she became a prolific writer of books about traveling, entertainment, and fashion and

also contributed an afterword to the German translation of a novel by Anita Loos. Her wartime diary gives full expression to the ambivalence that a person who thought of herself as an opponent of Hitler but also as a conservative German nationalist could feel toward the arrival of foreign troops on German soil. She gave her diary its shape in 1947 on the basis of notes and writing in code—for it would have been crazy and dangerous for her and her friends to keep such a diary during the years of the dictatorship.[13] Since her diary was published only in 1961 she also took the opportunity of preparing the text for publication to smooth out some of the more contradictory feelings she had consigned to paper in 1947. A posthumously published critical edition of 1992 restored some of the original observations.

On April 12, 1945, for example, she wrote: "What I loved no longer exists, the ideals have been reviled, the friends have fallen or were executed, the churches, the cities, the places of the most beautiful memories burnt." She originally continued with the following sentence, which was omitted from the text she published: "And when the others [the Allies] with their unmeasured hatred make their horrifying accusations, one has to be silent, because it is the truth." Hence the conclusion to her three-sentence entry was missing this important middle part when she first published it: "What should one still desire, what believe in, against what hold oneself upright?" (306). In the scene with the hoisting of the white flags she originally wrote about the Americans arriving: "Our new slavery is starting" (312n2), which seemed no longer appropriate in 1961. At the end of a futile discussion with a French officer about German guilt, when she explicitly refused his sympathy, she thought of her younger brother Jürgen, who had been killed on the Russian front, and expressed her own sense of being tempted by despair: "Sometimes I think that Jürgen has chosen the better part" (316). Yet her original diary continued with a reaffirmation of her will to live.

In her published diary Kardorff again confesses to guilty reactions to the Allied news reports on April 20, 1945, when she writes on "Hitler's birthday!" (as she emphatically points out): "Party bosses are committing suicide, well more than half of Germany is occupied":

The discovery of the concentration camp Oranienburg provokes unimaginable horror among the Allies. I hear it on the British

radio. What is being discovered now must be horrifying beyond measure. Even we in Berlin who learned much and guessed even more are speechless. Our imagination has turned out to be insufficient. (307–8)[14]

The manuscript of the diary reads rather differently:

> Bombs day and night. Oranienburg! The discovery of concentration camp atrocities appears to provoke the deepest horror. What horrible chaos, Heaven, have guilt and crime ever been avenged as quickly? There is a wrathful God. But I place my hope with confidence in his hands, the only way to endure these tensions. (309n3)

Confronted with the Allied "propagandistic exploitation" of the atrocities, she only regrets that the plans of the July 20 resistance were foiled, for its success would have permitted Germans "to wash this stinking-dirty laundry on our own. What a shame!" (309).

Kardorff quotes a Berlin-accented soldier who says that the war is ending like a horse race: "The horses have long returned to their stables when a man appears with a bell and rings it for the victor. That's where we are now" (306). She is glad that Nazi rule is done with, but she cannot warm up to the term *liberation* (*Befreiung*). After being lewdly propositioned by G.I.s and interrogated by a well-nourished Captain Herrell, who wants to find out whether she is a "good German" by asking her about membership in more party organizations than she ever knew existed, making her feel as though she were dealing with the Gestapo once again, she writes: "A strange feeling to be classified in such a fashion. I don't care in the least to have been, in their eyes, 'a good German.' They cannot simply measure the degree of our goodness or badness retroactively as though with a thermometer!" "So that is defeat," she concludes, as Germany's unconditional surrender is about to take effect. "Thoughtlessly, we had imagined it differently, that is to say, had not imagined it at all. Anything, anything at all had to be better than Hitler. But liberation? A strange word" (324). She ends the published entry for May 9 by contrasting the playing of victory hymns and ringing of bells around the world with her own situation: "We have lost the war. But had we won it, everything would be even more horrible" (324). This, too, was an emendation for publication, and the manuscript

version is far more ambiguous: "Why do we always have to lose wars . . . If we had won the war . . . Both equally horrifying. The eternal German dilemma" (324–25n2).

Between the No Longer and the Not Yet

Another 1945 German diarist, the children's book author, critical jour-nalist, and script writer Erich Kästner, most famous for his books *Emil and the Detectives* (English trans., 1930) and *The Missing Miniature* (En-glish trans., 1941), found what may be a perfect theatrical metaphor for reacting to a moment of both great change and great uncertainty. "People are running through the streets, worried. The short interruption in their history lesson makes them nervous. The gap between the no longer and the not yet irritates them. The stage is lit but empty. Where are the ac-tors? Won't the play go on?"[15] This is what Kästner's diary *Notabene 1945* (published in 1961) reports for May 7, 1945, but in his original diary the passage reads rather differently: "All are running around worried. The radio makes accusations of the German people for having allowed con-centration camps."[16]

Kästner's books had been burned and banned by the Nazis, but he continued to publish children's books and was given special permission by Minister of Propaganda Joseph Goebbels to work on the scripts for the films *Münchhausen* and *Kleiner Grenzverkehr*, though Kästner's name could not appear in the credits. He was an intellectual opponent of Na-tional Socialism who did not leave Nazi Germany, yet when he published his 1945 diary, he felt the need to omit the reference to the Allied accusa-tions which gave the people's worried running through the streets a much more specific context than the memorable aperçu that, however, perfectly defines the moment peace breaks out. What the quip "between the no longer and the not yet" with its empty-stage setting replaced gives it per-haps even more depth: it is as if Kästner himself had cleared the stage, and cleared it of the accusations one could hear on the radio.

It is interesting that both Kardorff and Kästner made such deletions and substitutions that later editors of critical editions had to restore. Käst-ner's 1998 editors comment that out of the rather simple original a stylis-tically enhanced and considerably expanded diary was created that has in

some stretches even a remarkable literary character (710). Yet with all that revision, Kästner did not offer an introspective analysis of his own entanglement in the Nazi system (711). On the contrary, in the revising process he strengthened the passages that emphasize the shared guilt of the Allies and complain about the suffering of the German population (711).

As early as February 12, 1945, Kästner had commented on Nazi propaganda about Russian rapes by reporting, with an odd sense of humor, how German women had reacted to the news: "The women did not doubt that such things are happening and could also be happening in Berlin very soon." Yet the women deny the importance ascribed to this matter: "The forced sexual act, whether committed in times of peace or of war, remains a subcutaneous process, and not the worst. A bayonet in the body is worse." Kästner also hears his wife's hairdresser put it more coarsely: "Better a Russian on your belly than a broken house on your head!"[17] In an entry on the anniversary of the burning down of his own Berlin apartment as the result of bombing, Kästner reports the event through the eyes of his mother, who wants to see exactly what is gone—"The piano, too?" she asks, and "also the carpets?"—before standing in the familiar courtyard for a long time, "looking expressionless into the vacant air above," the space that had once been taken by Kästner's apartment (37–38). In a cabaret skit inspired by his diaries, Kästner again chose a semicomic, black-humor way of representing the result of the firebombing, this time from the point of view of a phone call by a "hetaera" who ends her comic account by mentioning that all that remained of her entire apartment building was a glass bowl filled with pudding that had been sitting on a balcony and was found intact in a courtyard three houses down the street.[18]

On April 21, Kästner reports (on the basis of a radio broadcast, his editor surmises) that the concentration camp Buchenwald has been liberated and that the Americans have forced the party members of nearby Weimar to view the camp. "When they saw the half-starved inmates, the crematoria, and the piled-up skeletons many visitors reportedly fainted" (99).[19] On May 2, 1945, Kästner, who had meanwhile fled from Berlin to the Austrian town of Mayrhofen, reports a conversation with two friendly German truck drivers who have horrible news to tell, about "the shooting of Jews in Russia and Poland, and especially of the beautiful girls and young mothers whom one would have never recognized as Jewish. And about

how they, Willi and Alfred, had been eye and ear witnesses to the neck shots and to the riddling by submachine gun bullets of the half-dead and totally-dead who were lying in ditches" (118–19).[20] The passage was only slightly changed from the diary manuscript, though Kästner added for publication the sentence: "Occasionally, one or another of the shooters turned insane right there and then." In neither version does Kästner report his own reaction to hearing this report.[21]

The arrival of the first Americans takes place rather uneventfully in the night of May 5, 1945, the tank drivers and machine gunners smoking and letting the townspeople marvel at them, whereas the first Negro soldier, a gigantic, cigarette-smoking figure who gives an English-accented Bavarian "Grieß Gott" salute, makes a stronger impression on Kästner (153). Kästner soon tries to get back into writing and publishing, becomes the cultural editor of the U.S. Army's German-language paper, *Die Neue Zeitung*, and runs into old friends like the writer Wolfgang Koeppen and the film directors Robert A. Stemmle and (in American uniform) Billy Wilder.

Guilt and Innocence

Though Kästner did not react to the truck drivers' eyewitness report, the question of German guilt or innocence is repeatedly addressed in his published diary. In a long entry on May 8, largely added for publication, Kästner on the one hand mocks the claiming of their innocence by Austrians, by all Germans south of the Main river, and even by Hermann Göring himself, who asserts that he had been sentenced to death by Hitler and arrested by the SS. "Innocence is raging like the plague," Kästner comments sarcastically (147). On the other hand, Allied complaints that the "other," the good Germans, should have overthrown Hitler's rule on their own ignore the Allies' own complicity with Hitler: "The victors who seat us on the defendants' bench must sit next to us. There is room" (146). What follows is a whole series of rhetorical questions asking Allied "Pharisees" just *who* made treaties and concordats with Hitler, sent delegates to the Olympics in Berlin, and shook hands with the criminals rather than the victims—questions that he answers with "Not us," and the reminder that "the 'other' Germany was the country occupied and

tortured first and longest by Hitler," giving the Allies no right to throw the first stone since they are the ones who are living in the proverbial glass house (146).[22]

By contrast, Wolfgang Soergel, a German prisoner of war in a camp in Scotland, at about the same time expresses a strong sense of German guilt that he believes it would take a Sisyphean task to address forever after. The excerpt is from a diary entry of May 8, 1945:

> At the end of April British troops freed Nazi concentration camps, the British intelligence officers are giving gruesome reports. The worst kinds of criminals have been arrested, the photograph of the commander [Josef Kramer], the "beast of Belsen," is attached to the information board, a vile, despicable face. The reality is much worse than the whisperings and mutterings of the last months. The gates of the underworld are opening up. Lying on the ground is not an honorably defeated opponent, for we are regarded as a gang of murderers whose masks have been torn off. Blood, choking torture, skeletons, and mass death leave their tracks behind the defeated troops of the Reich. No cry for mercy will help when ears were deaf and eyes were blind. Accused are all Germans, from the youngest to the oldest member, on all of whom the fate of Sisyphus is now imposed, to have to try in futile agony and contrition to roll the stone of our guilt up, again and again, always in vain, since there can be no forgetting.[23]

Soergel's end-of-war comment was prophetic. How to react to the revelations of the atrocities (*Greuel*), how to respond to explicit and implicit collective accusations, did indeed become questions of central importance in postwar Germany. There was no forgetting, and simple assertions of innocence or ignorance, though they were often made, proved quite insufficient.

Defeat, Defiance, Defeatism

In the first half of 1945, Germany was, of course, militarily defeated. That invited comparisons with past military defeats. In 1939, the conservative

writer Ernst Jünger had published the dystopian novel *Auf den Marmorklippen* (On the Marble Cliffs), featuring the figure of the *Oberförster* (head forester), a haunting, seemingly banal and ordinary but really ruthlessly tyrannical character who was well understood by his readers as a timely allegory for Hitler or Stalin. On April 11, 1945, in Kirchhorst (near Hannover), Jünger looked back to the Napoleonic wars and to World War I, when he wrote in his diary:

> One does not recover from a defeat such as of Jena or Sedan. It signals a shift in the peoples' lives, and not only do countless people have to die but also that which moved us in our innermost selves goes under in this transition.
>
> One can see, understand, want, and even love what is necessary and yet be imbued with enormous pain. One has to know that if one wants to understand our times and their people. What is birth pang, what agony in this game? Perhaps both are identical, just like sunset is also sunrise for new worlds.
>
> "Defeated earth makes us a gift of the stars." This saying becomes true in an outrageous sense, spatially, spiritually, and extraterrestrially. The most extreme effort presupposes an extreme, still unknown goal.[24]

The pain of anticipating defeat could also stir feelings of national honor. On Sunday, April 5, 1945, the agricultural teacher Elfriede Jahn wrote in her diary: "Last night the Führer reportedly spoke—still full of confidence in victory,—when you see hundreds of tanks + vehicles of Americ., you can hardly believe it. . . . As a German—not as National S[ocialist], I still hope for a reversal of fortune. —Fichte's saying came to my mind today as I drove through the village and saw all the white flags, symbols of humiliation—'Unworthy is the nation that does not wage everything on its honor'—that's not to say that I must fight like a 'Werwolf' from an ambush, but I am fighting for my German character and custom by gestures and behavior toward the enemy."[25] Could the tense expression of the man in Vaccaro's photograph have embodied such a gesture of spite rather than mere worry?

Defeatism could also always move in the direction of absolute despair, and some of the entries for April and May in Kempowski's collection

Echolot consist simply of cemetery logs in Berlin listing women and men who committed suicide in those days, mostly by poison or by revolver (197–98).

Conquest

That moment at which war ends, that moment of dramatic and unpredictable change that could mean so much to the ordinary inhabitants of a village or town, and so much more to the surviving victims of Nazism, the moment that generated ambivalence in Germans opposed to Hitler and worries for the future among soldiers, and prompted writers to revise their initial responses for publication, was only a way station for many American soldiers. The Syracuse physician Sydney Stringer, for example, who was called to active duty in 1941, entered Germany from France at about the same time that Schneider, Keuyk, Kaletska, Kardorff, and Kästner had chronicled and that Vaccaro had photographed. In a letter to his wife, Helen, on March 28, 1945, Stringer writes: "Finally we came to a little village where white sheets, towels, pillow cases—anything to look like a flag of surrender—were hanging from blown out windows. The . . . desertion, the white flags and a few unsmiling people gave us a clue. We knew we were in Germany."[26] (Again, one thinks of Elfriede Jahn's promise to show her defiance in "gestures and behavior toward the enemy.") In another letter, Stringer describes the uneasy encounters with the populace: "Frequently we would get a glare of utmost hatred from passers-by and hear the curses being called on our heads through mumbling lips. It is a peculiar feeling to walk through a conquered city—combined curiosity, fear, interest and wide-eyed amazement" (245–46). On March 29 Syd Stringer comments on the food supply given to the soldiers: "Can you imagine being inside an invaded foreign country, Germany, at long last lining up on a chow line and getting pork, roast beef, corn, beans and white bread? It is too good to be true" (245). And on Easter 1945, when Schneider thought of resurrection, Stringer reflects: "I realized as I awoke that this is Easter Sunday. . . . All day long streams of refugees pass along the road. They are of all nationalities—former slave labor making their way west after being freed by our troops. I can't comprehend a situation like this. To see some of them go for the garbage pails was proof of constant hunger" (247–48).

Rape: *A Woman in Berlin*

Having made up my mind to hope no more, I got rid of a great deal of that terror which unmanned me at first. I suppose it was despair that strung my nerves.

— Edgar Allan Poe, "A Descent into the Maelström"[27]

What may well be the single diary from 1945 that reached the largest international audience was a book whose authenticity has been questioned. First published anonymously in 1954 in an English translation by James Stern under the title *A Woman in Berlin*, it is a German woman's diary, dated April 20 to June 22, 1945, particularly literary, and rich in references as well as in frighteningly vivid representations of the end of the war. Harcourt, Brace and Company launched an advertising campaign for it and provided a somewhat lurid cover of a déshabillée female figure outlined in white against a fiery red sky and seemingly growing out of a small photo silhouette of ruined Berlin, her knees blending into the columns of Brandenburg Gate. The Ballantine Books mass market paperback, published in 1957, kept the cover design but added the logo "So frank that the author cannot reveal her name" and the capsule summary "April 1945. . . . A woman's night-by-night account of how the Russians ravaged a city—and its women." (See the figure displayed on the facing page.)[28] The book reportedly sold half a million copies and was translated into Finnish, Swedish, Norwegian, Danish, Dutch, French, Spanish, Italian, and Japanese, and its first German edition came out in 1959. The second German edition of 2003 led to much public interest and debate, followed by a new English translation by Philip Boehm in 2005 and a mediocre 2008 film adaptation, directed by Max Färberböck.

Germany's capital was taken by the Russians, whose approach differed from that of the British and the Americans, and the city was not evacuated before that last, bloody battle in which an estimated forty thousand Soviet soldiers lost their lives.[29] Though rapes were not unheard of among other Allied soldiers, in the advance of the Russian troops toward Berlin they were commonplace—the staggering numerical estimate of 2 million rapes, 100,000 in Berlin alone, defies the imagination—and "rape" became one of the first associations with the phrase "Red Army in Germany 1945."[30] Russian soldiers' diaries from that time are rare, but in his long

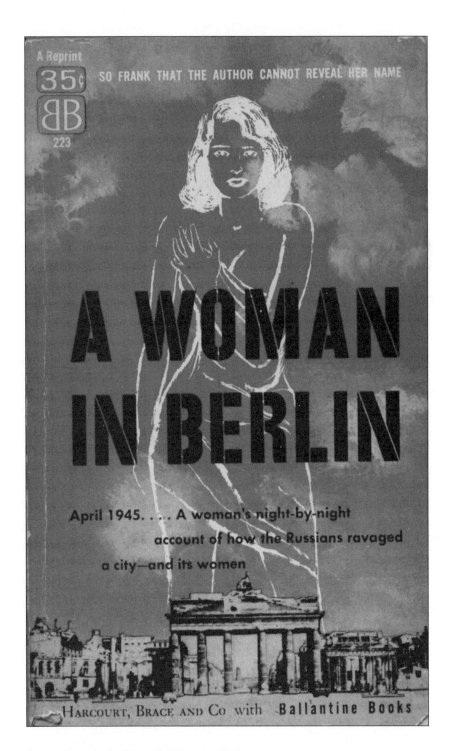

A WOMAN IN BERLIN

April 1945. A woman's night-by-night
account of how the Russians ravaged
a city—and its women

HARCOURT, BRACE AND Co with Ballantine Books

Cover of paperback edition of *A Woman in Berlin*.

ballad-like poem *Prussian Nights*, Alexander Solzhenitsyn, who was in the Red Army in 1945, represented decades later a poetic persona in the first-person singular who witnesses gang rapes and looting in East Prussia as well as killings, including that of a German communist even though he happily greets the Russians, for whom he says he has waited during the twelve years of Nazi dictatorship.[31] N. N. Nikulin, who later became an art historian at the Leningrad Hermitage, also was a soldier in the Red Army's advance onto Berlin. He describes in his memoirs the propagandistic agitation of the troops before entering Germany, their enormous consumption of alcohol, and weirdly funny as well as horrifyingly violent scenes that he witnessed, including rapes and a murder.[32] Bertolt Brecht, who had spent the war and early postwar years in the United States, followed by one year in Switzerland, arrived in East Germany in 1948. He noted soon thereafter in his work diary that "still, after these three years, the workers are, I hear it generally, trembling with the panic caused by the looting and raping following the conquest of Berlin. In the workers' neighborhoods the people had awaited the liberators with desperate joy (*die befreier mit verzweifelter freude erwartet*), arms were outstretched, but the encounter turned into an attack, which did not spare the seventy-year-old or the twelve-year-old and took place completely in the open."[33]

A Woman in Berlin, obviously composed by a well-educated, even erudite author, offers the fullest account of the arrival of the Russians in bombed-out Berlin. "Woman" or "Anonyma," the narrator of the diary, knows Latin, Russian, French, and English; invokes Aeschylus; and remembers the Spartan Leonidas.[34] She quotes Horace (*Si fractus illabatur orbis, / Impavidum ferient ruinae*) and the Vulgate (*noli timere*) in Latin; employs Hobbes's formula of *homo homini lupus* twice, and also refers to Russian rapists as wolves.[35] She prefaces her diary with an epigraph from Shakespeare's *A Winter's Tale*; thinks of Martin Luther's Wittenberg theses starting a revolution (April 22); discusses Pushkin with the Russians (April 30); reads Tolstoy's *Polikushka* for the umpteenth time (June 15); and secretly nicknames one of the Russian soldiers Alyosha after Dostoyevsky's *Brothers Karamazov* (May 2).[36] She adopts Nietzsche's maxim, "What doesn't kill me makes me stronger" / *Was mich nicht umbringt, macht mich stärker* (April 26); cannot sink her teeth into Joseph Conrad's *Shadow-Line: A Confession* because she has too many images in her own head (May 12); considers some of her own observations a small footnote to Oswald

Spengler's *Decline of the West* (April 29), a book she once dismissed with *Macbeth*'s phrase, quoted in English, as "a tale told by an idiot, full of sound and fury, signifying nothing" (June 13).[37] And she measures her own experience against Knut Hamsun's *Hunger*, a book that someone stole from her because its wrapping made it look as though it contained ration cards—a story, she writes, Hamsun would have appreciated (April 20).[38] She ironically compares the posture lewd Russian soldiers assume when they propose sex in return for bacon and eggs with the poses of Raphael's angels (May 28).[39] In addition, she refers to Cassandra, Casanova, and Candide; plans to participate in a publishing venture that will bring out books by Maxim Gorki, Jack London, Jules Romains, and Thomas Wolfe that had been banned in Nazi Germany; and mentions Mörike, Eichendorff, Lenau, Rilke, Hauptmann, and Goethe (from whose *Faust* and "Wanderers Nachtlied" she also quotes).[40] And though she does not acknowledge the source, she reports approvingly one of Lenin's sarcastic quips about German revolutionaries that "German comrades would storm a railroad station only if they could first of all buy platform tickets" (May 8).[41]

There may be more literary references in *A Woman in Berlin* than in any other writer's diary of the period, certainly more than in Kästner's or Kardorff's. And, unlike the other diaries from 1945 that I have examined, in which, even with much revision, a sense of random, daily observation prevails, this anonymous diary also has numerous passages of foreshadowings and backward glances, recurring rhetorical devices, structural elements, and leitmotifs as part of a continuous narrative structure, in the course of which the narrator and her city are transformed. It thus has aspects that are reminiscent of an epistolary novel or a prose drama.[42]

A Woman in Berlin has a clear beginning section (April 20 to April 26, 1945). The fact that April 20, the day the diary starts, was also Hitler's birthday has been forgotten by most neighbors, who refer to Hitler by the code name "that one" (*Jenner*).[43] The narrator describes the setting, a partly damaged residential block, probably in Neukölln or Tempelhof, where she has found shelter after her own building was destroyed by bombs. She introduces an extensive cast of characters in the neighborhood who are in anxious expectation of the end of the war, but it is clear that the social fabric has begun to disintegrate, and looting has become common. The second section (April 27 to May 8), also clearly demarcated, brings conflict and action as the Russians arrive and commit numerous rapes, including

multiple rapes of the narrator. In this situation, the narrator, who now lives with a widow and a Herr Pauli, decides to find a Russian protector—a "wolf"—to fend off the other soldiers, and she enters an alliance at first with the somewhat simple Ukrainian officer Anatol and later with an un-named major of whom she actually begins to become fond. In the third section (May 9 to May 30), which is also clearly set off and coincides with the moment Germany's unconditional surrender takes effect, the Russian attacks stop, she can finally sleep alone again, and she begins to look for work. On May 16 she meets the kind and well-educated Russian lieuten-ant Nikolai, who soon helps her and her neighbors, and she has many conversations with him, some in French. She takes longer walks in the destroyed city, begins to take part in hard labor, and performs difficult cleaning and laundry chores. Exhausted, she also once expresses a wish for religious support, for "manna, spiritual nourishment" (May 28).[44] The fourth section (May 31 to June 15) gives full expression to her excruciat-ing physical hunger on the insufficient food rations she receives for her hard work after the Russian protectors are gone. She feels like a "walking-machine" going to and from work; she also joins a Hungarian in a plan to start a new publishing house. In the fifth and shortest section (a single entry that is dated June 16–22), her fiancé, Gerd, returns from the war, is horrified by the strange humor of the narrator and the other women, and soon leaves her again.

The book's literariness thus extends far beyond the many explicit quo-tations and literary allusions; it is apparent in the carefully worked out structure and asserts itself immediately in the synesthesia of the often-noted first paragraph, dated April 20, 1945 and captioned "Chronicle begun on the day Berlin saw battle for the first time" (a caption that appeared on a separate title page in the 2003 German edition):

No doubt about it, the war is rolling toward Berlin. What yesterday was a distant rumble is today a permanent roar. One inhales the noise of guns. The ear is deafened; all it can hear is the firing of the heavi-est artillery. It can no longer detect the direction. We live in a circle of guns which contracts by the hour. (April 20)[45]

The journalist and critic Jens Bisky approached this opening skeptically and found that it reads like a film script, whereas the scholar Daniela

Puplinkhuisen offered a close, appreciative analysis of this passage, calling attention to the conflation of breathing and hearing in it, with the loud volume of the noise interfering with the narrator's ability of perception.[46] At the same time, this beginning suggests the situation of being encircled, surrounded, and trapped, thus foreshadowing well what is to come.[47] Similarly striking passages that appeal to several different senses and resemble modernist stage directions recur throughout the diary and structure it.[48]

The narrator's strong prose renders the grim spring setting—"Through the fire-blackened ruins the scent of lilac comes in waves from ownerless gardens"—as well as the fear of the Russians' arrival: "The word 'Russians' is no longer mentioned. The lips won't pronounce it" (April 20).[49] The topos of unspeakability recurs, directed by the narrator against her own attempt at describing the destruction of Berlin—"Poor words, you don't suffice" (May 10)—or offered by her instead of a response to hearing the story of a redhead whose lips were so bruised that they looked like a blue plum and whose discolored breasts were full of bite marks after she had been raped by twenty soldiers who stood in line for her: "There's nothing one can say—and we didn't try" (May 6).[50] Literary devices and unusual metaphors extend into, and define, the action of the narrative: thus, in fear, the narrator's heart beats in "syncope" (April 21), the prearranged knock at the door is a "violent dactyl" (April 29), and when the residents are cut off from outside information by newspapers or radio, the substitution of news by rumor and gossip is described in terms of the classical allegory of *fama*, which the narrator always imagined "as a veiled, murmuring female figure, Rumor. We feed upon it" (May 2).[51] Life itself seems to have become a genre, and the story of a young girl hiding under a chaise longue on which Russian soldiers were sitting, whether truth or fiction, makes the narrator comment: "We live these days in cheap novels and penny thrillers" (May 2).[52] The further employment of irony, anaphora, euphemism, emphasis, rhetorical questions, similes, reification, apostrophe (to herself, to her imagined reader, to her fiancé, Gerd), of clipped sentences and sentence fragments, of alternating past and present tense makes *A Woman in Berlin* a text that one could explore exclusively for its formal devices.[53]

The book's literariness and the narrator's verbal control form a counterpoint to the horrifying events represented, especially in the second

section, covering the period from April 27 to May 8. At the same time, however, these literary devices may intensify the reader's experience of the narrated events. Thus the narrator's changed sense of time is rendered in striking images of living in an unfamiliar limbo of timelessness: "I fig-ure that that day was Sunday, April 29. But Sunday is such a civilian word, meaningless at the moment. At the front there is no Sunday."[54] Or in an even more striking metaphor: "It's a strange life this, without newspapers, without a calendar, clocks or watches—a timeless time running on like water, with men in foreign uniforms as our only hands of time" (May 7).[55] Imagining Russian soldiers as the hands on her mental clock is a meta-phor worthy of a surrealist, all the more so since the book usually anchors its entries by date and time and the Russian soldiers' premodern fascina-tion with clocks and watches is also emphasized.[56]

The narrator's literariness also extends to the imagery of death. In her world, the line between life and death has been blurred, and the presence of dead people commands no more awe or respect: "Something I saw in the street today: A man was pushing a handcart, on it lay, stiff as a board, a dead old woman. Loose gray strands of hair, blue kitchen apron. The thin gray-stockinged legs stuck out of the rear end. Hardly anyone so much as glanced at it. Looked like garbage removal" (April 26).[57] She de-scribes this scene with artistic self-consciousness as a "picture" (*Bild*) and gives several other vignettes of encounters with death that are also labeled *Bild*.[58] Amidst debris and craters she looks at several double graves of couples who have committed suicide with revolvers or poison, at a burial site with a wooden stick marked merely "2 Müllers" in red pencil, and at a single grave of "the woman who jumped from the third floor when the Ivans were after her" (May 9).[59] "A sleeper, yes, a silent sleeper" turns out to be a euphemism for a dead man (May 8), and the analytical narrator even sets out to correct the common linguistic cliché of human cadavers' "sweetish smell," which she finds "imprecise and inadequate.[60] It strikes me not so much a smell as something solid, tangible, something too thick to be inhaled. It takes one's breath away and repels, thrusts one back, as though with fists" (June 12).[61] In his introduction, the book's first editor, Kurt W. Marek (his pseudonym was "C. W. Ceram"), then world-famous for *Gods, Graves, and Scholars* (1951), a best seller that popularized archae-ology, compared *A Woman in Berlin* not only to Hamsun, Louis-Ferdinand Céline, and Henry Miller, but also to Poe's "A Descent into the Mael-

ström," and he quotes the passage from memory that serves as epigraph to this section; there is, indeed, a distinctly Poesque, Gothic-ratiocinative side to the narrator of the diary. One could probably also read the book's pervasive and probing interest in death and mortality as a modern version of confronting *ars moriendi*, the art of dying.[62]

The dialogues expose the reader to many different voices. There are short cries of utter despair: thus when the baker stammers, "They're with my wife . . . ," it seems "impossible" to the narrator that "he should be able to put into his voice such emotion, look so naked, so exposed—something which until now I've witnessed only in great actors" (April 27).[63] The narrator's friend Gisela has gloomy expectations for the future, though at least she stops short of considering suicide by taking Veronal, a barbiturate frequently mentioned in the 1940s:

> She is convinced that the Western world, that of art and culture, the only one she considers worthwhile, is doomed. She feels psychologically too exhausted to start a completely new life. She doesn't think that for a cultivated person there'll be much chance, even less for any real intellectual work. But she doesn't consider Veronal or a solution of that kind. She intends to persevere, although without much hope or joy. (May 12)[64]

But there is also the gallows humor of the woman who ties her wedding ring into the elastic band of her underpants and comments drily, "Once they've gotten that far I shan't mind any more about the ring" (April 22); and there are vox populi folk sayings like the repeatedly cited "Rather a Russki on the belly than an Ami on the head" (April 22), a version of which Kästner also reported.[65]

Indicating a preference for being raped rather than getting killed by carpet bombing is representative of the tone of black humor that runs through the book. There is situational humor in scenes of unexpected comic relief: for example, at a moment of fearful apprehension—the first rapes have already occurred—it seems quiet, and the narrator undresses to wash herself, when suddenly a Russian appears who has entered the apartment through a back door—but he just walks through apologetically and politely asks for the way out, in German (April 27).[66] There are comic references to the major who acts, the narrator feels, as though he were

trying to follow Knigge, the German handbook of etiquette, especially the (imaginary) chapter on "raping enemy demoiselles" (May 2).[67] It is particularly the penchant for strangely, perhaps inappropriately, joking about things that may not seem inherently funny that defines a good part of *A Woman in Berlin*. A striking example is the Ukrainian soldier's vulgar comparison, meant as a compliment to the widow: " 'Ukraine woman like this. You—like that.' The 'like this' he had illustrated by forming a large circle with both thumbs and forefingers; the 'like that' by forming a small circle with one thumb and forefinger" ("Looking back at May 4").[68] This comment becomes a repeated joke among the German women and thus a leitmotif in the book; it is mentioned three more times before the ending, when it becomes, in its fifth appearance, the touchstone for the narrator's fiancé, Gerd's, shocked response to the German women of 1945.[69]

The narrator differentiates herself from the widow, and Antony Beevor cites as an indication of her subtler approach the narrator's dry May 8 comment, "my bed now has fresh linen, which was badly needed after all the booted guests" (perhaps better translated as "guests in boots" to capture the allusion to the fairy tale *Puss in Boots*).[70] Yet she also fully participates in the kind of humor she reports from others and jokes in an off-color manner, for example, when she explains with a proverb why she isn't afraid of getting pregnant: "On a much-used path grows no grass" (Looking back on April 29).[71] There is even subtle blasphemy in applying to this situation a proverb that may go back to Luther's exegesis of Christ's parable that the heart of a man who thinks only of earthly things resembles a well-trodden and walked-upon path. And sitting in a room together with three Russian soldiers who have brought food and with two rather plain women, one with eczema on her face and the other a bespectacled mousy housekeeper type, the narrator comments that looking at them "could make anyone lose interest in raping. God knows why these men should have chosen this place to make themselves at home, become such good providers for these women" (May 2).[72] The narrator herself uses the common term "gallows humor" (May 3–4) and adds her own coinage, *Schändungshumor* or "violation humor" (June 2), to describe the Berlin women's newly acquired custom of joking about the whole "business of rape."[73] While her more overt comments on gender roles and relations are sharply critical of men, as has been noticed by readers, it is as if she were appropriating—

perhaps also defusing—a male or even downright masculinist genre in such passages intended for comic effects.[74]

The book refuses to melodramatize rape as such and, as Janet Halley has shown, represents rape as highly differentiated, ranging from horrifying gang rapes and brutal violence that can drive women to suicide to close-to-consensual relations that the narrator herself analogizes to prostitution.[75] Exchanging access to her body in return for favors as she does with the major is for the narrator part of a more general exchange system that is in place from the very beginning of the book, when she reports trading French cognac for Danish canned meat or French soap for stockings brought in from Prague (April 20). She writes: "I can in no way claim that the major violates me. I'm pretty sure that one word from me would be enough for him to leave and never come back" (May 3).[76] Though some readers now might call it rape, the narrator explicitly does not.[77]

In fact, the book self-consciously mocks the expectation of a sentimentalizing representation of rape by ending the entry of May 7, 1945, with an added-on paragraph, "for the benefit of novelists," which uses exactly the kind of prose that *A Woman in Berlin* tries to avoid: cliché-ridden, empathy-craving, penny-dreadful writing in complete sentences:

> For the length of three heartbeats her body merged with the strange body above her. Her nails clawed into the strange hair, moans broke from her throat, and she heard the strange voice whisper foreign, incomprehensible words. A quarter of an hour later she was alone. The sun came in white sheaves through the broken windowpanes. Enjoying the heaviness of her limbs, she pushed some stray strands of hair from her forehead. Suddenly, and with uncanny clarity, she felt another hand, the hand of a distant, possibly already dead friend slide through her hair. Something welled up in her, tears poured forth from her eyes. She threw herself on her face and beat the pillows with her fists, bit into her arms and hands until blue-and-red tooth marks appeared. She howled into the pillows and wished she were dead. (May 7)[78]

A Woman in Berlin most definitely does *not* want to be a kitschy text like that, and such passages only call additional attention to the tone of the book: ranging from black-humor sarcasm and deadpan understatement to

learned allusion and semantic examination, it presents the mind of a narrator who remains curious about the world in even the most dismal circumstances, in the catastrophe, collapse, and total defeat in which she finds herself and which is embodied by the humiliation of being sexually violated. In its explicit antisentimentality her writing can seem hard boiled.[79] Her account of the first rape, by two Russian soldiers who trap her, focuses on her losing, then finding and clinging to, her bunch of keys, with her left hand, as she is lying on the floor, trying in vain to defend herself, with her right hand, as the first Russian tears her garter-belt (April 27), all narrated in a few sentences in the present tense.[80] After the next attack, during which she is only half-conscious, *rape* becomes a word that she can think, can write down with a cold hand, can speak out loud to get used to its sound. "It sounds like the last, the ultimate, the end of all things, of life itself. But it isn't" (May 1 looking back).[81] The narrator deals with her sexual violation by dissociation, and she imagines a non-corporeal "I" separated from her body: "It seemed as though I were lying flat on my bed and at the same time I could see myself lying there, while out of my body there arose a radiant white being, a kind of angel but without wings, which rose straight up. While writing this I can still feel the floating, rising sensation. It was, of course, a wish- and flight-dream. My I just let the body, this poor, soiled, abused thing lie there. The I withdraws and floats away, pure and white, into a white distance. My I shall have no part in what happens to me here. I remove all this from myself. Can I be going out of my mind?" (April 27).[82]

The deepest degradation she experiences is from a soldier who, after raping her, "slowly lets his spittle drop into her mouth."[83] Her physical reaction: "Paralysis. Not disgust, just utter coldness. The spine seems to be frozen, icy dizziness encircles the back of the head. I find myself gliding and sinking deep down through the pillows, through the floor. So that's what it's like—sinking through the floor."[84] It is this experience, rather than the forced intercourse, that makes her look for a "wolf" who would protect her against the rest of the pack.[85]

Notwithstanding the narrator's cold, at times analytical and at other times sarcastic, approach to brutal events, a countervailing tendency appears in passages about children, which permit the narrator (as well as the Russians) to express more tender emotions. This is not only the case when the narrator—wracked by deep self-loathing after the first rapes—recalls

her own mother's description of her as "one of those pink-and-white babies, the proverbial pride of every parent's heart" (April 29), the memory making her feel as though a ray of sunlight were entering "the tarnished bit of goods" that her body has become.[86] It also affects her as an observer of others; thus she reacts strongly (even more strongly than did the schoolteacher Schneider's diary) to the soft-faced children with high voices who wear much-too-large soldiers' uniforms to serve in the *Volkssturm:* "The fact that these boys have to be wasted before they have matured must violate a law of nature, must outrage the instinct for the preservation of the species. Like certain fish or insects which devour their progeny" (April 23).[87] The Russians, however, are genuinely kind to children. Thus the narrator highlights a moment at which "two tough Ivans" who had forced their way into an apartment with revolvers and shoved a young woman into a room "when suddenly, catching sight of the baby and the four-year old Lutz asleep together in the cot, they stopped short. . . . For fully a minute the two soldiers stared at the cot, then slowly, on tiptoe, withdrew from the apartment" (May 5).[88] [*Reading this part of* A Woman in Berlin—*and this may be one of the more difficult parenthetical insertions I am making in this book—resonated with stories my mother told me about May 1945, when she had to find shelter in the barns and refugee camps of Saxony on what became a five-month trek on the road from Silesia to Thuringia. She stressed that Russian soldiers would leave her alone because she could hold me—I was almost two years old then—on top of her at night. My mother had also prepared a little Russian phrase book. A letter that she wrote her niece on January 25, 1946, in which she mentions these nightly Russian attacks had this passage blacked out by an American or British censor so that it became partly illegible.*]

Antony Beevor has stressed the complex role of rape in war and differentiated the Red Army's practices near and after the end of World War II, especially in Berlin, from the use of rape as a terror tactic in the Spanish Civil War and in Bosnia.[89] Halley's reading of *A Woman in Berlin* has further called attention to the different interpretations various rapes receive in the book.[90] One particularly horrifying incident concerns a German lawyer who was married to a Jewish woman and resisted much pressure and endured hardship in the Nazi years for not divorcing her.

For months the couple had been looking forward to the liberation of Berlin, had spent nights by the radio, listening to foreign broadcasts.

Then, when the first Russians forced their way into the cellar and yelled for women, there had been a free-for-all and shooting. A bullet had ricocheted off the wall and hit the lawyer in the hip. His wife had thrown herself on the Russians, imploring their help in German. Whereupon they had dragged her into the passage. There three men had fallen upon her while she kept yelling: "Listen! I'm a Jewess! I'm a Jewess!" By the time the Russians had finished with her, the husband had bled to death. He had been buried in the front garden. The woman has disappeared, no one knows where to. A cold shudder runs down my back while I write this. A story of that kind cannot be thought up or invented. It is the ultimate cruelty of life, a blind mad act of fate. (May 18)[91]

The woman with eczema sheds tears of despair when telling the story: " 'If only it were over,' she said, 'this miserable bit of life!' "

The German-Jewish couple's "looking forward to the liberation of Berlin" is also the only time that the term *liberation* (*Befreiung*) appears in *A Woman in Berlin*, and its employment is absurd to the point of sacrilege. This is not even "liberation" in name only. Any notion of a justifiable revenge or of "balancing an account"[92] that a reader might have come up with in order to understand collective rapes is dispelled by a story in which a Nazi victim is victimized brutally once again, this time by the liberators. The story parallels Solzhenitsyn's ballad lines about the rape of a Polish girl and the grim killing of a German communist in *Prussian Nights*, and demonstrates vividly Beevor's comment that "Polish women and female slave laborers in Germany also suffered" from Russian rapes.[93]

The phrase of "balancing an account" that the author of *A Woman in Berlin* reportedly made to the book's editor Kurt Marek has a particular meaning, that of weighing Nazi atrocities against Russian war crimes. At least this is how Ann Stringer saw the book in her *New York Herald Tribune* review: "Just as one's mind had rebelled at the sights and smells of the concentration camp ovens and stacks of emaciated corpses, it now refused to accept the horror tales borne against an ally by members of the enemy nation which had constructed and operated those death chambers. But slowly the plain facts of the Russian orgy of victory compelled acceptance."[94]

The assertion in *A Woman in Berlin* that a "story of that kind cannot be thought up or invented" is, of course, a common rhetorical device for making truth claims in fiction, but the story may, indeed, be true; its function in *A Woman in Berlin* is that it highlights the importance of the national, ethnic, and political identity of the victim for the discourse of rape. It seems deeply wrong, even more deeply wrong than many other terrible things in the book, that to Russian rapists the difference between Jewish and German women is immaterial (even though they may have reacted to the Jewish woman's German words rather than to what she was so desperately trying to convey).

As the first American edition's cover design suggested, *A Woman in Berlin* is also an allegory of Berlin, of Germany in 1945, and rapes are tied to national history, to defeat (she calls it "bitter, bitter"), and to retribution.[95] It is telling that the unsigned preface to the German 1959 edition states that the book does not report an isolated case but a gray fate shared by masses, and that millions of women are still living who could report similar things ("Ihre Person ist ohnehin belanglos, da hier kein interessanter Einzelfall geschildert wird, sondern ein graues Massenschicksal. Noch leben Millionen Frauen, die Ähnliches berichten könnten").[96] On May 8, at the beginning of the fourth section of the book, the narrator reflects on the difference between rape as an individual peacetime crime (which would provoke different responses in society and the victim) and collective rapes in times of war: "But this is a question of a collective experience, anticipated, feared for some time—something which is happening to women all round us, an inevitable part of our present existence. This collective phenomenon of rape will also be collectively overcome. Each woman helps the other by speaking about it, by airing her experience, and giving her fellow woman a chance to air hers, thus ridding themselves of [literally translated, "spitting out"] their sufferings."[97]

May 8 is also the day on which Germany commemorates its unconditional surrender, and *A Woman in Berlin* refers to capitulation four times, inviting the reader to think of the book as a national story.[98] Thus she writes, "We have capitulated" on May 8 and when she hears a rumor of a victory parade on May 9, she comments, "Let them celebrate, it makes no difference to us. We have surrendered." The word *German* now sounds like a cussword to her when it appears on a Russian-authorized newssheet that reports the details of unconditional surrender (May 14). In

A Woman in Berlin a dominant metaphor of the moment peace breaks out is thus "surrender," though some defiance is mixed into the narrator's reaction, too.

And guilt and shame. The narrator notes on May 16 "that with all their reproaches and abuses, no Russian has so far reproached me for the German persecution of the Jews."[99] Yet one Russian soldier for whom she has to translate witnessed the German military in his hometown stabbing some children and "seizing others by their feet, smashing their skulls against a wall" (May 5).[100] This reported scene contrasts as sharply as one can imagine with the depicted Russian attitude toward children. One of the German women finds this information hard to believe, another asks whether they were army or SS, and the narrator concludes that, even if this "was a question of the SS, the conquerors will consider them as part of 'our nation' and present us all with the bill" (May 5).[101] This is one of several passages in the book in which *Woman in Berlin* addresses news about German atrocities in the East, concentration camps, and genocide.

The entry for May 27, 1945, for example, ends with the return of electricity and the Berlin radio broadcasting "mostly news and 'revelations': smell of blood, corpses, cruelty. Millions of human beings, we hear, have been burned to death in vast camps in the east, most of them Jews. It seems that their ashes were turned into artificial manure. And the most appalling of all: Every detail has been neatly registered in fat ledgers—a bookkeeping of death. I'm sure it's true, even about the bookkeeping. We are an orderly nation" (May 27).[102] When the radio plays Beethoven following this news, she responds with tears (one of the very few times in the book) and turns off the radio, as it is more than she can take.

The narrator hears more revelations on June 2, between jazz and hymns in praise of the Red Army, and on June 15 she reflects on this news while reading Aeschylus's *Persians:*[103] "With its woeful laments of the defeated it suits our own situation—and yet it doesn't. Our German misfortune has an extra taste of nausea, sickness, and insanity which can be compared with nothing else in history. Just now over the radio came another concentration camp report. The most atrocious aspect of this phenomenon is the tidiness and economy with which these death camps were run: millions of human beings turned into manure, soap, and felt matting. Such things were not yet known to Aeschylus" (June 15).[104] This passage also suggests that, for *A Woman in Berlin*, there can be no tragic form after such revela-

tions, and that perhaps the tone she chooses is the most appropriate, or the only one that she can think of. In any event, giving full expression to a tragedy of German defeat (in the tradition of Aeschylus) is inhibited by the news of what is not yet being called the Holocaust.

There is not much hope for a change for the better with the Allied arrival: there is immediately a new type of small-minded denunciation and political opportunism.[105] The Polish translator and supervisor who works for the Russians looks the way the narrator imagines a female concentration camp guard (May 30) and the flags Berliners show are simply recycled Nazi flags.[106] People now opportunistically emphasize their "non-Aryan" background, and the July 20 attempt to assassinate Hitler that Kardorff supported and Kästner helped to memorialize after the war garners only a cynical comment, reported by the narrator from a lady from Hamburg: "If Hitler had been done in on July 20 '44, he'd have retained some vestige of his halo and any number of people would have gone on thinking of him as a martyr" (May 18).[107]

She summarizes her own philosophy, adopted from a conversation with a Swiss woman, that "the sum of tears remains constant"—"no matter what Gods they worship or in what coin they are paid, the sum of tears, of pain and anguish with which everyone has to pay for his existence, remains constant." Yet she also recognizes that "he who believes in the constancy of the sum of human tears is no longer qualified to be a world reformer—is, in fact, unfit for any major public action." This leaves her holding on to life "out of curiosity, if for no other reason," and because it makes her feel good just to breathe and sense her healthy limbs (May 13).[108]

Diaries and Revision

Jens Bisky called attention to the changed ending of the 2003 edition, which omitted the last paragraph of the book, in which the narrator once again represents the actual composition of the book—in a manner that feels like romantic irony, as it makes the reader self-conscious about the origin of the text—and the changing way the original pages of what we are reading in print are to be imagined: "And there's another thing I've decided to do: I've borrowed the widow's typewriter and now I'm typing out my three volumes of diary on the white backs of old manuscripts I've found in the garret. Slowly, in order to save my energy. Clearly, and

without any abbreviations like 'rp.' But with a few additions, things that may occur to me here and there while I'm typing. I'd like Gerd to read it when he comes home. Perhaps it will help us find the way back to one another" (June 16–22).[109]

This conclusion seems related to the narrator's insistence on conveying to the reader (a reader beyond just herself) information about the paper on which the diary was written. This ending also harmonizes with her mentioning in the very first entry "the empty notebook" into which she is now writing (April 20), which she found in the garret where she has sought shelter.[110] This motif of mentioning the writing process itself is developed throughout the book and serves as a leitmotif and an aesthetic device that keeps reasserting the materiality of the notebooks (*Kladde*) and the recycled and now typed-upon manuscript pages and hence suggests the authenticity of the diary.[111]

In the first German edition of 1959 the phrase "the white backs of old manuscripts I've found in the garret" (which appears in the 1954 first English translation) is shortened to "paper I've found in the attic" ("Papier, das ich in meiner Dachwohnung fand"), but in the new 2003 German edition and the new English translation of it the whole passage is completely missing. It has been replaced by just two sentences: "Does Gerd still think of me? Maybe we'll find our way back to each other yet."[112] Bisky took this substitution as an indication of the inauthenticity of the whole book. The original typescript, which only Walter Kempowski was given to see and to authenticate—he had previously excerpted two pieces from *A Woman in Berlin* for his *Echolot: Abgesang '45* collection that covers the period from April 20 to May 9—would, according to the first English translation, have been written on the backs of manuscript pages.[113] Might removing this passage (though risky, since it had already been printed once) make it easier to continue to pass off a forgery (perhaps one originally committed by the editor C. W. Ceram) as an authentic diary? In any event, omitting this last reference to the diary itself means losing a concluding use of a motif that structures the book.

However, there is another variant that is perhaps more significant than that of the ending. It is a revealing story about the narrator's past, and it was missing completely in the 1954 translation (the book's first edition). It is set in Paris in the third year of Hitler's reign, about a decade before the action of the book, and it concerns the narrator's flirtatious encounter on

a rainy day in the Jardin du Luxembourg with a young man, a student like she was. Both speak French but recognize instantly that neither of them comes from France, and hence they play a game of guessing each other's nationality: the young man thinks the blonde narrator must be Swedish and she likes to believe he is a Monégasque—until her attempt to get into step with him when they walk together suddenly ends the banter, for he, recognizing the nationality of someone who wants to march in step with the person walking next to her, stops suddenly and exclaims, "Ah, une fille du Fuhrer!" She comments: "That ended fun and flirt. For now the young man introduced himself: not from Monaco, but from Holland, and a Jew. What did we still have to talk about? We separated at the next bend of the road. That experience had a bitter taste; had to mull over it for a long time" (May 11).[114]

This story is told to answer the question the narrator asks about her own guilt or innocence, her implication in Nazi rule, and it is inserted in the German editions right after the reader has learned about how quickly and opportunistically Germans have turned away from Nazism. "Everyone turns his back to Adolf, no one has ever been for him. Everyone has been persecuted, no one has ever done any denouncing."[115] It is at this point that the narrator seems to move toward a self-examination, but only in the German edition of 1959, not in the 1954 translation: "Was I myself in favor? Opposed? In any event, I was in the midst of it and have inhaled the air that surrounded us and colored us, even if we did not want it to" (May 11; m.t.).[116]

What is this new, or previously omitted, episode intended to show? That the narrator was rejected by a Jew because she was a German? Or that she rejected a Jew because she may have shared the Nazi core belief that Germans should not associate with Jews, perhaps because she had "inhaled the air that surrounded us and colored us"? What is the logic of the rhetorical question, "What did we still have to talk about?" Was it her or the young Dutchman who ended the conversation? Or was it believed to be self-evident to the reader that a young German student and a Dutch Jewish student in Paris would have nothing to talk about in 1935 or 1936? Why would the episode of the thwarted German-Jewish romance not appear in 1954? Hans Magnus Enzensberger mentions in his foreword that the new edition was able to restore "passages that had previously been excluded, either to avoid touching on delicate matters or to protect the privacy of

people still alive," but did this page-long restoration of the non-meeting-of-minds between the narrator and an unnamed Dutch student in Paris meet either of those criteria?[117] Are there perhaps more passages in the manuscript that are still too delicate today? Antony Beevor writes in his introduction to the new English translation that the 1954 translation was "incomplete," and one could look at this passage as an example of making the new edition more "complete."[118] Yet what does that mean for the last paragraph of the book, which is missing only in the new editions? Could an omission really make the new translation, and the new German edition on which it is based, *more* complete?[119]

Diaries are texts that are written privately but are probably kept for the purpose of rereading—why else would they be written?—and of adding on corrections, afterthoughts, and new events that make a past expectation seem false or justified. Hence they provide opportunities for revising, at least a little, especially when they are transcribed from notes or short-hand, copied from handwritten notebooks and slips of paper to typed man-uscript pages, or fleshed out from brief notes to fully presented scenes. Writers' diaries may also be written with an eye toward other readers and toward publication, thus are even more likely to undergo revision before reaching print.[120] Aesthetic embellishment and revision undertaken with the intention of finding a more literary language for representing reac-tions to recorded experience is therefore to be expected in published dia-ries. Hence there is nothing unusual about the changes that the diaries from the end of the war have undergone.

And yet it does seem noteworthy that in the three published diaries by Ursula von Kardorff, Erich Kästner, and the anonymous woman in Ber-lin, a direct response to the end of World War II in a concise metaphor or an unambiguous reaction seems to have been inhibited—and that in all three cases, this inhibition was connected with news on the radio about the atrocities committed in German concentration camps or with reflec-tions about individual culpability. As we have seen, in her entry for April 20, 1945, Kardorff rearranged that information and added the comment that her imagination had been insufficient; in *Notabene 45* Kästner omit-ted the camp news as the source of the sentence he kept—that people were running around with much concern—but chose a truly memorable formula for May 7 nonetheless, that it marked a "gap between the no longer and the not yet"; and the printed versions of *A Woman in Berlin*

show that a whole page was inserted into the May 11 entry of her 1945 diary between 1954 and 1959 (or perhaps omitted from publication in the 1954 edition), a page that was intended to examine the narrator's own sense of involvement with National Socialism. The end of World War II seems to have provoked a particularly intense search for just the right response, making some diaries perhaps more interesting for what writers thought they *should* then have felt and formulated than for what they actually did write down as their recorded reactions to the events of a given day.

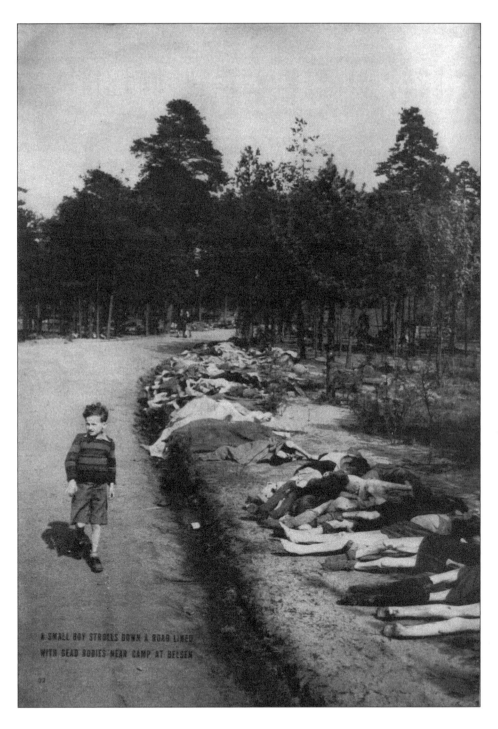

A SMALL BOY STROLLS DOWN A ROAD LINED
WITH DEAD BODIES NEAR CAMP AT BELSEN

Young boy walks past corpses. *Photo by George Rodger, as it appeared in Life, May 7, 1945, 32. Getty Images/ Time & Life, 50605938.*

May 7, 1945

On the day Germany capitulates, bringing World War II officially to its end, Life *magazine runs a cover story on "The German People." The issue includes many cheery advertisements in color as well as harrowing photographs in black and white, but the image introducing the photo-essay on "Atrocities" has a particularly haunting and intriguing quality.*

Malevolent Rectangles of Spectral Horror

A Photographer and His Subject

> We are poor passing facts,
> warned by that to give
> each figure in the photograph
> his living name.
>
> —Robert Lowell, "Epilogue"

A young boy, neatly dressed in shirt, patterned woolen sweater, knee-length shorts, light-colored socks, and leather shoes, walks toward the photographer along a curved sunlit road around midday. His short shadow is sharply outlined on the light ground. He seems to be moving at a brisk pace, for the blur that is his right hand indicates that it must be in motion. His head is turned to the left (his right), perhaps to evade the sunlight, as he squints a bit, but he seems to be looking straight at the camera, hence also at the viewer. He appears to be walking along a line, as children often do, a line that is clearly visible on the sandy road in the foreground. In the distance, and foreshortened, two women walk on the road toward the boy. The road comes out of a park-like forest of mostly young, slender, and thin-trunked pine trees, which nearly fills the upper half of the photograph, up to what could have been drawn as a horizontal line.

The shock comes at the lower right half of the photograph. A large parabolic wedge, formed by the curving road and a path near the bottom of the trees, protrudes into the otherwise tranquil image. The embankment of the road is covered with the corpses of hundreds of emaciated adults, some dressed, some covered with sheets, pieces of clothing, or blankets, some naked. Several pairs of naked legs, some of them skeletally thin, point in the direction of the walking boy. The bodies appear to have been deliberately placed, lined up really, on the embankment for some mysterious purpose. At first glance, these figures seem to be sleeping. Once it is clear that these are corpses, however, the boy's head seems not only averted from the sunlight but also from a horrific sight he does not want to confront.

The photograph has the effect of a frightening nightmare; it is reminiscent of a particularly upsetting version of the Hänsel and Gretel fairy tale, set in some terribly bewitched forest where horrifying crimes have been committed and the rule that the dead should be buried has been violated. The contrast between the vertical tree trunks and walking figures and the horizontally positioned cadavers on the ground dramatizes the line between life and death that has been violently crossed in the events that must have preceded the taking of the photograph.

The little boy is our entry point into the image, and viewers are likely to sympathize with him. Why does he have to walk alone along a path lined with corpses? Why would such a young, seemingly innocent child be placed in such a position? When the photograph was first published in *Life* on May 7, 1945, it carried the caption "A small boy strolls down a road lined with dead bodies near camp at Belsen."

These words, probably not chosen by the photographer but by the magazine editors, reinforce the contrast between the small boy who "strolls" and the dead bodies, resolving the ambiguity of the term *camp* by giving the horror depicted a name, that of concentration camp Belsen.[1] On the page facing the photograph with the small boy, the meaning of Bergen-Belsen and of another Nazi concentration camp, Buchenwald, is further visualized with photographs of dying men and women, of starving people packed in triple-decker beds, and of the effects of malnutrition on prisoners.

Such concentration camp photographs were disseminated with General Dwight D. Eisenhower's encouragement. Having seen the dead and barely living inmates and the surviving slave laborers at Ohrdruf, a subcamp of Buchenwald near Gotha, on April 12, 1945, he felt the need to make sure that such sites would be documented. In his memoir *Crusade in Europe* (1948), Eisenhower writes about the experience rather vaguely and obliquely, as if at a loss for words, not even mentioning the name of the "first horror camp" to which he refers as he recalls that he "came face to face with indisputable evidence of Nazi brutality and ruthless disregard of every shred of decency. Up to that time," he continues, "I had known about it only generally through secondary sources. I am certain, however, that I have never at any other time experienced an equal sense of shock." Only hours after visiting "every nook and cranny of the camp," because he wanted to be able "to testify at first hand about these things," Eisenhower urged officials in Washington and London "to send instantly to Germany a random group of newspaper editors" and political representatives saying that "evidence should be immediately placed before the American and British publics in a fashion that would leave no room for cynical doubt."[2]

The common sentiment Eisenhower gave expression to was: "We are told that the American soldier does not know what he was fighting for. Now, at least, he will know what he is fighting against."[3] Widely disseminated photographs of the victims of mass atrocities in concentration camps became a powerful tool in the last weeks of the war and continued to be of importance for the reeducation effort that followed. Not only the military and political leadership but also various magazines encouraged photographers and journalists to document campsites. In April 1945, Lee Miller photographed Dachau and Buchenwald for stories in *Vogue*. *Life* sent David E. Scherman to Dachau, Buchenwald, and Penig; John Florea to Nordhausen; William Vandivert to Gardelegen; and Margaret Bourke-White to Leipzig-Mochau and Buchenwald.[4] Photographs of atrocities offered viewers a means of vicariously witnessing scenes of extraordinary human suffering to which they had previously been immune. Susan Sontag, for example, remembered the moment in July 1945 at which she saw photographs of Bergen-Belsen and Dachau for the first time in a bookstore in

Santa Monica, California: "Nothing I have seen—in photographs or in real life—ever cut me as sharply, deeply, instantaneously. Indeed, it seems plausible to me to divide my life into two parts, before I saw those photographs (I was twelve) and after, though it was several years before I understood fully what they were about." Sontag continues: "What good was served by seeing them? They were only photographs—of an event I had scarcely heard of and could do nothing to affect, of suffering I could hardly imagine and could do nothing to relieve. When I looked at those photographs, something broke."[5] Chaim Potok saw the photographs of Belsen in magazines and newspapers and describes in his book, *In the Beginning* (1975), the effect those "large, sharp, black and white and starkly horrifying" photographs had upon him:

> Every day now there were photographs. All through May the flow of rectangles continued across the ocean onto the pages of newspapers: hills of corpses, pits of bones, the naked rubble of the dead and the staring eyes and hollow faces of the survivors. . . . I . . . tried to penetrate the borders of the cruel rectangles—and I could not do it. They lay beyond the grasp of my mind, those malevolent rectangles of spectral horror. They would not let me into them. . . .
>
> Later . . . I sat in the class and could not keep my eyes upon the words in my volume of Talmud. I gazed out the tall wide windows at the street, and there, upon the cobblestones, saw the photographs of Bergen Belsen. Grotesque forms with skeletal arms and legs and rib cages and heads lay stacked like macabre cordwood on a stone ramp. . . . Off to the right there were trees and a patch of sky.[6]

The letters to the editor published in a subsequent issue of *Life* overwhelmingly supported the publication of such photographs, even though they may be "nauseating" and "hard to take."[7]

The *Life* photographer who went to Bergen-Belsen after the camp was liberated on April 15, 1945, was Englishman George Rodger, born in Cheshire in 1908. He spent a number of years in America before becoming connected with *Life*. He was known both for high aestheticism in photographic composition and for daring documentary coverage of the London blitz, the Allied invasion of Normandy, and the liberation of France, Belgium, and Holland, producing strikingly beautiful photographs with stark

themes (though his self-professed emphasis at the time was on clarity of subject, not on beauty of composition). When Rodger went to Belsen, he may already have seen photographs taken in other liberated camps.[8] Rodger took the photograph of the small boy on April 20, 1945—which was also Hitler's fifty-sixth and last birthday. It was one of thirty-four pictures he took of Belsen, including several scenes in close vicinity to the location where he photographed the boy and made the two other images that appeared in the same issue of *Life*. Entering Belsen was a horrifying experience for the photographer, who at first believed he saw many sleeping figures but soon realized that they were thousands of corpses.[9]

Rodger worked with a 35mm Leica and a Rolleiflex, taking photographs from an elevated position, most likely his jeep. He had indeed been photographed atop a jeep in Paris with Robert Capa when covering the liberation celebrations, and when he later remembered entering Belsen, Rodger said: "I was with four Tommies in a Jeep and among the first to get in and the horror affected me tremendously."[10] Rodger's wartime driver, Dick Stratford, recalled the remove he felt while steering his jeep around Belsen, Rodger snapping photographs: "There was nothing we could do. We just said hello to people and that was all. There was no possible conversation."[11] The line along which the boy is walking was probably drawn by the tires of Rodger's jeep. One could thus look at the photograph with the categories that Robin Kelsey has proposed marking a tension between "arrangement" of the careful photographic composition as a whole and the "interruptant" of the line on the road.[12]

A reviewer who closely examined the photograph and determined that it could not be a snapshot and that the boy has definitely noticed the photographer, speculated that perhaps Rodger may have seen the boy walking along the road and asked him to go back a few steps in order to be photographed. Perhaps Rodger may have even called the boy to the scene because he thought—rightly so—that the presence of the young boy would make for a better photograph.[13] In his published diaries, Rodger mentioned that after his earlier "candid camera" work he had to adjust to the requirements of *Life* magazine whose readers "expected pin-sharp, purposeful, even posed pictures. I had to develop a *LIFE* technique, though posed pictures were anathema to me."[14] In an interview published in 1995 Rodger mentioned, however, that he was taciturn and not in the habit of talking much with his subjects, although he also stressed that the boy had

no objection to being photographed and was even very cooperative, which may or may not imply a conversation.[15] Rodger also said self-critically that even at Belsen photographic composition had mattered to him.[16] The moment in time that this photograph freezes thus remains somewhat shrouded in mystery.

Life used Rodger's photograph in the issue with Percy Knauth's illustrated cover story on "The German People," which begins with an account of the March 25 suicide of Helmut Lotz and his family in Frankfurt and also includes photographs of German children.[17] The image with the little boy at Belsen—given a full page by the editors as the lead picture—opened the photo-essay with the title "Atrocities: Capture of the German Concentration Camps Piles up Evidence of Barbarism that Reaches the Low Point of Human Degradation" (shortened in the table of contents to "German Atrocities"). It was part of the harrowing photojournalism that surrounded the liberation of concentration camps in Germany more broadly.[18] That context suggested certain ways of seeing the image. Prominent in Allied photography of the time was the theme of perceived German indifference to the scenes of horror and suffering. *Life* magazine's caption cast the little boy's stance, his "stroll," and his casual expression, as part of that story line. Such framing put the image in the company of much of the other photographic documentation of this moment.

For example, Margaret Bourke-White provided one of her photographs of a girl shielding her eyes near a pile of corpses at Dachau with the caption, "Fräulein, you who cannot bear to look, did you agree about the Jews? Will you tell your children the Führer was good at heart?"[19] Bourke-White used polemical captions that seemed intended to provoke a hostile reaction toward Germans in general throughout her 1946 book *"Dear Fatherland, Rest Quietly": A Report on the Collapse of Hitler's "Thousand Years."* The book serves as a good indication of the vindictive and punitive Allied attitude toward Germany around the end of the war. A *Life* photograph of emaciated prisoners in bunks on the page facing that of the small boy at Belsen was also taken by Margaret Bourke-White.

"Germans Are Like This," Lee Miller's June 1945 photo reportage for *Vogue*, was similarly anti-German, permitting no distinction between Nazis and other Germans. Miller wrote in the accompanying text: "They were repugnant in their servility, amiability, hypocrisy. I was constantly

insulted by slimy German invitations to dine, in German underground houses, and amazed by the audacity of Germans who begged rides in military vehicles and tried to cadge cigarettes, chewing gum, soap. How dared they?" And further: "We claimed to be waging war on the Nazis, only. Our patience with the Germans has been so exaggeratedly correct that they think they can get away with anything. Well, perhaps they can. In the towns we have occupied, the people grin from the windows in friendly fashion. They are astonished that we don't wave, or return their smiles." Visiting Köln, Miller found the few people she saw "palely clean and well-nourished on the stolen and stored fats of Normandy and Belgium." Her photographs on the pages facing this text juxtaposed pictures of, as the captions explained, "Orderly villages, patterned, quiet" with "orderly furnaces to burn bodies," and of "German children, well-fed, healthy" with the "burned bones of starved prisoners." Of course, these captions may have been the magazine editor's.[20]

Reading Rodger's Photograph

In such contexts, Rodger's photograph of the small boy at Belsen became an allegory, not just of the contrast between life and death but also of the gulf between ordinary, relatively well-off, well-clad, and innocent-seeming Germans and the Nazis' starved, tortured, and slaughtered victims who were rarely referred to as Jews in 1945 reportage. Seen this way, the healthy-seeming boy in the picture appeared to some viewers not as someone worthy of sympathy but as an uncaring witness to the bloody results of a reign of terror. Such contexts unmasked the pose of innocence and urged viewers to hold back the compassion that the image at first may have made them feel. Together with many other photographs of the camps, Rodger's image could thus be seen as a contribution to an indictment of Germans. Documentary photography and film could become a form of accusation, and indeed, Rodger's and Bourke-White's photos reportedly were used as evidence in the prosecution of war criminals.[21]

Rodger's *Life* photograph also raised ethical questions. Edith Wyschogrod, a philosophical critic interested in the ethics of remembering, noted: "The child is neatly dressed and seems well fed. He looks straight ahead seemingly oblivious to the dead. The child's glance refuses the negation of death, turns away from it yet cannot help reinstating it. The photographer

as historian who captures such a moment becomes one with the internal narratological voice of the child. Subsequent historians may ask, 'Why is the child not emaciated?' 'why is he allowed to roam the grounds still strewn with corpses?'"[22]

Dagmar Barnouw, a historian who attempted to complicate the melodramatic 1940s views of American innocence and German collective guilt, found it hard to imagine that the child had playfully run ahead of the adult women in that kind of a setting. The boy seemed unchildlike to her, with a head too large for his small body, making one think of an old man rather than a child. Furthermore, Barnouw speculated about what else the boy might have seen and what and whom he would tell about it—whether he might have seen dead bodies before this moment, perhaps after air raids; whether his father died in the war; whether death and destruction had become everyday events for him; whether adults had spoken about it; whether there were adults in his world at all, or they had all been infantilized by political ideology. In her reading of the photograph Barnouw diagnosed an overall sense of numbness and isolation in the child.[23]

The photograph did not only fascinate philosophers and critics of photography but it also became an icon that was republished many times.[24] A widely discussed recent history of the postwar period, for example, opens its first picture insert with Rodger's photograph, accompanied by the following heading: "Shortly after Germany's defeat in 1945, a child walks past the corpses of hundreds of former inmates of Bergen-Belsen concentration camp, laid out along a country road. Like most adult Germans in the post-war years, he averts his gaze."[25] This rather didactically allegorical caption of the image appeared as late as 2005, a full sixty years after the photograph was taken. It transforms the boy into someone who is like "most adult Germans" (in the collective), like those who averted their glance from camp horrors. The facing-page headline "Atrocities" and text provide a context for the photograph, and the identification of the boy as a representative German would seem to make his squinting glance at the photographer a politically and ethically meaningful gesture that reveals a deep, nationally shared character flaw. The implication of the caption could be spelled out as follows: Not having prevented the genocide that was committed in their name, Germans of all age groups should now at least confront what they are collectively responsible for. The boy in the photograph *should* have faced the dead and looked in shame and

horror to his left.[26] Though the picture may make viewers enter it through the figure of the boy who looks at the camera, this caption forces them to keep their distance from the child and to view him not as a poor innocent young bystander walking about a hellish adult world but as a person deeply implicated in the hell that surrounds him. The romantic legacy of viewing images of children as the embodiment of innocence (that was also operative in the occupation powers' policy directive that children were exempted from denazification) is thus challenged by a more Gothic vision of the child as a consenting accomplice of perpetrators. The boy's glance alone seemed to serve as the basis for this judgment.

To Look or Not to Look?

The boy might not be looking at the dead for other reasons, of course: what if he had been told that there was danger of catching typhus from the cadavers? A typhus epidemic had indeed ravaged the camp population of Belsen. In March 1945, Anne Frank and her sister Margot died in Belsen of typhus. The camp was so infected, in fact, that it had to be burned down, barrack by barrack, and by May 21, 1945, only the former SS buildings remained and were reused as a Displaced Persons' camp until 1950.[27]

Another possibility is to imagine that the boy *had* looked at the bodies in horror just before the photograph was taken—the curved road would have made it hard for him *not* to see the dead—but now found his attention drawn to the uniformed photographer high up on his jeep. In that sense, he is looking at, rather than looking away from, something.

Furthermore, it is open to question whether looking or not looking is the more ethical choice in such a disastrous setting, a problem that is only intensified by the fact that we as viewers are directing our gaze at this photograph at first through the boy while wondering why the boy is not looking at the corpses but at the photographer—and thereby at *us*. "Why are they looking at me?" Ariella Azoulay asks about photographed subjects in order "to rethink the civic space of the gaze and our interrelations within it." She writes: "The photographed subjects of numerous photographs participate actively in the photographic act and view both this act and the photographer facing them as a framework that offers an alternative—weak though it may be—to the institutional structures that

have abandoned and injured them."[28] In that sense, looking at the camera may have expressed the boy's understandable wish to interact with a world different from the one he found himself in. Looking away might also indicate the impact of what he saw—he may have been, like an adult would be, cognizant of what he was seeing. Wyschogrod put it well when she wrote that the child's glance "refuses the negation of death, turns away from it yet cannot help reinstating it." In her reading, "the child's face becomes the escape route for an unsayability that seeps into the visual image and contests any narrative articulation of what the camera captures, a world where death and life are virtually indistinguishable."[29]

Versions of a Photograph

What if the boy were simply shy, or had been taught never to look at grown-up nakedness? The starkly exposed nakedness of some of the dead bodies in the foreground so close to a young boy must, in fact, have seemed too scandalous for publication to the editors of a family magazine: turning Rodger's square-shaped Rolleiflex photograph into *Life*'s full-page rectangular vertical format, they also cropped the image by about one fifth on the right (as well as a smaller section on the left) and touched up the remaining part in order to exclude some naked corpses and create the impression that the cadavers still visible in the foreground had been covered by clothing or blankets.[30] As a result, the faces of two dead women that are turned toward the viewer in Rodger's original photograph were also deleted from the version published in *Life*. Rodger's original photographic composition thus gave the viewer the choice of first confronting either the blank stare of the dead faces of two female corpses lying on the ground or the squinting glance of the young boy walking along the road, a grim alternative that the editors of *Life* eliminated. Though Rodger did not comment on this photograph in his diaries, his remarks on the problem of working with the square-formatted Rolleiflex to produce main key pictures for a magazine that only very rarely published square photographs are pertinent: "I lost much time in conjecture as to what piece of my square picture I should leave for the printer to mask out—top or bottom for a horizontal or either side for a lead vertical."[31] It is thus possible to imagine that Rodger anticipated the cropping the magazine editors undertook.

Young boy walks past corpses. Bergen-Belsen, April 20, 1945. *Photo by George Rodger. Getty Images/Time & Life, 50605938.*

Comparing closely the issue of *Life*, the website at Getty Images (the heir to the copyright of *Life* magazine), and a 1995 print, reportedly made from an original negative, one realizes that there are actually three versions of Rodger's photograph and that the starkness of the scene (as shown in the new print from Rodger's negative) was altered most dramatically in the cropped *Life* printing of 1945, but that it has also been modified in the photograph as it is now digitally archived at Getty Images.[32] The result is that Rodger's original photograph is most widely known in its tampered versions, both of which cover the dead bodies' nudity differently, with the *Life* magazine version also cropping the dead women's faces.[33]

Equally problematic is the identification of the child in the photograph as a German boy, for which there is, after all, no evidence in the picture itself—only in the contexts in which it has been viewed and in the captions it has been given much later, including the heading that appeared for

a long time on the copyright holder's official website at Getty Images: "Young Boy Walks Past Corpses: Young German boy dressed in shorts walks along a dirt road lined with the corpses of hundreds of prisoners who died at the Bergen-Belsen extermination camp, near the towns of Bergen and Celle, Germany, May 20, 1945."[34]

The Boy in the Photograph

In fact, there is printed commentary on Rodger's photograph that forces a rereading of the meaning of the boy in the picture. Several sources from the 1990s have variously identified the boy not as a German bystander but as a Dutch boy—a Dutch Jewish boy, a Jewish child, or a survivor of Belsen.[35] An authoritative book about George Rodger offers support for this reading, captioning the photo with "A Dutch Jewish boy walks among the dead, Bergen-Belsen, 1945."[36]

This context transforms the central figure from a child accomplice suspected of not caring enough to a boy who has escaped the fate that has been met by so many others, whose dead bodies serve as somber evidence of that hard fact. His looking at the camera seems all the more justified now. Seen in this light, does not even his gait seem to change? We can now look at him differently: headed toward a still uncertain future, a terrible recent past behind him—and perhaps, like so many mythical heroes who got out of Hades, he simply must not look back.

Though this interpretation imbues the image with a new sense of escape and survival, the subject is neither a mythic hero nor a pictorial allegory but an individual—a real person. In 1995, he was identified in print, in the catalog text of an exhibition that included the original photograph, as Sieg Maandag.[37] In 2001, the book *Mémoire des camps* reproduced the photograph and identified the boy by name in the caption: "George Rodger, Sieg Maandag, jeune survivant juif hollandais, marchant sur un chemin bordé de cadavres de détenus, Bergen-Belsen, vers le 20 avril 1945 (Time-Life)."[38] On January 21, 2005, *Le Monde* used the photograph

with the same caption as a stock image accompanying a review of books on the Holocaust; various websites and Russian blogs ("Steppenwolf") followed.[39]

Once given a name, once identified, the child portrayed in Rodger's photograph can no longer appear as a mere allegory. His name promises a story of just one boy who had a chance encounter with a photographer in 1945 that resulted in a stark and memorable image. What was that one, that individual story? No Maandag biography has been written, and the project to make a film about him in 1978 was never completed. However, on at least three occasions—all of them about half a century after World War II—Sieg Maandag gave detailed interviews that vividly illuminated his life before and after Belsen.[40] In addition, there is a published memoir by Hetty Verolme (née Esther Werkendam), a Dutch woman who had been interned as a child at Bergen-Belsen; and there is new scholarship on the camp.[41] On the basis of these sources one can offer a brief biographical sketch of the boy, captured photographically in that one frozen moment on April 20, 1945, and get a glimpse of the road that led him to Bergen-Belsen and of the trajectory of his life afterwards.

Sieg (Simon) Maandag was born at the Zuider Amstellaan (now Rooseveltlaan) in Amsterdam on August 24, 1937. He was thus seven-and-a-half years old at the time Rodger took his photograph. His father, Isaac, was a diamond merchant—in fact, the family had been in the diamond trade for generations—and his mother Keetje (Kitty) did not work. Together with his parents and his younger sister Hendrika (Henneke), Sieg was arrested during the German occupation and held in the Hollandsche Schouwburg, a theater used by the Nazis as a pre-deportation collecting point, where Sieg remembers hearing a voice screaming from one of the boxes: "If you don't shut up now, you're all going to Auschwitz."[42] He also saw his father getting beaten after talking back to one of the guards. Then the Maandags were deported to the Dutch transit camp Westerbork, where, Sieg remembers, his father smuggled him into a theater to see a revue performed by German Jewish actors who had escaped to Holland but were captured there.

From Westerbork, the Maandag family became part of a long, grueling transport of diamond cutters and their families who were deported to Bergen-Belsen. With later transports, this group grew to approximately

four hundred Jews, whom the SS planned to use to create a diamond industry at Bergen-Belsen (opened in March 1943, originally as a prisoner-of-war camp and detention center for Jews who could be exchanged for German prisoners). Sieg remembers horrifying scenes at the roll call square (*Appellplatz*) that had a pit in which prisoners were punished for even the smallest infractions and where some died: "Anyone who did something against the rules, for example, stealing a piece of bread, was thrown in there. Fourteen days later they would lift him out again in front of all of us, a wreck. Or dead." He saw how "a man was killed one hour after we arrived—he had been with us. I saw him carried away on a wheelbarrow. Slowly you get used to it. You see a dead man, you see five." Death became a frequent occurrence, and Sieg acquired a deep kind of fright that stayed with him afterwards. "Fear, there was fear everywhere. I've kept that fear with me for years." The family slept in triple-decker bunk beds in the barrack they shared with many others. (They were detained in a separate barrack in the "star camp"—for they had to wear the Jewish star on their civilian clothes—in the part of Bergen-Belsen that also held hostages for exchanges with German prisoners-of-war. One such U.S.-German exchange took place as late as January 25, 1945, on the Swiss border.)[43] Sieg remembers that at the beginning of the internment a rabbi gave lessons and the children played hide and seek, danced, and sang songs, among them "Frère Jacques."

Suddenly one day (it was December 4, 1944), Isaac Maandag was taken away, and Sieg would never see his father again. According to the Holocaust research center Yad Vashem, the father died while still at Belsen. After the war, Sieg met a man who had been in the same transport as Isaac Maandag but would not tell how Sieg's father had died, implying that he had met a horrible death. One day after Sieg's father was gone, Sieg's mother was also deported. (When it turned out that no raw diamonds would be forthcoming for the diamond cutters to work on, the SS decided to deport the 175 men to the concentration camp Sachsenhausen, where they had to work producing instruments. The 165 adult women were mostly transported to Helmstedt-Beendorf, a part of the Neuengamme concentration camp, where they had to produce spare parts for the airplane industry and work in other forms of hard labor.)[44] These deportations left their children in an uncertain situation. A deportation list (*Transportliste*) for fifty-five Dutch children and one Hungarian woman was typed up for Decem-

ber 5, 1944. It includes the names Simon and Hendrika Maandag. However, this group was not deported, and the diamond workers' children were left parentless at Belsen, in a kind of limbo, in constant fear of being sent to Auschwitz, of getting killed.

On December 6, 1944, the day after the deportation of their mothers, the "diamond children" were moved into a newly established children's barrack, ominously called orphanage (*Waisenhaus*), in the very large women's camp. It was a barrack that had previously been used as the star camp's morgue. "Everything was senseless. . . . We had no good reason to live—we would die!" was what Sieg remembers feeling. Young Jewish nurses in the women's camp, among them notably Luba Tryszynska-Frederick and Hermina Krantz, took care of the children. Tryszynska-Frederick, a Polish nurse who had been transported to Belsen from Auschwitz, "defied all the camp's rules," Maandag recalls, "and secretly took care of us. If you walked out in just a shirt, she would call after you: it's cold, put something extra on." She watched over and helped procure food for the children as much as was possible. Still, hunger ruled, and some children died in the four and a half months they spent in Belsen without their parents before liberation.

The barrack was terrible, with several children sharing the same beds next to walls that were crawling with bedbugs. One night Sieg discovered that the boy he shared his bed with was dead. He then pushed the boy out of the bunk, hearing his body crash to the floor. "I was shocked by the noise of the body crashing to the floor but, at the same time, I felt relief at finally being able to have a good night's rest. And I slept. It's hard to believe. There really aren't any words for it." The latrine was just a wooden bar, and the stench everywhere was terrible. Right outside was a sandy path, and the patch next to it was used by the female camp guards (*Aufseherinnen*) to deposit a growing pile of corpses. Sieg remembered a woman, close to death among the corpses, who tried to sit up, waved, and made weak gestures toward the children, signaling that she wanted food. One day the children heard of a transport to Auschwitz. Sieg felt desperate, and he said to his sister Henneke, "This is the end." But she simply replied, "Stop whining, we'll get out of here." Sieg felt that "those words were so resolute, I just had to believe them. That's what I clung to; that she said: we'll get out of here."

In the months before liberation the situation in Bergen-Belsen deteriorated dramatically: as the German army retreated, the constant evacuations

of prisoners from other concentration camps in the East made the inmate population swell from 22,000 on February 1 to 60,000 on April 15, 1945, the day of liberation. During this time supplies of food and all other provisions dwindled, diseases like typhus and yellow fever (*Fleckfieber*) spread rapidly, and malnutritioned inmates fell victim to tuberculosis, intestinal infections, and many other illnesses. Conditions were so terrible that on March 1 even camp commander Josef Kramer—who had come to Belsen from Auschwitz and would be sentenced to death at the Belsen war crime trial and executed December 13, 1945—sent a detailed, desperate call for help, to his SS superiors in Berlin, requesting massive supplies, including food, beds, blankets, medication, and dishes for around 20,000 inmates as well as the end of any new transports.[45] The death rate was about 250–300 a day, and a huge open pit that served as a mass grave was insufficient as about 13,000 bodies lay around unburied.[46] The corpses were interred only after liberation, between April 18 and 28, 1945, a process George Rodger as well as British military photographers documented in gruesome photographs, one of which concluded *Life*'s "German Atrocities" photo essay, and another one of which showed children watching the scene of the removal of the corpses onto trucks for mass burials.[47]

Rodger also wrote in an essay on Bergen-Belsen, which appeared in *Time* on April 30, 1945, how he had witnessed "the ultimate in human degradation" in "the six-square-mile, barbed wire enclosure in the heart of a rich agricultural centre" that "has been a hell on earth for 60,000 men, women, and children of a dozen different nationalities who were being gradually starved to death by SS guards. . . . During the month of March, 17,000 people died of starvation, and they still die at the rate of 300 to 350 every 24 hours, far beyond the help of the British authorities, who are doing all possible to save as many who still have strength to react to treatment." He continued: "Under the pine trees the scattered dead were lying, not in twos or threes or dozens but in thousands. The living tore ragged clothing from the corpses to build fires over which they boiled pine needles and roots for soup."

Blocking out all the horror and death that surrounded him and believing with his sister that they would get out—this was how Sieg Maandag managed to survive. He had dreams of Holland, of his mother, and of his home, and he began to imagine liberation as a battle, with tanks rolling in. When Bergen-Belsen was finally liberated, without military action, on

April 15, 1945, Sieg and his sister Henneke were found among the fifty-four Dutch children who were still alive.[48] Sieg remembered German guards suddenly running away and Allied soldiers arriving who did not want to come near the prisoners who stank like hell and were covered with lice: "We were in camp, but the camp was open already. We came out one morning and we heard that any day it could happen now. . . . The Canadians and the English came. They were coming with the tanks. These guys, they were shocked when they saw us. Jesus Christ. . . . A few must have been Americans. They came into the camp, and they saw these people, and they went in, and they came into the house, but they did not want to come in there, because that was terrible, for a guy who was well fed. The Americans had beautiful uniforms with white scarves. I saw this guy with a helmet. . . . They were very rich at that moment. I'm going to see what's happened, and *uuuh!*, he stepped back. You could get sick from there, typhus, cholera, whatever."[49] (The British Army entered in protective clothing with hoods and quickly set up a DDT disinfection station at the camp entrance. George Rodger had to go through a DDT dusting before entering Belsen.) It was this set of circumstances that Sieg Maandag had to experience as a child, and it was five days after liberation that George Rodger took the photograph of him, on the curving road inside the women's camp, not far from the children's barrack: "The road . . . that's where we played hide and seek," Sieg remembered.[50] Patrick Gordon Walker, who visited the camp at the same time, recorded several programs about Belsen for the BBC, and one of them ends with the Dutch children singing a song in honor of the British liberators.[51]

The coincidence of this photograph, which "remains hard on the eyes" (as the interviewer Yvonne Laudy put it), seems to divide Sieg Maandag's life into a "before" and an "after," and he has often gone back to looking at the photograph, saying "that's me," pointing at the boy in the picture. He could reminisce about the moment the photograph was taken, remembering—in an interview with Roos Elkerbout of the Shoah Foundation videotaped in 1995—that he was summoned to have a "liberation photograph" (*bevrijding foto*) taken.[52] In that interview Sieg then speaks of the liberation and the photographers that came and mentions, displays, and points to the photograph of him taken by George Rodger, who had passed away a few weeks earlier. He points at himself in the issue of *Life*, which he has in front of him, and mentions that he and Rodger met again years

after the photo was taken and that he has some photos of that second meeting. He remembers the moment the picture was taken and agrees with Elkerbout that he looks timid (*schuchter*) and unworldly (*wereldvreemd*) in the photo. He adds that he was fearful for many years afterward.

He seemed happy to answer the questions that Thomas Rahe, another interviewer, asked about this moment, even the question of why he was so well dressed and having to argue about where the clothes had come from.

> *Interviewer:* Regarding the picture. The explanation for the fact that you are quite well dressed for the picture is that after liberation you got new clothes from the magazine.
>
> *Sieg Maandag:* This is not from the magazine. I don't know what you mean by the magazine. *Die Magazine!* [German for store rooms]. No, there was nothing. That was from the piles, there were piles of clothes. I remember those *schappen* [Dutch for shelves]. Shelves of clothes of people who died. Germans who were killed. Children. I could have chosen from the—how do you say it in German, closets? *Regale.* I said give me these. That is what it was.[53]

Of course, Sieg Maandag could not have known until much later that his photograph appeared in a popular American magazine. However, the publication of the photograph had a direct effect on his life. Nico Maandag, an uncle of Sieg's who was living in New York, bought a copy of *Life* in May 1945 and recognized his nephew in the photograph. He bought more copies and sent one to the Amsterdam Diamond Exchange—Nico Maandag, too, was in the diamond trade—where the Maandags were well known, and asked for information about the family. His efforts ultimately brought to Sieg's mother the news that her son was alive, and this resulted in Sieg and his sister's ultimate reunion with their mother.[54] However, the reunion did not happen instantly. At first, the children had to stay at Belsen for "a few weeks after liberation," according to Sieg. "We were stamped on the forehead, shaved and deloused," their "shirts crawling with vermin." And: "We got some bread, chocolates, cigarettes, we had to acclimatize slowly." Then, accompanied by Luba Tryszynska-Frederick on their journey in a British ambulance, Sieg and his sister were taken to Breukelen in Holland, to live with an uncle and an aunt, an older, childless couple, not

terribly tolerant toward the children's camp-acquired conduct. Once his aunt flew into a rage when she found Sieg hiding his shoes under his pillow so that they would not get stolen. Sieg was depressed and longed for his mother. Sieg also remembered his seemingly indelible fatigue, sleeping for hours upon hours at his aunt's home. As it turned out, this was not just the ordinary fatigue of a camp survivor, for Sieg was diagnosed with tuberculosis and had to spend time at the Bergstichting in Laren and then in the Amsterdam Jewish hospital (*ziekenhuis De Joodsche Invalide*). It was there that he had his first contact with his mother who suddenly walked into the hospital room. After being deported from Belsen, Kitty Maandag had survived hard labor in German salt mines, then was quarantined in Sweden for a year, and finally was able to return to Holland, where she went to the Red Cross but was told: "No, your children have not returned, and neither has your husband." Sieg's mother refused to believe that.[55] She "inquired everywhere, also at the Diamond Exchange. And," Sieg adds, "they showed her the picture of me from *Life*. She searched until she had found Henneke and me." She also learned that her husband had died.

Sieg still needed recuperation time in Switzerland. After he finally returned to Amsterdam, where the Maandags were now living at Johannes Verhulststraat, the topics of the war and of Belsen were soon closed: "No, at home we hardly ever talked about the war. We had had enough of it." Sieg experienced problems in school, where not much consideration was given to his special circumstances and he had fallen behind. "Camp is over," was the attitude meeting him, as if Belsen had been some sort of summer camp, and he felt that he looked like a fool in class. He had to seek psychiatric help when he was older. He was trained as a diamond cutter, and he tried his hand at designing clothes and in the wholesale trade of textiles, but he was neither happy nor successful in those ventures. He did, however, feel the lure of other worlds, and he wanted to go to faraway places. He took a trip to Morocco for half a year in a Ford Transit bus that he'd rebuilt into a camper. He traveled extensively through Central and Southeast Asia, visiting places like Kabul, Bangkok, and Bali. He responded strongly to holy sites in India, to being able to have philosophical conversations with cab drivers, and to a general spirit of searching for truth and wisdom.

On several occasions in the early 1970s, he met Karen Ralph, a beautiful and adventurous young American woman from Syracuse, New York, who was traveling as an overland trekker. First they saw each other in

Afghanistan, finally they met in Nepal, and Sieg quickly realized that Karen was "the woman of his life." They settled back in Amsterdam, married, and had two children: a daughter, Sarah, born in 1978, and a son, Simon, born in 1981. In 1981, Sieg and Karen Maandag and their children were all photographed together by George Becht.

When his children asked him later, "Dad, what was the war like?" he would sometimes simply answer, "I am alive." At other times he would recall an incident such as the time he hid under his father's coat while watching a theater performance in Westerbork. Sarah remembers her father's remark, when discussing the concentration camp, that the guards and other Germans that worked there were as much victims of the Nazi system as they, the prisoners, were.

Sieg Maandag had meanwhile started a career as a painter. (His painting "Brood" can be seen in the background of the family portrait.) His artwork covers a great variety of themes, ranging from hyperrealism to nonrepresentational styles. Herman Hennink Monkau has prepared for possible publication a volume of Maandag's representative paintings. In some paintings one can perhaps find traces of the traumatic time in his childhood. Maandag simply comments: "Picasso said: painting is therapy." In interviews, he has articulated his worried reaction to new genocides in Rwanda and the Balkans: "The world is one big trauma."

When Sieg Maandag looked at James Nachtwey's June 1994 Magnum photograph of a Hutu boy "with a piece of his ear missing, a cut across his face, his mouth open in bewilderment," he, also the subject of a famous photograph, identified with the person portrayed in another haunting image and commented that the boy "will never be able to get over it. He'll spend the rest of his life staring into the distance, wondering what they've done to him. So, should I talk about my suffering? There've been moments when I thought: I'll just jump out of a window. Should it be about that? No, the traumatized need help. And if I can do my bit. . . ."

Reunions

On April 15, 1995, the fiftieth anniversary of the liberation of Bergen-Belsen, Sieg Maandag participated in a reunion with Luba Tryszynska-Frederick in Amsterdam and was photographed there together with her and with many of the other former "diamond children."[56] Max Werkendam

THE TEMPTATION OF DESPAIR

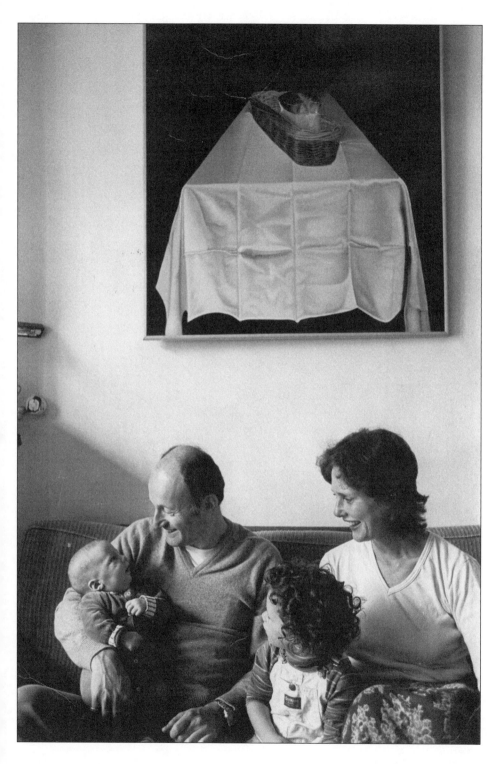

The Maandag family. 1981. *Photo by George Becht.*

Sieg Maandag, artist. 1981. *Photo by George Becht.*

and his sister Hetty Verolme, who five years later was to publish *The Children of Belsen*, her memoir of the diamond children's experience, were also present at this event.

The assembled survivors sang Tryszynska-Frederick's praises in a fifteen-stanza poem by Gerry Lakmaker, each stanza beginning with "If it wasn't for Luba." Here is the ending of the praise song:

> If it wasn't for Luba, we couldn't have shown
> How grateful we are, but not us alone
> To-day the Dutch Queen, through the Lord-Mayor related
> That Luba be granted, although rather belated
> A medal to wear and for many to see
> For services rendered to humanity.
>
> And now we are here, together with Luba
> Who looks very happy like everyone's buba
> Remembering the past some fifty years ago
> When hunger was rampant and morale very low
> But now we are happy so let's give a cheer
> If it wasn't for Luba we wouldn't be here.[57]

Tryszynska-Frederick did, indeed, receive the queen of Holland's Medal of Honor. One wonders whether Tryszynska-Frederick was one of the women that one can make out in the background of the road on George Rodger's photograph.[58]

In 1978, Henk Poncin, a Dutch documentary filmmaker, planned a film about his close friend Sieg Maandag. During the course of the planning the idea emerged to include a reunion between Maandag and George Rodger. Rodger and Maandag did indeed meet again in 1981 in Amsterdam, and the reunion was filmed. Rodger had often wondered what might have happened to the boy he had photographed on that horrible road, and he was very happy to see Sieg again. Karen Maandag still has some 16mm film material of this reunion of the photographer and his subject. The film was ultimately never produced because of a disagreement between the producer, George Becht, and Frans Bromett, the cameraman/director/scriptwriter.[59]

George Becht also took stunning photographs of the reunion (perhaps with George Rodger's camera), among them one of Rodger and Maandag

George Rodger–Sieg Maandag reunion. 1981. *Photo by George Becht.*

poring over the May 7, 1945, issue of *Life*, apparently engaged in an animated conversation about their first encounter.[60] They look at each other intensely, Rodger's right hand resting on the magazine and his left index finger positioned on the part of the magazine showing the embankment of that sandy road, while his former subject points his left index finger at his photographer, so that their elbows create a trapezoid shape that seems to echo the foreshortened *Life* magazine under the photographer's hands. The photographer and his subject were thus united in another intriguing photograph that contains the original image.

George Rodger had been deeply affected by the experience of photographing Belsen. His biographer speaks of Rodger's sense that having taken these photographs constituted a trauma, and his feeling of having done something "unspeakable and forbidden."[61] For Rodger, April 20, 1945, was so harrowing that he felt as if he had become one of the perpetrators, for he was dehumanizing the corpses for his art, "subconsciously arranging groups and bodies on the ground into artistic compositions in his viewfinder" and "treating this pitiful human flotsam as if it were some gigantic still life." In *Dialogue with Photography* he commented:

It wasn't even a matter of what I was photographing, as [much as] what had happened to me in the process.

When I discovered that I could look at the horror of Belsen—the 4,000 dead and starving lying around—and think only of a nice photographic composition, I knew something had happened to me and I had to stop. I felt I was like the people running the camp—it didn't mean a thing.[62]

This was the culminating moment in the development of a photographer who had never been "particularly interested in photographing the horror of war," but who, "despite five years of covering the war," as he commented, didn't know until Belsen "what effect the war had had on [him] personally." So Rodger said to himself, "This is where I quit," and he promised himself "never again to photograph a war."[63] In his diaries he noted that the horror he found at Belsen was too great to comprehend, but that he had to "try and show it in [his] photographs, as it was an example of man's inhumanity to man that the world had to know," but that he was not "proud of [his] pictures" and "vowed never to cover another war or to profit by others' suffering."[64] In his later work he would, indeed, move away completely from depicting war and violence. In 1947, together with Robert Capa, Henri Cartier-Bresson, and David Seymour, he became one of the cofounders of Magnum Photos, an independent agency that provided a broad outlet for his later photography.

And not unlike Sieg Maandag, George Rodger was attracted by traveling to faraway places and took photographs in the Sahara, South Africa, Sudan, and Uganda, spending a long time with the Nuba. His 1949 photograph of "The Wrestlers, Kordofan, Sudan" became another one of his iconic images. When asked to define his own approach, Rodger answered: "I like to create something—it sounds terribly smug—which gives me pleasure to look at."[65] He specified: "It's a view of 'what's out there,' reproduced in a form that's interesting and pleasing to look at. But the form comes from within you—from inside your head, or your heart."[66]

The photograph of Sieg Maandag at Bergen-Belsen was the only one of his concentration camp images, terrifying though it is, that Rodger said in an interview he could look at again and again. For, unlike the more than twelve thousand people who died in Bergen-Belsen after liberation, from exhaustion and contagious disease, this boy survived.[67]

George Rodger died on July 24, 1995, only a few months after he gave this interview. In 1999 Sieg Maandag fell ill with a seriously debilitating illness that incapacitated and immobilized him and to which he ultimately succumbed on September 22, 2013. His sister Henneke lives in Antwerp.

Questions

What light do historical and topographic contexts throw onto the meaning of a photograph? Do the alternative identifications of the child in the photograph restrict us to a view of history according to which a given subject must be either an accomplice to perpetrators or a victim? Does the time before the photograph was taken and the time that lapsed between Rodger's and Maandag's first encounter and their second meeting matter for a photograph on which its own fleeting moment and harrowing place are so strongly inscribed? How important is it that this photograph is best known in its touched-up and cropped versions? What do captions, and what does biographical information about the photographer and his subject, do to our initial reaction to a photograph? Can such contexts explain why Rodger's photograph of the boy at Belsen would seem to speak to us (to me, at least, who was dressed very similarly when I was Sieg's age), speak to us so much more strongly than so many other photographs from 1945? Could it have its effect perhaps only because it was so carefully composed? Why does it seem to want to say something more than what the early allegorical readings, what the debates about looking or not looking, focused on? Could that something include the possibility that the photograph, despite the massive presence of corpses in it, ultimately is not only about death and the temptation of despair but also may contain a small kernel of hope, of survival, embodied in the young figure, looking at the camera and moving forward along the line of the track in the road? And yet is that glimmer of hope not also offset by an abiding sense that what the young boy is not looking at in this photograph would follow and accompany him and his photographer, and perhaps even anyone who has seen this image, forever after?

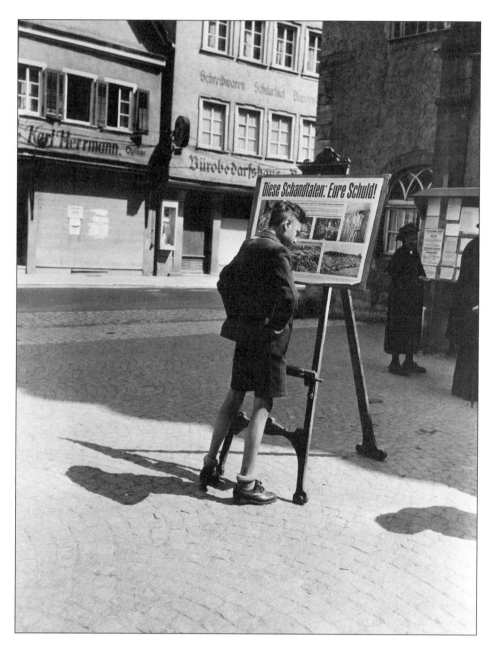

A German youth examines a display of photos titled "These Atrocities: Your Guilt," put up by the 63rd Infantry Division, 7th U.S. Army. Bad Mergentheim, June 18, 1945. *Photographer not identified. © Imperial War Museum, London, EA 71580.*

June 23, 1945

Martha Gellhorn publishes "Dachau: Experimental Murder" in Collier's *magazine.*

After Dachau

Of Private Vengeance, Collective Guilt, Life in Ruins, Population Transfers, and Displaced Persons

> To a realistic German who tries to envision his future welfare within
> the peace terms and administrative system brought about by defeat,
> there is ample ground for discouragement.
>
> —"The Relation of Bombing to Suicides,"
> *The United States Strategic Bombing Survey* (1946)

Seeing concentration camps at the end of World War II could have a radi-
calizing, life-changing effect.[1] The journalist and novelist Martha Gell-
horn's response to Dachau is a case in point. The camp was liberated by the
Americans on April 29, 1945, and she saw it a few days later. The essay she
wrote for *Collier's* about her experience carried the title "Dachau: Experi-
mental Murder" and was illustrated with a grim half-page panorama, in
somber, apparently quickly sketched and photography-inspired black and
gray tones: the reader sees the ground covered with the emaciated bodies
of many, many prisoners and the obese corpses of two SS guards; there are
bent figures huddled in front of two barracks, big crematoria dominate the
foreground, and a watchtower is visible in the back. The artist was the
Moravian-born immigrant William Pachner, whose extended family was
murdered in the Holocaust, and whose work changed during the war years
from cheery, colorful advertising designs and light-hearted comic cartoons
to the somber style that his grim and gray-toned "German Train" (oil on
board, 1944) and his illustration for Gellhorn's report represent.[2] Pachner's

image matched Gellhorn's article, for she, too, focused on the difference between prisoners and guards, even in death: "Nothing about war was ever as insanely wicked as these starved and outraged naked, nameless dead. Behind one pile of dead lay the clothed healthy bodies of German guards who had been found in this camp. They were killed at once by the prisoners when the American Army entered. And for the first time anywhere, one could look at a dead man with gladness."[3]

Gellhorn, Ernest Hemingway's third wife and a close friend of war photographer Robert Capa, had reported from the Spanish Civil War, and she covered World War II from the invasion of Normandy to Germany's unconditional surrender.[4] She was known as a hard-boiled writer, but she was quite overwhelmed by what she saw on arriving at Dachau:

> Behind the barbed wire and the electric fence the skeletons sat in the sun and searched themselves for lice. They have no age and no faces; they all look alike and like nothing you will ever see if you are lucky. We crossed the wide, crowded, dusty compound between the prison barracks and went to the hospital. In the hall sat more of the skeletons and from them came the smell of disease and death. They watched us but did not move: No expression shows on a face that is only yellowish stubbly skin stretched across bone. . . . All the prisoners talked in the same way—quietly with a strange little smile as if they apologized for talking of such loathsome things to someone who lived in a real world and could hardly be expected to understand Dachau. (16/28)

Gellhorn registered her difficulty in accounting for what she had seen in the camp and learned about the medical experiments that had been carried out there, for "you cannot talk about it very well, because there is a kind of shock that sets in and makes it almost unbearable to go back and remember what you have seen." She ended her report with a strong exhortation of "never again."

> I was in Dachau when the German armies surrendered unconditionally to the Allies. It was a suitable place to be. For surely this war was made to abolish Dachau and all the other places like Dachau and everything

that Dachau stands for. To abolish it forever. That these cemetery prisons existed is the crime and shame of the German people.

We are not entirely guiltless, we the Allies, because it took us twelve years to open the gates of Dachau. We were blind and unbelieving and slow, and that we can never be again. We must know now that there can never be peace if there is cruelty like this in the world.

And if ever again we tolerate such cruelty we have no right to peace. (30)

Private Vengeance

Radioed from Paris and published in *Collier's* on June 23, 1945, Gellhorn's report marked an experience that changed her and that would not leave her. It stayed with her so much that she drew on it for a book that reworked the desire for retribution—a wish that was palpable in her expression of gladness at seeing the murdered guards. In her novel *Point of No Return*, Gellhorn staged a private vengeance undertaken by her protagonist Jacob Levy. In a later letter Gellhorn explained the background of her novel that was originally published in 1948 under the biblical title *The Wine of Astonishment* (drawn from Psalms 60:3):

> I have always written from compulsion. . . . Not anything with my own life; compulsion about the lives of others. I wrote *The Wine of Astonishment* which was titled and in my mind is always *Point of No Return* in order to get rid of Dachau. The whole book, for me, was that: to exorcise what I could not live with. (But Dachau, and all I afterwards saw: Belsen etc., changed my life or my personality. Like a water-shed. I have never been the same since. It's exactly like mixing paint. Black, real true solid black, was then introduced, and I have never again come back to some state of hope or innocence or gayety which I had before.) The article on Dachau was written immediately, the same week. The book was two years later. There is always a difference anyway between journalism and fiction. In journalism I spend my time trying to keep myself from screaming.[5]

Gellhorn's novel moves from a war plot set around the casualty-heavy Battle of the Bulge and a love story between the Jewish G.I. Jacob Levy and Kathe, a Catholic waitress from Luxembourg, to an existentialist, absurdist, almost surrealist final moment. It comes with Levy's violent outburst that is prompted by people who are laughing just a short distance away from the camp at Dachau that he has just seen, very much through Gellhorn's eyes. A few months earlier, Jacob was ready to give up his Judaism and to convert to Catholicism for Kathe's sake. He had even told her his name was "John Dawson Smithers," which was the name of the southern lieutenant colonel whose jeep he drives, and Kathe always called him "Jawn." At that stage in the novel, his aspirations might be called assimilationist. (Whether the self-given name "John" evokes the Baptist or the Evangelist, it in any event reinforces Jacob's unconscious readiness to give up thinking of himself as a Jew.) Seeing the concentration camp, however, toughens Jacob and makes him redefine himself in violent antithesis to German civilians.[6] The caption on the cover of the mass paperback edition says, "*He lied to her . . . was driven to violence . . . Because of the secret within him!*"

The novel has vivid scenes of battle and of the advance of the American unit into Germany, some good character sketches, and a sharp representation of the casual, everyday anti-Semitism in the U.S. Army, but the scene most likely to impress the reader is that of Jacob Levy's violent action. Coming out of Dachau in his jeep, he thinks of the Jewish victims and remembers: "Momma has black hair, too, long black hair."[7] When Jacob sees six German civilians, four men and two women, standing in the street, talking eagerly and laughing, not moving aside when he honks his horn, he sees them "as he had seen no one in his life before" (290). Though there is plenty of room for him to pass by, he intentionally accelerates and drives the jeep right into them, killing three. (The reader is not told whether Levy killed only men or whether there were women among his victims.)[8] It is a lurid representation of a pointless act directed at literal "bystanders" whose only known crime was laughter. Yet it is an act Jacob Levy explicitly wants to own and to let define him. Even though the novel goes on to ponder whether Levy should defend his "private vengeance" (296) as mere accident, jeep malfunction, or result of combat fatigue, it is Gellhorn's description of Levy's act that stays with the reader:

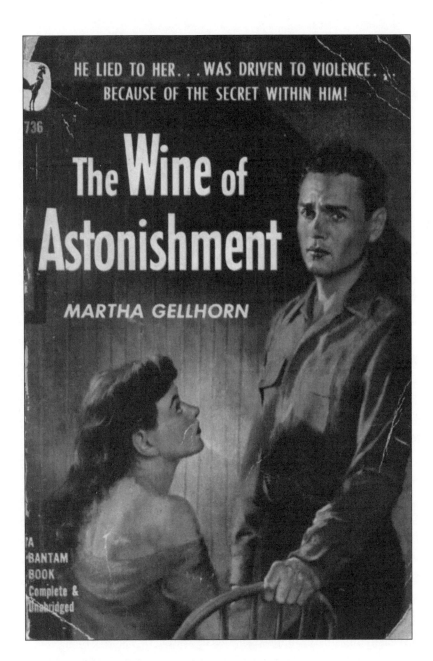

Cover of paperback edition of *The Wine of Astonishment.*

The grinning pink faces dared him to bother them. They didn't have to move for anyone. They'd gotten away with it. Laughing, he thought, laughing out loud in the street to show me.

The people in the freight cars must have screamed a long time before they died. When the wind was right, the ashes from the chimney must have blown down this way. Not a mile away, not even a mile. They knew, they didn't care, they *laughed*. Hate exploded in his brain. He felt himself sliding, slipping. It was hard to breathe. He held his fist on the horn and pressed his foot until the accelerator touched the floor. At sixty miles an hour, Jacob Levy drove his jeep on to the laughing Germans. (292)[9]

Having seen Dachau, Levy, in this shrill scene, looks at *all* Germans as mass murderers, or at least as accessories to murder. Since Levy is redefining himself through this deed, there is an element in it of the psychology of the oppressed finding self-liberation through admittedly futile acts of violence.

Gellhorn's fantasy of Levy's private vengeance partly reminds the reader of André Breton's "Second Manifesto of Surrealism" (1930), advocating a total revolt that "expects nothing save from violence" culminating in the "simplest Surrealist act," that of "dashing down into the street, pistol in hand, and firing blindly, as fast as you can pull the trigger, into the crowd," thus "putting an end to the petty system of debasement and cretinization."[10] Levy's act also anticipates notions of psychologically justified emancipatory violence of the colonized, as it would be articulated in *The Wretched of the Earth* (1961) by Frantz Fanon, for whom "at the individual level, violence is a cleansing force. It rids the colonized of their inferiority complex, of their passive and despairing attitude."[11] Jacob Levy's efforts at assimilation—made apparent by his spontaneously telling Kathe not his real name but a false, Christian one—could be read as symptoms of such an inferiority complex, an internalization of negative images, or at the very least, as an unconscious repression of his sense of being Jewish. Yet his dramatic act at the end does change Levy who "was not sorry about the krauts and he never would be" (321). "Once in his life he had done something, of his own will, for nobody he knew, not caring what became of him after" and he wouldn't "sneak out of it" (322).[12] Having lost his faith, he is mired in despair, wishes he had died when his jeep hit a tree

after killing the three German civilians, and finds that the world has "grown ugly and strange, after Dachau" (323). Yet just like Gellhorn's article ends on a "never-again" note, so her novel concludes with Jacob's newly acquired sense of militant confidence: "I won't take a thing from anybody and if they come to get me, I'll fight. They'll never get me or anybody of mine in a death transport; they'll never put us behind barbed wire" (323–24). This new fighting spirit in the name of "me or anybody of mine" is not accompanied, however, by a turn toward Jewish religion or community engagement, and Jacob seems headed toward intermarriage.[13] In fact, thinking of Kathe, to whom he wants to tell the truth and explain everything at the end, gives him a feeling of new hope and responsibility. Whereas Jacob Levy's earlier expressions of self-effacing assimilation echo a long tradition of American immigrant history, his violent outburst in which ethnicity—or perhaps just a more militant and proud version of assimilation—seems to be affirmed in a flash anticipates something of the mood of the 1960s.

If Gellhorn's vivid writing reflected how she had been changed by the experience of seeing Dachau, then the extensive coverage of Nazi atrocities to which she contributed affected readers and viewers vicariously. The writer James Agee worried that the mobilization of hostility toward Germans in general might be the intended propagandistic effect of such reportage: "The simple method is to show things more frightful than most Americans have otherwise seen, and to pin the guilt for these atrocities on the whole German people," Agee wrote in 1945, on the occasion of newly released documentary films he refused to watch. He feared that "the passion for vengeance is a terrifyingly strong one, very easily and probably inevitably wrought up by such evidence, even at our distance" and that "there would be no finding victims, or forms of vengeance, remotely sufficient to satisfy it. We cannot bear to face our knowledge that the satisfaction of our desire for justice, which we confuse with our desire for vengeance, is impossible. And so we invent as a victim the most comprehensive image which our reason, however deranged, will permit us: the whole of a people and the descendants of that people: and count ourselves incomparably their superiors if we stop short of the idea of annihilation."[14] Lieutenant Colonel Smithers's comment in Gellhorn's novel that, "compared to Dachau our war was clean" (331), would seem to be just the kind of articulation of comparative moral superiority that Agee abhorred.[15] Gellhorn's

reportage also concluded that the concentration camps demonstrated "the crime and shame of the German people." One wonders how Agee would have reacted to Gellhorn's novel—or how Gellhorn might have responded to Agee's article, which was published in the *Nation* about a month before her report on Dachau appeared in *Collier's*.[16] The kind of differentiated view that James Agee wished for in the immediate aftermath of World War II hardly carried the day, though there were others who shared Agee's concern.[17]

Guilt Placards

Upon his arrival in Bad Nauheim in May 1945, the Anglo-Irish writer James Stern noticed that while the attention of the Americans was focused on the center of the spa, the Kurhaus, formerly a German field marshal's headquarters that had been directly hit by a precision bomb, the natives "were drawn elsewhere." Stern describes the scene:

> We found them in small groups, standing in front of trees, before the town's proclamation board and the empty windows of closed shops. They stood there, silent, motionless for several minutes; then shaking their heads, they walked slowly away. What they saw on these trees, boards and shop-windows, what faced them in some prominent spot in every village and town, was a large notice from which glared a heading in immense black letters:
>
> WHO IS GUILTY?
>
> Under the heading were a number of enlarged, rather blurred photographs: hundreds of naked human skeletons on the open wagon of a goods train; what looked like a mountain of garbage was a mountain of ash and charred human bones; men in striped prison clothes hung from gallows, while children and babies lay on their backs on the ground, dead from starvation.

Stern notices that none of the spectators uttered a word: "A woman would occasionally put a hand or a handkerchief to her mouth as though to stifle the moan or cry of horror; an elderly man with his mouth open would stare as though hypnotized for a few minutes; then one by one they would

Guilt placard. *Bundesarchiv Koblenz, Signatur Plak 004-005-005.*

walk slowly, silently away." The reactions they show to the inescapable
barrage of these "guilt placards," as Stern calls these public displays, makes
him try to imagine the citizens slowly moving into their rooms, reaching
for relief on the radio, only to hear a "voice of accusation" echoing the
message of the poster, *"Who is guilty of the atrocities committed against hu-
manity in your midst . . . ?"* What might their true reaction be, Stern won-
ders, to this and the next set of posters, with clearer photographs and the
bold caption "YOU ARE GUILTY!"—but he finds it impossible to penetrate
the silent masks of the natives. The fact that the Russians, as an officer
tells him, do not use guilt placards but give helpful information on the
radio about the extent of the destruction of Berlin, provide practical details
on utilities and food rations, and play music, including works by Jewish
composers, makes Stern think "about the larger issues of propaganda and
collective guilt."[18]

There are copies in archives of such posters with the bold headlines
"Wessen Schuld?" (Whose Fault?) and *"Diese Schandtaten: Eure Schuld!"*
(These shameful deeds: your fault!) as well as a photograph of a perhaps

twelve- to fourteen-year-old boy who is looking closely at the placard that is displayed on an easel on a cobblestone road at midday, in front of closed shops for eyeglasses and stationery (see the photograph facing the opening page of this chapter).[19] The unidentified photographer captured the youth in short pants who seems to be reading the caption to the atrocity photographs on the poster that the Sixty-Third Infantry Division of the Seventh U.S. Army had put up in the small town of Bad Mergentheim (Württemberg) in 1945. Whatever that boy's immediate reaction to such both taboo-breaking and guilt-instilling images may have been, is up to our guesswork just as much as the response of Stern's imaginary Nauheim citizen, or that of viewers of atrocity documentaries who, as Erich Kästner reported in February 1946, walked away in silence or with evasive or self-defensive comments.[20] In June 1945 Ursula von Kardorff, at whose diary of the end of the war we looked earlier, mentioned with consternation that local people who were shown horror photographs of Dachau by a group of priests who had been imprisoned there said that these were really images from the attack on Dresden; yet Kardorff herself also complained a few days earlier that the Allied radio programs addressed Germans in the manner of a shrill and rigid old governess.[21] What seems clear anyway is that at least in the Western zones it would have been difficult for Germans not to be exposed to such images and to a debate about collective guilt in the immediate postwar period.[22] Stern's own observation was that with very few exceptions Germans did not "express any feeling of guilt," and he has a simple explanation for it: "The feeling of guilt among Germans is so colossal that they simply cannot face it, much less give it expression."[23]

The Effects of Bombing

James Stern's mission in 1945 Germany, where he traveled with W. H. Auden (whom he calls "Mervyn" in the book), was to do research for the U.S. Strategic Bombing Survey on the psychological effect of the air war on the populace (and perhaps that is why the Americans' attention was directed at the bombed Kurhaus).[24] The absurdity of asking people in completely destroyed cities a series of rather mechanical questions devised by social psychologists about the effects of bombing was only too

apparent to Stern, for he took—perhaps inspired by the officially established "indirect interviewing method"—the opportunity to engage in longer conversations with people he interviewed, those he met, and friends and acquaintances from his prewar time in Germany whom he visited. The official team survey report included sample answers to the questions, an evaluation of more than eight hundred intercepted letters that mentioned the bombing, and generalizations about the lowering of German wartime morale as an effect of bombing.[25] Stern's own report—originally it was meant to be written jointly with Auden—was most striking in its juxtaposition of precise military information and its attempt to imagine the experience and to find metaphors that are not clichés "in the face of hardly comprehensible catastrophe" (95).

Thus Stern tells the reader factually that Darmstadt suffered only "one raid of the classical saturation type," on September 11, 1944, lasting fifty-one minutes and totally destroying more than half of the city center's 8,400 dwellings. According to the casualties reported to various police stations, "8,433 human-beings were killed or burned to death and 2,439 were seriously wounded. In the tremendous heat, witnesses told us, adult bodies turned brown and in a split second shrunk to the size of babies. After the raid more than 49,000 survivors (roughly half the population) fled to nearby towns and villages" (94). Then Stern tries to penetrate these statistics as he realizes that the inhabitants of Darmstadt talk about this single air raid differently from people in cities like München that had been bombed 92 times from 1942 to 1945:

They talked of it as perhaps the survivors of Hiroshima talked of their single experience of less than a year later, as The Nightmare that cannot be imagined by those who didn't experience it, not ever to be forgotten by those who did. Some—like the once-certified who do not speak of insanity—could not be persuaded to talk of it at all. How many of us, the unbombed, the uninvaded—I've wondered since—do seriously consider sharing shattered Europe's sleep: the waking up every morning in some unlighted, unheated hovel to see all about us for miles the great graveyard, the permanent memorial of one short nightmare that would live with us and with our surviving children—unmentioned, unmentionable—to the end of our days? (94)

Stern, whom we encountered before as the original and witty translator of *A Woman in Berlin*, represented ruins in his own account as if he were a writer in search of appropriate metaphors. Living in a bombed city may feel as if one had awakened from a nightmare in a cemetery, but the remains of the city strike Stern also as "a high sea, a tempestuous ocean of pink rubble with jagged, perforated walls sticking up between the great waves" with "tidal monsters" too immense to permit the question of how long it would take to rebuild when the more pressing question is "how long it will take to dispose of the rubble" (95). The distinction between land and sea has been dissolved. In Frankfurt Stern finds it hard to recognize the city in which he once lived, and the metaphor that comes to his mind is that of "acres of corpse-like buildings with their black, hollow eyes," a scale of destruction so vast it makes him think not "as something done deliberately by man to man, but as an earthquake—The Earthquake, the phenomenon of our era" (83).

Returning from his American exile to Germany in 1945, the novelist Alfred Döblin similarly noted the growing extent of devastation, "huge factories . . . leveled as if by earthquake," as he was approaching the city of Mainz, reduced to "merely rubble as far as the eye could see, faceless masses of it, foundations, iron girders, façades."[26] And the photographer Tony Vaccaro said that he liked to put photographs of human destruction and of earthquakes together—"the earthquake of war and the earthquake of earthquake."[27]

In Nürnberg's vast scenes of destruction Stern noticed the kind of detail in a ruin that also fascinated numerous other observers: "a four-story modern building which had been split clean in half, as though by a knife, so that open to the public gaze stood four white-painted 'privies,' one under the other, all alike, and all intact down to the chains hanging from the ceilings" (261). The historian David Brion Davis who, as a young G.I., was stationed in Mannheim in 1945–46 and wrote many letters home to his parents observed that "three-story houses were sliced in halves and quarters, exposing tiled bathrooms and living rooms with light fixtures still intact."[28] It is this incongruous transformation of an interior into an exterior, making private spaces publicly visible, that appears in numerous ruin descriptions of the immediate postwar years. Such ruins in Breslau

Artist painting war ruins. Frankfurt, May 1947. *Photo by Tony Vaccaro/AKG images, File AKG_200138, file reference 2-K15-F1-1947.*

(destroyed by a prolonged artillery battle rather than by aerial bombing) made Hugo Hartung think of toy houses: "torn-open apartments that are open like doll's houses and put on display a private world of happiness to the curious or the indifferent lookers-on."[29] Zelda Popkin, to whose novel *Small Victory* (1947) we shall turn later, was reminded of a theater set by such a ruin and drew on the cemetery-like sensation of heavily bombed Frankfurt in her Gothic description through the lens of her southern protagonist Randolph Barlow: "The brown shells of houses that towered over heaps of plaster and timber and stone had their fronts sheared away, like stage sets, and the papered walls, pink, green, and blue, had been ploughed and rutted and striped by recurrent rains. Private rooms stood indecently naked; an empty bed, all alone, three flights up on a cracked, rain-soaked wall, still hugged its corner, still held its bedding, and perhaps—his flesh crawled at the thought—still held the bones of a child or a woman; a bathtub dangled above a flush bowl."[30]

The façadeless houses that exposed to public view Gothic scenes of violent deaths seemed to stand for the complete collapse of civilization, of respectability, of proper conduct generally that the embellished fronts of intact houses might have promised. The "privies" and all private spaces revealed to public gaze suggested the dissolution of spheres that need to be separated in civilization. The photographer Margaret Bourke-White's comment seems apt: "In normal life one rarely sees violent emotion openly expressed; usually such torrents of fury and desperation as we were observing are released behind closed doors."[31] What was also revealed was, in James Stern's phrase, "the hidden damage" in a land in which every German had become suspect as a possible perpetrator or accomplice, but which had also been destroyed by civilian-casualty-intense Allied bombing, so that to the Swedish novelist Stig Dagerman (at whose postwar report we'll soon be looking more closely) the large group of honest German anti-Nazis appeared to be "Germany's most beautiful ruins, but for the present as uninhabitable as the collapsed masses of ruined dwelling." This was so because as Germans they could not "hold shares in the final victory of the Allies," but as antifascists they could not "be partners in the German defeat."[32]

Postwar writers gave much effort to representing ruins. In fact, ruins were such a central presence that the first wave of German postwar literature was called *Trümmerliteratur*, rubble literature. John Dos Passos, like

many other American observers, was struck by the general hustle-bustle of people moving about the ruined landscape, a scene that made him, too, search for appropriate metaphors: "Frankfurt resembles a city as much as a pile of bones and a smashed skull resembles a prize Hereford steer, but white enameled streetcars packed with people jingle purposefully as they run along the cleared asphalt streets. People in city clothes with city faces and briefcases under their arms trot busily among the high rubbish piles, dart into punched-out doorways under tottering walls. They behave horribly like ants when you have kicked over an anthill."[33] Alfred Döblin found everything "destroyed, smashed to bits," including his beloved Alexanderplatz in Berlin, and Tietz Palace, the department store of which he had vivid memories, resembled "a man whose neck has been snapped with one blow, whose skull has been driven down onto his chest."[34] The posters and advertisements remaining on the buildings in streets that were "dead and yet not dead" made the ruins look like "a corpse in a brightly colored apron, wearing a cheap bracelet" (299–300). Döblin marveled at the Germans' apathy, their "odd, detached attitude" with which they treated the destruction of the cities, "this diluvian catastrophe as if it were some unfortunate accident, like a large fire. Occasionally, one of their poets or wordsmiths will undertake to describe this calamity that passes all understanding, and will call upon apocalyptic images to that purpose. It has an artificial ring to it" (278). Like Dos Passos, Döblin was struck by the busy people and noted that Germany's "citizens are running around in the ruins like overwrought, industrious ants on a crushed anthill," that, for example, in Stuttgart, the "swarms of people . . . , their numbers increased by an influx of refugees from other cities and regions, move about the streets among the colossal ruins as if nothing at all had happened, as if the city had always looked like it does now" (279).

The Swiss playwright Max Frisch, who visited München in April 1946 found it strange to behold there a "curious sight":

A conqueror on horseback, still riding toward the emptiness of a vanished room, proud and upright on a pedestal of misery, surrounded by burnt-out shells of buildings, outer walls whose windows are as empty and black as the eye sockets of a human skull; he too has not yet taken it in. Through a doorway beneath budding trees protrudes a frozen avalanche of rubble; it is an enchanting baroque doorway,

and it looks like a mouth in the act of vomiting, suddenly out of no-where vomiting forth the contents of a palace. Above it, the crumbling wings of an angel, solitary like all beautiful things, grotesque; the surrounding silence, bathed in bright sunshine, of something that has ceased to be, of finality. "Death is so permanent."[35]

Frisch extended the imagery of death when he observed the fragile, skeletal transparency of churches and buildings:

Even the great church, the Liebfrauenkirche, is an open space, filled with the flutter of birds. In the middle stands a single column, like a guest, like a returning wanderer looking around; somewhere one can see the beginnings of an arch, the shreds of a painting catching the sun. The roof is a black skeleton. And from here too one can see right through to the other side: there are chimneys still standing, high on an upper floor a bathtub, a wall with faded wallpaper and the black ornaments of fire, tongues of soot, windows full of distant skies and moving clouds, of springtime. Often it is possible to see right across one street into the next, even if it is through a web of red rust; the remains of a fallen ceiling. Hardly a house in the way of the view; only when one looks straight down a street does it give the impression of what it once was, leading me to think here is a street that has survived. But even here I find, as I walk on, gaping holes on both sides. The picture is the same almost wherever I go: a city, but spacious and sparse as an autumn wood. If it had been an earthquake, a blind act of Nature, one would find it just as difficult to understand, but at least one could accept it without trying to understand. (16)

For Frisch the experience was literally haunting, for he recorded a nightmare about ruin-inspired shipwrecks that appear floodlike in a lake near his Swiss home, and "only their masts show above the surface," making him wonder "how the passengers manage to stay alive" (19). And when he visited Frankfurt and saw "the grass growing in the houses, the dandelion in the churches," he imagined that he was witnessing the slow return of the forest primeval and the emergence of a world after the end of human history: "Suddenly one can see how it might all continue to grow, how a forest might creep over our cities, slowly, inexorably, a sprouting unhelped by

human hands, a silence of thistles and moss, an earth without history, only the twittering of birds, spring, summer, and fall, the breathing of years which there is no one to count."[36]

In September 1946, Erich Kästner published an account of Dresden in *Die Neue Zeitung*. The city where his parents lived and that he had last seen before the bombing was a stone desert that made him think at first of Sodom and Gomorrah, but then he settled on a series of maritime associations: "The splintered churches are lying around as if they were wrecks of gigantic steamships, hurdled on land by a cyclone. The burnt-out towers of the Church of the Cross and the Hofkirche, of city hall and the castle look like cut-off masts. The golden Hercules on top of the steely rib cage of city hall reminds you of a ship's masthead which, though closest to the sky, strangely—the stuff of legend—survived the fiery typhoon. The stony planks and canvasses of the stranded colossi had melted and molded like lead in the ember-breath of the hurricane. What ordinarily takes a whole geological age, to transform stone—that has been brought about by one single night."[37]

The Swedish novelist Stig Dagerman's *German Autumn*, perhaps the best single contemporary report on Germany in 1946, devotes a striking chapter to describing the ruins he saw everywhere. Dagerman feels that Köln's "cathedral looms melancholy, sooty and alone in a pile of rubble with a fresh red wound along one side which seems to bleed at twilight" and that "in the small towns of the Rhineland ribs stick out of bombed timber-houses." From a train in Hamburg Dagerman has "an unbroken view of something resembling a vast dumping-ground for shattered gables, free-standing house-walls whose empty window-holes are like wide-open eyes staring down on the train, unidentifiable fragments of houses with broad black smoke-scars, tall and boldly sculptured as victory monuments or small as modest gravestones." Dagerman went on with his account of the "gigantic wasteland" he saw: "Rusty girders poke out of the gravel-heaps like the stems of long-since foundered boats. Slender pillars which an artistic fate carved out of collapsed tenements rise from white piles of crushed bath-tubs or from grey piles of stone, powdered brick and melted radiators. Carefully manipulated façades, with nothing to be façades for, stand there like scenery for a play that was never performed. All the figures of geometry are on display in this three-year-old variation on Guernica and Coventry: regular rectangles of school walls, small or large triangles,

rhombi and ovals of the outer walls of the huge tenements."[38] The refer-
ence to Guernica and Coventry is meaningful, serving as a reminder of
the fascists' first use of urban bombing of innocent civilian populations as
a part of modern warfare. Dagerman also reports that one of his conversa-
tion partners, a woman who had lost all her possessions in the bombing of
Hamburg, mentions that she "had already lost her faith and hope in the
bombing of Guernica" (23) and when Dagerman says that he is sorry
about the loss of her home "she is one of the very few who admit: 'It began
in Coventry'" (24).

When Gertrude Stein and Alice B. Toklas visited Germany in 1945,
Stein at first seemed to refuse any metaphor for ruins. She wrote up the
visit in her unmistakable style, resorting to a childlike tone and deadpan
repetition rather than to any representational strategy or visualization:
"and off we all went to see Germany," she wrote, "we had seen it ruined
from the air and now we saw it ruined on the ground. It certainly is ru-
ined and not so exciting to look at."[39] However, when her trip took her to
Köln, "the most destroyed city we had seen yet," she commented that "it
is natural, of course it is natural to speak of one's roof, roofs are in a way
the most important thing in a house, between four walls, under a roof,
and here was a whole spread out city without a roof. There was the cathe-
dral but it looked very fragile as if you pushed it hard with your finger
your finger either would go through or it would fall over." And in München
she observed: "One would think that every ruined town would look like
any other ruined town but it does not." To Stein, the Bavarian city "with
all its big open spaces gardens and stadiums and everything looked not so
much ruined as dilapidated, it looked completely dilapidated, as if in a few
years it would just sort of not exist." Gertrude Stein also posed for a *Life*
magazine photographer in front of the ruins surrounding Frankfurt
cathedral.[40]

From incongruous grotesques and geometrical figures to transparent
forests and shipwrecks, one is amazed at the array of metaphors writers
employed to evoke the incomprehensible, fragile world of ruined cities,
"drearier than the desert, wilder than a mountain-top and as far-fetched
as a nightmare," as Dagerman put it.[41] Again and again observers were
fascinated and horrified by the contrast between the imagery of death
(corpse, skeleton, decapitation) and the sense of an odd new busyness of
life (an anthill that has been kicked or crushed). Ruins seemed hauntingly

anthropomorphic (ribs, wound, eyes, vomiting), and the inversion of inside and outside in houses that had been cut open or in half reminded writers of stage sets or upside-down worlds.[42] The fact that the vast ruinscapes that gave cities an eerie sense of transparency were not the result of a natural disaster (like a cyclone or a diluvian catastrophe) but man-made was all the more frightening and made observers think of geological times in the deep past as well as about the end of time, whether it was a vision of judgment day or the anticipation of a posthuman future at which the distinction between inhabited, settled land and open sea was eradicated. The earthquake as a parallel may vaguely allude to the Great Lisbon Earthquake of 1755, which had made philosophers question the notion of a benevolent God. And Döblin's reference to the Deluge summons the notion of "the terrible voice of justice in history" for him. Let anyone here "try to avoid thinking about retribution," even though he reminded himself that "millions of people who lived here then did not take part. They merely watched as the witches' sabbath was celebrated."[43]

Though one could, along the lines on Georg Simmel's famous essay on "The Ruin," see an intriguing aesthetic fusion of art and nature in some of the ruins of the 1940s that were beginning to be overgrown, they were not much like the ideal romantic ruin, whether from antiquity or the middle ages, in which a slow process of deterioration and dilapidation was accompanied by a gradual emergence of natural growth. The ruins of the 1940s showed in an even more intense way what Simmel deplored in some of the Roman ruins: they made the viewer only too aware that they were the result of human destruction.[44]

Ruin Photography

Germany's ruined cities were perhaps even more extensively photographed than they were represented in writing. After her coverage of the war and of camps at Buchenwald and Leipzig Mochau, which she "forced [her]self to map with negatives," Margaret Bourke-White was assigned by *Life* magazine to "make a thoroughgoing series of photographs of the bomb damage inflicted by our Air Force on major German cities and industries." She took many of the shots from the air, thus documenting from a bird's eye view the fullest possible extent of such massively destroyed big cities as Hamburg, Bremen, Köln, Ludwigshafen, Würzburg, Nürnberg,

Postman in the old city of Frankfurt. May 9, 1947. *Photo by Fred Kochmann, S7ko/1.539.* © *Institut für Stadtgeschichte Frankfurt am Main/Fred Kochmann.*

and München. She was flying in a small plane with a pilot who was so professional that Bourke-White could take photographs block by block, comparing the cityscapes below to her Baedeker guidebook maps, from altitudes as high as two miles and as low as twenty feet. She used her wartime, worn-out Rolleiflexes because with all the looting done by Allied soldiers she was unable get a new one, not even at the Rolleiflex factory in Braunschweig.[45]

Showing people, in some cases people in recognizable professions, in the disorienting environment of ruined streets was a motif photographers chose with some frequency.[46] For example, Fred Kochmann represented a postman on his way to deliver mail amidst the rubble piles at near Frankfurt's Römerberg and city hall.[47] Seen from behind, wearing a dark suit and cap, and carrying a leather bag fully packed with mail over his right shoulder, the postman's vertical figure is sharply outlined against the bright, sunlit path between rubble mounds that seems slightly overexposed in the photograph. The mailman's ordinary professional readiness to bring letters to their destination clashes with the ruins, empty façades, and hollow buildings he is walking toward. Will he be delivering mail in ruins? Does he know the addressees who live in cellars underneath those unin-

habitable and transparent shells of buildings to which the strong sunlight lends an almost ghostlike brightness? Similarly, Carl Weinrother showed a Berlin postman in a flowing cape delivering mail in a ruin-covered Kreuzberg street, walking toward the viewer. An anonymous photographer in Hamburg focused on a man, probably a war veteran, moving about on crutches, his right leg amputated from the thigh down, whose black silhouette is sharply outlined against a bright cobblestone street lined with rubble, and he is walking away from the viewer toward one knows not what, for not a single intact building can be made out in the ruins he is approaching. Werner Bischof showed a shopper or flâneur, dressed in a regional costume with a Tyrolean hat and tall boots and carrying a large basket, walking along abandoned streetcar tracks in a completely ruined street of Freiburg; in Nürnberg, Ray D'Addario portrayed a woman walking up a cobblestone road framed by snow-dusted rubble toward a partly repaired ruined house; Otto Hagel showed a young boy carrying a school backpack walking down a stone staircase leading toward the hollowed-out ruins of Pforzheim. Most commonly, the human figures are shown from behind, but Victor Gollancz also posed frontally, facing his photographer at the center of a street in Düren—it is wet and reflects Gollancz's figure as well as the outlines of the ruins and rubble that flank the street.[48] The angle several photographers chose seemed intended to stress the departure of these ruined-city street views from the familiar genre of perspectival urban photography like that of a Parisian boulevard, and going back to an earlier tradition of *veduta* painting, because in ruin photography the vanishing point of the perspective itself seems to vanish amidst the irregular mounds of rubble or end in upsettingly empty façades.[49] (One of Dagerman's sentences similarly captures the photographers' sense of streets as only a faint memory of the past: "We walk for a while on what had been the pavements of what had been the streets and look for what had been a house but never find it.")[50]

Tony Vaccaro's vast photo archive of the last war and early postwar years includes much ruin photography. Many of Vaccaro's postwar images generate a tragicomic dialogue between human beings and the grim world of destruction that surrounds and has permeated them, as if he (as did Dagerman in prose) were searching for the correspondence between damaged cities and their damaged inhabitants.

Life on a balcony. Mannheim, November 1948. *Photo by Tony Vaccaro/AKG images, AKG_205326, file reference 9-1948-11-0-H4.*

"Life on a balcony," one of Vaccaro's photographs in this manner, shows an old woman who in November 1948 refused to leave her bombed-out apartment in Mannheim (127); she is sitting alone on her balcony in a thoroughly ruined (and in its upper floors quite transparent) apartment building from the Wilhelminian period.[51] Like one of the Fates of antiquity, this grandmother figure seems to be knitting, attempting to seem impervious to the destruction that is surrounding her; a thin, knotted-together string that one can barely make out also hangs down from her impressively designed cast-iron balcony and served, as Vaccaro remembers, as the lifeline of her supply of sustenance.[52]

Perhaps working in the tradition of Walker Evans's Depression-era photographs, Vaccaro at times used the contrast between billboards and the

surrounding reality, including human figures who seem to challenge what the poster may proclaim—so that the pronouncement may come to seem hypocritical. One of Vaccaro's masterpieces is the photograph, "'The Best Years of Our Lives': A Hollywood Movie at the Thalia Theater, Darmstadt, October 1948" (125). The centrally visible film title—which has the effect of an ironic caption that is incorporated directly into the image itself—clashes so very dramatically with the scene into which the poster has been placed that one cannot help but laugh at the contrast. The movie billboards stuck on the awning are about the only things of substance on the Thalia Theater building's otherwise hollow, and, on the first floor, completely transparent ruin of a façade. The dreary street life in front of the theater consists of a wooden cart drawn by two haggard horses, and three pedestrians, among whom a bespectacled middle-aged man with a briefcase stands out. The photograph ironically contrasts American abundance symbolized by Hollywood glamour and German poverty and destruction. William Wyler's film, by the way, has a not at all sugarcoated plot about the difficult return of two war veterans to their ordinary family and work life.

Vaccaro also employed the common motif of contrasting statues embodying Germany's cultural past with ruined environments. Thus his "Ode to Joy? Monument to Friedrich Schiller" (Frankfurt, February 1946), asks the viewer to contemplate the intact Schiller statue, surrounded by mounds of rubble and ruins (75). "Roßmarkt with Gutenberg memorial," taken from a low angle, shows the monument devoted to the beginnings of book printing against the background of the tall ruins of Frankfurt's residential and commercial buildings as well as of Katharinenkirche. A high point of cultural history is surrounded by destruction. And his 1947 "Artist painting war ruins" (reproduced in this chapter) is self-reflexive in capturing photographically the process of representing a ruin in watercolors. Tellingly, the painter seems hesitant to trace with his brush the exposed and transparent parts of the building that were destroyed.

A good number of postwar photographs show busy crowds of people in places that were not only ruined, but also overpopulated, in scenes that inspired Dos Passos's and Döblin's "anthill" metaphor: people living in and under destroyed buildings, in air raid shelters, crowding jam-packed streetcars and horse-drawn carriages, filling trains inside, outside, and populating even the roofs of the cars with so many passengers as to defy

Roßmarkt with Gutenberg memorial. Frankfurt, 1947. *Photo by Tony Vaccaro/AKG images, AKG_200153, file reference 5-F2-D12-1947.*

belief; crowded black market scenes and long, long lines of people in front of food shops and bulletin boards or queuing at ferries to cross rivers in cities where all bridges had been destroyed. And there were photographs of crowds of women clearing rubble, or men rushing to work with briefcases in their hands.

Children were a popular motif in photographs taken among the ruins. In 1945 the Swiss professional photographer Werner Bischof captured "two German girls skip, light-footed, and smiling," in the empty shell of a ruined, roofless church in Friedrichshafen and about a dozen children playing a ring game on a cobblestone street in front of the horizontal panorama of ruined Freiburg, and not a single intact building is in view. For Bischof traveling around war-torn European countries meant "the destruction of [his] ivory tower," as he confided to his diary, and he felt that he could "no longer take photographs of pretty shoes," as he wrote his father. As his editor put it, Bischof did not "fall prey to the facile rationalization of desperation and despair" and did not return to his earlier work in photographic abstraction, but kept documenting life in postwar Europe.[53] Fred Kochmann, who took twenty-six hundred photographs between 1945 and 1950, observed six girls doing another ring

game next to a deep bomb crater and a group of boys and girls playing happily in front of the empty shells of houses near city hall in Frankfurt: "Children did not feel lost among all those heaps of stones," his editor Helmut Nordmeyer comments, because for them "hollow-eyed ruins . . . became mysterious caves and enchanted places in which one could play marvelously."[54]

[*This was certainly true for me, for after we moved to Frankfurt, I also played in the ruins quite close to where Kochmann had taken this photograph; the ruins served as a completely normal playground, with an intact pissoir in an otherwise completely destroyed and roofless restaurant. The inner-city ruins were leveled only in 1956.*

My first and quite memorable experience of seeing the ruins in Frankfurt was connected with an odd semantic confusion. We were then living in Kronberg, a small nearby town with a castle, a Burg, *and we had often walked from there to the next town, Königstein, which had a much bigger castle called* Ruine.

Hence I thought that "ruin" was the word for a bigger castle. When my father took me along to Frankfurt one day, it was obvious to me that Frankfurt was much bigger than Kronberg or Königstein. Hence I asked him hopefully whether Frankfurt had a Ruine, too, and expected to be able to see a truly gigantic castle. My father responded, with an ironic laugh, just look around you, these are all ruins. I still remember my deep disappointment at seeing ugly burned-out buildings rather than castles, and distinctly noticed a painting hanging on a wall of an upper-floor apartment building, the front of which was gone. I was surprised that in my readings for this book I found Stig Dagerman making a imilar semantic connection in the first postwar years when he wrote that amidst all the ruins of Germany, "there is still one city that charges admission to a ruin: Heidelberg, which was spared the onslaught [of the bombing campaign] and whose beautiful old castle ruin looks like a demonic parody in an age of ruins."][55]

The Hungarian-born *Life* photographer Robert Capa showed children playing at the edge of a bomb pit as if they were in a sandbox; he also captured three boys looking up at a vast four-story ruin.[56] The Berlin photographer Erich Seidensticker portrayed three little girls immersed in a game of lining up pieces of rubble along a curb delimiting a sidewalk now covered by mounds of debris.[57] Ray D'Addario photographed a young boy in the ruins of Nürnberg.[58] As a G.I., David Brion Davis took a photograph that he sent home to his parents: "A boy standing in the ruins of his

The romantic Taunus mountains. *Postcard of castles, ca. 1950.*

former home in Stuttgart. March 1946."[59] In February 1946, Tony Vaccaro portrayed "two charming girls in the ruins" of Frankfurt, dressed in overcoats, long stockings and leather shoes, holding a bag between them and smiling at the photographer—while they are standing on a street on which not a single intact building can be made out and two male adults are walking in the background. Among his other photographs of children "the boy with three loaves of bread" (Ludwigshafen, October 1948) is noteworthy, as it shows a young boy holding two loaves under his right and one under his left arm, smiling in front of a transparent ruin façade and rubble; he wears a patched jacket and a soldier's cap, is missing a piece of his front tooth but giving the photographer (and us viewers) a broad smile, as he seems clearly happy about his bread.[60] In 1950 Paul Rötger, who as a youth had been arrested together with an activist Catholic priest by the Gestapo in 1937, and then trained as a graphic artist, photographed three children playing ring-around-the-roses next to Frankfurt cathedral, already partly covered with a new roof but still without windows.

Are children in such photographs suggestive of hope amidst the overpowering imagery of destruction—do they bring to mind that an old world has died but that a new generation is rising? Does their presence reinforce the associations of ruins with dollhouses or toy cathedrals that would fall

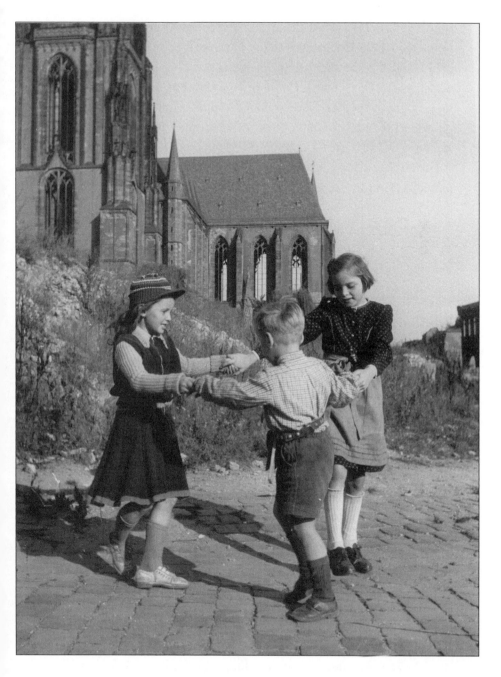

Children playing in the area between Frankfurt cathedral and city hall. 1950. *Photo by Paul Rötger,* ©
Institut für Stadtgeschichte Frankfurt am Main/S7C 1950/19.01.01.

over if you simply pushed them? Was the choice of portraying children near scenes of horrifying destruction a form of artistic kitsch—as Dagerman found it to be the case in the work of a postwar painter of ruins whose studio he visited in Hannover? "There was in one of the paintings, Dagerman writes, "a programmatic ruin—a quite unrealistic stage-set ruin in the background, in front of which were two playing children and flowers. Bad theatre—nothing else."[61]

Do the children in ruin photography suggest their apparent lack of caring in their readiness, in a grim situation, to play and laugh and have a good time instead of facing up to the past, of which the destruction that surrounded them could have served as reminder? One only has to think back here to the captions the boy at Belsen received when he was believed to be a German boy, or of Gellhorn's Jacob reacting to German adults laughing, to imagine such readings of photographs of children in ruins.

Or does the children's presence in these photographs perhaps serve to subtly question the belief in the collective guilt of "the whole of a people and the descendants of that people" (to use Agee's phrase)? Thus when Max Frisch sees thin-faced children playing in Frankfurt in May 1946, the thought comes to his mind that they have never seen an intact city, then, that this is not their fault, "less their fault than that of anyone of us," and that they need help, not only to be saved from hunger like all other children, but also to be told that they are not damned, not ostracized, regardless of who their fathers and their mothers may be. "We owe them more than pity; we must not for a single moment doubt them, or it will be our fault if it all happens again."[62]

Judging the Desperate Collectively

A few pages later in his 1946 diary Frisch reflects more fully on judgment and mercy, as he notes that many conversations with Germans move toward a moment when Germans want to somehow justify themselves and ask him to judge and exonerate them; when he refuses to do so and is either silent or reminds them of a few things one must not forget, he is met with the complaint, unspoken or voiced, that he is judgmental. Can mercy mean surrendering judgment, he asks? And what actions should follow mercy? He often feels that the only possible future is with the desperate ones (*bei den Verzweifelten*) but wonders whether the daily misery

has the effect of making recognition and change more difficult in Germany. "When I have a deadly case of pneumonia and someone reports that my neighbor had died and that it was my fault (*Verschulden*), it may be that I hear it, see the images one places in front of my eyes, but it does not reach me. Deadly misery, one's own, narrows my consciousness to one point. Perhaps that is why some conversations are so difficult; it turns out to be inhuman to expect of a human being to see beyond his own ruins" (46–47). Frisch thus sees the ruins as impediments to a fuller understanding of the recent past, inhibiting Germany's development toward becoming a country like other countries.

Sooner or later in the coverage of Germany after World War II, whether prompted by representations of atrocities committed in Germany's name or by German misery among the ruins, the topics of guilt, silent complicity, and hoped for exoneration arise, while visitors may feel drawn toward sharply judgmental or mercifully compassionate reactions. Max Frisch was not the only writer to represent a dialog between a visitor and a German along these lines, an attempt at communicating that did not go anywhere. James Stern, too, reported such conversations, and Alfred Döblin devotes an entire chapter of *Destiny's Journey* to an exploratory talk he had with a German woman in her twenties that illustrates the crisis of verbal communication. Döblin represents it in dramatic form, as a dialog between a "He" and a "She" in a chapter titled after one of her comments about the Allies at VE Day, "They Had Such an Opportunity. . . ." It ends with the woman saying to herself after they have said good-bye: "I'd like to scream in his face: *You're right, a thousand times over, I'll put it in writing. But you can take your being right and go straight to hell. (She sits down angrily and weeps.)*"⁶³ Dagerman, too, represents such dialogues, and one of his interlocutors, "Fräulein S.," says (similar to Döblin's "She") that the English "had the chance to show what democracy is but they didn't take it. . . . And the fact is we have lost everything: homes, families, possessions. And how do you think we suffered during the raids! Do we need to be punished more—haven't we been punished enough already?"⁶⁴ Another German interlocutor tells Dagerman: "This lack of guilt should be regretted, it need not be understood, but one ought to keep in mind that one's own sufferings make it more difficult to understand other people's sufferings" (32). A communist who spent six years in Buchenwald and speaks to Dagerman "maintains that the conditions existed, that in April

1945 the public mood was right for a short but intense reckoning" (97). One could easily imagine a dramatic performance of such postwar dialogues or nondialogues, all the more so since such conversations about German guilt and denial and about missed Allied opportunities have so often been repeated in subsequent decades.

One of the strengths of Dagerman's report is that he gives the horrifying settings of such conversations much room. His *German Autumn* starts with the gloomy season in which masses of refugees keep arriving from the East: "Ragged, staring and unwelcome, they crowded in the dark, stinking station-bunkers or in the giant windowless bunkers that look like rectangular gasometers, looming like huge monuments to defeat in Germany" (5). The mood of hunger, thirst, suspicion, distrust, and despair that he sketches is then fully developed in detailed descriptions of the cellar-pools in which hungry families eke out a bare existence by eating the few unsavory things they manage to find, their prolonged wet bunker life making them resemble fish. Dagerman enters and describes the repulsive urinals and former Gestapo cellars that bombed-out residents and refugees now must call home, and he highlights the black-humor-like moments in their lives. Thus, for example, a man argues with his wife and colleagues whether the bushes and the mosses growing on the ruins are "to be considered as progress or decline" (9), and strangers in ruined cities are asked by inhabitants "to confirm that their city is the most burnt, devastated and crumbled in the whole of Germany. It is not a matter of finding consolation in distress—distress itself has become a consolation" (19). Dagerman not only writes about cities, but also captures the Gothic sense of much of the supposedly healthy 1940s countryside whose "good health is only apparent" (93), where soldiers lie buried under pleasant slopes and where memories of recent violence is always present, while the "population increased tenfold" and new refugees are arriving all the time, the overpopulated houses "already inflamed by the hate, envy and hunger of the overcrowded" (95).

Against this background, Dagerman sees the military occupation critically, with its strict calorie allocation to the people (in contrast to "the well-being of the Allied soldiers"), of requisitioning houses, thus "making five German families homeless to make space for one Allied family," and of paradoxically attempting to "eradicate militarism by means of a mili-

tary regime, to try to foster contempt for German uniforms in a country swamped by Allied uniforms" (16–17).[65] All of this creates more hopelessness and makes "the soil for democracy more sterile" (17), and he characterizes the denazification *Fragebogen* Germans are required to fill in as "a kind of ideological equivalent of tax returns" (66).

Dagerman imagines the figure of a questioning foreign journalist who finds the Germans he interviews in their waterlogged cellars recalcitrant and feels morally superior to them. He "interviews the family on their views of the newly reconstituted democracy in their country, asks about their hopes and illusions, and, above all, asks if the family was better off under Hitler." The answer fills him with "rage, nausea and contempt," and the journalist "scrambles hastily out of the stinking room, jumps into his hired English car or American jeep, and half an hour later over a drink or a good glass of real German beer in the bar of the Press hotel composes a report on the subject 'Nazism is alive in Germany.'" Though Dagerman concedes that this type of reporting of many journalists and visitors is "in its way correct," it is "misleading if it does not at the same time convey a sufficiently indelible picture of the milieu, of the way of life to which these human beings under analysis were condemned" (10). "If you ask a drowning man if he was better off when he was standing up on the quay the drowning man will reply: 'Yes.' If you ask someone starving on two slices of bread per day if he was better off when he was starving on five you will doubtless get the same answer" (10). Isolating such responses from the contexts in which they are given amounts to a lack of imagination, and the voices that Dagerman's "journalist" represents "reject such an imagination because it would appeal to an unreasonable degree of sympathy" (11). Such sympathy is withheld "on the grounds of moral decency," in view of "the cruelties of the past practised by the Germans," of which, Dagerman writes, "there can only be one opinion, since of cruelty in general, of whatever kind and whoever practises it, there can only be one opinion." But, Dagerman asks, "it is another matter if it is now right, if it is not indeed a cruelty, to regard the sufferings of the Germans as justified" because of their failed war of aggression. He reminds his readers that "German distress is collective whereas German cruelties were, despite everything, not so," and that condemning "the accused to an inhuman existence" runs against any sense of earthly justice (11–12). The core of

Dagerman's argument is that the reporter should have been humbler "in the face of suffering, however deserved it may have been, for deserved suffering is just as heavy to bear as undeserved suffering" (17).

Along the way, Dagerman invokes the left-liberal British Jewish writer and publisher Victor Gollancz, who, in his book *Our Threatened Values* (1946), collected numerous examples of a new kind of callous righteousness, ranging from a 1945 BBC broadcast about the dismal situation of German hospitals in which the reporter added "that his object was not to arouse pity for our late enemies, but to point out the inexpediency of permitting the development of epidemics 'anywhere where there are Allied troops,'" to another radio report on the Potsdam conference, contrasting, without disapproval of the disparity, "German families . . . living on a diet largely of potatoes and irregular bread" with the lavish array of food preparations undertaken for the American delegation at the conference, including "two ten-ton mobile refrigerators . . . full of the best cuts of meat . . . , fresh fruit, strawberries, melons, tomatoes and hearts of lettuce" in addition to all kinds of "wine and spirits and liqueurs."[66]

Gollancz argued from a position of liberal humanism for pity and mercy toward Germany, for "some degree of personal and national humility, some attempt at least to modify the complacent self-righteousness that comes so easily to almost everyone of us" (27). Gollancz explicitly extends his sympathy even to the very worst Germans. "I am sorry for every man, woman or child who is in pain and distress, including . . . [Josef] Kramer of Belsen whose face was pilloried in almost every newspaper for all the baser public to make a mock of. Indeed, I am sorriest of all for people like Kramer, since there is more, there are spiritual things as well as physical, for which to pity them" (23).

Gollancz had published an explicit prewar critique of Nazi anti-Semitism and written a strong 1943 warning that 6 million Jews would be killed if nothing was done to stop the massacres that were underway and had already resulted in more than a million Jewish deaths.[67] After the war, he was therefore not surprised by "revelations" since he had been trying since 1933 "to rouse a lazy and skeptical public" against the Nazis (27). Yet he was now horrified by the common postwar comments "that the whole German nation was guilty: if not, why didn't they protest against these outrages and revolt against Hitler, no matter what the cost?" People who made such

demands did not ask "what they would have done in similar circumstances: they did not pause to wonder whether, when the cost of which they talked so glibly would have been death or torture not for themselves alone but for their children also, they would have been . . . sufficiently heroic to run the risk of it" (27–28). He also added that people who asked such questions had not raised their voices in protest against the Nazis when they risked nothing more than "the loss of a few seconds of time and the expenditure of some negligible fraction of energy" (28).

From such premises Gollancz offers a harshly critical assessment of pretty much the whole range of Allied punitive postwar policies, from the Yalta and Potsdam agreements and the Nürnberg trials to the intentional lowering of calories for the population, reeducation, fraternization bans, reopening of camps for political prisoners in the Soviet zone, forcing German prisoners of war to hard labor—much of it justified with the reference to German collective guilt and based on the "horrible vice of personalising a race or a nation and depersonalizing the individuals that make it up," something that Jews had suffered from particularly (114). He was worried that the cumulative effect of Allied policies might be disastrous. "Which makes people saner, hope or despair?" he asked rhetorically (112). Gollancz took a six-week exploratory trip to the British zone of occupation in the fall of 1946 and published *In Darkest Germany*, parts of which first appeared in various British newspapers, a harrowing account of the living conditions of the German population in overcrowded bunkers, windowless cellars, and barely inhabitable areas of ruins. The book was accompanied by 144 photographic plates illustrating the disastrous health conditions Gollancz encountered, ranging from hunger edema, emaciation, and open scars, to children in bunker schools, barefoot or wearing completely ruined shoes. Gollancz's *Our Threatened Values*, as well as *In Darkest Germany*, criticized the Allied authorities for their failure to provide sufficient humanitarian help, for inconsistent and uncoordinated policies, and for political censorship.[68]

Population Transfers

One of Gollancz's concerns in both of these books was with the vast territorial rearrangement and the forced expulsions that started in 1945, continuing through subsequent years, and he included graphic descriptions by journalists and observers of the treatment refugees and expellees

received and the unbearable conditions under which they continued to have to live. In *Our Threatened Values*, Gollancz cites eyewitness accounts and newspaper stories from the *Manchester Guardian* and the *Daily Herald*, reporting "the abominable cruelty with which these expulsions were, and are being, carried out" in Polish-occupied Germany and Czechoslovakia. The Sudeten Germans, he writes, for example, have to wear discriminating armbands and are given starvation rations, their property is confiscated, they have to perform what amounts to slave labor, and they are confined to camps while awaiting expulsion.[69] The Polish expulsions, too, were hardly done in "an orderly and humane" fashion, as the Potsdam agreement had stipulated: the process may have meant being expelled from one's home at ten minutes' notice, forced into train transports lasting seven to ten days without sufficient food or water, while the expellees' luggage was stolen and many of the women were raped. Arriving in the Western zones of Germany, the expellees showed signs of mistreatment and were diagnosed with serious illnesses, including typhus, creating a health hazard.[70] Gollancz cites the dire, massive need for beds and clothing for hundreds of thousands of expellees who have arrived, for example, in Schleswig-Holstein, and he also describes a dismal camp near Oberhausen for expellees from Polish-occupied Germany who had been living in that camp for four months and before that in a bunker.[71]

Victor Gollancz was one among many Western intellectuals and reporters who took an active interest in these vast movements that were then euphemistically called population transfers, a term George Orwell included in his critique of "Politics and the English Language."[72] Whereas border rearrangements after World War I had left populations where they were while reassigning them to different countries, in the post–World War II world changing borders also came to mean relocating large populations in order to create more ethnically homogeneous nations that seemed to hold the promise of greater stability and of peace.[73] "One of the greatest mass migrations in history is in progress," started a *Washington Post* report from Poland on October 21, 1945, and it continued to itemize the movements of millions of German refugees and expellees, millions of Russian soldiers heading home, millions of Soviet and Polish citizens forced by the Nazis to work as slave laborers in Germany and now returning (the so-called "Displaced Persons") and, "the strangest migration of all—the territorial shift of Poland itself. Losing one third of her total 1921 to 1939

area to the Soviets, gaining land from Germany equal to one fifth of that area, Poland has played leapfrog westward." The *Post* estimated a conservative total of more than 25 million who were on the road in 1945 and 1946, one of the largest examples of people's migrations in history.[74]

The effects were dramatic for Germany, which lost one-fifth of its pre-war territory and in the remainder of the country had a significantly reduced housing capacity due to bombing. One in six West Germans and almost one in four East Germans were refugees or expellees from outside of the new German borders, so that many areas in the four zones of occupation had to deal with a huge population influx at what was already a difficult time. The teacher Schneider, in whose diary we read about the first arrival of the Americans, noted that refugees constituted more than 40 percent of the population of his village of Schönberg.[75] While figures of up to 20 million German expellees and refugees can be found in print, a plausible scholarly estimate is a total of between 12.5 and 13.5 million.[76] Though not prominent in American public memory today, the history of the expulsions has remained a defining feature of postwar Germany, at times referred to by critical scholarship as if it were only a convenient opening for Germans to claim victim status rather than to face their roles as perpetrators.[77] Yet it was a large and troubling set of events in its own right, and the international postwar press reported these vast movements, highlighting especially the problems in the American and British zones, and calling attention also to the humanitarian crisis that these huge figures represented.[78] From as far away as the Indian subcontinent—which was soon going to be caught in its own population transfer upheavals of partition—the *Times of India* published good coverage of the European population transfers in 1945.[79]

The American press was particularly engaged. In August 1945, Louis M. Lyons wrote in the *Boston Globe* about Sudeten Germans who were forced by the Czechs to wear yellow armbands and were robbed of their property "under the eyes of the American army." The preexpulsion concentration camp he was permitted to visit looked clean, but a captain admitted that "they have some trouble with their guards and the German girls." Lyons thought that the average G.I.'s reaction must be that "this is the sort of thing we were sent to Europe to end. It is just what the Nazis did."[80] In September 1945, the *Chicago Daily Tribune* ran an article by its Paris correspondent Larry Rue who saw refugees in Berlin fainting from

hunger or collapsing on the road. Rue noted that average American soldiers resented the propaganda that instructed them not to show any pity for the defeated Germans, he quoted British sources that drew parallels between what happened after the collapse of fascism and what happened at Belsen, and he ended the report on a strong and sarcastic note: "Scattered throughout our occupation zone are victims—mostly women and children—who made the trek from the east. The allies have taken some measures of precaution—they have ordered the burgomeister to have lots of graves dug now before the frost sets in."[81]

Though photographs accompanied some of the reports, they generally failed to convey the horror of the experience, as images of a covered wagon or two, or even a larger trek of people walking through a landscape need a detailed caption to make clear to the viewer that this is not a bucolic scene. An exception is a particularly strong photo essay, "Displaced Germans: Driven from Their Homes by Poles and Czechs, They Pour Unwelcome into Berlin," that appeared in *Life* in October 1945, with British photographer Leonard McCombe's striking work from around the bombed Anhalter Station in Berlin, including images of improbably overcrowded trains, of a weak old man who had arrived in a cattle train jam-packed with refugees, of a woman who had walked for a hundred miles and whose swollen ankles had split open, and of a teenage refugee girl who had been raped by hoodlums on a train. The editors of *Life* were worried enough about the compassion-inducing nature of the "terrible and shocking" images that they instructed their readers to remember this: "These displaced Germans are being treated callously but not with the deliberate cruelty which their government once inflicted on others. They are, at least, allowed to live. These people allowed themselves to fall so low in the eyes of the world that the world, seeing their suffering, finds it hard to feel sorry for them."[82] Private Wilson, a reader, responded to the photographic essay from Keesler military hospital in Mississippi with a conflicted letter to the editor stating that, mindful of the horrors Germans had inflicted on others, he had "tried to act hard brutal while reading it," but that "somehow a lump appeared" in his throat all the same.[83]

A photograph by Walter Sanders for a photo-essay on U.S. "Wives in Germany" in *Life* is more understated than McCombe's images, but represents the contrast between sheltered viewers and the expellees rather effectively, and its detailed caption also serves as interpretation.[84]

Wife and daughter of U.S. soldier sitting in first class dining car of train looking out window at German expellees traveling in boxcars from Silesia to Westphalia, with British soldier standing on ground between two trains. 1946. *Photo by Walter Sanders. Getty Images/ Time & Life, 50611799.*

In addition to journalistic and photo reportage, eyewitness accounts individualizing stories of the expulsion as well as public protests intended to change American policy appeared. In November 1945, the Jesuit journal *America* published "Death March from Silesia," a detailed account by a refugee that the journal hoped would help throw light on the little-known expulsions that were taking place in the Russian zones of occupation and show that "the spirit of Hitler marches on and still lives in Europe."[85] The report suggests the chaotic circumstances under which the expulsions took place, since neither the refugees nor the authorities knew exactly what was happening or what could be done:

> "Move on!" That is the only word you can hear. But no one can say where to go.
> The streets of Görlitz [on the new Oder-Neiße border] are jammed with endless streams of bewildered people. Carts and wagons are pulled by men and women, living skeletons. During my week in Görlitz the food rations were as follows: for one week, 250 grams of bread,

50 grams of meat and either three pounds of old potatoes or one pound of new potatoes. I spoke with the director of the welfare office and the three priests of the parish churches in the town. All were desperate; they had no place to turn for help. One could see that they were at their wits' ends. I walked through the camps, the town buildings, formerly the sites of festivals, now places of hunger, misery, death. Shelter was given refugees for one night, but not a bite of food could be furnished. All were forced to continue on their way the next day. Many, too weak to go on, must die. I counted 16 coffins on a car rolling through the streets. I have taken a photograph of 114 coffins in Nikolai Church; they contain the bodies of those brought for Christian burial in the past two days. . . .

All bridges across the river have been blown up. Over one small temporary bridge the endless stream of Silesian refugees flows. Standing on the left bank of the river one can see the Polish soldiers stop German refugee carts, loot them completely, remove the horses and then let the people go on. Completely looted of their possessions, hungry, exhausted, without a single means of help, they give way to despair. One woman murmurs: "This rope is all that remains to me; I'll hang myself today."

The suicide figures in the town of Görlitz rise enormously.[86]

[*This is another moment at which I must include a difficult personal note. It does not sound right to say that "I" too was on the refugee trek and on the road for five months, making my way from Silesia to Thuringia, because I was only two years old at the time, but my mother certainly was part of the masses of women, children, and old people who were moving from town to town, mostly on foot, without being given permission to stay anywhere for more than a night or two in open-air camps or on make-shift straw floors in school buildings, and she carried me along in a baby carriage. In the fall of 1945 she learned that my grandmother, who had fallen out of an open freight train outside Dresden, and my sister, who was taken ill and whom she had had to leave in a hospital in a town near Görlitz where my mother was not permitted to stay on, had both died.*]

A number of intellectuals in the United States and other countries raised their voices against the expulsions. In November, 1945, the Zürich *Weltwoche* published a protest by the Berlin-born émigré Robert Jungk, who would later become popular as a historian of atomic research and as a

founder of futurological studies. Based on unnamed sources, among them a Caritas worker, "From a Land of the Dead" drew a grim picture of violence, plunder, mistreatment, lawlessness, hunger, illness, and suicide. Jungk intended to bring this desperate situation of an outlawed population to the attention of world opinion, hoped for a Russian humanitarian intervention, and ended with the argument that more was at stake than "merely" the lives of a few million Germans, for this was a matter of the moral purity and strength of the world's antifascist movement: "When all those who fought Hitler and Mussolini under great sacrifices in order to build a better world permit that their struggle is now exploited and sullied by rowdies and chauvinists, then we see little hope for the future. It was correct to accuse the Germans of having closed their eyes to Nazism's atrocities because they believed in their country's mission. Should the champions of democracy have to accept the same charge in the future? We, too, will share culpability [*mitschuldig*] if we do not reveal the outrages daily and hourly that are being committed today in the name of democracy and of freedom."[87]

In February 1946, a committee of the World Council of Churches in Geneva that included the archbishop of Canterbury and the prominent Protestant minister and outspoken anti-Nazi Martin Niemöller (who had been imprisoned in the concentration camps Sachsenhausen and Dachau for seven years) supported the suffering defeated people with the encouragement that the "springs of their recovery" were within, lay with a turn to God, but the Council exhorted the victorious nations that they had responsibilities, too, and that they "should combine justice with mercy," for to "seek vengeance against their former enemies by depriving them of the necessities of life, or by mass expulsion of their populations, or in any other manner, can only bring fresh disaster."[88]

A New York–based Committee against Mass Expulsion published, in early 1947, a thirty-two-page pamphlet titled "The Land of the Dead: Study of the Deportations from Eastern Germany." It drew on the journalistic coverage of the expulsions, on eyewitness accounts, and on a Swiss welfare organization doctor's report, and it explicitly quoted at length from *America*'s "Death March from Silesia" whose author was now identified as a Silesian priest, as well as from Jungk's reportage, whose title had obviously served as inspiration. The introduction was signed by nineteen important intellectuals and public figures, among them Roger N. Baldwin, the founder of the American Civil Liberties Union; the philosopher and

psychologist John Dewey; the journalist Varian Fry, who had helped Jews escape from Europe during World War II and had published a 1942 article on "The Massacre of the Jews" in the *New Republic*; Princeton dean and professor of modern languages Christian Gauss; the lawyer Arthur Garfield Hays who had served for the ACLU at the Scopes Monkey and the Sacco and Vanzetti trials; the Unitarian minister and cofounder of the NAACP, John Haynes Holmes; Catholic priest, interracial activist, and editor of *America*, John LaFarge, S.J.; president of Hunter College and former editor of *Commonweal* George N. Shuster; anti-Nazi journalist and ex-wife of Sinclair Lewis, Dorothy Thompson; and journalist and pacifist Oswald Garrison Villard.[89] The anti-Nazi and anti-Stalinist political writer Christopher Emmet who later helped to found the Council on Germany chaired the committee.

The Land of the Dead offered a very full and vivid contemporary description and indictment of the expulsions, covering a quantitative overview, the origin of the problem in a violation of the Atlantic charter, the moral issue, the departure from Versailles, the contrast to Danish and Italian behavior in border adjustments, economic and political consequences, food shortages, employment and housing crises, infant mortality rates, and health problems. Emphasizing that the Poles were "the victims first of Hitler's aggression and second of Allied betrayal," the pamphlet concludes that, "like the monstrous record of Nazi crimes," the policy of expulsions shows "the depth to which humanity can fall." The pamphlet explicitly rejects the "theory of collective guilt which is in itself the quintessence of totalitarian doctrine, for instead of judging each individual on his merits he is judged and punished as a member of a racial, religious, and political group. The real collective guilt is that of humanity itself, which under the conditions described is capable of producing almost any iniquity." The 1947 pamphlet calls for American leadership in protecting minority groups anywhere: "What happened to Sudetens and Eastern Germans today could happen tomorrow to Moslems in India; to Jews in Palestine; to whites in South Africa; to Negroes in the United States."[90] The *New York Times* covered some of the main points in an article published the day after the committee's protest was made public.[91] After the International Refugee Organization (IRO) was created, some of the members of the Committee against Mass Expulsion pointed out in a letter to the *New York Times* that the new IRO was "debarred from even attempting to deal

with the greatest body of displaced persons—the millions who have been deported from their homes not by Hitler but by the Allies, not during the war but during 'peace.'"[92]

I had expected far less concern for the expulsions in the contemporary Allied press and was surprised by the extent and sharpness of the detailed, critical coverage from journalists as well as from church-affiliated intellectuals and radical and liberal writers. I was even more surprised by the extent to which parallels between Nazi horrors and the injustices of the postwar 1940s were then being drawn, and how readily comparisons between Nürnberg indictments of Nazi crimes and postwar Allied policies were being undertaken.[93] Of course, the various protests appear to have had little effect on the carrying out of these policies.

Despite the press coverage and the protests I found few contemporary literary works of any merit that are devoted to this topic.[94] Refugees and expellees are often mentioned in passing, at times in memorable passages, but it is rare that one finds this great forced migration of people represented directly and centrally. The vast, chaotic stream of millions of people as well as so many of the small details that accompanied the expulsion appear not to have inspired much writing in the period, like the "slips of paper written by one refugee to another" posted on houses, fences, and trees, "notes from parents seeking their daughters," the renaming of cities and streets that had their German origins written all over them, or the new settlers moving into apartments and houses that their inhabitants had left as if they had just gone out for a walk but would not get to see again in their lifetime.

The two most interesting works I have come across characteristically represent Germans fleeing and being expelled either at the time before or after the often violent encounters with the Red Army or with Polish or Czech militias. Thus, though both authors apparently drew on autobiographic experiences, Kurt Ihlenfeld set an entire novel in fearful anticipation of the imminent arrival of the Soviet troops in the Silesian countryside, but let the novel end before the Russians actually get there, while Gerhart Pohl located some of his best short stories in freshly Polonized Silesia where single German figures confront the new environment after the mass expulsions had already taken place.[95] Interestingly, both Ihlenfeld and Pohl also included scenes intended to remind the reader of the brutal German occupation of other countries and of the Holocaust in their

works, thus aiming not for "a balancing of accounts" but for an understanding that the postwar events were also a direct consequence of and reaction to Nazi brutality.⁹⁶ The cited Silesian priest wrote that Polish soldiers responded to being questioned about their cruel methods, "The SS was much worse in Poland." Yet the Allied relocation policies were not directed against the SS but against the entire East German population, which is why the Silesian priest reported "these hopeless words from the refugees: 'Why must we, the Eastern German population, pay for the war alone? Why must we alone pay for the Nazi cruelties?'"⁹⁷

Winter Thunderstorm

An explicit and expansive mode of Christian thought (of a liberal humanist nature) animates an epic novel that is set during the mass escape of German civilians from the advancing Soviet army, whose artillery the young boy Gottfried believes is a February thunderstorm that gives the novel its title. The thunder-like noises that are being heard by others, too, make them anticipate the end of their world. First published in 1951, Kurt Ihlenfeld's *Wintergewitter* is divided into four parts, "Chronicle," "Diary," "Conversation," and "Legend." The novel's overarching images and metaphors evoke a world that is changing, sinking, disappearing, and coming to its end, of people being dispersed.⁹⁸ In parts, *Winter Thunderstorm* reads like an epitaph to German Silesia, as Ihlenfeld uses epigraphs by Silesian writers Andreas Gryphius, Joseph von Eichendorff, and Jakob Böhme and employs melancholy realist strategies in evoking the Silesian countryside near Liegnitz in the "Chronicle" section. In the "Diary" part he describes a pre-Christmas visit to Breslau in the manner of a elegy, evoking the beauty of the city before its destruction: the city appeared ominously illuminated in the kind of sallow light that precedes a thunderstorm, the history-conscious river seemed to suggest a natural symbiosis of peoples rather than the hostile nationalism of political boundaries, and the city's coat-of-arms, a plate on which the severed head of John the Baptist is lying, adds to the minister's sensation that "country and city are trembling in anticipation of the blow of the axe that will sever their roots" (349–52). When he alludes to what will be the new boundary of the Oder-Neiße line, the minister thinks that the names of the two rivers sounded strange, like Euphrates and Tigris (339). Tellingly, the novel is dedicated

to three men who died in the 1940s: Jochen Klepper, a Silesian-born Prot-
estant writer who committed suicide with his Jewish wife and daughter in
1942, after Adolf Eichmann had turned down a request for an exit permit
to go to Sweden—and Ihlenfeld, who was friends with the Kleppers also
uses one of Klepper's poems as epigraph to the "Diary" section of the book;
Siegbert Stehmann, a theologian and writer, who was denounced for sub-
verting military morale and sent to the Eastern front where he was killed
in 1945; and Ludwig Wolde, a classicist humanist translator and biblio-
phile publisher who, in bad health, was expelled from Austria after World
War II and passed away in Bavaria in 1949.

In *Wintergewitter* Ihlenfeld apparently drew on autobiographic experi-
ences and the stories of his friends. Like the novel's central figure of the
Lutheran minister, Ihlenfeld, too, moved from bombed out Berlin to ad-
minister a parish in rural Silesia and then fled before the advancing Red
Army to a small town near Dresden. The haunting story in "Diary" of
Herr von Schindel whose Jewishness is discovered by a Nazi official and
who is, very close to the end of the war, still deported, presumably to his
death, is intertwined with the story of Jochen Klepper (simply called K.
in the text of the novel) whose unmarked grave in Berlin-Nikolassee the
minister visits after also going to the nearby grave of Kleist, another sui-
cide. And an unnamed lieutenant who becomes the central figure of "The
Legend" and dies at the hand of a sniper seems to be modeled on Siegbert
Stehmann.

Early on in the novel the first refugees appear in the parsonage and are
viewed through the eyes of children, as Gottfried plays host to the refu-
gee girl Anna who tells him about the sudden departure and the nine-day
long trip they have taken so far, of artillery rumbling and of gunshots.
Later they continue their dialog, Gottfried providing details about the
bombing. He tells Anna how prisoners in striped suits had been ordered
to carry away a bomb that had not exploded, describes sirens howling like
cats and tells her that he was afraid when bombs were whizzing over the
house, "like a long whistle, like a locomotive" and that it was funny when
the basement began to "dance," when floors and walls moved as during an
earthquake.[99]

The minister provides a meditative perspective to the refugee theme as
the first trek arrives in the village, and he sees a woman and a girl who
"have already crossed the boundaries of the wonted life with one foot.

They live in transition. Facing the future. One cannot deal with them as one deals with sedentary residents. One has to address them as what they are already: *refugees.*" And that word, *Flüchtlinge*, resounds in him for the first time "with the force of a bell tolling, like an apocalyptic secret word."[100] The minister wants to engage the woman in a conversation, but she talks to him first and indirectly asks him whether it would be all right for her to commit suicide, a "flight" not in the sense of refugees fleeing, but a flight from life prompted by fear of what might come. She asks whether it would be wrong when done out of fear, and the minister responds that it would be wrong under any circumstance.[101]

The refugee scenes—groups of people fleeing, moving through the landscape—find a horrifying counterpoint in a women's death march that the minister's village witnesses in broad daylight and that Ihlenfeld describes as an inhuman parody of a bucolic scene of shepherds, Daphnis and Chloe–like, guarding a herd. The tired herd moves slowly, surrounded by dogs. The sound is not that of a pastoral flute but that of a whistle that the female guard in a grey jacket blows. Addressed to an incredulous Frau Müller who, with the whole village, can watch the scene openly through their windows, the minister describes the "dark, billowy herd of women" who must have arrived out of "the depth of extreme darkness of the abyss" in the bright snowy daylight of the village and are walking barefoot, or with high-heeled summer shoes, or with rags wrapped around their feet, with a mere remnant of reminders of a better former life shimmering through their hellish misery. "What do you think, Frau Müller—are these living human beings or are they perhaps already dead? Or mere silhouettes of human beings? . . . We are spectators, you understand, lookers-on in a pageant that has something too shameless about it to make watching it permissible" (154). And yet, though everyone, men, women, and children, can see the "women's herd," no one goes and helps up a woman who has fallen, embraces her, or says, "You are cold, dear sister, I want to warm you up, come with me into my house" (155). When the minister thinks back to the German refugees' arrival after seeing this scene his thinking changes: "Not that I hold in lower esteem what could be seen this morning. But I must from now on *always view it together with this here. For it belongs together. It will not be separable again*" (155). Ihlenfeld thus draws an explicit connection between the story of Nazi atrocities and the story of the expulsion.[102] The tragic story of his friend Jochen Klepper

whose grave the minister visits on the second anniversary of his suicide and the arrest of Herr von Schindel remind him of the isolation (*Vereinsamung*) of the persecuted, which he understands is part of the system of persecution. These episodes further enhance the atmosphere of despair that pervades the novel. Is suicide sometimes justifiable, after all?

In the last section another Silesian refugee trek, "nothing but a moving village," heads west while the last German soldiers, the lieutenant and his tank crew, have orders to push toward the east. The soldiers greet the people in the trek who barely respond in the cold. The wind pressure is so strong that everything seems to glide and skid on the snow, "creating the impression as if everything were moving in a strangely creeping haste."[103] The next trek the tank encounters is a group of nuns fleeing west. When the members of the tank crew enter the houses of a mostly deserted village, they debate whether taking things from deserted places is plundering. "On the door of a courtyard they had found a note on which the owner had asked to go easy on his belongings." Can it be plunder to take things from a house like that? Ihlenfeld creates an evocative scene in representing the open houses, a shop, and a school that look as though the inhabitants had intended to leave only for a short while: "In pots and bowls they found half-boiled, half-fried meat, food preserves stood around, chickens cackled, they saw eggs lying in the straw. . . . Does anyone leave his house that unattended who does not want to come back?"[104] This is close to the end of the novel, by which time the refugee stories have become intertwined with the background of the genocidal Nazi regime.

The lieutenant surveys the deserted village—and these are the moments in which the loss of the Silesian countryside is indirectly expressed in the novel. He is tempted to prohibit his men from entering the houses but also sees the futility of giving such an order. When he steps into the village church, he remembers that he had often gone into churches in countries where his uniform revealed him to be an enemy, but the lieutenant always felt connected to other countries, he mentions France and Norway, because of the works of literature he had read and the characters in them that he hoped to meet in their own countries—even though poets always add something that is otherwise hidden from human understanding, a secret.

For example, he could not look at the Abbé Donissan as anything but a living man—the central figure of that great French novel that

an older friend, already enrolled as a university student, had given him for his confirmation, to the consternation of his parents. Yes, he slowly began to notice himself that such a poetic figure had entered him more deeply than many a real person whose path he crossed every day. He would have loved to encounter Abbé Donissan in France, but it turned out that he did not exist. Had Bernanos lied? No, he did exist—so to speak, multiply divided in hundreds of actually living priests, among whom he got to meet more closely about as many as there were original apostles. (484)

Thus in the middle of war, the lieutenant had gone searching for the passionate, ascetic face of Abbé Donissan from Georges Bernanos's *Sous le soleil de Satan* (Under Satan's Sun) to seek truly fraternal conversations with any *curé* he could find. Re-creating a bit of the atmosphere of Donissan's philosophical conversations with Abbé Menou-Segrais in the "Temptation of Despair" section of Bernanos's novel, the lieutenant now, as the war is just about to end, engages in a dialogue with a captain in which he expresses his hope that "out of our despair, out of the futility of our service" something invisible might yet emerge, like a divine plan in which God's mercy might transform suffering as well as guilt and give meaning to sacrifice. The lieutenant's last response to the captain is that he has no more confidence in anybody except God (572). At this moment, the lieutenant is killed by a sniper. The novel ends with aphoristic excerpts from the lieutenant's diary, among them these: "The country to which I want to return does not exist." And: "I have seen foreign countries. War has made them accessible to me. As an enemy I entered them. But my heart was full of friendship. It shuddered with any victory news. I mourned when the others were cheering. Did I want our downfall? No—I wanted the return of Law. And my dilemma was that I could not want one without at the same time wishing for the other. In foreign countries my own fatherland became foreign to me" (589).[105] The lieutenant's and the minister's voices almost merge in such pronouncements, as the novel maintains to the end its somber blend of existentialist skepticism and religious hopefulness, of deep German sadness and inhibited cosmopolitan openness. For Ihlenfeld, the sense of loss, of which the refugee plot is only one indication, is both deep and inevitable, but would be unbearable if it were not for religious faith.

How Many Murderers Are There Today?

This question is also the title of a 1948 short story by Gerhart Pohl, a grim tale set during the German occupation of France and dedicated (with an exclamation mark) "to Albert Camus!"[106] It focuses on Mrs. Vidal, a French mother who, before a mass execution in retribution for a partisan bombing, pleaded and was granted her wish by a German officer to let at least one of her three sons live, and the officer gave her the choice which one it should be. (It is a plot that vaguely anticipates that of William Styron's novel *Sophie's Choice*.) With a heavy heart she chose Claude, felt like the murderer of her other two sons, André and François, and considered the German lieutenant only the henchman who acted on the choice she had made. Now, after liberation, it is Claude who has become the leader of a crowd engaged in the retributive killing of the German jailor of her sons. "We are all murderers," she answers her own (and the story's) question, whispers into Claude's ear, "You have no idea how many murderers there are today," and dies as the Marseillaise is being played at the victory celebration.

The story opens a collection of Pohl's short stories, *Wieviel Mörder gibt es heute?* (1953), for which it sets the tone in pursuing questions of injustice and retribution as well as of good deeds and the rewards they can reap. For each action in the present there is a past act that can help to explain it, to give it meaning. Several of the stories deal with the new postwar situation against the background of the German wartime occupation of Poland and the Holocaust but also of good deeds and friendships that could, in a different world, have bridged national and ethnic divides.

In "Son of the Prophecy" ("Sohn der Prophezeiung," 1947),[107] Barnabas, a Polish lieutenant who is buying a moleskin coat from the German musician Steiner turns out to be the baptized son of a Polish Jewish Germanophile who was murdered by Germans at the Majdanek concentration camp. Barnabas recognized his father's German shoes there in a vast pile of footwear, for the father had loved German shoes. Coming back from Germany, he had also once sung for his three sons, in Richard Tauber style, Goethe's love aria "Oh Maiden, My Maiden," from Franz Lehár's operetta *Friederike*.[108] The father then made the prophecy, "you will get to know the Germans and you'll be transfigured"—the prophecy, his son Barnabas comments sarcastically, that was fulfilled for

him at Majdanek. (The name "Barnabas" itself, Steiner explicates, is derived from the Hebrew and means "son of the prophecy.") Having agreed on the price for the moleskin coat, Barnabas mentions casually that his father had seen the operetta in Breslau and asks Steiner where exactly that might have been. Steiner, who has to wear a white armband identifying him as a German in postwar Breslau, points "over there," across a sea of ruins to some pale-golden beams in a heap of rubble that he calls "tomb." Steiner now explains that he was the director of that performance and that his wife sang the part of Friederike, and he adds: "That is the rest of Friederike. The theater's ruins have buried her." The first edition of the book accompanied this scene with a melancholy line drawing, an epitaph to the muses in ruins.

This concluding dialogue, spoken while the men have reached an agreement and are counting the 4,000 złoty for the coat, ends a story that explicitly addresses Barnabas's and Steiner's different issues of the possibility of revenge and the charge of collective guilt. As if in response to Martha Gellhorn's Jacob Levy, Pohl's Barnabas wonders, "Whom should I have killed?" Were Steiner, Barnabas's doctor, the owner of his hotel, or his motorcycle repairman all part of the "devil's brood"? Barnabas also asks: "Should I shoot all of you dead, because that damned Majdanek existed—because you tolerated it?"[109] And as if in response to James Stern's wondering about German reactions to charges of collective guilt, Pohl's Steiner resorts to the metaphor of the biblical flood. "The murderers were detached from God. That is why they are being, or will be, sentenced. And those who have tolerated the flood now suffer from its mud" (78).

"Angels' Masks" ("Engelsmasken," 1950) is set in October 1945 or 1946 in an ancient German village, now renamed Mostowice, where a Polish family, the Sowinskis—Josef, Wanda, and their young daughter, Mariechen—have been relocated and assigned a shop with an adjacent farmhouse and stable. The story opens when Mariechen sees a tattered German soldier faint and collapse in their courtyard. She believes he is dead and summons her parents to the scene, calling the never-named soldier "a Hitler." Josef and Wanda have to decide what to do with the man who is still breathing and in need of help, while there is a prohibition in effect for anyone who harbors members of the dissolved German army. The German soldier reminds Josef of the German beasts who had almost killed him, while he reminds Wanda of the angel who saved her and

Mariechen in the war. They move the soldier inside their house and close the shutters. Now the story turns to the past. The Sowinskis' home village of Pilica had been brutally burned down by German troops in 1943, but the goodhearted German soldier Peter from Upper Silesia had helped her and Mariechen escape, also giving them provisions. Josef had been taken to Buchenwald for a hard labor detail in a quarry where his best friend Jacek died, to whom Josef vowed revenge. Is the German soldier like Wanda's guardian angel or like Josef's devilish torturers? Should he be sheltered or handed over to the Polish militia?

Focusing on the half-awake German soldier, who was forgotten in a prisoner-of-war transport, the story flashes back to the soldier's last conversation with his father, at the Breslau train station: the father had exhorted him to resist criminals like those German soldiers who brutally tortured and killed families in Volhynia, in random retribution for a partisan action. Then the father died mysteriously at the front, though what happened was officially called a "hero's death." Awaking, the soldier mumbles *głód*, the Polish word for hunger. Now Josef begins to see in the weak, hungry, suffering figure the image of his dead friend Jacek and suddenly has a change of heart. Just as he had done to Jacek at Buchenwald, he feeds the soldier, chewing bread until it is soft, then administering it to the man's mouth. Josef will no longer go to the militia and report him. Instead the Sowinskis keep hiding the soldier until he has recuperated and then help him get away by smuggling him into a freight train filled with ragged German prisoners of war who have been released and are heading home. Guardian angels can wear many different masks, the story concludes, embedded as it is in religious metaphors of redemption. Wanda's prayer in front of a colorful picture of the crucifixion for the "resurrection of the many who are enclosed in stone" (25) has been heard, at least in the case of her husband. Just like the soldier Peter had protected Wanda, so Wanda helps save the German soldier, and Josef's conversion from a hard-hearted avenger to a caring man who empathizes with a fellow human being who is suffering, even though he wears the uniform of a former enemy, completes the fairy-tale-like ending.

The story may end on this note of reconciliation, but it is not achieved at the expense of silencing the horrors of the past. Josef's interrogation and experience at Buchenwald, the burning down of Pilica, and the strongly visualized atrocity in Volhynia that turned the German soldier's father

toward resistance are powerful flashpoints of the "six-year-period" (as the Polish characters refer to the German occupation) against which the selfless and self-endangering generosity of the Sowinskis is just a small gesture of hope. Keeping the horrors of the past in such a sharp focus, "Angels' Masks" avoids any direct or emphatic representation of the German expulsion, the strongly implied background to the story's setting. Instead it suggests the tensions among the newly relocated Polish inhabitants of Mostowice who came from "various provinces of their country, from ceded territories, and from England, France, and Belgium. They are still strangers to each other, even hostile in mistrust, envy, and groundless suspicion" (19–20). The sudden appearance of the soldier in this world is thus like that of a ghost from the past, a figure who evokes both hellish and angelic associations. That the Sowinskis risk five years of imprisonment for sheltering and aiding this ghostly figure makes their still tenuous new ownership of the shop and the farm in this "ancient German village" complete, for they have generously acted according to the age-old rules of hospitality and the command to "love thy neighbor," and they have bravely ignored a politically motivated edict. In the second printing of his short story collection, Gerhart Pohl chose *Engelsmasken* rather than *Wieviel Mörder gibt es jetzt?* as the title of the book.

"Earth and the Dead" ("Die Erde und die Toten," 1951) also represents Polish-German and German-Polish acts of kindness against the background of the transformation of Silesia from a German province to an all-Polish region, here suggested in telling details, some of them grim. It is the story of a failed attempt by a German man to pass for Polish in a place where "the war has not yet ended," as the story states. Wilhelm Schwalbe is an individualist who does not care much about the catastrophes of human history caused by political leaders, and for him it is simply "natural to remain" in his and his ancestors' homeland in 1946, regardless of the political transformation that seems just another one in a series of changing emblems of power: after all, Piasts, Bohemians, Hungarians, Habsburg, Prussia, and Imperial Germany had all shaped but not outlasted Silesia. *Natürlich— bleiben* (remain here, naturally) is thus Schwalbe's motto, repeated four times in the story. After military captivity in a Polish contingent of the Red Army where Schwalbe had to cool the liberation army's hatred for Germans, where he was beaten, kicked, interrogated, and then forced to work as a hard laborer removing the rubble of ruins, he manages to escape.

Schwalbe speaks perfect Polish (a fact he hid in captivity) and learns that Marian Nowakowski, his closest high school friend from Breslau's ancient Matthias-Gymnasium, has now been appointed editor of the new Breslau newspaper *Trybuna*. Marian had saved Wilhelm once from drowning in the Oder, and Wilhelm had rescued Marian from a Gestapo basement. Now, with Marian's help, Wilhelm Schwalbe obtains new papers identifying him as "Witold Szwalbe,"[110] supposedly returning to Poland from a German D.P. camp, and he is hired to work for Marian's newspaper. Marian, who is originally from Posen, which had also changed emblems of power repeatedly, the Ulica Mickiewica turning into Goethe-Straße and back again,[111] shares with Wilhelm/Witold the notion that simply keeping loyal to the "earth and the dead" mattered more than any national identity. Wilhelm's emergence as a "new citizen of the liberated western provinces" is made possible "in the chaos of the beaten old city on the Oder, now crowded by an inflowing as well as an outflowing, or expelled, populace" (41). Though "millions had been expelled and condemned to the fate of rootlessness," Wilhelm would remain and hold on to the "mask" of Witold Szwalbe, while being unchanged (except for sporting a small, attractive beard), "until this war was over" (43), and he is, of course, speaking about the postwar period. Studying Polish history, economics, and culture as well as the numerous orders of the new regime, he prepares for his new job.

The reader now expects a comedy-of-manners plot of a German ex-soldier playing the part of a Polish newspaperman who helps to provide fake backgrounds in support of the supposedly age-old Polishness of Breslau, now called Wrocław—a city-sized parallel to Szwalbe's own made-up Polish past and name. One also imagines that a section on the day-to-day workings of the newspaper might follow. Yet the plot quickly turns away from such possibilities. When Witold appears at his new job, Marian gives him advance pay and asks him to come back the next day so that he can be introduced to the director of the paper. Witold walks around the "canyons of misery" in the thoroughly ruined city of Breslau where hustling-bustling life is yet going on, has some vodkas in a workers' bar, and suddenly decides to go to the cemetery to visit his father's grave. In captivity, he had kept his parents' wedding rings sewn into the cuffs of his pants, and the earth on which he wanted to stay was also, after all, his father's burial ground. He takes a taxi to the cemetery whose Polish name

he does not know and tells the inquisitive driver the lie that he wants to find the grave of "a German uncle of his father" (44). The deserted city of the dead that he finds has been desecrated furiously: broken and splintered tombstones are lying around, and disturbed burial sites are uncovered and overgrown by weeds. The grave of a famous Gypsy king has been opened and searched for valuables, and his gold teeth have been smashed out of his skull. Robbed bodies in other looted graves are also in the open. Tearing away some ivy, Wilhelm sees his father's body in a broken vault, the skull separated from the trunk. Strangely elated, he holds the skull in his hands and against his own forehead, as if to engage in a conversation with the father, then puts it back in the tomb, carefully covering it with loose earth. Suddenly he hears the scary phrase "stone-dead" (*mausetot*) enunciated in a cold voice (47). It is the voice of the taxi driver, and this is a second moment at which the reader expects a plotline that does not follow. There is no dangerous outing of "Szwalbe" by one of his former guards, no violent interaction at all, but a shared moment of atonement, for Wilhelm quickly recognizes that the chauffeur is the same Polish youth whom he had caught in the war when the boy was trying to close the grenade-damaged grave of his mother one night, whereupon Wilhelm had simply sent him back home with the comment, "stone-dead." The men look at each other, feel tied to "the expiatory community of all of the dead in all of the earth," and forgive each other for their reciprocal guilt (47).

Returning to Marian's apartment, Wilhelm tells his friends what has happened and that, as a result, he is now ready to leave Poland. After Marian fails to persuade Wilhelm to stay "till the war is finally over," he pours some vodka for both of them, and the friends say good-bye. The chauffeur happily drives Schwalbe to a peasant on the Neiße near Görlitz who helps him cross the new border. When the peasant asks why Schwalbe wanted to leave, the chauffeur says that Schwalbe was a German without a homeland. The peasant answers, "And we? Poles without a homeland," and wonders whether everything was not simply a descent to hell, "though we idiots think it is progress" (50).

In the wake of dramatic political change, is it possible to remain individually loyal to the earth of one's ancestors when one has to change one's name and lie about one's own deceased father? the story asks. Schwalbe's name means "swallow," but he cannot be a bird of passage while "the war is

not yet over." (For contemporary readers, his name would probably have evoked associations with "Operation Schwalbe," the series of forced transports in 1946 and 1947 of about one hundred thousand Silesian expellees in freight cars to transit camps in the British zone.) Schwalbe's comedy of escape, his masquerade in a new identity and hope of a new beginning are quickly canceled by the somber scene in the city of the dead. The nightmarish descent into the world of the violated tombs makes impossible his cheery readiness to participate in journalism about Poland's "liberated western provinces." Wilhelm's holding his father's skull seems to be a somewhat lurid conflation of Hamlet's encounter with the ghost of his father and the "Alas, poor Yorick" speech. The extended graveyard scene that also mentions the tombs of other famous German Breslau citizens reminds Schwalbe (and the reader) that "population transfers" also included an eradication of the past, an effort that was not just fake but also ugly and violent.[112] Under such circumstances trying to remain loyal to the earth and the dead is doomed, for it requires acquiescence to the desecration of a father's tomb. Pohl's interest in showing reciprocal acts of forgiveness and good deeds in this story does not lead to enduring transnational friendships. Even though the reader may secretly hope for such friendships against all odds, this only adds sadness to the experience of reading Pohl's actual story line. Showing one's friendship or one's readiness to reciprocate in the context of "Earth and the Dead" means helping a friend to get out of his city that is in the process of being made newly homogeneous, hence needs to forge a new past and expel the witnesses and expunge the remnants of its true history.

It is telling that the typescript of the story shows that Pohl undertook the most extensive revision in the scene in which Wilhelm tells Marian of his decision to leave the newly Polish city. In a long handwritten insertion, Pohl originally let Wilhelm say emphatically: "Off with the mask! And on your knees before God's face" and added the comment that Wilhelm "was sad that his friend did not seem to approve the decision." These passages no longer appear in the published text that condenses their dialogue but adds Wilhelm's hissed accusation, "*Du falscher Hund!*" (you duplicitous dog) when Marian says "Na zdrowie!" (Cheers!) after pouring glasses of vodka.[113] Pohl seems to have struggled with the problem of the effect the changed political situation has on the old German-Polish high

school friends. And Pohl's difficulties with this scene may be emblematic of the quandary German writers experienced in confronting the theme of forced expulsion.

Both "Angels' Masks" and "The Earth and the Dead" are set when the first waves of the expulsions have already taken place, whether in a small village or in the Silesian capital, Breslau. Both represent an individual German ex-soldier from Silesia who benefits from gestures of human reciprocation under the new Polish regime. Both stories also end with the newly homeless German protagonists going west, crossing the Oder-Neiße boundary, and thus serving as vague allegories of defeat and expulsion. Both "Wieviel Mörder gibt es heute?" and "Son of the Prophecy" are more explicitly concerned with the Nazi past, with retributive killings in occupied France and the concentration camp Majdanek, but they also represent Pohl's interest in a reconciliation, a balance, an understanding, however tenuously achieved. Thus Steiner in "Son of the Prophecy" has to mourn losses as does Barnabas, and the French mother who had to make the terrible choice of sacrificing two sons to save one feels like an accomplice of the Nazi occupation and views her saved son as a murderer. The reader in 1953 might have expected a volume with the title *How Many Murderers Are There Today?* to deal with German war criminals—which may be why Pohl changed the title of the second printing to "Angels' Masks" (*Engelsmasken*)—but, working within a generally religious and specifically Christian framework, Gerhart Pohl tells his vivid, concentrated, and intense postwar stories in such a way that suffering as well as guilt get universalized.

Chess Boards of Utter Despair: Displaced Persons' Camps

In May 1946, Max Frisch witnessed a group of refugees, spoke with a former inmate from Dachau, and saw a new camp. He transformed what he observed at the Frankfurt Railroad Station into a rather beautiful prose vignette that quickly captures the hopelessness, alienation, and fragility of expellees:

> Refugees lying on all the steps, and one has the impression that they would not look up even were a miracle to take place in the middle of the square; so certain are they that none will happen. One could tell

them that some country beyond the Caucasus was prepared to accept them and they would gather up their boxes, without really believing. Their life is unreal, a waiting without expectation, and they no longer cling to it: rather, life clings to them, ghostlike, an unseen beast which grows hungry and drags them through ruined railroad stations, day and night, in sunshine and rain; it breathes in the sleeping children as they lie on the rubble, their heads between their bony arms, curled up like embryos in the womb, as if longing to return there.[114]

In Harlaching he meets an old gentleman whose "striped pajamas and bare neck recall familiar pictures." Frisch finds out that, indeed, this man "did spend six years in the concentration camp at Dachau. But he does not speak of that; rather, of the time before, the causes." The man says: "All of us in the camp agreed that it was not our sons' fault, never mind how much they were mixed up in it—" (23)

Having seen new barbed wire being put up and having experienced an army inspection, Frisch comes across a "camp in a forest clearing" near Landsberg. He writes: "It reminds me of a farm for silver foxes perhaps, everything fenced in and tidy and straight as a die, a chessboard of utter despair, people, washing on the line, children, barbed wire" (26). Frisch does not specify what kind of a camp he saw, but it is likely that it was the Landsberg camp for Displaced Persons (D.P.s). Such camps were set up immediately after the war for between 6 and 7 million slave laborers who had been brought to Germany during the war and who needed to be repatriated quickly as well as for other non-Germans who were in Germany.[115] Among the D.P.s were about 70,000 Jewish survivors of the Holocaust and, later on, the so-called "infiltrees," about 200,000 newly arriving Jews who had survived World War II in the Soviet Union, had then been repatriated to Poland where they were in many cases not welcome—there was a bloody anti-Jewish riot in Kielce in 1946—and mostly made their way from there to Berlin and the Western zones of occupation in Germany and Austria.[116]

Administered by the new United Nations Relief and Rehabilitation Administration (UNRRA), these camps served as temporary shelters and transit points for D.P.s from most European countries. By the end of August the *New York Times* reported that about 70 percent of the D.P.s had

been repatriated, but that large numbers of others remained in the camps.[117] The camp existence lasted longer for non-Jewish East Europeans— Ukrainians, people from the Baltic countries as well as others now considered Soviet citizens, Poles, Hungarians, Mennonites from different countries—who were not only forced laborers but also others who for one reason or another had stayed in Germany during the war. They were gradually being considered "non-repatriable" or they actively refused, sometimes at the threat of suicide, to be forcibly repatriated to the Soviet sphere of influence, where they feared, with some justification, that they would be treated as traitors and punished severely or killed. A much-noted 1946 article in *Stars and Stripes* reported a harrowing scene at Dachau concentration camp, in which two barracks now served as camp for Soviet D.P.s. When the U.S. Army attempted to forcibly remove nearly 400 prisoners and put them on a train headed for to the Soviet zone, more than thirty of them attempted to commit suicide and eleven of them actually died. " 'It just wasn't human,' one of the guards said. 'There were no men in that barrack when we reached it. They were animals. The GIs quickly cut down most of those who had hanged themselves from the rafters. Those still conscious were screaming in Russian, pointing first at the guns of the guards and then at themselves, begging us to shoot.' "[118] Wolfgang Jacobmeyer reports that after this "suicide orgy" the 368 remaining Russians were repatriated anyway, even though six of them managed to escape during the transport, despite the presence of Russian officers and American soldiers. The policy of forced repatriation only changed once the vast majority of Soviet D.P.s had already been returned.[119]

Jewish D.P.s from Eastern Europe, although they were classified by nationality rather than as Jews, could not be repatriated anywhere, and they were eagerly waiting in the camps for hard-to-obtain visas to Palestine, the United States, Canada, or Australia. The fact that some of the most notorious Nazi concentration camps were being reused by the Allies to house Jewish D.P.s in the postwar period met strong reprobation by Earl G. Harrison whose scathing 1945 report to President Truman put the critique memorably: "As matters now stand, we appear to be treating the Jews as the Nazis treated them except that we do not exterminate them. They are in concentration camps in large numbers under our military guard instead of S.S. troops. One is led to wonder whether the German people, seeing this, are not supposing that we are following or at

least condoning Nazi policy."[120] Harrison, formerly commissioner of immigration and, at the time of the report, dean of the University of Pennsylvania Law School, furthermore pointed out that "many of the Jewish displaced persons, late in July, had no clothing other than their concentration camp garb—a rather hideous striped pajama effect—while others, to their chagrin, were obliged to wear German S.S. uniforms. It is questionable which clothing they hate the more." He reported that "they wonder and frequently ask what 'liberation' means" and suggested that these "despairing survivors" need to be recognized as Jews and not just by their nationality: "While admittedly it is not normally desirable to set aside particular racial or religious groups from their nationality categories, the plain truth is that this was done for so long by the Nazis that a group has been created which has special needs. Jews as Jews (not as members of their nationality groups) have been more severely victimized than the non-Jewish members of the same or other nationalities."[121] Though the Harrison Report's request for 100,000 entry visas to Palestine did not prompt the British government to change its policy, its appeal to create special and less restrictive camps for Jews did have the effect that conditions for Jewish D.P.s did improve. As Atina Grossmann suggests, given the restrictive U.S. immigration policy and the British permission of only a trickle of migrants to Palestine, this decision made the camps virtual "magnets" for more Jewish arrivals as well as for Zionist organizers.[122]

Though the Bergen-Belsen concentration camp was burned down in May 1945, the SS barracks remained standing and were transformed into a Jewish Displaced Persons' camp that remained open from 1945 to 1950, with a population that peaked at more than 11,000 in August 1946. Some of these years were richly documented in a three-volume album of more than 1,100 photographs taken by the Lithuanian-born secretary Zippy Orlin and by her co-worker "Willy with the Leica," including images of weddings, of education from kindergarten to vocational training, of theatrical events, holiday celebrations, medical services, sports activities, a May Day demonstration, and a memorial service of the liberation of Bergen-Belsen.[123]

The format of the family photo album was also used in another D.P. camp, that of Frankfurt-Zeilsheim, with a population that reached 3,570 in 1946. There Ephraim Robinson, a Warsaw-born agronomist who spent the war years in the Soviet Union, took more than two hundred photographs

Anti-British demonstration in D.P. camp Zeilsheim. Ca. 1946/1947. *Photo by Ephraim Robinson. United States Holocaust Memorial Museum, Washington, D.C.*

of daily life in the D.P. camp with a Leica and put them together into an album, published by his daughter who writes in the introduction that his photographs chronicle a people building *a lebn afs nay*, a new life.[124] Several scenes depicted are similar to the ones in Orlin's album, including weddings, births, theater performances, piano concerts for Purim, and so forth, but there are also photographs of Eleanor Roosevelt, David Ben Gurion, and other famous visitors to the camp, portraits of the UNRRA directors of Zeilsheim, and dramatic scenes like a raid by the American military police, the arrest of a man recognized as former "Kapo" by the D.P. police, and even demonstrations requesting "liberation from the camps" and "cessation of the English terror in Palestine."[125] Forward-looking and even optimistic though some of the scenes may look, there is also a somber note palpable in the album, and not only in those photographs that are explicitly "in memoriam."[126]

It was most likely at the Zeilsheim D.P. camp kindergarten that Anna Kaletska (the woman cited earlier who was liberated by American tanks while on a forced march toward Bergen-Belsen) was working at the time David Boder interviewed her. She came from the Jewish community in Kielce that she tells Boder once had twenty-four thousand members, of

whom only three hundred survived—and forty-two of those survivors were massacred in Kielce after the war. Anna Kaletska, who had survived slave labor at Auschwitz but had lost her husband and found out after the war that her daughter who had been hidden by a Christian woman had also been killed, tells Boder at the end of her interview that there are twenty Jewish children in the kindergarten where she works: "And I play with them, and then I forget about all that. Again I have around me Jewish children. But after work, to come alone to my room—today is a holiday. Where are all mine, who used to celebrate the holidays with me?" Her interview was interrupted by paroxysms generated "by depressing memory associations" and a sense of survivor guilt, as Boder diagnoses her highly emotional state.

The psychologist Dr. David Pablo Boder, who was born in Latvia, studied at Vilna, Leipzig, and St. Petersburg, earned his Ph.D. at Northwestern University, and taught psychology at the Illinois Institute of Technology, was able to interview his subjects in a variety of languages, including German, Yiddish, Russian, English, French, Polish, Spanish, Lithuanian, and Latvian. Working with the new tool of a wire recorder and carrying 200 spools of carbon wire to Europe in 1946, Boder conducted more that 160 interviews with Jewish and non-Jewish survivors and otherwise traumatized people, 70 of which he transcribed and 8 of which, including the one with Anna Kaletska, he published in 1949 under the title *I Did Not Interview the Dead*.[127] In the introduction to his book Boder writes that he was inspired by Eisenhower's invitation to journalists to come and see for themselves. Boder hoped that his book, for which he also examined UNRRA records, would create a better understanding of D.P.s and their problems. "The displaced persons," he writes, "in spite of their sorry state today, are not riffraff, not the scum of the earth, not the poor devils who suffer because they don't know their rights, not idlers who declaim that the world owes them a living. They are uprooted people. They represent the members of all classes of society—farmers, industrial workers, teachers, lawyers, engineers, merchants, artists, housewives—who have been dislocated by a world catastrophe" (xviii). Boder's book and his larger collection of interviews are remarkable as oral history.[128] In addition, Boder, as a psychologist, proposed a "traumatic index" that he hoped would be a helpful method "of assessing human experience" in general, including "the exploration of the personality of any adult or child who has come

into conflict with life and social institutions" (xviii). He suggested twelve elements in this traumatic index, ranging from "brutal and abrupt removal from environmental stimuli" and "enforced performance of meaningless tasks" to "chronic overtaxing of physical and mental endurance" and "brutal punishment for trivial infringement of camp rules." As a general approach to the psychological traumas that result from such treatment, he proposed an understanding of a process that is the reverse of the anthropologists' notion of acculturation, "the incorporation of the individual into the group" (xix), "for what is dealt with here is an unprecedented and planned *deculturation* of personality on a mass scale" (xix).[129] Boder concluded with the statement that explains the title of his collection, that these "verbatim records . . . are not the grimmest stories that could be told—I did not interview the dead" (xix). Yet being brought so close to death and experiencing personal trauma and loss of family members and friends, several of Boder's witnesses make mention of feelings of despair and tell stories of others who have succumbed to the temptation of committing suicide.

Small Victory

According to her own autobiography, *Open Every Door* (1956), the journalist, public relations expert, and writer of film-noir-style detective fiction Zelda Popkin undertook the venture of going to Europe in 1945 with the American Red Cross in response to the great loss she felt after the death of her husband. "This is a time of starkness, of despair," she writes, "yet here and now begins the third dimension, the growth in depth which makes a human being rich. The pit of suffering has been reached, the greatest loss, long dreaded but feared so secretly it never was verbalized, not even within one's self. Ahead lie years. Will they be years of mummifying, living yet not alive? Or, with nothing left to dread, will they be years to move about and find another world?"[130] That "other world" was a prolonged stay in France, Germany, and Austria during which time Popkin worked helping Displaced Persons. Her hotel room in Paris was dingy, but the sight of Frankfurt in ruins was worse, as she "saw the awesome aspect of defeat, the acres of brick skeletons which had been homes, the rubble heaps, the stone piles with chimneys stuck atop, caves thrown together, where the defeated cooked and slept. The rubble heaps wafted the stench of overripe death" (O 277–78).

Her attempt to approach what she saw from a moral high ground, to remain aloof from Germans and care only about their victims was not always easy to maintain. When she saw people going by in a truck, standing up under a tarpaulin in the icy drizzle, she wondered: "Who were they? Homeless victims or Germans dispossessed? It's hard to tell. All misery wears one face" (O 278). The first full scene she witnessed put her resolve to a test, perhaps because the subject vying for her pity was a young German child:

> A G.I. lounged against the Bahnhof wall. He took a cigarette from a full pack, struck a Zippo, drew in a lungful of smoke. A girl—she might have been eight or ten—crept to his side. *"Cigarette für papa?"* I heard her beg.
>
> The G.I. took the cigarette from his mouth. Slowly he lowered it and let it drop. The girl swooped for it. Deliberately, he brought his foot down on her hand. I heard her anguished yelp before I fled, stomach churning, across the street. There is no greater obscenity than cruelty. Yet he did this to one of *them.* What's happening to you? Have you begun to pity *them?* (O 279)[131]

This was a scene important enough to Popkin that she had already included a version of it in her novel *Small Victory* (1947), in which the North Carolinian professor of history Randolph Barlow is the character who is made to witness this small and senseless act of everyday cruelty that frightens him.

> One of the soldiers took out his cigarette pack, flicked open his lighter, inhaled. A thin, white-faced girl, damp and shivering, sidled over to him and stood hungrily watching the spirals of smoke. The soldier glared down at her. She smiled crookedly. "Cigarette?" The soldier took his butt from his mouth. The child's pinched face lighted. *"Für Papa?"* she asked eagerly. The soldier let the cigarette drop. The child darted forward to grab it. His heel came down sharply, just missing her fingers. Without a whimper, she turned and started to run. The G.I. twisted his heel, grinding the cigarette to dust on the pavement. Then, tight-lipped, he took out his pack and lit a fresh smoke. It seemed to Barlow an act of savage spite so petty and futile that it cheapened the

soldier who did it. Yet he said nothing, and asked himself fretfully, What's got into me? Do I feel sorry for *them?*[132]

Perhaps Popkin created Barlow as a southerner so that he could be particularly prone to look at the world also through the eyes of the defeated. Yet it is noteworthy that Popkin does not tell the exact same story twice, for in the novel, the soldier's heel misses the child's fingers just barely whereas in the autobiography, "he brought his foot down on her hand" so that the act of random cruelty against a child is magnified.

Even though Barlow is an expert and has published a book about the history of German militarism, Popkin's idealistic professor does not know how to react to the contrast between conquerors and conquered that meets him in the intense coldness of ruined Frankfurt in 1945. "All the days of November were gray and raw cold, the brown grayness of rubble heaps next to the pavements, of bombing silt still in the air, of weeds that had sprouted and flourished and frozen on the refuse of houses and men, of even the people, creeping through mists and fine rain. The cold was a barbed, bitter thing that came from the soul, as much as from winter" (S 159). Barlow cannot imagine the hateful master race aspirations in the poor ragged figures he sees; he recognizes only the appearance of the victors and of the defeated on his way from the bombed train station to the completely intact U.S. Headquarters in the former IG Farben building, where he has to work through piles of denazification questionnaires. "The victors looked young. They were straight-standing, ruddy. They looked warm and well fed and content and indifferent. The beaten seemed old, neatly dressed and well shod, but wax pale and ineffably tired and indifferent. The eyes of the women, deep in their sockets, had a common lackluster, as though all emotion were drained but despair. The men showed nothing, not even despair" (S 28). The poverty and hunger of the beaten contrasts sharply with a lavish American dinner in a nearby *Schloss*. Barlow wonders self-critically whether the very act of military occupation has changed Americans. In a letter home he writes, *"We are now where they were in Norway, in Greece, in France and in Holland. We are the hated. Can you guess what it means to people like me to know they are hated—or feared?"* (S 55).

Barlow is torn by violently ambivalent feelings toward Germans and deeply moved by the encounter with a Polish pianist who tells Barlow, "each word measured, deliberate, trip hammer," the harrowing story of a "friend"

who survived in a packed freight train by standing on top of others and who survived Belsen, too—and it is "perfectly plain" to Barlow that "the Pole spoke of himself" (S 51–52). Barlow's experiences in Germany and the haunting stories he hears alienate him more and more from Iola, his wife back in the United States, to whom he writes fewer and fewer letters.

About a third of the way into the novel, Barlow meets the UNRRA worker Helen Kimball who introduces him to Pincus Gold, a survivor of Dachau and Buchenwald who would like to study medicine. Later Helen takes Barlow for a visit to the D.P. camp in Zeilsheim, where they also witness a Jewish wedding. It is here that the novel gets to the heart of Popkin's concern. The wedding stands under the shadow of the concentration camp experience, as does the entire life in the D.P. camp. A twelve-year-old boy tells Barlow "matter-of-factly" that he saw his father being taken to the ovens and his mother beaten to death (S 143). There is a somber atmosphere, with people looking for ways to get out of the camp, to get to America. The wedding ceremony begins, but when the bridegroom is giving the bride a piece of the ritual bread she suddenly screams "no!"— for she had given her mother bread that was poisoned in the *lager* and the mother had died. The bride only stops crying when Helen gives her a pair of polished turquoise earrings as a wedding present. "The bride touched each earring with just the tip of her finger, as if she could not and dared not believe they were hers, and again moved to offer them back." Helen wants the gift to be the first "of the good things" the bride would have from now on, but Barlow now recognizes that there is a concentration camp number tattooed on the bride's naked forearm, and his eyes mist with tears (S 144).[133]

That this wedding gift serves as symbol of hope only to be dashed becomes clear later in the novel when Barlow sees the very same earrings in the possession of a major who got them from an M.P. and who now plans to give them to his German girlfriend. The major explains that the M.P. "picked this stuff up in one of the camps. They were searching the place— you know, black market stuff, schnapps, cigarettes, uniforms, and damned if he doesn't find these. . . . Woman put up a holler. Said they were hers. Given to her for a present. Now— . . . he knew damn well that was bunk. This was American stuff. Where would she get something like that? . . . Cost me a carton of Luckies" (S 251–52). Barlow tries to buy the earrings back but is refused and walks out furiously, thinking: "A fräulein will wear

Helen's earrings; Helen's earrings, given with love, stolen, in cruel, callous search. Good God, do you let these things happen? Haven't you hurt them enough? Must there still be terror, insult, *from us?*" (S 252)

Popkin represents the problem of the D.P. camps not only from Helen's humanitarian UNRRA point of view, but also as the military administrators see it: as the problem of feeding and sheltering not only all the slave laborers who do not want to go home to Poland, Ukraine, or Yugoslavia but also the Jews who are coming in, "hundreds every day" in Berlin (S 186). Barlow ultimately succeeds in getting D.P. Pincus Gold admitted to medical school at the University of Heidelberg, soon to reopen, against the explicit wish of an openly anti-Semitic German professor.[134] This is the "small victory" of the novel's title, but it is diminished by the compromise the military government agrees to as part of this arrangement, namely that survivor Gold's matriculation is made possible only on the basis of the establishment of a new policy, a *numerus clausus*, or 10 percent maximum quota for Jews at the university. It is clear from *Open Every Door* that Popkin drew on actual conversations about the reopening of the German universities and the possible place of D.P.s in them. When the major in the Education Office showed Popkin the mimeographed directive, she remembered asking him, "Major, why did we fight the war?" (O 290). She commented: "The *numerus clausus*, the hush-hush technique for practicing anti-Semitism in American colleges, had been made official policy by Americans in Germany" (O 290). In Popkin's papers there are documents corroborating this event, as some scenes of the novel seems to be directly inspired by close personal observation. In one of Popkin's interview notes, a Mr. McCracry apparently condoned such measures, devised explicitly to keep Jews from crowding German medical schools. And on July 26, 1947, Judge Simon H. Rifkind, Eisenhower's advisor on Jewish Affairs, sent a handwritten note to Popkin in which he reminisced about some of their meetings, but adds: "A conference of the kind you describe actually took place in my office. I confess, however, that my concern was not with numerus clausus. My object was quite different—to differentiate the Jewish D.P.—to exempt him from the two year physikum. We compromised. The . . . rule remained."[135] Still Popkin decided nine years later to describe a meeting with Rifkind in which he was reported to have said: "This was the best I could do. They offered me 2 per cent. I got it up to 10" (O 291).

Of course, as a teacher at a southern college who had grown up in Savannah, Barlow is no stranger to racial segregation, and even though there is no formal quota for the small number of Jews who apply to Barlow's college, the racial quota is closer to zero for Negroes. Barlow not only tells Helen about his childhood in the Jim Crow South (S 100–101), but he also can only answer, "Don't be absurd. You know how it is in our part of the country" when Helen asks him how many Negroes there are at his college (S 202). Even though Barlow does not "condone" it, the social arrangement of racial segregation is such a part of him that he is reminded of Jim Crow practices when he is inside the U.S. headquarters: "The staircase was gargantuan, the corridors endless. He ambled up one, down another, around bends and twists, past wash-rooms, separately labeled 'Officers' and 'Enlisted Men,' reminiscent of those back at home that were marked 'White' and 'Colored'" (S 32).

Barlow remains self-doubting and ambivalent in response to what he sees. When he finds the Jewish army officer Jimmy Ahrens fraternizing with a German secretary, Barlow is again torn by contradictory emotions:

> The thing that shocked me most was that Ahrens is Jewish. He is Jewish and Anna-Marie is a German. That was the indecent thing. She is his enemy, his unforgivable enemy, sister or daughter of those who loosed the dogs on Pincus Gold's mother, killed his father and sisters and brother. Sister or daughter of those who would have killed Ahrens himself, if he'd lived on this side of the ocean. . . . Why, his flesh should have crawled. . . .
>
> He stopped. He thought, I'm doing to Anna-Marie just what they did to the Jews. Condemning a race. What do I know about her? What she thinks? How she feels? Who her family were? How she got along all those years? (S 175)

Ahrens's later kills Anna-Marie and himself, in one of the IG Farben manager's houses. Popkin thus includes a suicide in the generally depressive atmosphere of her novel, and while she leads the Pincus subplot only to its bittersweet "small victory," the future of the D.P. camp remains uncertain, Helen's wedding gift is never restored to the Jewish newlyweds, and the reader who might expect a redemptive love story to develop between

Helen Kimball and Randolph Barlow is disappointed that it remains explicitly unconsummated in the novel. Even though Barlow knows that "in despair or defeat . . . a man must get drunk" (S 232) and spends a night drinking and talking with Helen, even though they kiss each other lightly on several occasions (S 239, 247, 270, 273), they pointedly do not sleep together when they have the chance on Christmas Eve, and the narrative voice, close to Barlow's point of view, explains: "But the end or the midpoint of love between grown man and grown woman need not be getting to bed. There could be friendship, deep, tender; the rich comradeship, the giving and taking of gifts of the spirit and mind. That was the good of being full-grown" (S 276).

In a novel that makes reference to Helen of Troy, Dante, Shakespeare's Shylock, and Thomas Wolfe's *You Can't Go Home Again*, the last literary allusion is to a line from the graveyard poetry of Thomas Gray, "The paths of glory lead but to the grave" (S 266).

<u>Observations on Personality and Work of Professor Carl Schmitt.</u>

1. The request submitted by Mrs. Carl Schmitt and by a Professor Dr. H. Schneider (unknown to this writer) on behalf of Carl Schmitt's library, induces this writer to make some additional observations concerning Carl Schmitt's personality and activities. They may be useful for determining his continued detention and, beyond this, for considering whether he should be treated as a war criminal. These remarks are based on about thirty years close familiarity with Dr. Schmitt's career, personality and work.

2. I do not hesitate to qualify Carl Schmitt as the foremost German political scientist and one of the most eminent political writers of our time, comparable in influence on world opinion perhaps only to Harold Laski, though in the reversed sense in that Laski is the literary protagonist of democracy while Carl Schmitt, on the other hand, has become the leading authority on authoritarian government and totalitarianism. Broadly speaking he is a man of near-genius rating. He possesses not only a vast and by no means sterile erudition, drawing from an immense store of factual information such constructive conclusions as have greatly contributed to the shaping of the things to come in the past. He is one of those rare scholars who combine learning with imagination; book knowledge with a realistic sense of what is possible in politics; scientific training with political versatility. Without doubt Carl Schmitt is the most prominent personality in the field of public law and political science Germany has produced since Georg Jellenik.

3. To his and the German people's misfortune Carl Schmitt abused his gifts for evil purposes. A brief survey of his intellectual development may serve to support this statement.

In his early years in Strassburg Schmitt came under French influence. He began his scientific legal work in the field of the theory of criminal law and legal philosophy. If I remember correctly, he started his academic career as a lecturer at the School of Business Administration (Handelshochschule)in Munich prior to the first World War. Around 1917 he published the first of his books which attracted nation-wide attention, entitled "Romantic Politics" (Politische Romantik) which stressed the irrational and mystical ingredients of political dynamics. At that time he applied for admission to the Law Faculty of Munich University; but the fossilized and reactionary academicians of this Law School, distrustful of his superior talents and considering him more a journalist than a lawyer, rejected his application, a fact which deeply and justly embittered his life. Not before the late Twenties he obtained a full professorship (Ordinariat) in the University; until then he had to satisfy his ambitions with the less respected chair of a Professor of constitutional law at the School of Business Administration (Handelshochschule) of Berlin.

Under the Weimar Republic he distinguished himself by a critical attitude towards the incipient German democracy; yet his criticism was constructive in that it pointed out defects of its political structure which, if remedied in time, might have led to its preservation. His two outstanding contributions were a book on the anatomy of dictatorship (Die Diktatur) which went through several

-1-

October 4, 1945

Amherst professor Karl Loewenstein, accompanied by Captain Fearnside, goes to Kaiserstuhlstraße 19 in Berlin-Schlachtensee with the task of writing a report on the library of Berlin professor Carl Schmitt who has been arrested on September 26, apparently at Loewenstein's request.

Dilemmas of Denazification

Karl Loewenstein, Carl Schmitt, Military Occupation, and Militant Democracy

> Apathetic, depressions, listless and indifferent, just lying around, a feeling of decline and destruction. There is only one who can wake me up and strike me: Bernanos, and even he only with *Under Satan's Sun.*
>
> —Carl Schmitt, diary entry of July 6, 7, 8, 1930

Why would one professor have another professor arrested, then have his library confiscated? The answer to this question will take us forward and backward in time, until we can return to the postwar moment. First, forward.

In 1958 Karl Loewenstein, a professor at Amherst College, published his book *Verfassungslehre* (Constitutional Theory), a work that has been reprinted several times. A reviewer of the book made an interesting point: "Loewenstein's *Verfassungslehre* is diametrically opposed to that of an author who is not named in the text and with whom Loewenstein refuses to engage in a scholarly way in this context: the one by Carl Schmitt. . . . In a certain way it is an 'anti-Schmitt' from the point of view of a republican reading of political liberalism."[1] The fact that Loewenstein did not mention Schmitt by name was clearly not due to ignorance: it was instead

a studied avoidance in this late work, for, as we shall see when moving backward in time, their lives and careers had indeed intersected at key moments of the twentieth century. Schmitt and Loewenstein shared some intellectual interests even as the two legal scholars also diverged dramatically in their views of the nature of constitutions, the lessons to be drawn from the Weimar experience, the Nazi ascent to power and establishment of its legal system, the American occupation and denazification of Germany, and the possible future of democracy in Europe after the end of World War II. Both were also eager readers of political theory from antiquity to the twentieth century, and both observed political developments actively in their own times, often making pointed and witty comments, for both were given to express themselves discursively as well as in occasional pithy phrases and memorable aphorisms. Born only three years apart from each other, Carl and Karl might have known each other personally from their student days; they certainly knew of each other, at least on one occasion in 1925 exchanged offprints of articles they had written, cited each other, and commented on each other in published works as well as in their private diaries. Their different ways of thinking touch on some hardly marginal questions of the past century and invite readers to draw comparisons and contrasts. In what follows I shall juxtapose some telling excerpts from their writings and trace their trajectories and conflicts. In the context of this book, these juxtapositions between Schmitt and Loewenstein also constitute a dialogue between a German and an American (or more precisely, a German who came to symbolize National Socialism and another German who had become an American and stood for occupation and denazification).

Carl Schmitt (1888–1985) is, of course, the far better known theorist of this pair. He studied at Berlin, München, and Straßburg, received his doctorate at Straßburg in 1910, wrote his 1914 habilitation on *The Value of the State and the Meaning of the Individual*, then taught at Greifswald, Bonn, the Berliner Handelsschule, Köln, and, from 1933 to 1945, at Berlin University, ascending also to the position of Preußischer Staatsrat in 1933.[2] After World War II, he lived as an independent lecturer, author, and consultant, thus augmenting his professorial pension. Schmitt had a predilection for essay-length books (pamphlets, or *Broschüren*, really) and published a great number of them. Among his publications *Die Diktatur* (1921; Dictatorship), *Politische Theologie* (1922; Political Theology, 1985), *Der Begriff*

Carl Schmitt. Berlin, April 24, 1936. *Photo by Studio Atelier Bieber/Nather, Bildarchiv Preußischer Kulturbesitz bpk 10017795, Bb N40573/Art Resource.*

des Politischen (1927; The Concept of the Political, 1976), *Verfassungslehre* (1927; Constitutional Theory, 2008), *Legalität und Legitimität* (1940; Legality and Legitimacy, 2004), *Land und Meer* (1942; Land and Sea, 1997), and *Theorie des Partisanen* (1963; Theory of the Partisan, 2007) may be the most influential. He was skeptical of the United Nations Human Rights declaration because he considered it unenforceable until there emerged a world state with a world constitution. A lifelong conservative and for some years a vocal and even strident supporter of the extreme Right, he is now often cited or invoked by writers on the Left. The current Schmitt vogue, inspired by Giorgio Agamben and the journal *Telos* and sanctified

by the connections between Schmitt and Walter Benjamin (who cited Schmitt and wrote to him and whose *Ursprung des deutschen Trauerspiels* Schmitt read and annotated carefully), is in sharp contrast to his dismissal by Frankfurt School intellectuals, in the context of whose work I first learned of Carl Schmitt, with Theodor W. Adorno omitting passages of Benjamin citing Schmitt and excluding Benjamin's letter to Schmitt from an edition of the correspondence, or with Herbert Marcuse and Otto Kirchheimer writing stinging critiques of Schmitt's thinking.[3] In February 2012, Google Scholar listed 26,900 citations for Carl Schmitt, including his own works, and there are several websites exclusively devoted to him.[4]

Karl Loewenstein (1891–1973) studied in Paris, Heidelberg (with Max Weber), Berlin, and München, received his first law degree in München in 1914; after serving in the infantry in World War I he was admitted to the bar in 1918 and received his doctorate a year later with a dissertation on *People and Parliament after the Theory of the State of the French National Assembly of 1789: Studies in the History of the Dogma of Immediate Popular Legislation.*[5] He practiced law in München, while publishing prolifically, completed his habilitation in 1931, writing on "Versions of Changing a Constitution: Examinations of Constitutional Doctrine in Relation to Article 76 of the Reich's Constitution," and then taught at the University of München as a *Privatdozent* (1931–33).[6] Shortly after the Nazis took power, he, as a Jew, lost his university position, his office was stormed, and he emigrated to the United States in December 1933, where, with the help of the Emergency Committee in Aid of Displaced German Scholars he assumed a two-year teaching position at Yale before being offered a position at Amherst College where he received an honorary M.A. in 1940 and was appointed as full professor of political science and jurisprudence. After working on Latin American politics on a Guggenheim fellowship and serving as legal advisor to UNRRA he took a position in the Legal Division of the Military Government in occupied Germany and worked on denazification. The legal historian and dean of the law school at Erlangen, Erwin Seidl, offered Loewenstein a professorship in 1946 that he declined, and after a prolonged series of academic maneuvers by the University of München, where the law faculty consisted more or less exclusively of former Nazis, he was made a professor there in the fall of 1956, just before he turned sixty-five, but was then immediately put on leave

Karl Loewenstein. Undated. *Photographer unidentified. Karl Loewenstein Papers, Amherst College Archives & Special Collections. Box 80, folder 2.*

(*beurlaubt*) for this last and only year of service so that he never assumed his position there. He was instrumental in the creation of the postwar constitution of Bavaria and in the development of postwar political science at German universities, advised the German Social Democratic Party, advocated an international human rights declaration, and also anticipated debates about the need for humanitarian interventions in sovereign states. He was awarded the Order of Merit by the Federal Republic of Germany in 1972.

Loewenstein also liked essay-length works and published numerous long articles in leading American law journals in addition to such substantial books as *Hitler's Germany* (1939) and *Political Reconstruction* (1946). I first

came across Loewenstein in Edmund Spevack's *Allied Control and German Freedom: American Political and Ideological Influences on the Framing of the West German Basic Law (Grundgesetz)*, a book that discussed Loewenstein's concept of "militant democracy" in the context of the West German constitution. In February 2012, Google Scholar had 1,930 citations for Karl Loewenstein, including his own works.[7]

Premises

One starting point for both Schmitt's and Loewenstein's reflections was thinking about the nature of political representation and about how constitutional states can deal with state power in relationship to the *volonté générale*, the public will that conferred power to rulers in the first place. Rousseau had recognized a circularity in imagining government as the result of the public will even though the public will needed to be already articulated and constituted in order to create the constitutional framework that defines government as a public servant. For the Catholic Schmitt, there therefore had to be a more absolute and transcendent sense of authority and state power—his thinking tended to circle around Hobbes and Jean Bodin—at first religiously based and later on as pure articulation of itself, as the power of decision-making as such. Hobbes had argued, Schmitt writes in *Dictatorship*, "that outside the state there is no law and that the value of the state lies precisely in creating law by deciding disputes about law," for "the decision contained in law is, normatively considered, born out of Nothing."[8] This became most apparent for Schmitt in the power of declaring the state of emergency, of siege. "Sovereign is he who decides about the state of exception" is the often-quoted opening sentence of *Political Theology*. "The state of siege reveals the essence of state authority in the clearest manner. Here decision deviates from legal norm."[9] The core of law lies in the decision to declare a state of emergency, the "exception" (*Ausnahme*) in the Weimar Constitution that suspends ordinary basic rights, for "the rule lives only from the exception."[10] Schmitt's aim was to understand the nature of power itself. The centrality of a strong, politically decisive state in Schmitt's thinking was also articulated in *The Concept of the Political*, which includes these two key sentences: "The concept of the state presupposes the concept of the political," and "the specific political distinction to which political actions and motives

can be reduced is the distinction between friend and enemy."[11] As Schmitt's biographer Reinhard Mehring explains, Schmitt wanted to exclude the outside or neutral perspective of international law and therefore limited the specifically political category, in analogy to a personal relationship, to the dualism of participants, appealing to a strong, politically decisive state that defends its monopoly of politics by distinguishing friend and foe.[12]

For Loewenstein, the discovery of techniques of political representation was equal in importance to the invention of the steam engine and the use of atomic power.[13] A sense of "power mystique" in state power—its being perceived as far more than a mere expression of the general will and exceeding it—may always remain active, even in total democracies, but it is a demonic quality that could and should be tamed by the division of powers and by guarantees of individual rights—his thinking centered on Montesquieu, Locke, and Jefferson. Loewenstein found shortcomings not just in Hobbes but also in Rousseau, for "if Hobbes's omnipotent Leviathan were replaced by the no less despotic general will which brooks no opposition, liberty would suffer its final destruction. The pragmatic Montesquieu built the concept of liberty into the process of political power itself by the technique of the 'separation of powers': liberty is safe only if the several power holders, to whom state functions are assigned, separately, restrain themselves mutually and reciprocally."[14] It was Montesquieu's merit to have cut up the almighty Leviathan of state power into functional pieces and thereby helped the preservation of freedom of those who are subjugated to it. Equally important was Locke's emphasis on individual liberty, and both of their thinking found expression in various eighteenth- and nineteenth-century bills of rights and democratic constitutions.[15]

The central task for Loewenstein was to imagine national and international legal frameworks in which pure expressions of power could be curbed and subjugated to democratic structures that guarantee individual rights and division of power, even if that meant getting help from other democracies and suppressing antidemocratic forces within a democracy. This was a general issue that had its specific application in the postwar situation, of course. Thus Loewenstein used as an epigraph to *Political Reconstruction* an excerpt from Jefferson: "I do not indeed wish to see any nation have a form of government forced on them; but if it is to be done, I

should rejoice at its being a free one."[16] Loewenstein believed that "what is needed is a Baedeker through the world of democracy," and his empirical survey of constitutions and their problems in many countries aimed to provide just such a guidebook.[17]



Loewenstein, indeed, imagined constitutions in antithesis to Carl Schmitt, whom he did not mention in his *Verfassungslehre*, but to whom he alluded repeatedly, for example when he titled a section "Against the Shadow of the Leviathan" (the phrase to which the title of the cited review alluded) or when he wrote about sovereignty, in direct and undoubtedly intentional antithesis to Schmitt: "Perhaps it is fair to say that sovereignty is nothing else, and nothing less, than the legal rationalization of power as the irrational element of politics. He who is legally entitled to exercise or who ultimately exercises political power in the state is sovereign."[18] Loewenstein's emphasis on legal entitlement clashed directly with Schmitt's stress on the state of siege, a limit case of such entitlement.

Weimar

Both Schmitt and Loewenstein were concerned with topical problems of parliamentary systems. For example, both were close to unanimous in their critical view of the British electoral system that could create majorities far out of proportion to the percentage of votes a party actually received. In 1925, Loewenstein sent Schmitt his published critical essay *Minority Government in Great Britain*, and Schmitt responded with a polite letter not only praising Loewenstein for an achievement in political science that was rare in Germany and promising him that he would not miss any opportunity to call attention to this essay but also announcing a shipment of Schmitt's own essay *The Rhinelands as Object of International Policy* to Loewenstein.[19] Schmitt may have been all the more favorably disposed toward Loewenstein's essay since it referred to Schmitt's 1923 treatise *The Crisis of Parliamentary Democracy* favorably and prominently, right on the first page, and called it spirited (*geistreich*). Schmitt returned the favor when, in his *Verfassungslehre* of 1927, he adopted Loewenstein's argument about the disparity between the numbers of British voters and of parliamentary mandates in his historical overview of parliamentary systems and quoted Loewenstein lavishly in a long footnote that recapitulated his thesis.[20]



Both Schmitt and Loewenstein also responded to and commented on the political crises of the Weimar Republic, but whereas Schmitt approached issues from the point of view of state power, Loewenstein's emphasis was on securing individual citizen's basic democratic rights in the context of political systems with divisions of power. Given Schmitt's interest in the state of emergency, it was paragraph 48 of the Weimar Constitution that received his special attention. That provision reads as follows:

If a state fails to perform the duties imposed upon it by the federal constitution or by federal law, the President of the Federation may enforce performance with the aid of armed forces.

If public order and security are seriously disturbed or endangered within the Federation, the President of the Federation may take all necessary steps for their restoration, intervening, if need be, with the aid of the armed forces. For the said purpose he may suspend, for the time being, either wholly or in part, the fundamental rights described in Articles 114, 115, 117, 118, 123, 124 and 153.[21]

The President of the Federation has to inform the Reichstag without delay of any steps taken in virtue of the first and second paragraphs of this article. The measures to be taken are to be withdrawn upon the demand of the Reichstag.

Where delay is dangerous a state government may take provisional measures of the kind described in paragraph 2 for its own territory. Such measures are to be withdrawn upon the demand of the President of the Federation or the Reichstag.

All details will be regulated by a federal statute.[22]

This was the *Ausnahmeparagraph*, the article of exception that tragically permitted the suspension of basic civil rights in "case public safety is seriously threatened or disturbed." In his *Verfassungslehre* (1928) Schmitt saw the tensions in the Weimar constitution and emphasized the coexistence of aristocratic presidential powers in this constitutional provision on the one hand and plebiscitary tendencies on the other. Hence Schmitt imagined—before it actually happened—the "Auflösung des Parlaments" (dissolution of parliament) by way of an "Auflösungsrecht des Präsidenten" (right of the President to dissolve the Reichstag).[23] In *Legalität und Legitimität* (1932), he added the guarantees of basic human rights in

"Grundrechtsteil (ratione materiae)" to the legal basis for referenda, "Volksentscheiden (ratione supremitatis)," and to extraordinary presidential empowerment, "außerordentliche präsidentiale Maßnahmebefugnisse (ratione necessitatis)" and now saw three extraordinary principles coexisting in the Weimar Constitution.[24] Schmitt thought that the dissolution of the Weimar Republic was already embodied in its constitution, and he saw presidential power as the only possibility to preserve the order of Weimar in the political crises of the late 1920s and early 1930s. Schmitt therefore supported this strategy with the governments of Franz von Papen and Kurt von Schleicher. Mehring pointed out that Schmitt saw his essay in retrospect as a desperate "attempt to save the presidential system, the last chance of the Weimar constitution, from a jurisprudence that refused to ask who was friend or foe of the constitution."[25]

Loewenstein also did scholarly work on the Weimar constitution's provision for constitutional changes, focusing on article 76, in an at times critical engagement with Schmitt.[26] Schmitt had a "rather interesting" debate in his seminar on Loewenstein's book on that topic in 1931.[27] Loewenstein was far more worried than Schmitt about the Weimar emergency measures of 1931 and expressed serious misgivings about their constitutionality.[28] He later looked back at the employment of paragraph 48 in Weimar and wrote that whereas initially this paragraph was employed in much the same way as the state of siege had been invoked in Imperial Germany, the rapid economic decline as a consequence of inflation led to the transformation of invoking emergency rights into a tool of addressing socioeconomic questions (like finances or unemployment), quite against the meaning of the paragraph intended by the constitution. As William Ebenstein put it, "Not since the days of Charles I of England has a parliamentary body been convened as rarely and sparingly as was the German Reichstag in the last three years of the Weimar Republic."[29] And when the Reichstag became hopelessly divided after the 1930 elections, emergency legislation became such normal legislative practice that Heinrich Brüning as well as subsequent "presidial" cabinets governed with it until the final collapse of the republic. Loewenstein concluded that under Hitler the cancellation of basic constitutional rights by the decree of February 28, 1933, on the basis of article 48 of the Weimar constitution, became the "Magna Charta of the concentration camp" (in fact, the first camp,

Dachau was opened on March 20, 1933), and he reminded readers that the state of siege in Germany that took effect on that date was lifted only by the Allied occupation forces after the German defeat.[30]

The Nazi Years, 1933–1945

It was in this process of legal and constitutional transition from the Weimar Republic to Nazi Germany that Schmitt played an active part. Interestingly, on March 20, 1933, after the Nazi accession to power and the establishment of emergency measures, Schmitt recorded in his diary a dream vaguely focused on Loewenstein: "Dream of a Jew whose name is Löwe (lion) and who accuses me of having called him a lion. I reply to him: Man is the being of all beings (odd [Loewenstein], lecture a.m.! Salto mortale into metaphysics)."[31] Though Schmitt had made last attempts to help stabilize Weimar, he very quickly started supporting the NSDAP, joining the party on April 27, 1933 (member no. 2098860, he kept the party up to date about his changes of address).[32] He ascended to the most prestigious law professorship at the Friedrich Wilhelm University of Berlin, and exactly on his forty-fifth birthday, was appointed by Hermann Göring to serve as Preußischer Staatsrat, together with conductor Wilhelm Furtwängler, industrialist Fritz Thyssen, sea admiral Adolf Lebrecht von Trotha, and many from the party, SS, and SA hierarchy. This newly created body of seventy lifetime and salaried members replaced the previous parliamentary representation of the Prussian provinces. Schmitt, who had already helped to draft laws that made smoother the transition from the Weimar democracy to the Nazi dictatorship, further participated in the legalization of the new regime.[33] In retrospect he would claim having felt superior to that regime and having tried only to instill some meaning into the newly empowered movement: "I wanted to give National Socialism a meaning from my own vantage point," as he later put it.[34]

His biographer calls Schmitt's publications of the early Nazi years "Sinnstiftungsschriften" (writings intended to create meaning), and it is one of the deepest ironies about Schmitt that the political theorist who is now most celebrated (or vilified) for emphasizing the "state of exception" thought in 1933 that the National Socialist state needed a constitutional framework or at least a strong advisory council and perhaps hoped that

the Preußischer Staatsrat might be a model of such an organ. Of course, the Nazis were only too happy to rule on the basis of emergency measures alone and without any advisory board or a new constitution. The cited paragraph 48 served as the legal base for governing, and fundamental human rights remained suspended for twelve years, a rather elastic interpretation of the paragraph's phrase "for the time being." The Staatsrat became merely a ceremonial institution.

Schmitt's writings in the 1930s were attempts to sanction the destruction of any legality, perhaps best embodied in his readiness in 1934 to endorse retroactive penalization, the new system's departure from the basic principle of justice, "nullum crimen sine lege" by the new maxim of "nullum crimen sine poena" that Schmitt explicitly advocated. Instead of being a state operating by the "rule of law" (*Rechtsstaat*) according to which no crime exists that has not been previously defined by a law, there was in Nazi Germany a "just state" that made sure that no crime whatsoever would go unpunished. The battle between the new organic concept and a merely formal, mistrustful, liberal notion of Rechtsstaat was not a semantic quibble but a matter of "victory or defeat, friend or foe."[35] Hence such questions as basic rights or the banning of all political parties except the NSDAP could not be meaningfully approached from merely formal notions of a Rechtsstaat. Schmitt ingratiated himself to the new regime by explicitly endorsing Hitler's dismissal of "bourgeois-legitimistic compromise"; by praising the abolition of the separation of powers and the new power of the executive to legislate, to create even constitutional law; by highlighting that usury was sanctioned as freedom of enterprise in a formal Rechtsstaat; by deploring specifically that Jews could still marry Christians and that a "non-Aryan" background was an insufficient reason for losing many forms of employment in the new Germany; and by emphasizing the need for *Artgleichheit* (identity of species or race) and racial belonging.[36]

On August 1, 1934, a month the after the so-called Röhm-Putsch, or "night of the long knives," in which dozens of SA members and many others were murdered—including Kurt von Schleicher whose government Schmitt had supported and attempted to stabilize—Schmitt published the essay "Der Führer schützt das Recht" (The *Führer* protects the law). There he distinguished the new legal system from liberal legal thinking of the past which, Schmitt wrote, had turned the penal code into a "Magna

Charta of offenders" (Franz von Liszt's famous quip) and constitutional law into a "Magna Charta of traitors." Such liberal approaches would never be able to do justice to the new role of the Führer as judge and embodiment of the law. In truth, the act of the Führer was veritable jurisdiction and needed no further legalization and indemnification. It was not subject to legal procedure but was in itself the highest form of justice.[37] Schmitt praised the clear temporal limitation placed on murdering Hitler's wayward followers to a period of three days, and he ended on the happy note that, despite disapproval from anti-German voices, the German state had found the power and the will to distinguish friend and enemy.[38] Schmitt was thus able to adapt his focus on the state of exception and his favored friend-foe distinction, familiar from *Political Theology*, *The Concept of the Political*, and *Legality and Legitimacy*, and to turn these notions into praise for the Nazi state.

Though he had expressed anti-Semitic sentiments before, Schmitt now became very aggressively, even vilely anti-Jewish in his publications.[39] Let me cite three examples from this period. The first two also come from the *Deutsche Juristen-Zeitung*, the important German legal publication of which Schmitt had become the main editor in June 1934. On October 1, 1935, Schmitt published "Die Verfassung der Freiheit" in praise of the new Nürnberg laws governing German citizenship, the change of the flag, and the prohibition of interracial sex and marriage. Since Schmitt had already deplored in print the continued legality of Jewish–non-Jewish intermarriage in Nazi Germany it comes as no surprise that he favored the law carrying the official title *Gesetz zum Schutze des deutschen Blutes und der deutschen Ehre* (Law for the protection of German blood and German honor). Schmitt stylized the Nürnberg laws as "Constitution of Freedom" in contradistinction to mistaken liberal adaptations of French notions of the *citoyen*, alien to German blood and German honor (an allusion to the name of the new law). Hence Schmitt welcomed the replacement of the tricolor Weimar flag with its "side-by-side of colors . . . without the power of a real sign" by a single-colored flag, the flag of the National Socialist movement with the sign of the swastika at the center.[40] Schmitt added a warning to Jews, because the Führer had already indicated that if the current measures did not lead to the desired results a reexamination would be in order that might bring about a law assigning the solution of this problem to the party.[41]

On October 15, 1936, Schmitt published his concluding remarks at the congress of German law professors that he had convened, "Die deutsche Rechtswissenschaft im Kampf gegen den jüdischen Geist" (German legal scholarship in the battle against the Jewish spirit).[42] His speech covered the application of "Rassenkunde" (racial science) or "Rassenseelenkunde" (science of the soul of race) to the practical pursuits of law professors, ranging from compiling a bibliography identifying Jewish scholars to eliminating their books from libraries for the benefit of students, who should be guided away from routine dissertation topics that distract them from pursuing new and necessary subjects inspired by current needs of the German people. (A bibliography of works by Jewish legal scholars was indeed assembled and published by Kohlhammer in 1936.)[43] Jewish and non-Jewish legal opinions must never be put on the same level, he argued. A good part of the talk was devoted to the problem of scholarly citations, and Schmitt proposed (in a clear departure from his own practice in the pre-Nazi years) that if Jews had to be cited at all they should always be identified as Jews, since Jews could not be kept from writing in German: "A Jewish author has no authority for us, not even a 'purely scholarly' authority. This statement is the premise for the treatment of the question of quotations. A Jewish author is for us, when he is quoted at all, a Jewish author. The addition of the word 'Jew' is nothing extrinsic, but something essential, since we cannot prevent the Jewish author from employing the German language."[44]

Schmitt then raised the problem of citing half-Jews or scholars who were kin of, or married to, Jews ("jüdisch versippt"), ultimately dismissing his own question as quibbling, which he considered a typically Jewish trait. "The problem of quoting will necessitate the clarification of many detailed questions, e.g. the question of quoting half-Jews, of those related to Jews, etc. Let me warn from the very beginning against putting such marginal and borderline questions into the foreground. . . . It is a particularly typical Jewish technique to distract attention away from the core of the matter to dubious marginal and borderline questions."[45] He rehearsed notions of Jews as parasites, quoted passages from Hitler's *Mein Kampf* approvingly, and exhorted his audience to remember that the Jewish question also had a German side to it, that of a tragic German dependence on Jews. Reflecting on the relationship of Friedrich Engels to Karl Marx, he wrote: "How was it possible that a German man from the valley of the Wupper could be-

come so completely dependent upon the Jew Marx?"[46] It hardly took someone of Schmitt's intelligence to come up with such trite anti-Semitic party-line verbiage, which grotesquely bordered on involuntary parody. One can probably agree with Reinhard Mehring that this stage in Schmitt's intellectual development has cast a permanent shadow over his work.[47]

Was Schmitt's excessive anti-Semitism a reaction to his fear of having enemies within the Nazi hierarchy, especially the SS? Did he want to compensate for criticism that had been voiced of him by sounding the shrillest possible anti-Semitic note? A short time after the conference he was publicly humiliated in *Das Schwarze Korps* (The Black Corps), the paper of the SS. Two anonymous articles mocked Schmitt for not having become a Nazi early enough, for having had Jewish friends, and for being consistent only as a Catholic thinker.[48] The secret SS files on Schmitt, mostly from 1936, went further than accusing him of being a mere turncoat and an opportunist.[49] Some letters charged that Schmitt had planned his anti-Jewish-themed law conference in October 1936—by which time the Jewish problem in the legal profession had supposedly already been settled by the removal of Jews from professorships—only to distract attention from the Catholic Church's opposition to National Socialism. The letters also requested that Julius Streicher, editor of the most anti-Semitic Nazi paper, *Der Stürmer*, not attend Schmitt's conference (SD 47–48), although he had been invited. (And indeed, Streicher did cancel his participation and merely sent a telegram with his best wishes for a successful meeting.) The published conference volume, *Das Judentum in der Rechtswissenschaft: 1. Die deutsche Rechtswissenschaft im Kampf gegen den jüdischen Geist*, included Schmitt's own fierce introduction and afterword as well as papers that were presented at the anti-Jewish conference; Schmitt sent the book to Heinrich Himmler, head of the SS, and pointed out the shared, still topical task of purifying the German legal profession from the Jewish spirit (SD 125).[50] Another long letter viewed his interest in international law and his Italian connections as a sly move, permitting him to keep in touch with conservative Catholics; hence this letter proposed prohibiting him from traveling to Italy (SD 112–16). A note questioned whether the letters from Jews that Schmitt claimed to have passed on to the Gestapo actually existed (SD 120).

Other documents from Schmitt's SS file include detailed reports on his lectures, conversations, and publications, the latter with a detailed,

well-researched account of passages in Schmitt's publications that he himself had revised after 1933, eliminating all positive references to Jewish scholars like Erich Kaufmann while leaving intact critical comments on Hans Kelsen—so as to appear more consistently anti-Semitic, and retroactively so (SD 177–80).[51] There is also a letter denouncing Schmitt to Göring and implying that Schmitt should lose his position as Preußischer Staatsrat (SD 142–43). On the other hand, Hans Frank, later Generalgouverneur in occupied Poland, wrote to Gunter d'Alquen, the editor of *Das Schwarze Korps*, urging him to stop the campaign against Schmitt, and a carbon copy of this letter was also sent to Himmler (SD 127–29). Göring criticized d'Alquen in another letter (SD 235), and the case against Schmitt seems to have been settled by early 1937, at which point he had lost some of his political offices though he kept his positions as Preußischer Staatsrat (largely a symbolic title after 1936) and as professor of law at Berlin.

My last example comes from a speech Schmitt gave in 1939, then published and revised several times during the early years of World War II, *Völkerrechtliche Großraumordnung mit Interventionsverbot für raumfremde Mächte* (Spatial Organization in International Law Combined with the Prohibition of Intervention by Other Powers).[52] Inspired by the 1823 Monroe Doctrine—to which Hitler also referred in a speech to the Reichstag on April 28, 1939—Schmitt argued geopolitically for a new spatial world order based on the creation of large power spheres (*Großräume*) that are not political units into which all countries are incorporated (Brazil and Argentina are not part of the United States, for example) but spheres of influence dominated by the most powerful country in each of these areas, with an explicit prohibition of interventions from powers outside a given sphere.[53] Older empires like Britain thought of bodies of water like the Mediterranean as streets or shortcuts connecting isolated territories, whereas for Mussolini's Italy the Mediterranean was its *Lebensraum* and a more organically connected sphere of influence. (Schmitt had once met with Mussolini and also sent Mussolini a copy of *Völkerrechtliche Großraumordnung*.) For the German Reich, which was, unlike universalistic empires, essentially ethnically or folk based (*wesentlich völkisch bestimmt*) the natural spatial sphere of influence was in Europe, especially in the East where a great number of peoples and minorities lived who were—apart from the Jews—not *artfremd* (alien in kind or species, the antonym of *artgleich*) and could thus be considered part of the *Großraum*. The Versailles system of "minori-

ties" had already been overcome in such treaties as the German-Russian border and friendship treaty of September 28, 1939 (following their joint invasion of Poland).[54] It was a treaty that referred to German and Russian "mutual imperial interests" (*beiderseitige Reichsinteressen*) and specifically rejected any interference by third powers, hence adhered to Schmitt's *Großraum* principle. "In our days, 1940," he commented after the division of Poland between Germany and the Soviet Union had been completed, "the new order of space and peoples is beginning to emerge."[55] It was part of a new conceptual order of international law that "takes as its premise the concept of the *Volk* and leaves intact the ordering element implied by the concept of the state but attempts, at the same time, to do justice to today's spatial sense and to the real political living powers; that ordering element can be 'planetary,' i.e. global, without extinguishing states and peoples and without steering—as in the imperialist international law of western democracies—from the unavoidable transcendence of an old concept of the state into a universalist-imperialist world law."[56] Schmitt quoted Anglo-American sources and alluded to the frequently quoted "Jew [Harold] Laski," thus apparently following his own new rule of identifying Jews in citations.[57] And in a seventh section that he added to the fourth edition of the book in 1941, he made his anti-Semitic point more generally, after mentioning a number of scholars, including Georg Simmel and Hans Kelsen: "These Jewish authors have, of course, no more created the extant spatial theory than they have created anything else. Yet they were here, too, an important enzyme in the dissolution of concrete orders determined by space."[58]

Not surprisingly, Schmitt's Nazi publications caught Loewenstein's attention. Loewenstein who, as a Jew, had lost his teaching position in München in 1933, followed the National Socialist legal system and scholarship closely from the safety of the United States where he had managed to emigrate. In the essay "Law in the Third Reich" (published in the *Yale Law Journal*, 1936), Loewenstein commented specifically on Schmitt's "Der Führer schützt das Recht." Loewenstein took exception to Schmitt's justification of the retroactive legislation and of Hitler's "liquidation" of his political enemies: "It means that the 'Führer' and his group are beyond the rule of law, *legibus solutus* in the proper sense of the term. One of the leading jurists of the regime, Dr. [Roland] Freisler, admitted that the action had no basis in written law, and the crown jurist of the Third Reich, Herr

Carl Schmitt, qualified the act as one of 'genuine jurisdiction not subject to justice but supreme justice in itself Law is no longer an objective norm but an emanation of the 'Führer's will.' "[59] Loewenstein believed that "this assertion is tantamount to a blunt denial of the separation of powers and the rule of law" and invoked Montesquieu in his accompanying footnote: "In despotic government, one man alone, without law and without rule, determines everything by his will and by his whims."[60] In this essay, Loewenstein joined other scholars and referred to Schmitt as the "crown jurist of the Third Reich."[61] Commenting in the same article on the Nürnberg racial laws (which Schmitt had praised), Loewenstein also quipped: "Racial intermarriage during the 19th and 20th centuries gave rise to the creation by the National Socialists of a mass of hairsplitting distinctions, which a regime with a greater sense of humor certainly would have called 'talmudical.' "[62]

For Carl Schmitt, the way out of the Weimar crisis was to create a strong, even authoritarian state; for Karl Loewenstein it was to mount a new, better defense of democratic structures against the enemies of democracy. In response to the developments in Germany, and among fascist parties in many countries in interwar Europe more broadly, Loewenstein supported the concept of "militant democracy" that was to have a postwar afterlife in West Germany as "wehrhafte" or "streitbare Demokratie," a democracy strong enough to ban parties whose sole aim was to bring about an end to democracy.[63]

> *Democracy Becomes Militant.* . . . More and more, it has been realized that a political technique can be defeated only on its own plane and by its own devices, that mere acquiescence and optimistic belief in the ultimate victory of the spirit over force only encourages fascism without stabilizing democracy. Since fascism is a technique bolstered up *ex post facto* by ideas, it can be checked only by a similar technique. It took years to break through the democratic misconception that the principal obstacle to defense against fascism is democratic fundamentalism itself. Democracy stands for fundamental rights, for fair play for all opinions, for free speech, assembly, press. How could it address itself to curtailing these without destroying the very basis of its existence and justification? At last, however, legalistic self-complacency and suicidal lethargy gave way to a better grasp of reali-

ties. A closer study of fascist technique led to discovery of the vulnerable spots in the democratic system, and of how to protect them. An elaborate body of anti-fascist legislation was enacted in all democratic countries. The provisions were drafted precisely for checking the particular emotional tactics of fascism.[64]

In "Dictatorship and the German Constitution, 1933–1937," also published in 1937, Loewenstein again briefly criticized Schmitt, as he deplored "the progressive dilution of the bill of rights during the last years of the Republic under the auspices of the versatile Carl Schmitt who served the government of the Republic not less eagerly than the Third Reich."[65] Loewenstein noted that "although it has been repeatedly hinted that a completely new constitutional document will be drawn up which would supersede the Weimar Constitution of August 11, 1918, the plan, if ever seriously contemplated, has not as yet materialized" (537). Whereas Schmitt may have been hopeful at first that he might be the one who would be drawing up such a new constitution, Loewenstein presciently doubted that a new constitution would ever be enacted in Nazi Germany because by its very nature a written constitution "creates subjective rights" and "involves a limitation on sovereignty, which in dictatorial ideology is fundamentally absolute and supreme" (538). "The transformation of parliamentary into presidential government had been possible only by shifting the legislative powers from the Reichstag under the emergency powers of Art. 48" (539), he wrote. Loewenstein considered the *Ermächtigungsgesetz* (the law of empowerment) the "first organic statute of the Third Reich" (541) and found noteworthy that "an intrinsically illegal act is capable of giving birth to a new legal order" (543). And here he did quote Carl Schmitt's *Verfassungslehre*, which had held that a new constitutional order needed to be "submitted to the original power of the entire German nation" (543, Loewenstein adding in the note: "Such, at least, was the opinion of Herr Carl Schmitt and his school who were influential before and after the 'fall of men' [meaning the light-hearted change of colors of former opponents of the regime] in March 1933; see Schmitt, *Verfassungslehre* 92ff., 99, 105 [1928]"). And a later footnote à propos of Hindenburg again blamed Schmitt for being an opportunistic turncoat: "It fits well into the picture of political corruption accompanying the transition from the Republic to the single party state of the National Socialists that he who, by virtue of

his oath, was to be 'the custodian of the constitution,' as Herr Carl Schmitt and others emphasized, became the official 'protector of the Third Reich' immediately after the manipulators of the 'national revolution' had persuaded him to change his colors" (554n60).

Postwar

In 1945, Schmitt's and Loewenstein's fortunes were reversed. In June of that year Schmitt refused to fill in the Fragebogen (the denazification questionnaire) that the first postwar rektor of Berlin University, the philosopher and psychologist Eduard Spranger asked him to complete in order to clear himself.[66] Schmitt lost his professorship and never taught again at a German university after 1945. He wrote, while imprisoned by the military government in 1945–1946, in *Ex Captivitate Salus* (first published in 1950): "I looked at my interrogator and thought: Who are you really to call me into question? Whence your superiority? What is the nature of the power that empowers you to ask me such questions, questions that even call me into question and are therefore in their final effect only snares and traps? . . . I'm curious about the intellectual premises of each allegation, of each and every accusation and accuser. Therefore I amount to neither a good defendant nor a good prosecutor. But I still prefer being a defendant to being a prosecutor . . . I find prosecution even scarier than inquisition. Perhaps that goes back to theological roots for me. For diabolus means accuser."[67] He identified with Tocqueville—not as the political theorist whom Loewenstein praised for his articulation of pluralism—but as someone who wrote from the position as a defeated man (*Besiegter*) and saw so clearly the antagonism of the United States and Russia though both, with their different means, would lead the world to a centralized and democratized stage.[68] Retrospectively he viewed his own career in Berlin of the 1930s in the light of Edgar Allan Poe's "A Descent into the Maelström" (1841): "A maelström dropped us off here. Berlin became our fate, and we, its victims, became Berlin's fate."[69] In hindsight Schmitt, whose writings of the 1930s had vociferously participated in the radicalization of Nazi ideology, perceived himself as part of an unexplained "we," as a victim who was dropped by quasi-natural forces into the vortex of Nazi Berlin.

Loewenstein returned to Germany as legal adviser to the American military government, and apparently at his suggestion, Schmitt was arrested on

September 26, 1945, and held at the interrogation center Berlin-Wannsee.[70] (It was a few days later that Loewenstein went to see the collection of books in Schmitt's house, which had been turned into a lending library for scholars. Loewenstein took along a copy of Schmitt's *Völkerrechtliche Großraumordnung* and of "Der Führer schützt das Recht" and recommended that Schmitt's library be impounded and made available to military intelligence; on October 16, 1945 the Office of the Director of Intelligence did, indeed, order the confiscation of the books.)[71] Schmitt's case was cleared by the investigating committee (*Berliner Sicherheits- und Überprüfungsausschuß*) on June 27, 1946, with approval from the American authorities forthcoming on August 2, 1946, and he was released on October 10, 1946. On March 17, 1947, the political scientist Ossip K. Flechtheim, a returning emigrant whose dissertation Schmitt may have refused to advise, summoned Schmitt a second time to a hearing at Nürnberg on March 24, where he was then held and interrogated four times by Robert M. W. Kempner (April 3, 11, 21, and 29, 1947) before being released in May.[72]

The dialogues with Kempner suggest Schmitt's efforts to portray himself as someone who, after a brief fling of wishing to defend National Socialism (to which he, however, felt superior), was in fact, only a scientifically working scholar and at times an intellectual adventurer who quickly became suspect to the party and was under public attack and secret surveillance by the SS. Schmitt described his attitude toward the "Jewish question" more ambiguously than Kempner seemed to realize:

> *Kempner:* How did you consider the Jewish question, in general, and how it was treated in the Third Reich?
> *Schmitt:* A great misfortune, from the beginning.[73]

Kempner did not ask back what exactly he meant by "misfortune" and specifically confronted Schmitt only with one direct quote from his Nazi publications:

> *Kempner:* The accused is shown his publication of "Spatial Organization in International Law," 4th edition, and read the following sentence on page 63:
> "These Jewish authors have, of course, no more created the extant spatial theory than they have created anything else. Yet

they were here, too, an important enzyme in the dissolution of concrete orders determined by space."

... Do you deny that this is the purest style of Goebbels? Yes or no?

Schmitt: I deny that it is Goebbels' style in content or form. I would like to stress the need to observe the highly scientific context of this passage. According to its intention, method, and formulation it is purely a diagnosis.[74]

... All I have said, especially this sentence, is by motive and intention meant scientifically, as a scientific theory, which I am ready to defend in front of any forum of academic colleagues in the world.[75]

Apart from insisting on the scholarly nature of his dismissal of Georg Simmel and Hans Kelsen because they were Jewish, Schmitt pointed out more generally: "There is nothing being brought against me other than what I have written."[76] Kempner reminded Schmitt of the consequences that intellectual work can have:

Kempner: You have the blood of an intellectual adventurer?

Schmitt: Yes, that's how thoughts and insights arise. I accept the risks. I always pay my bill. I've never played the one who does not pay what he owes.

Kempner: But if what you call searching for insights ends in the murder of millions of people?

Schmitt: Christianity has also ended in the murder of millions. This you do not know unless you have experienced it yourself. I do not feel like many an insulted innocent man, to whom something terrible has happened.

Kempner: But you can not compare ... [77]

Kempner brought up Schmitt's legal writing from the early Nazi years more generally:

Kempner: Did you not say that German legislation and German jurisdiction have to be filled with the spirit of National Socialist [sic]?

Yes or no?

Did you say that between 1933 and 1936?

Schmitt: Yes. I was Head of the Section from 1935 to 1936. I felt superior at that time. I wanted to give National Socialism a meaning from my own vantage point.[78]

The interrogations ended with Schmitt conceding that he was ashamed to have written such things but did not want to wallow in the fiasco he had experienced.

The transcriptions of these interrogations have been published and would be worth an adaptation as dialogue in a drama, but I would here like to return to one more aspect of the relationship between Schmitt and Loewenstein.

As we have seen, Loewenstein had commented on Schmitt in print in the 1920s and 1930s. When he worked as legal advisor to the military government, he quickly and most actively pursued the case of Carl Schmitt. On August 14, 1945, he "wrote [a] memo on the arrest of Carl Schmitt," according to his office diary, and Loewenstein's private diary on August 16, written at Max Eyth-Str. 32, his Dahlem residence, in partly hard-to-decipher shorthand also appears to contain the words "Col MacLendon Zur Public Safety. Carl Schmitt verhaften Schlachtensee."[79] In his memorandum on Schmitt, Loewenstein viewed him as what one could call an armchair perpetrator, or *Schreibtischtäter*, and therefore wanted him sued as a war criminal—which neither the military government nor the Nürnberg tribunal was ready to do. Can a mere intellectual be considered a war criminal? On August 15, Loewenstein entered into his office diary, "Tried in vain to get procedure in motion to have Carl Schmitt arrested," and on August 16, Loewenstein reports a meeting at the Public Safety Division in Berlin at Boltzmannstraße 20: "Talk with Cpt. Hess (apparently former German, well informed) Major Wynie (?), uninterested. He will go into the matter and if Schmitt appears to make trouble for the occupation 'we will arrest him for you'; I countered 'You need not arrest him for me, but for the de-nazification of Germany.' "[80] At the same time, Loewenstein also confronted the dilemmas of denazification as a central ingredient of reeducation more generally and made various recommendations on how to move forward in the process toward reestablishing democracy in Germany. He was, for example,

worried that too much denazification could touch the Weimar constitution, an outright repeal of which would be ill advised.[81]

On November 9, 1945, his fifty-fourth birthday and about six weeks after Schmitt's first American arrest, Loewenstein was hard at work finalizing his memorandum, "Observations on Personality and Work of Professor Carl Schmitt" (see the reproduction at the beginning of this chapter).[82] Dated November 14, 1945, its final version was written on an umlaut-less American typewriter, apparently in response to a request made by Schmitt's Serbian-born wife, Duschka, and by his former student Hans Schneider that the impounded library be returned. (Duschka Schmitt reportedly also spoke with Loewenstein on November 19 about her husband's case.) Loewenstein claimed "about thirty years close familiarity with Dr. Schmitt's career, personality and work" and wrote what sounds at first like a letter of recommendation. He called Schmitt "the foremost German political scientist and one of the most eminent political writers of our time," "a man of near-genius rating," "one of those rare scholars who combine learning with imagination," and so forth. But the countermovement appeared quickly in that, unlike Harold Laski, "the literary protagonist of democracy," Schmitt "has become the leading authority on authoritarian government and totalitarianism" and in that Schmitt "abused his gifts for evil purposes." Loewenstein applauded Schmitt for his "constructive criticism" of the defects of Weimar's political structure, and singled out for praise Schmitt's *Verfassungslehre*, the very book that Loewenstein would not mention in his own *Verfassungslehre* a decade later. "It is to his credit to have discovered much earlier than most of his colleagues the dangers inherent in article 48 of the Weimar constitution emergency power of the Reichspraesident . . . which later led to the overthrow, by legal methods, of the Weimar Republic by Hitler." Loewenstein also quoted Schmitt's perhaps most famous sentence, "Sovereignty rests with who controls emergency powers" (*Souveraen ist, wer ueber den Ausnahmezustand gebietet*).[83]

Yet Loewenstein deplored that Schmitt's "authoritarian predilections" prevailed, and he mentioned that Schmitt had turned away from Catholicism after being denied an annulment of his first marriage and had become a free thinker yet embraced and helped to popularize the nineteenth-century Spanish bishop Doñoso Cortes, "one of the great forerunners of fascism, Nazism and Spanish falangism." And Schmitt's "insistence on the use of

emergency powers by a government preluded the turn he took upon the advent of Hitlerism in 1933." Soon after the election of March 5, 1933, when the Nazi Party obtained power to make regional and national appointments, Schmitt revealed himself "an ardent supporter of Hitler's dictatorship which seemed to him the fulfillment and climax of his intellectual desires."[84]

Loewenstein suggested that a complete bibliography be assembled of Schmitt's writings since 1933 (hence also his interest in confiscating and examining Schmitt's library) and then offered very detailed comments on the two essays from the period that he had taken along from the inspection of the library. He characterized "The Führer Protects the Law" correctly as "a glowing defense of Hitler's assassination" of countless victims "who were put to death without indictment and trial." Schmitt's printed words, Loewenstein was convinced, really helped to support the regime, and "many lawyers in foreign countries were led to believe in the justice of Hitler's act because an eminent legal authority had defended him." And Schmitt's essay, "entitled (somewhat cumbrously)" "Spatial organization in international law combined with the prohibition of intervention by other powers" (in Loewenstein's translation), "defends the aggrandizement of Germany at the expense of weaker powers in a pseudo-scientific and superficially rather convincing way," and advocates "the 'right' of the German nation to impose on other peoples its form of life and government in the interest of large-scale spatial planning."[85] Schmitt's international reputation—that his wife had invoked to secure his release—was what made his case even more worrisome to Loewenstein because Schmitt's *Verfassungslehre* had become a standard textbook in Latin American law schools, and his writings have had a lasting influence on falangists and authoritarians in Spain and elsewhere.

Hence Loewenstein concluded his memorandum with the urgent plea to keep Schmitt under arrest, for his release "would constitute a blow to incipient democracy in Germany and to public opinion abroad" and would be considered by those with authoritarian leanings elsewhere "a victory of Nazism over Military Government."[86] (The fact that Schmitt had eliminated any positive references to Jewish scholars in Nazi-era republications of his earlier works of which Schmitt's SS surveillance file had kept such meticulous track appears not to have been noticed by Loewenstein or by Kempner.) This document was meant to support Loewenstein's argument that he had made a month earlier in "Library of Professor Carl Schmitt" that "Schmitt qualifies as a war criminal. He is one of the intellectual

instigators of Hitler's acts of aggression and aided and abetted them by his influential authorship." Hence Loewenstein concluded that this case should "be submitted to the War Criminals Commission for further action."[87] But while Schmitt remained under arrest for more than a year, no trial ever emerged: the concept of war crimes was narrowly drawn and included only a small group of politicians, industrialists, and criminal perpetrators.[88]

Although Schmitt was denied most visiting rights and had difficulties accessing paper while under arrest, he wrote many, many manuscript pages in the immediate postwar period that were later published by him in *Ex Captivitate Salus* and posthumously in *Glossarium*. Schmitt thought that the occupation was "not a permanent status" and quipped: "The victor in a just war makes a judge of himself."[89] Schmitt warned of idealizing democracy, later mocked West Germany's constitution, the *Grundgesetz*, for veiling the lack of German sovereignty due to military occupation and absence of a peace treaty, was uninterested in the DDR (as was Loewenstein), and referred to the federal republic sarcastically as "Persilien," alluding to the whitewashing letters used in denazification hearings named after the detergent Persil.[90]

Indirectly recanting his 1935 endorsement of murderous state violence in "Der Führer schützt das Recht," Schmitt was now unambiguous in condemning the inhumane cruelties through which perpetrators made themselves "outlaws":

> The *atrocities* [he uses the English word] in the special sense, which were committed before the last World War and during the war, must indeed be considered "mala in se." Their inhumanity is so immense and so evident that it suffices to determine the facts and the perpetrators in order to have cause for criminality regardless of positive penal codes. Here all arguments of natural perception, human feeling, reason, and justice coalesce in such an elementary manner as to justify a verdict of guilty that needs no positive norm in any formal sense. There is also no need to ask to what extent the perpetrators had a *criminal intent* [he uses the English word]. All of this is self-evident. He who raises the objection of the "nullum crimen" in the face of such crimes and points to the extant penal code would put himself in a questionable light.[91]

He now again modified his friend-enemy antagonism and arrived repeatedly at a new, less well-known formula adapted from a poem by Theodor Däubler: "The enemy is an embodiment of our own question." It comes from a "Song to Palermo" of 1919. Stimulated by the view of the coffinlike Mount Pellegrino, the poet addresses his strange hymn to the varied history of Sicily, imagined in a mating of the victorious Moors with the feminine land from which the land yet emerges as winner. The arrival of the freedom-loving Normans who chase away the Moors leads to a long sensuous apostrophe to Sicily that includes the line to which Schmitt was drawn, "Der Feind ist unsre eigne Frage als Gestalt."[92]

Schmitt refused to look back at his own complicity or to apologize for his highly visible public support of anti-Semitic measures and his private termination of any contact with Jews like his long-time editor Ludwig Feuchtwanger (who asked his author for help in letters Schmitt did not bother to answer after 1933).[93] Schmitt also never mentioned his reaction to first finding out about those atrocities he mentioned—though on October 27, 1947, he did respond to the atomic bomb: "Aggressor is he who drops the first atomic bomb. Duty to wait with the dropping of the first atomic bomb; that is the 'juridical' solution of the problem."[94]

He continued on an anti-Semitic note in the postwar years and defined himself in opposition to the Jewish spirit: "For Jews always remain Jews. Whereas communists can improve themselves and change. That has nothing to do with Nordic race etc. Precisely the assimilated Jew is the real enemy. It serves no purpose to show that the Protocols of the Elders of Zion were false."[95] At this moment his postwar recognition that "the enemy is an embodiment of our own question" (which came from a rather odd source in the first place) seemed to have been forgotten again.

In a sarcastic note of August 17, 1949, published only posthumously, Schmitt mentioned Loewenstein by name, twice, in fact:

So there is now a powerful empire in America, which occupies and dominates us in Europe. I have had some doings with the power of the mighty American empire as a member of occupied, dominated, and totally defeated Germany. I was arrested, they have taken away my most intimate property, my library, they put me in a cell with criminal offenders, in short, I have fallen into the hands of this mighty American empire. I was curious about my new masters. But I

have up to today, for 5 years, never spoken to an American, but always only with German Jews, with Mr. Löwenstein, Flechtheim and the like, who certainly were not new to me, but whom I have known well for a long time. A strange master of the world, this poor Yankee, so fashionably modern with his ancient Jews. I have had dealings with neither Indians nor Puritans, nor with Mexicans nor Aztecs nor Incas: always only with German or Austrian Jews. Quaint masters of the world. Global security forces à la Truman and Roosevelt. Morgenthau—Löwenstein—Ebenstein.

I am disgusted by a world made by people for people.[96]

Schmitt's private invective confirms the sense that he did talk with Loewenstein, too, though neither chose to write more about their encounter, or reencounter. This note suggests that Schmitt at this point saw himself as an "anti-Loewenstein" and that he viewed Loewenstein as an embodiment of the Old World Jew. Perhaps there was also a faint memory of a deeper animosity that was apparent in Schmitt's 1933 dream of a lion getting angry at him for having called him a lion, the dream that Schmitt associated with Loewenstein.

Loewenstein's concern with Schmitt was not only a personal matter but also part of his multiyear exploration, as advisor to the Legal Division, the Justice Ministry Branch, and the Reorientation Program of the Military Government, of the best possible procedures to criminalize those Nazis really responsible—which was a problem of unmanageable magnitude. "In the American Zone, 3,623,112 persons were deemed subject to the Law for Liberation. The denazification courts handled 950,126 of these cases; the public prosecutor . . . suspended the rest without charges. 2,504,686 were amnestied."[97] This reflects the state of affairs as of August 31, 1949, and in the American zone alone. Loewenstein was aware of the paradox of democratic reeducation through the route of compulsory denazification under military supervision. The "Military Government finds itself on the horns of a dilemma," he wrote in a memorandum of September 14, 1945. "Either it has to confine itself to appointing to office non-Nazis—which is tantamount to paralyzing the administration of justice,—or it has to resolve to use the services of former party members for the bench and in administrative agencies."[98] The second possibility seemed the only realistic one, but it meant that bad Nazis had to be weeded out from good ones.

Loewenstein tirelessly weighed the advantages and disadvantages of the "vintage" method for denazification (differentiating nominal party members by the date on which they had joined the party) against other ways of separating the most active "*Partei*-Genossen" (party comrades) from mere "*Kartei*-Genossen" (nominal file-card members)—even though he himself was skeptical of that distinction.[99] He recognized that denazification was not popular and quoted a Bremen lawyer who told him: "The categories established are formalistic; the practices are unfair and in conflict with the principles of justice and due process; they are reminiscent of the Gestapo, particularly in fact that the procedure, on the basis of the inadequate Fragebogen is secret and that no hearing is permitted."[100] Loewenstein also wondered publicly whether the famous Fragebogen were really that helpful in the process, especially when it came to the legal profession:

A special *Fragebogen* exists for the legal profession. Intended to draw an exhaustive portrait of the professional and political personality, it contains some 200 detailed questions, covering education, career, and political affiliation. The experienced official could by scanning the *Fragebogen* evaluate it on sight, almost with the facility of the musician reading a musical score.

This questionnaire approach has proved plainly unsuited to the appraisal of moral or intellectual attitudes. The *Fragebogen* is little more than an accumulation of elementary facts, at best helpful only in weeding out tangibly Nazi-tainted men. It never revealed, in the case of a judge with an impeccable paper record, how he had behaved in office, in what decisions he had participated, whether his opinions reflected subservience to the regime; or in the case of a practicing attorney, whether the Nazi bosses were among his clients, or whether he had appeared before the party courts (which decent lawyers refused to do). It goes without saying, however, that no substantial scrutiny by overworked and unsophisticated AMG [American Military Government] officials was physically possible.[101]

Loewenstein predicted that a long state of legislative and political tutelage would be necessary to accompany the reeducation efforts in which he also engaged, familiarizing ordinary Germans as well as educators with

democratic techniques in public lectures and a little handbook on the American Constitution, for example. Looking back, he found that the technique of legislative tutelage "had its full share in the 'reeducation' process by which the Germans became capable of assuming the parliamentary responsibilities cast upon them by the new constitutions."[102] In his office diary he often sounded desperate, and in his personal letters he remained skeptical of the future.

Despite Carl Schmitt's arrests and interrogations, Loewenstein's efforts to have Schmitt tried came to nothing. The Wiener Library head note to the SS file on Schmitt puts it well: "He remained a controversial figure, having never been formally charged with complicity with the Nazi regime, nor ever exonerated."[103]

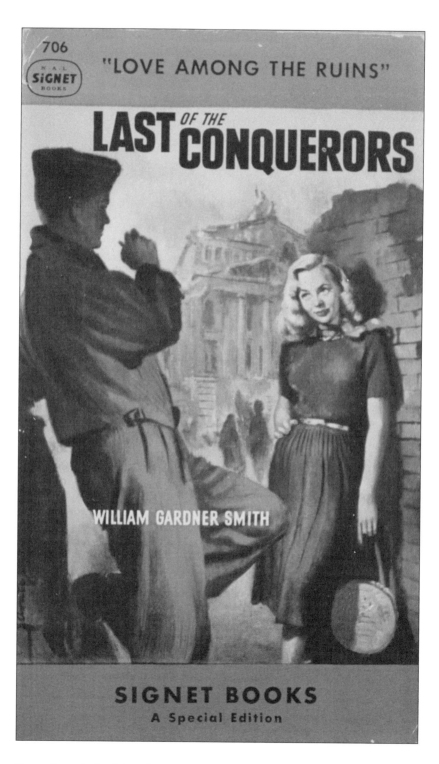

Cover of paperback edition of *Last of the Conquerors*.

January 8, 1946

William Gardner Smith is inducted into the U.S. Army and sent to Germany, from where he writes reports for the Pittsburgh Courier, *and begins his career as novelist and essayist.*

Are You Occupied Territory?

Black G.I.s in Fiction of the Occupation

> It is good I gave glory, it is good I put gold on their name.
> Or there would have been spikes in the afterward hands.
> But let us speak only of my success and the pictures in the
> Caucasian dailies
> As well as the Negro weeklies. For I am a gem.
> (They are not concerned that it was hardly The Enemy my fight
> was against
> But them.)
>
> — Gwendolyn Brooks, "Negro Hero"

The paradox did not go unnoticed: a racist dictatorship was conquered by a foreign army that had as one of its goals the eradication of racism among the defeated—while the victorious army itself was racially segregated. "How wrong was the Führer in his hatred of the Jews," the African American journalist Roi Ottley, a war correspondent for the important Negro weekly *The Pittsburgh Courier*, reported Germans as asking, "when your white Americans encourage us to hate the blacks?" Hence Ottley pointed out in 1951 that Germans "recognize the indecent inconsistency in a Jim Crow army occupying the Third Reich of Hitler."[1]

Similarly, Edith S. Sampson, a member of the U.S. delegation to the United Nations traveling in Germany, found that "German civilians frequently commented on the contrasts between our democratic pretensions

and our practice of segregation in the occupation forces. They often asked me to explain this contradiction. It was obvious to me that our chief objective, which is to cultivate a democratic spirit in Germany, is definitely handicapped by the continuation of segregation and discrimination. This gives the Germans who are not yet cured of Anti-Semitism a feeling of justification."[2] Racial separation was the norm in the U.S. Army, with blacks having positions inferior to those of whites. German prisoners of war—there were over 340,000 of them in the United States by 1945, two thirds of them in the South—had noticed that they were given privileges that their black guards did not enjoy, a fact Nazi propaganda exploited during the war.[3] Black soldiers did not hold ranks of authority, black units generally were led by white officers, and blacks were heavily concentrated in menial positions as drivers, workers, cooks, and service personnel. In 1945 nearly half of the U.S. soldiers in the Quartermaster Corps and one third of those serving in the Transportation Corps were African Americans. In the same year three-quarters of all black soldiers were in the Service Forces.[4] It is because of these proportions and the restrictions that they reflect that photographs of black army cooks and of African Americans driving jeeps and trucks became iconic images of the end of World War II and of the occupation. [*I saw so many black military truck and jeep drivers as a child that I can hardly recall any other American vehicle operators.*] Also popular were photographs of black soldiers playing jazz or amusing themselves in segregated bars. Racial segregation was taken to its extreme with the American Red Cross's segregated blood banks for blacks and whites.[5]

President Harry S Truman began the initiative for desegregating the American armed forces in 1946, but it only got underway during the Korean War. His Executive Order 9808 of December 5, 1946, established a committee on civil rights that in October 1947 issued the report *To Secure These Rights;* in the spirit of that report, Truman's Executive Order 9981 of July 26, 1948, provided for the integration of the military, but it was not immediately made a reality.[6] General Omar N. Bradley opposed Truman's order, the *New York Times* supported Bradley's views, and in 1948 Eisenhower testified before the Senate Armed Services Committee in favor of continuing segregation at the platoon level.[7] By 1952, only 7 percent of black American soldiers in Europe were serving in integrated units.[8]

The stationing of a very large number of African American soldiers outside the United States after World War II (an average of 50,000 blacks in a total of about 400,000 G.I.s in Europe in the year 1946, for example) may thus have seemed to black G.I.s like a vast social science experiment, with the black soldiers themselves in the midst of it.[9] Many of them supported the drive that the *Pittsburgh Courier* had started in 1942—and that traveled under the name "Double V campaign" with the memorable slogan, "Victory for Democracy at Home and Abroad."[10] Holding up both hands and letting one's fingers form a double V became *the* African American gesture in support of the war and in opposition to segregation.

The G.I.s found themselves victors, conquerors in thoroughly destroyed cityscapes. In Nürnberg, some black military policemen were deployed as highly visible guards of war criminals like Otto Ohlendorf, who led the Einsatzgruppe D and was directly responsible for the murders of approximately ninety thousand Jews and commissars in the Soviet Union from 1941 to 1942 and who was tried and sentenced in the 1947 Einsatzgruppen trial and hanged in Nürnberg in 1951. The Army Signal Corps photograph that portrays Ohlendorf standing between two tall African American guards as he receives his death sentence under the clock in the Nürnberg courtroom may have reminded viewers of the contrast between American democracy and Nazi horrors.

The public display of Nazi atrocities in 1945 and at the Nürnberg tribunal also did much to intensify the campaign for black civil rights in the United States. Thus when "bigger-than-life" photographs of the horrors of Buchenwald and other camps were shown to audiences in Missouri, the *Chicago Defender* reported that the residents of Sikeston wondered whether that display would remind local whites of the brutal 1942 lynching there of Cleo Wright.[11] For African American intellectuals, the Nürnberg trials provided a new opportunity to seek international help in their struggle against continuing discrimination, racial violence, de jure segregation, and long-standing inequality. As early as January 19, 1946, the satirical novelist and editor George S. Schuyler commented in his editorial column "Views and Reviews" in the *Pittsburgh Courier*: "This seems to be open season for war criminals. Some small fry and Axis stooges have been officially strangled in Germany, England, the Philippines, Japan and other places. . . . The Nurnberg show is scheduled to continue for eight or nine more weeks before Goering and company are found guilty of everything

in the book and doubtless sentenced to be hanged. The only war criminals that have not been indicted and grabbed are those on the Allied side and the Italian thugs" (7).[12] His column then turned to the Italian war crimes against Ethiopia, but soon others picked up his argument and applied it to the United States.

For example, the National Negro Congress was encouraged by Justice Robert H. Jackson's opening speech at the Nürnberg trials to submit the case of 13 million "oppressed black human beings to the United Nations in a plea for justice." "For the mad brutality of the Nazis, America has substituted a calculated technique of persistent oppression and humiliation designed to create in the Negro a slave mentality to replace the actual shackles of servitude. As a substitute for mass murder, we have achieved a series of erratically timed violent injustices and occasional mob murder designed to make the Negro a neurotic personality living in timidity and terror."[13] In a *Chicago Defender* column of September 7, 1946, John Robert Badger quoted Justice Jackson and requested that his Nürnberg principles be applied at home. Badger asked, after mentioning the slave trade, massacres of Indian aborigines, and Herero wars: "What, indeed, about the present oppression of Negro Americans?" Badger gleefully imagined a tribunal of U.S. politicians based on Nürnberg precedent with death sentences for southern segregationist governors Eugene Talmadge and Theodore G. Bilbo.[14]

On October 19, 1946, Roi Ottley followed suit in the *Pittsburgh Courier* and translated the "Nürnberg principle" into American terms, focusing especially on the notion of shared culpability, so that "today the North is responsible for the lynchings in the South. Moreover it means that no white person in America can reject responsibility for Tennessee or Georgia." Ottley focused especially on the category of "Crimes Against Humanity" and concluded that the newly established "principle of collective guilt can now be applied to the American scene."[15]

Inspired and drafted by W. E. B. Du Bois, a detailed petition to the Commission on Human Rights of the United Nations, titled "Appeal to the World: A Statement on the Denial of Human Rights to Minorities," was submitted to that commission in 1947 by Walter White in the name of the NAACP and other civil rights organizations.[16] At the end of a thorough historical survey, written by various scholars, culminating in a detailed account of lynchings, other forms of antiblack violence, and legal

discrimination, the petition summary, written by Du Bois, appealed to the "United Nations through the world court to take the protection of such deliberately unprotected citizens [American Negroes] under international jurisdiction and control." Du Bois continued: "We appeal to the world to witness that the attitude of America toward American Negroes is far more dangerous to mankind than the Atom bomb; and far, far more clamorous for attention than disarmament or treaty." The petition concludes in the highest rhetorical register: "Therefore, People of the World, we American Negroes appeal to you; our treatment in America is not merely an internal question of the United States. It is a basic problem of humanity; of democracy; of discrimination because of race and color; and as such it demands your attention and action. No nation is so great that the world can afford to let it continue to be deliberately unjust, cruel and unfair toward its own citizens."[17]

According to Gunnar Myrdal's influential study *An American Dilemma* (1944), white American attitudes in the mid-1940s rested on the concern for "race purity" with its primary command to prevent amalgamation, and on the rejection of "social equality" in any form of racial mingling and especially in interracial sex and marriage, which were prohibited in thirty of the forty-eight states, among them all Southern states, where the majority of black Americans resided.[18] It was believed that segregation would have to be maintained in all social, political, and legal aspects in order to prevent the clear public danger of intermarriage because what Myrdal called the "anti-amalgamation maxim" was "the keystone in the white man's structure of race prejudice" and "the end for which the other restrictions are arranged as means."[19]

The occupation of Germany put into sharp focus the cognitive dissonance, or what Roi Ottley called the "indecent inconsistency," between American democratic aspirations and Jim Crow rule. According to Maria Höhn and Martin Klimke, the black soldiers' reports from occupied Germany "allowed African Americans in the United States to imagine a space where the freedom and equality denied them in their own country became possible" and made white Americans increasingly aware "that their country's mission in postwar Germany made them vulnerable to charges of hypocrisy." Hence the occupation "revealed the contradictions between America's ideals and the reality of life for African Americans" so that "postwar Germany emerged as an unexpected site for advancing the civil rights

cause."[20] And as has become apparent, most especially in Roi Ottley's argument, the notion of "collective guilt" proved useful to African American intellectuals who could apply it to put white America on the defensive, provoking new, distinctly postwar protestations of racial innocence.

The black soldiers who were stationed in Germany also confronted German racial attitudes that were deeply affected by twelve years of Nazi rule, which had included the advocacy of racial purity, the banning and criminalization as *"Rassenschande"* (racial shame) of interracial ("Aryan"-Jewish) sex and marriage in the Nürnberg laws (so emphatically first asked for, and then endorsed, by Carl Schmitt) and relentlessly racist propaganda, especially against Jews but also against other "non-Aryans."[21] A military government opinion survey taken in Germany in April 1946 showed that about a third of the respondents still expressed openly racist attitudes toward Jews and only a slightly smaller number toward blacks.[22] As late as 1951, though more than half of German respondents to a once-classified survey said they would be willing to invite western Allied soldiers into their homes, the numbers dropped by about half when it came to Negro soldiers, with the majority declaring themselves unwilling to do so.[23]

Against this background, how were interracial couples, how were the children of black soldiers and German women viewed and represented in the postwar years? What were the preferred images and story lines for imagining black G.I.s in postwar Germany in selected examples of literature, scholarship, and journalism? Since the end of the war in Europe marked only one "victory," that over fascism and tyranny abroad, around which issues did the struggle for the second "V," that over segregation at home and in the army, develop and gain urgency? Was antiblack racism put into any context with anti-Semitic racism in the years immediately after the Holocaust? A variety of sources, most centrally American and German fiction of the period, can provide us with some answers to these questions, with characters, settings, and plotlines from a variety of viewpoints, thus conveying some inwardness and depth to individual experience in this large-scale social experiment.

Last of the Conquerors

Born in Philadelphia in 1927, William Gardner Smith went to the Benjamin Franklin High School, was an avid reader of Ernest Hemingway and

Richard Wright, perhaps also of Gertrude Stein and William Faulkner, and knew early on that he wanted to become a writer. After graduating at the top of his class, and beginning to work as a reporter for the Philadelphia office of the *Pittsburgh Courier*, he was drafted in 1946 and, after basic training, sent to Europe; he was assigned to work as clerk-typist for the 661st Truck Company in Berlin, where he also was in charge of the motor pool. He continued to write for the newspaper until he was honorably discharged in February 1947. During the voyage that took him back to America he started writing a novel, and he enrolled at Temple University on the G.I. bill. Farrar, Straus accepted the manuscript of the novel for publication, and Smith's book appeared in print on August 17, 1948, under the title *Last of the Conquerors*. He published three more novels and a nonfiction book and settled as an expatriate in Paris, where he died of cancer in 1974.[24]

Published to positive reviews, *Last of the Conquerors* draws on Smith's own experiences and incorporates some of his reportage confronting the race problem in the U.S. Army.[25] The hero and narrator is the young Pennsylvanian African American G.I. Hayes Dawkins who in his civilian life worked in a photographic studio. He is now stationed, soon after the end of the war, first in Berlin, where he is with a quartermaster unit and then near Heidelberg, in the transportation corps. In Berlin he falls in love with the twenty-four-year-old German secretary Ilse Mueller, and their idealized romance lasts through the entire novel. One of the early utopian moments occurs when Hayes and Ilse go swimming at Wannsee beach and Hayes feels free from the racial burden of his American upbringing: "I had lain on the beach many times, but never before with a white girl. A white girl. Here, away from the thought of differences for a while, it was odd how quickly I forgot it. It had lost importance. Everyone was blue or green or red. No one stared as we lay on the beach together, our skins contrasting but our hearts beating identically and both with noses in the center of our faces. Odd, it seemed to me, that here, in the land of hate, I should find this one all-important phase of democracy. And suddenly I felt bitter" (44). American racial segregation had made mixed bathing a rarity; in fact, in 1947 Chicago A.M.E. Zion Bishop William J. Walls criticized the U.S. Army in Berlin for permitting the use of the swimming pool at Andrews Barracks to Negroes and whites only on separate days, and he reported that the pool would always be "drained after

Negro troops swim in it."[26] [*This detail had a particular resonance for me because as a German student at the Freie Universität Berlin in the 1960s, I was given access in Andrews Barracks to this huge marble swimming pool that had its SS past written all over it, though I had no inkling of the pool's postwar segregationist restrictions.*] Because of the rarity of mixed bathing in the United States, European bathing scenes like the one Smith describes were newsworthy in the black press, and photographs of them appeared in *Ebony* and in the *Baltimore Afro-American, Ebony* adding more spice to the image with its caption, "Nudism, widely practiced in Germany, is totally absent at Wannseebeach."[27]

Hayes Dawkins is strategically placed among other African American soldiers who represent a broad spectrum of individual traits and racial attitudes. There is, for example, the New Yorker Randy, who was injured in the Battle of the Bulge, hates Germans and says that quite openly in the faces of three German girls with whom the black soldiers are drinking in a bar: "You're all the same. All of you. The same people we're sittin' with tonight is the ones that burned people in them camps and punched Jews in the nose," he tells them, laughingly. A blonde girl responds softly: "I know that it was very bad what the Germans did to the Jews. But every German did not do it. Not every one. Many, but not all." "The hell with that," Randy dismisses her objection. "All of you are the same. Every damn one of you." Now another German girl, "the angry one," challenges Randy sarcastically: "How can you talk? What about the white Americans? In your country you may not walk down the street with a white woman. The white Americans hang you from trees if you do" (35). Randy slaps her in the face, but she just laughs at him.

Whereas Randy seems relatively hopeful about America, Austin Holmone, nicknamed "Homo," is deeply disaffected with the United States and ultimately defects to the Russian zone with the intention of staying in Europe (107–8). The somewhat Puritanical Chuck Henry, who is called "Professor" and who, like Smith, was a reporter for the *Pittsburgh Courier* before getting drafted, reminds the others that imagining a better world at home in America is nothing but a fantasy. For Hayes this is quite literally the case: The made-up American-dream stories of life at home that Hayes tells Ilse clash with Smith's grimmer representation of Hayes's dingy Philadelphia neighborhood with dirt and rodents, rendered in interior monologues that are italicized in the book (73–81).

Hayes's own initial prejudices against Germans dwindle as he observes how surprisingly accepting Germans are of blacks. This is especially true of the German women who work and readily socialize with the black soldiers in the quartermaster unit. And here the novel reveals one of the many ironies of the segregated army—that black soldiers, because they labored in all-black quartermaster units, worked directly with German women and had access to food supplies, the most desirable black market commodity, and that those working in motor pools had more mobility than other G.I.s. Hence segregation may actually have facilitated fraternization with foreign women for black soldiers.

Hayes meets one of Ilse's neighbors, who has adopted "Sonny," the four-year-old son of a German woman and a black G.I. The sense of time is somewhat problematic here, as the novel suggests 1946 as setting, and it was published in 1948—in either case, too soon after the war to account for a four-year-old *Besatzungskind*.[28] (Perhaps this subplot substituted for a possible family story between Hayes and Ilse that Smith ultimately decided not to write.) Hayes finds that Sonny is a close friend of a neighbor's child in Berlin (91), and he also learns that about two hundred Negroes lived in Berlin through the entire Nazi period. The *Pittsburgh Courier* showed much interest in stories of black people who had lived in Nazi Germany, and it published not only a William Gardner Smith story about Madeline Guber Goodwin, one such woman in Berlin, but also a serialized autobiography by Martha Stark, a black woman from Nürnberg.[29]

In *Last of The Conquerors* Ilse and Hayes often go to see operas, a form of entertainment Hayes has not known in America but nevertheless learns to appreciate; once they also hear a concert directed by African American expatriate conductor Dean Dixon (57–58). Soon Hayes feels completely at home with Ilse, her uncle, and her aunt—even though he harbors no hope for a democratic future of "*the* German," whom he sees as unpolitical and deferential: "I knew . . . that he would never show enough interest to make a democracy work" (59). As cited earlier, the Professor also thinks that the occupation is "failing miserably," for "we have not succeeded in interesting the German people in such democratic institutions as elections, political parties, and the like. We have not to any noticeable extent changed their way of thinking. They are still the same people they were when our troops first crossed the Elbe" (104). The failure of the occupation that the novel anticipates is also due to American hypocrisy; Hayes contemplates

writing a book that will tell "how the Germans listen attentively to speeches on democracy and then look around at the segregated camps and race riots over white women and listen to the slurs on Negro soldiers on the streets, and then how the Germans in the coffee houses along the Hauptstrasse and Berlinerstrasse gather and laugh at the Americans who preach a sermon on what they, themselves, do not yet know" (141). A German character who was a prisoner of war at Camp Lee, Virginia, tells Hayes that in America "they do almost the same thing with your people—the black Americans—as the Nazis did here with the Jews" and reports how when he was a prisoner "sometimes a black soldier would come to guard us. At time to eat the soldiers would take us to a restaurant. But you know what? We could eat in the restaurant, but the soldiers could not. Because they were black. The prisoners could eat but they would not serve the guards. Back in the camp the German soldiers laughed about that. It was very funny" (165).

The novel does not miss an opportunity to put to shame the self-congratulatory language of the conquerors and to raise a question about what seemed at the beginning "this great adventure . . . , this occupation duty" (14). In fact, the metaphor of military occupation seems most apt as a pick-up line to German girls: "Are you occupied territory?" Hayes thus asks the girl Anna-Liza when he is really drunk (147).

Smith focuses on many telling aspects of the postwar moment. The narrator notices the mountains of rubble that Germans work to clear like Lilliputians (18), and the Professor has the eerie feeling that one can still sense the bodies buried underneath. Ilse gives Hayes a laconic account of her own sad past, her thwarted attempts to find happiness, expressed in deliberately simple vocabulary:

> First I was a child and I was happy a little but not much because always I did think of love and to be married and so I could not be happy until that happened. Then there was the war and I was not happy that my brother had to go to the war. Then I was married and I did not love my husband and so I had a divorce. Then the bombs did fall on Berlin and my home was hit by the fire bombs and I did stand outside of my house and look at the fire and cry and my mother did cry and everything did burn, everything, everything. Then the Russians did come to Berlin and that was more bad than the bombs and I was

afraid to go on the street and they did come one day to my house, three of them, and my father was there and he did beg the Russian soldiers to leave me alone and they did laugh at him and throw me on the bed and do things to me. Now I do not think I will ever be happy. (46)

"I did not say anything," is Dawkins's response to Ilse's account, not only of the bombing but also of her rape by Russian soldiers.[30] Smith intersperses his paratactic and Hemingwayesque prose (that also sounds a bit like Gertrude Stein) with obvious translations from German ("Have you enough pillows?") and with countless italicized German words and phrases like *Straßenbahn* (streetcar), *schwarzer Liebling* (black darling), and *Was soll es heute sein?* (what would you like to have today?) as well as with dozens of American acronyms of the occupation era (USFET, RTO, ETO, PX, etc.).[31] One character reads *Die Neue Zeitung*, the German-language newspaper issued by the military government.

There are references to D.P.s, the universal presence of cigarettes, and American popular culture. Hayes and Ilse pass "the Polish Displaced Persons Camp" and look "at the black-clad Poles," but no further interaction occurs (170). Later they walk by "an internment camp for Germans, guarded by Poles," and Hayes's wave to a guard goes unreciprocated (189). Smith gives an account of the pervasiveness of the smoking culture on the American as much as on the German side and of the cigarette currency—Ilse's uncle is stunned that Hayes has a ration of twelve packs of cigarettes per week (173–74). Smith interweaves many references to American music (Nat King Cole, Lucky Millinder, and Ida James) and Hayes complains when he hears a German band trying to play swing: "You can't play 'Flying Home' to waltz time" (33). Yet Hayes also enjoys waltzing with Ilse. There are ventures to the movies reflective of the novel's cultural bent: Hayes sees Billy Wilder's *The Postman Always Rings Twice* and Howard Hawks's *The Big Sleep* but also a racist short of the Mantan Moreland/Step'n Fetchit variety:

The house was dark and the movie film had been underexposed just enough so that the white actors were clear enough but all you could see of the Negro were his eyes and mouth. We saw a lot of his mouth. The Negro said "yassah" very often and, when mysterious noises

came from upstairs, the white actors were very brave but the Negro's eyes opened very wide like spotted golf balls and his mouth opened wide into a big cavern with white borders. He ran in terror and hid behind the skirts of his stalwart white mistress, who soothed his ruffled nerves and told him, courageously, that nothing would hurt him. The picture was a comedy. Later, after all of the soldiers had seen it, the picture would be released for the German theaters. They would enjoy the picture very much. (169)

Smith's main concern lies not in exploring German-American relations but in exposing the racism of the U.S. Army, and Hayes's love affair with Ilse serves to point that out. A white G.I. shouts to Ilse out of his jeep, "Hey beautiful, why the hell you wastin' your time walkin' down the street with a goddam *nigger?*" (96). By contrast, English and Russian soldiers are very friendly, as are the Germans. The only anti-Semitic utterance in the novel is made not by a German but by a white American captain who drinks with the black soldiers. "I like you fellows in my company" (103), he tells them—but soon goes on to say: "There was one good feature about Hitler and the Nazis." He explains: "They got rid of the Jews" and "We ought to do that in the States" (105). The black soldiers give signs of disapproval and leave; the narrator later wonders about the "captain who thinks it is possible to be friendly toward one minority group and hate another" (144).

The conversations among the black G.I.s and much of the action center on the pervasiveness of racism in the U.S. Army, where black soldiers are considered inferior and are constantly harassed, subjected to V.D. examinations, and forced on a massive scale to accept discharges under all sorts of pretenses. "Our battalion had fifteen hundred men. Seven hundred and sixty-four of them would be discharged" (203). In his journalism from Germany, Smith had also reported on this not-so-subtle removal of black troops against their will and on their reluctance to return to the States.[32] In the novel, this policy leads to an incident involving the soldier Kenneth Stevenson (or "Steve"), one of the black G.I.s who works, like Hayes, as a typist and who refuses to type blank discharge forms. He is unjustly court-martialed for disobeying an order, but at this point—and it is one of the high points of the action of *Last of the Conquerors*—he is driven to such an outburst of desperate rage that he shoots officers, one of them fatally,

and then makes a dramatic escape in a truck (228–30) headed for the Russian zone. As a result, Hayes, who witnesses the shooting and, upon Steve's orders, starts up the getaway truck, is coerced on a trumped-up threat to take his discharge and to return to America, where he will go to Temple University as a student on the G.I. Bill (as did Smith).

Before leaving, Hayes promises to remain eternally faithful to Ilse and to return soon, but she, who has followed him illegally from Berlin after his transfer to the fictional Bremburg, is ever the pragmatic European woman, saying understandingly: "It is all right if you go out with other girls. And it is all right if you go to bed with them. That is necessary. You are a man and that is necessary. Only do not fall in love with any of them" (257). Before the good-bye, Hayes asks Ilse to light two cigarettes—in the style of Paul Henreid and Bette Davis from the film *Now Voyager* (1942)—but Ilse prefers to smoke one cigarette together with Hayes. She still has a difficult trip ahead of her back to Berlin without a travel pass and she needs every cigarette she can get for bribes. Hayes gives her three cartons as a good-bye present. It is a parting of subdued sadness, and the reader may remember at this moment the double death of the soldier Mosley and his German girlfriend when Mosley was about to be shipped back: "The girl had killed him and committed suicide" because "she couldn't stand it for him to leave forever" (72).

A critic saw the moral center of this cinematic novel in the irony that African American soldiers have to learn "the meaning of freedom from America's enemies."[33] C. L. R. James found that the novel "expresses the lyricism of young people making love even in [the] unpropitious environment" of occupied Germany, and that for Smith as a Negro "the perspective of freedom . . . is a permanent part of his consciousness."[34] The *New York Times* review complained that "there's no suggestion that the Germans who extend equality to the Negro share the guilt of racial crimes more terrible than any dreamed of in the United States, nor that their equalitarianism is based considerably on the opportunism that always exists between the victors and the losers." Yet the review, which invokes Gunnar Myrdal at the start, ends with the assessment that the novel's "real value lies in its portrait of a military ghetto—of what the Negro soldier feels, thinks and hopes for, and what he found—ironically, in the wrong country."[35]

The novel ends with a soldier shouting,

"Say Hayes, I hear you're shipping home today."

Hoarsely, "Yeah."

"Tough." (262)

The novel's epigraph, taken from one of Smith's own *Courier* articles, tells the reader what lies ahead: "*someday, I'm going back to Germany.*" Yet the hard-boiled ending on the word *tough* makes a permanent separation from Ilse more plausible, leaving the reader with a depressing last impression. After what Hayes Dawkins experienced in Germany, America would never feel like "home" again.[36]

Home

White American authors writing about the occupation appear to have been less eager to represent black G.I.s as central figures. In a 1945 essay in *Life* magazine, Gertrude Stein briefly mentioned a black battalion near Frankfurt's airport where a soldier, Victor Joell, quoted Stein's poetry to her, which gave her pleasure. She continued in her idiosyncratic way: "Another thing. Negroes even those born and bred and schooled in the South, don't talk with a Southern accent any more. Why is that?"[37] Stein also posed for the camera with African American soldiers in the U.S. Army Air Corps, but that photograph was not among those published in *Life* along with her essay. From some novels of the period one could likewise get the impression that the occupation was a whites-only affair.

In her short story "Home," first published in *Harper's* in 1951, however, Kay Boyle does focus on an unnamed "colored GI from Mississippi" who, having "been lent a temporary dignity by the uniform he wore," takes a little German boy who is standing in the rain outside an American Shopping Center on a clothes-buying spree.[38] At the end, the boy is outfitted in rodeo shirt, blue jeans, and tie-shoes, but the German saleswoman tells the G.I. that the boy gets dropped off at the shopping center every day, that Germans "don't know the difference between good and evil any more," and that he should take the clothes off that boy and put him back outside in the rain, for "Germans like that deserve nothing, nothing!" "Well, at home," the black soldier replies while paying for the boy's new clothes, "at home, ma'am, I never had much occasion to do for other people, so I was glad to have had this opportunity offered me" (162). The soldier, "who had known

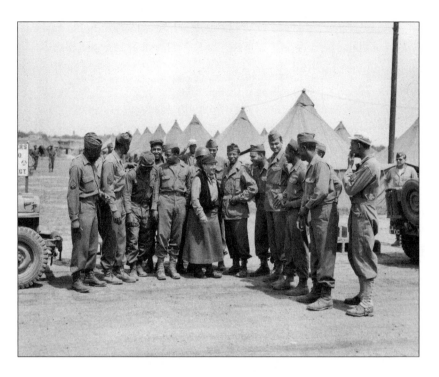

Gertrude Stein meeting with company of African American soldiers in the U.S. Army Air Corps during a tour of postwar Germany. July 1, 1945. *Photographer unidentified. Getty Images/Time & Life, 92937945.*

only leaning Negro shacks," felt elated at becoming "the provider, the protector at last, the dispenser of white-skinned charity" (159).

The story may be sentimental, but it is told very effectively and evokes memorably the surrealistic setting of the American Post Exchange with its popular music and its kitschy advertising (a reproduction of Whistler's mother with the inscription "You Have Only One Mother," is intended to inspire Mother's Day purchases); the P.X. serves as an American enclave "set aside from ordinary life" of the "ruins and rubble of the city." In a generally depressive atmosphere, the wish for "home" emerges at the very beginning, and the theme of home is further developed in a series of unobtrusive references. "It was the time of the day to turn home," the story's second sentence begins, "and a sadness seemed to fall, with the rain, upon the city streets, as if, at this hour, the entire city had come to recognize the reason for its physical destruction, and the burden of its nearly unatonable sin" (149). Differently from the "dependent children" and the

"dependent wives," the G.I.s "come in loneliness to this lighted island which could not be accepted as home, but which might be taken for a little while as home's facsimile" (151). Even though the P.X. is just a weak copy of home, the Mississippian G.I. protagonist who has been to Germany only for a few weeks and does not speak any German considers English "the language of home," "the only one that made any sense at all." The denim of the boy's blue jeans has a strong smell, "like the smell of home upon the air" (156). The black soldier's final response to the German saleswoman, with its doubled reference to "home," is thus the carefully prepared ending of a story that suggests that the wish for a home may be stronger in the somewhat artificial world represented here than any real place that can actually be called home. The sense of "home" may be evoked by smells and the sound of a language, but from the ruins of the German city to the artificiality of the Shopping Center, facsimiles of home have taken command, and the word *home* seems to be more important than its actual reality.

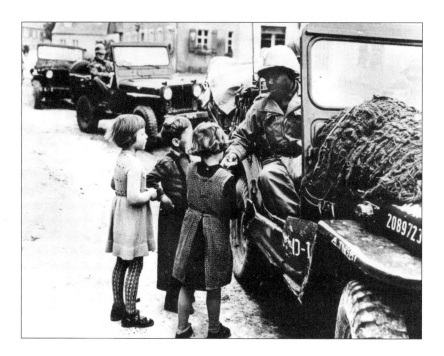

African American soldier presenting German children with chocolate or chewing gum.
1945. *Photographer unidentified. Süddeutsche Zeitung photo 46362/reference 46992.*

Kay Boyle's understated story thus makes some of the same points as Smith's novel—and Smith also included a brief scene of children asking black G.I.s for chocolate and looking happy and saying "danke" when they receive it (15). For Boyle's unnamed African American serviceman stationed in Germany, an even uncalled-for act of generosity can afford a fuller sense of humanity that is denied him in America.

At the same time, the story reinforces the image of the black soldier's particular generosity toward German children. The marginalized Americans did not seem to share some of the Army's vindictiveness toward Germans. (One only has to think of the scene of the American soldier's petty sadism toward the German girl that Zelda Popkin reported in autobiography and fiction that I discuss in Chapter Three.) The last of the conquerors thus was kind to the least of the conquered.

[*The particular kindness of black soldiers toward German children may be a stereotype, but if so, it is a cliché that I experienced as a child: black G.I.s driving by in trucks and jeeps were always smiling at us children, and a black man who worked for the occupation authorities on several occasions gave me delicious Marabou chocolate, which one could not then get in Germany. While working on this chapter I found a 1948 photograph of myself with my doll, named Maxi, which my mother had knitted for me out of leftover wool. I know how easily one could come up with all sorts of problematic readings of this image, but it also does suggest a friendly relationship to a maternally and lovingly created image of blackness in my early childhood.*]

Walk in Darkness: A Democracy of Desperation

Two postwar novels develop the kind of plotline that Hayes and Ilse's story never reaches, for they concern black G.I.s and German women who have relations that result in pregnancies. The author of the first novel, *Walk in Darkness* (1948), is the cosmopolitan Hans Habe, who was born Jean Békessy in 1911 in Budapest to parents who were of Jewish origin but had converted to Calvinism. He made his career as a journalist in Austria and in Switzerland (where he worked for a Czech newspaper), emigrated to France and the United States, and after the war, went to Germany where he edited the American-controlled *Die Neue Zeitung* for the military government. It was the newspaper for which Erich Kästner also worked, and it was published on the very same printing press that had previously produced

Maxi. 1948. *Photographer unidentified.*

the official Nazi daily, *Völkischer Beobachter.* Habe died in Switzerland in 1977.[39] He was a prolific writer of fiction and nonfiction. Five of his fifteen major novels were best sellers, and *A Thousand Shall Fall* (1941) was translated into twenty languages and turned into the MGM film *The Cross of Lorraine* (1943). Apart from *Walk in Darkness*, the novel on which I shall be focusing here, Habe also published two books worth noting. *Our Love*

Affair with Germany (1953) is a provocative and sharply critical account of American occupation policies in Germany, which Habe considered a failure; and *Off Limits* (1955) is a panoramic novel of the occupation with a fraternization subplot involving a sixteen-year-old München girl, Inge Schmidt, who gets pregnant by a black G.I. When *Off Limits* was serialized in the popular German weekly *Revue*, it generated a heated debate in Germany, which included attacks on Habe as a former American major, "Morgenthau boy," and reeducator now posing as a German writer, whereas the American reception considered the novel too pro-German.[40] In one of its epigraphs, *Off Limits* also offers a possible source for Smith's choice of his title *Last of the Conquerors:* it is the proclamation, "We have come as conquerors, not as liberators," which Habe ascribes to Eisenhower and which he may have adapted from the stern language of the Joint Chiefs of Staff Directive JCS-1067.[41]

In *Walk in Darkness* (1948), Habe chose to write a novel that, though told in the third person, adopts the point of view of Washington Roach, a black G.I. from the Harlem ghetto who comes to Germany.[42] The novel was first published in English translation, and Habe's shorter German original *Weg ins Dunkel* appeared in print only three years later; as was the case with other books that Habe published both in German and in English, the two versions differ significantly.[43] Inspired by Habe's encounter with a Negro unit in the American occupation forces, his novel seems to be indebted to Richard Wright, as it is divided into three books that could well have been titled, in the manner of *Native Son*, "Fear," "Flight," and "Fate"; the book also ends with the protagonist's execution for murder, just like Wright's novel. Set in 1946, *Walk in Darkness* begins with a psychosocial characterization of Washington Roach as type: angry, hardboiled, isolated, back from prison, alienated. "What was Harlem or America to him" (13), Habe asks. No wonder that Washington, who is thirty-five and has led a regular life only when he was in the wartime army, reenlists and goes to Europe.

In *Walk in Darkness*, as in Smith's novel, the protagonist's friendship with other black soldiers is most important. Thus Washington finds a friend in the Memphis-born soldier who "called himself Carter G. Redding, as others called themselves Thomas Jones or William Smith," and "was black in the same way that other people were white" (20): Redding is a calmer countertype to the troubled protagonist.[44] Habe also provides the

reader with vivid details of the occupation: for example, at the entrance to the P.X., women and children "studied all the uniformed Americans for any sign of an encouraging look or a good-natured face, which instantly set the children to begging and the women to smiling" (20). Washington is stationed in a camp at the outer edge of a Bavarian village near München. At a dance, he meets the young German country girl, Eva, and he soon becomes benefactor and provider for her whole family. He is intent on marrying her and asks the army chaplain Father Durant for help. Durant tells him: "That's probably not as simple as you may think. You know that marriages between Americans and Germans are allowed only under certain circumstances. The girl has to be of good character and politically untainted. And if the marriage takes place, you must leave Germany immediately" (47). But Washington is determined to get married, all the more so once Eva gets pregnant. He fills in the famous Fragebogen (the denazification questionnaire) for her, but the army still turns down his request for permission to get married. Angered by this outcome, Washington defies army rules and settles on an unauthorized marriage that is performed by the sympathetic Father Durant. The wedding night is interrupted by a racist mob of German ruffians who want Washington to leave Eva's parents' house, and Washington is threatened with a court-martial for having bypassed army regulations.

He chooses to go underground and work as a black market racketeer and brigand in what Habe calls "a democracy of desperation" (132), a phrase the *New York Times* and *Los Angeles Sentinel* reviewers happily picked up. Indeed, there is much emphasis in *Walk in Darkness* on the contrast between the problematic world on the surface, where "life meant wretchedness, starvation rations, battle for the smallest piece of bread, children who hungered, struggle over new political systems, intrigue of nation against nation, and intrigue of all nations against the strangers the war had spilled onto the coasts of the continent," and the underground, "lawless but free of misery, preying on scarcity and manipulating for its own benefit what little was available, contemptuous of the boundaries newly drawn on the surface, welding victor and vanquished together in an indestructible solidarity of crime" (132).[45] As in Smith's novel, there seems to be little optimism about the political efficacy of military occupation or about the future of the United Nations. However, "The chauvinism and divergent interests that worked against the success of the United Nations

of the upper world were no impediments to the functioning of the nations united in the underworld" (133). Habe's underground includes Germans, Americans, Displaced Persons, Jews and former Nazis, Poles, Estonians, Hungarians, Russians, and Yugoslavs, a "vast community that functioned in darkness" and that "accepted Washington Roach" (134).

Eva turns out to be duplicitous. She keeps meeting her German boyfriend Kurt and opportunistically uses Washington. When Washington comes to see her secretly and urges her not to get an abortion, she tells him: "I hate you! You and your black child!" And when Washington asks her, "Didn't you ever love me?" she laughs shrilly.

"You? I love you? To be with you makes me sick. You—"
He interrupted her. "If you say 'nigger' now, I'll strangle you" (162).[46]

This is a particularly cruel moment, but Washington clings to Eva regardless, trusts her to his own detriment, and becomes obsessed with their child, Louise, whom Eva wants to abandon and whom she soon gives to another woman.

The woman she chooses is Selma (in the German version of the novel, her name is Martha), a Jewish survivor who has suffered—the Nazis have sterilized her—but Washington deeply mistrusts her *because* she is Jewish, and he wants to take his daughter away from her. "The child was with Jews. With a Jewess who could not have a child herself. So he'd have to be doubly careful. Jews, he knew, were not like other white people. They were worse. There were many Jewish merchants and landlords in Harlem. They were all swindlers" (180).[47] If William Gardner Smith represented moments of black interracial solidarity with Jews against an anti-Semitic white American officer, Habe shows the currents of hatred and bias running in all directions, and only in the last third of the novel does Washington Roach slowly overcome his own anti-Semitism. This begins when Selma engages Washington in a dialogue about black and Jewish suffering (214), and a sermon-like speech by Father Durant pushes the point further and sounds like an authorially endorsed general pronouncement: "You're speaking of Selma the way many deluded people speak of Negroes. Don't you see, Roach, what a vicious circle that is? You hate the Jews. The whites hate you. You hate the whites. The whites hate other whites because they are Jews or Germans. The Jews hate the Germans.

The Germans hate the Jews and Negroes. Is the vicious circle to go on forever? Are we going to end up with everyone hating everybody?" (231). Then Father Durant quotes the passage from the First Epistle of St. John that gives the novel its title: "He that hateth his brother is in darkness, and walketh in darkness, and knoweth not whither he goeth, because that darkness hath blinded his eyes" (1 John 2:11). Encouraging Washington to be the first to give up his hatred, he adds, "Hate is a walk in the dark, Roach. The light will only break through when we learn to stop hating one another" (232).[48]

When Washington finds out that Eva has betrayed him and that his underground outfit is doomed, he nevertheless feels a strange sense of freedom. Having killed a trooper, he escapes to France where he hides on a remote farm with Selma and finally begins to see her in a new light: "If he had only met Selma then, instead of Eva!" he thinks for a moment. "They would have refused him permission to marry just the same, for he was black and she was white, even if she was a Jew" (275). But just when the police arrives to arrest him, a "shadow of mistrust [falls] across his heart" (277), as he believes that Selma advises him to run away only to keep his child for herself. As a result he gets arrested, and only after that does he realize that "maybe the way I felt about Selma was no different from the way other people feel about me. Ever since Eva told him that the baby was with Jews he had mistrusted Selma. Now he felt that he knew as little of Jews as white people knew of Negroes." He recognizes that "perhaps he should have looked at Selma simply as Selma from the start. It was too late for all that now. Nevertheless, the idea seemed important to him, as the confessional seems important to a believer on the verge of death" (279).

When Washington Roach is put on trial, Father Durant and Carter speak in his defense, as does Selma, who "pictured his battle for his child in whom, she said, he saw the crown of his life and an escape from the misery of his existence" (290). Washington knows he'll be sentenced to death and has no fear, but his concern for the future of Louise, who now is in a New Jersey state orphanage, makes his mind race. He asks his parents, from whom he is completely alienated, to take care of his daughter, but they think Louise is too white-looking for their Harlem neighborhood. Father Durant tells Washington, however, that Selma will be coming to America and will get custody of Louise. Washington is moved to tears and tells Father Durant to ask Selma to forgive him (311). Having

asked for forgiveness for his anti-Semitic prejudices, he is now ready to face death. (Washington does not ask for forgiveness of his murder of the trooper: perhaps it is a sign of the 1940s that conversion of one's racial attitude seemed more important than repentance for criminal actions.)[49] Blindfolded at the end, "he could no longer see, and yet it was as if he were striding out of darkness for the first time" (314).

The *New York Times* gave the Hungarian-born author credit for his courage to tell a novel from the point of view of "a Harlem-born Negro," and the newspaper praised the novel for creating a real character in Washington Roach and showing his growth. The last chapters, the reviewer wrote, "are written with a sincerity and compassion which should stir every heart."[50] On the pages of the *Pittsburgh Courier* Habe received high praise from Josephine Schuyler (the wife of novelist George Schuyler) for his characterization of Washington. who "steals and murders and yet we like him." This makes her ask, "How Does Habe Do It?" Her answer is that the reader learns how much Washington is haunted by color prejudice and how loyal he is to his daughter and even to his unfaithful wife.[51] The *Los Angeles Sentinel*, a black newspaper, found that *Walk in Darkness* was "written with intensity and compassion" and judged it a "deep-probing novel exposing the spiritual and emotional turmoil of the old world and the new."[52] J. Saunders Redding, writing in the *Baltimore Afro-American*, found the character of Washington Roach "an exaggeration of one aspect of the colored man as a social being. He is an exaggeration of our fear," a fear he only overcomes at the end. Redding added, however, that "nearly everything else in Hans Habe's book is good—the pictures of occupied Germany, and of Germans, the portraits of Chaplain Durant and of Carter, the dissection of prejudice, of army fumbling, or army ignorance" and found that the novel, "melodramatic as it is in spots, is better than just good" and "worth reading."[53] In 1952, Hollywood producer Richard Goldstone considered turning the novel into an independent film.[54] *Walk in Darkness* was adapted for the stage by William Hairston for an off-Broadway production and first performed on October 28, 1963, at the Greenwich Mews Theatre, starring Clarence Williams III in the role of Washington Roach.[55] In one of his autobiographies, Habe was happy to be able to quote an approving letter by African American expatriate actor John Kitzmiller, who had written Habe that never before had a white man been able to enter the soul of a Negro so completely.[56]

Wolfgang Koeppen's *Tauben im Gras*, first published in 1951 and translated into English in 1988 as *Pigeons on the Grass*, contains two plotlines involving black soldiers (among its more than thirty characters) in an unnamed city that feels like München.[57] It is a novel that first of all calls attention, however, to its *form*, an experimental modernist structure inspired by Gertrude Stein (from whose opera *Four Saints in Three Acts* the title is taken), William Faulkner (to whom the stream-of-consciousness writing with shifts in time and point of view, often marked by acoustic triggers, is indebted), John Dos Passos (whose quoted headlines, radio news, and music attempt to capture a form of urban restlessness in prose), and James Joyce (whose mythical method the novel adopts with numerous classical allusions to Odysseus, Circe, the Sirens, and Nausikaa as well as Oedipus, Styx, Hades, Medusa, and the golden fleece, allusions that aim to give depth to the contemporary setting of a novel that takes place in the course of a single day that can be identified as February 20, 1951).

Koeppen was born in 1906, and although he devoured Joyce's *Ulysses* when it was first published in German translation in 1926, his writing before 1945 was not much marked by modernist experimentation.[58] His first postwar publication was an edition of Jacob Littner's *Mein Weg durch die Nacht: Ein Dokument des Rassenhasses* (1948), a Jewish survivor's autobiography that Koeppen extensively revised for publication, retitled, and late in life falsely claimed as a novel of his own.[59] Yet Koeppen made *Tauben im Gras*, his own first postwar production, a firework of modernist techniques—quite self-consciously so, since stream of consciousness is commented on in the novel and likened to yeast or a river. The Steinian title is made explicit by the novel's epigraph, "Pigeons on the grass alas" (quoted in English), and a second time by a lecture given by the character Edwin, a writer who may have been partly modeled on T. S. Eliot or Thomas Mann. The reference to Stein is also significant since her work was banned in Nazi Germany.[60] There are further discussions of modernist literature in the novel, and the German emigrant Professor Kaiser gives the reader full catalogues and examples of the major European and American modernists from Kafka to Hemingway. Koeppen's high modernism has the effect that the reader cannot always be sure who is speak-

ing, or thinking, or quoting whom. As in Smith's *Last of the Conquerors*, bits of American popular music waft through the text, but Koeppen uses *"Night-and-day," "Candy-I-call-my-sugar-candy," "Stormy-weather,"* or *"Bahama-Joe"* both as leitmotifs and as triggers that mark shifts in point of view.

The novel is characterized by a tone of romantic melancholia and fatigue of all politics—and that includes the past as well as the present, Nazis as well as military occupation and Cold War. In fact, language seems to reveal only frightening continuities between the Nazi and the postwar years. There are allusions to the Nazi genocide, especially in the story of Henriette Cohn.[61] There is also a reference to Tarnopol, close to where Littner (the Jewish survivor whose life story Koeppen had edited) had hidden out during the war. Battlefields and the air bombing are mentioned, and there is a bird's eye view of the ruined city.

The American military occupation is refracted through a reference about the porter Josef, who follows the "liberator, conqueror," a racketeering fantasy, the mention of requisitioning, the representation of a Café Schön for black soldiers, and collectively made German comments on Americans:

> Women, women dressed in fashion and like tomboys, women proudly ladylike and boyish, women in olive-green uniforms, female lieutenants and female majors, smartly made-up teen-age girls, a whole lot of women, and then civilian employees, officers and soldiers, Negroes and Negresses, they were all part of the occupation force, they populated the square, they called out, laughed, waved, they steered the lovely automobiles that hummed the song of wealth skillfully among the already parked vehicles. The Germans admired and despised all this display on wheels. Some thought, 'ours used to march.' In their minds, it was more respectable to march in a foreign land than to drive. (62)

In this novel's vast stream, or yeast, of consciousness, there are strands that center on the two black G.I.s in the book, Odysseus Cotton, from Memphis, Tennessee, and Washington Price, from Baton Rouge, Louisiana. Odysseus, who walks through the city followed by the porter, Josef, elicits conflicting thoughts in nameless girls who see him:

"the nigger, that fresh nigger, horrible nigger, no, I wouldn't do it"
Bahama-Joe, and others thought, "money they've got, so much money,
a black soldier earns more than our chief inspectors, US Private, we
girls have learned our English, League of German Girls, can you
marry a Negro? No race law in the USA, but ostracism, no hotel will
let you in, the halfblack children, occupation babies, poor little ones,
don't know where they belong, not their fault, no, I wouldn't do it!"
Bahama-Joe, saxophone flourish. A woman stood in front of a shoe
store, she saw the Negro walking by, mirrored in the window, she
thought, "the sandals with the spike heels, I'd like those, if you could
just once, those boys do have some bodies, virile, saw a boxing match
once. Papa was exhausted afterwards, but not him." (30)

The novel also presents an animalistic mingling fantasy involving Odys-
seus and Susanne (Kirke): "It excited both of them. Everybody watched
the snake with four legs. Never would they let go this embrace. The snake
had four legs and two heads, one white and one black face, but never would
the heads turn against one another, never the tongues loose venom upon
the other: they would never betray each other, the snake was a single be-
ing against the world" (179–80). This odd passage seems told from the
narrator's point of view, and the figure of an Ouroburus-like black-white
sexual union recurs later in the novel (206).

Washington Price drives a "horizonblue Sedan" (36), and, in a flash-
back to "the bad years, forty-five, forty-six, forty-seven" (37), Carla Beh-
rend sits next to him as he is steering his jeep; he brings her chocolate,
canned goods, and cigarettes and says "Auf Wiedersehen" every night.

By the sixth week, Carla couldn't take it any longer. She dreamt of
Negroes. In her dreams she was raped. Black arms reached out for
her: they came up out of the cellars under the ruins like snakes. She
said: "I can't stand it." He came with her to her room. It was a kind of
drowning. Was it the Volga? [An allusion to Carla's husband, missing
in Russia.] Not icy a fiery stream. The next day, the neighbors came,
her acquaintances came, her old boss at the Wehrmacht came, they
all came, wanted cigarettes, canned goods, coffee, chocolate, "tell your
friend, Carla"—"your friend can get it at the central exchange, in the
American department store, Carla." (38)

She moves in with Price, is faithful (although German men think that now that she has a black boyfriend she would go to bed with just anybody), and she gets pregnant. She is afraid that discriminatory signs, "Whites Unwelcome, Blacks Unwelcome," apply to both of them, and she remembers that it was "for Jews Unwelcome that the father of her son, without knowing or particularly wanting it so, had gone to war" (52). She does not want to have the new child, "dark, mottled" (52); she thinks of Nazi propaganda, "Negroization, war propaganda in the Völkischer Beobachter, Race Betrayal" (54). Price wants to marry her even though in Baton Rouge they would kill him for it, and he goes shopping for Carla and the baby.[62] Carla's twelve-year-old son, Heinz, is proud of "der Nigger meiner Mutter," his "mother's nigger" (63), and the other children are full of respect for him.[63] Carla and Price are in a Negro Club planning to go to France to open a bar there, "Washington's Inn," where everyone is welcome, but are stoned by an angry mob ostensibly trying to punish the murderer of a taxi driver (though it is none other than Odysseus Cotton who has killed the cab driver). The reader does not learn whether Carla and Price are alive or dead at the end. A critic's summary of the novel as a "melancholy lament" is apt.[64]

Dreams of a G.I. Father?

The works by William Gardner Smith, Hans Habe, Wolfgang Koeppen, and Kay Boyle operate in different stylistic registers but also show some similarities in their fictional representation of black G.I.s in postwar Germany. Smith's predilection for hard-boiled prose, parataxis, and diction translated from another language, puts him in league with Hemingway, and Koeppen's primary and declared inspiration comes from Stein, Joyce, and Faulkner. Habe once explained proudly that he was writing "as if Joyce and Kafka had never lived" and invoked Tolstoy and Dostoevsky as models to aspire to, but he also clearly read Richard Wright—and he did choose "Roach" as Washington's surname, as if alluding to Kafka's "Metamorphosis."[65] Boyle employs the leitmotif of "home" in a carefully structured story that also takes its central image as its title and makes one think of Flannery O'Connor or of O'Henry. Smith chooses a political title, Habe a biblical, and Koeppen a modernist one, while Boyle names the story after her central leitmotif. Realist, modernist, and antimodernist techniques thus help these writers to create strong and vivid representations of individual

black G.I.s in their social, military, and civilian contexts in the American zone. All four writers question the language of conquest and seem to express little hope for democracy in postwar Germany. The texts have a depressed undertone and emphasize the ruins in their settings. The most hopeful social worlds would seem to be those of Hayes and his male buddies and of Roach's underworld democracy of desperadoes, the most promising relations those between soldiers and children. The writers pay attention to the power of racial prejudice, and some draw explicit connections between anti-Semitism and antiblack racism.

The three novelists imagine fraternization plots, but not one of them has a happy ending: Smith ends with a parting, Habe with an execution, and Koeppen with mob violence and a stoning. Both Smith and Habe show transformations in their black protagonists: Hayes becomes more open toward Germans, and Habe's Washington Roach overcomes his anti-Jewish feelings. Koeppen seems to record things as if the whole book were in scare quotes—the modernist style serving him like a shield against sentiment. Both Smith and Habe write about love, whether well placed or misplaced; Koeppen does not seem to even mention the word. Habe and Koeppen take their plots to the crossroads of a possible abortion, and though Smith included the adopted "Sonny" in a brief sequence, only Habe's Louise brings to the foreground the issues of a child by a German woman and a black soldier. While demonstrating Roach's depth of affection, Louise's role is secondary, however, to that of her parents and her foster mother.

Perhaps it is possible to generalize that on a deeper level these examples of postwar fiction are concerned with the role of African American G.I.s as father figures. Developing a complex part for their black G.I. protagonists, marked by a tension between paternal potential and social constraints that may inhibit that potential's full realization, mattered to writers of the late 1940s and early 1950s. Both Koeppen's Washington Price and Habe's Washington Roach oppose an abortion when their German girl friends get pregnant. Habe's Roach actually becomes a father who is overwhelmed by deep emotions when he first sees his baby Louise (while he is already wanted as an army deserter): "He stood bent over the child and stared at it. It was the loveliest baby he had ever seen" (177). After the nurse takes the child again, Roach says, "Louise. My daughter" (178), and his concern

about the future of his daughter is what propels much of the plot of the last third of the novel.

In other cases, the paternal role is more symbolic. That is true for the unnamed G.I. in Kay Boyle's "Home" who plays an affectionately generous paternal role toward the German boy whom he clothes, as he "dreamed the brief, clear dream of love about the boy. For the duration of the dream, the boy was his, the authority of family, of country, of Occupation even, having discarded him; and the soldier, who had known only leaning Negro shacks, became the provider, the protector at last, the dispenser of white-skinned charity" (159). The physical gestures Boyle describes—the soldier's first placing, then keeping, one hand on the boy's shoulder, for example—further enhance the feeling of a paternal-filial relationship. In the case of William Gardner Smith, the improbable presence of the four-year-old occupation child Sonny may allow Hayes Dawkins to perform a pseudo-paternal function, for he immediately asks Sonny's foster mother how she manages to feed him and says: "If you could let me, sometimes I would take him in the camp to eat with me" (91). The scenes that follow show Hayes picking up Sonny to climb into a streetcar and presenting him to the other soldiers, and Sonny holding Hayes's hand on the way back—while the passengers comment on how sweet Sonny looks, and Ilse and Hayes realize that with Sonny they must appear like a family to the other passengers. "They think he is our son," Ilse says, and Hayes answers, "I know" (94).

It is also an explicitly a paternal role that Koeppen's Price plays in relationship to Carla's son Heinz:

He is going with my mother, he eats at our table, he sleeps in our bed, they want me to say Dad to him. That came from the depths of joy and of pain. Heinz could not remember the father who was missing in action on the Volga. A photograph that showed his father in gray uniform meant nothing to him. Washington could be a good father. He was friendly, he was generous, he didn't punish, he was a well-known athlete, he wore a uniform, he was one of the victors, to Heinz he was rich and drove a big, horizonblue car. But Washington's black skin spoke against him, the obvious sign of being different. Heinz didn't want to be different than others. He wanted to be exactly like the

other boys, and they had white-skinned, native-born fathers accepted everywhere. Washington was not accepted everywhere. (63–64)

Koeppen spells out the symbolic role of the black G.I. as father figure, both as a source of joy and of pain for Heinz: joy because of Price's good paternal qualities, and pain because of the difference that makes Price subject to contempt from others.

The African American struggle for full civil rights in the period was often phrased in the metaphor of "manhood." Yet symbolically playing the role of *paterfamilias* (rather than "native son") may also have been a desire that could be realized in the occupation of Germany more readily than was possible within the United States.[66] The general metaphors of tutelage and reeducation cast U.S. soldiers of all racial backgrounds in the role of at least teacher, if not parent. This may have been all the more attractive to German youngsters because of the poses American G.I.s struck displaying a casualness, or *Lässigkeit*, that differed from the then common straighter posture of German grown-ups.

The coolest, least European, and hardest-to-imitate body postures were probably performed by black G.I.s. In his novel *Off Limits* (1957), Hans Habe captured some of the new and interesting poses that G.I.s brought to Germany.

They were strange soldiers: they were evidently unable to stand up-right. They would generally lean against a wall, standing on one leg like storks, with the other leg bent at the knee and the sole of the foot lying flat against the wall. Others would crouch, always in the same position, their haunches on their heels; for hours on end they would sit there like frogs. These storks and frogs would smoke cigars or chew gum, rarely talking to each other, and when some girls addressed them they would usually just utter a few obscenities. After all, obscenities could hardly be regarded as a violation of the Non-Fraternization Law. For the most part the men leaning against the bombed-out theater wall were Negroes, and many of them were generous: they would toss a cigarette to the passing girls, follow them with their eyes and laugh among each other, but they would not go with them. It was too dangerous to go with them.[67]

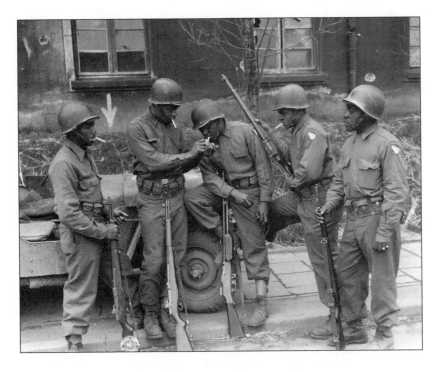

Ulysses Woods, James Spence, John Fagan, Leon W. Thomas, and Arthur Landis. They volunteered for front-line duty—taking a break between instruction periods. March 28, 1945. *Photographer unidentified. OWI/RG 208-AA Box 32 (Allies and Axis, 1942–1945).*

Black G.I.s who taught a new way of carrying oneself, a way that was furthermore sweetened by chewing gum or chocolate, could thus be perceived as unusual pseudo-parental figures who differed from other parental authorities available in postwar Germany.

D.P.

The notion of black fatherhood in Germany was also explored by Kurt Vonnegut in his touching short story "D.P.," first published in the *Ladies' Home Journal* in 1953.[68] On the first page of the journal publication, two passages adapted from the story were highlighted for the reader and framed the text of the first few paragraphs. The first excerpt suggests that the term "D.P." is being used metaphorically to refer to the boy who is "displaced" (but not technically a "Displaced Person"): "Joe was the most displaced little

old person the American sergeant had ever seen." The other passage appears below the text and reads: "'Sister!' gasped Joe. "My father—I just saw my father."[69]

The relationship between the military and a displaced child takes center stage in the story. Set in an orphanage for abandoned and parentless children that is run by Catholic nuns in a town on the Rhine in the American zone of occupation, the story at first directs the reader to take the point of view of a carpenter who likes to guess the parentage of the children whom the nuns march through town in a ragged parade. The carpenter believes he can identify a little orphan girl as French by "the flash of those eyes," and he argues with a mechanic whether a flaxen-haired boy is Polish, a question that the mechanic's laconic comment, "They're all German now," does not resolve.[70] All of this is just the prelude to the appearance of one boy about whom no argument is needed: "There we have an American!" This boy is described as a "lone, blue-eyed colored boy" who speaks only German. The nuns have more or less randomly named him Karl Heinz, but the carpenter gave him the nickname Joe, or the brown bomber, after Joe Louis, and that name stuck. "And if *he* isn't a German too!" the mechanic adds, hoping for a new German heavyweight boxing champion. Joe is a dreamer and wonders about his origins, a question that an older boy had provoked in him. Was his father an American? What was an American? Were all Americans dark-skinned? Then one day, the carpenter tells Joe, teasingly—as the nun is quick to point out—that Joe's father is in town, in the woods above the school, and Joe is immediately ready to make the connection when he sees "a massive brown man, naked to the waist and wearing a pistol, step from the trees."

Although the nun tells Joe that that man is not his father and forbids him to go up into the woods, Joe breaks out of the orphanage at night in search of his father. A black American sergeant discovers him but can't make sense of the boy who stammers in German that he is searching for his father. "Don't rightly know what to call it. . . . Talks like a Kraut and dresses like a Kraut, but just look at it a minute." Soon Joe is surrounded by a dozen soldiers who don't understand him; then he is joined by a black lieutenant who speaks German. When asked, "What's your name and where are your people?" Joe answers "Joe Louis And you are my people"; he believes that the sergeant is actually his "papa," and he clings to him. The sergeant and the lieutenant try to persuade Joe to go back to the

orphanage, they and the other soldiers heap gifts on him—a wool-knit cap, a watch, a pocket knife, and a whole case of chocolate "D bars" from their ration—and they promise to visit him if they can because they'll be moving the next morning. Back at the orphanage the other children mill around Joe, and he proudly proclaims that he has seen his father, "as high as this ceiling, . . . wider than that door," and as brown as one of his chocolate bars, which he then offers to the kids in the orphanage. He continues to brag in order to silence a doubter: "My papa has a pistol as big as this bed, almost . . . and a cannon as big as this house. And there were hundreds and hundreds like him." Asked for proof that the man was, indeed, his father, Joe says that his father had cried when leaving and promised to take Joe back home as fast as he could.

The black army unit is, for Karl Heinz/Joe, an intensified fulfillment of the wish for a father, embodying a promise of home for the displaced child in the orphanage, and the tall and strong sergeant whom he makes out to be his father assumes mythic proportions for the boy. But all the soldiers act spontaneously in paternal roles and surprise themselves with their generosity, their instant gifts for Joe, and their instruction to him on how to use the knife. The story has a sentimental effect because the father-child relationship is established while we know all along that it is a make-belief arrangement generated perhaps by the metaphor of "your people" in the sense of "people with darker skins." But it still conveys a new strength to "the most displaced little old person" the sergeant had ever seen. Vonnegut's "D.P." suggests the wish fulfillment of an all-male family romance while the boy still returns to the nuns' orphanage at the end.

The German Boy and the G.I.

That a pseudo-paternal (or avuncular) role could be played by soldiers of all backgrounds in postwar Europe becomes apparent in many photographs that show G.I.s, both black and white, together with German children.[71] If a G.I. could enjoy playing the role of a benevolent parent, then the children could be fascinated by the new and different adult figure they could then try to imitate. Tony Vaccaro took a photograph near Worms in December 1948 that may best embody the spirit of this relationship and that may therefore serve as coda to this chapter (even though the soldier in this memorable photograph is not an African American). It shows an American soldier in

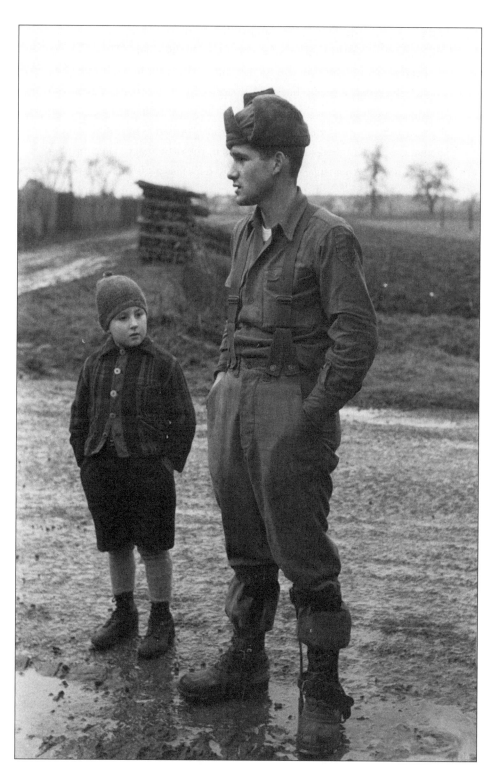

German boy and U.S. G.I.: A new peer for a German child. Near Worms, December 1948. *Photo by Tony Vaccaro/AKG images, file AKG_245553, picture reference 9-1948-12-0-H1-2.*

the kind of casual pose that had not yet become common in Germany: standing on a muddy road, both hands in his pockets, his white undershirt visible near his neck under his army clothes, his boots at a comfortable angle, this G.I. seems deeply relaxed as he looks into the distance to the left. His figure takes the vertical center of the photograph, but to the left there is a young boy who seems to be just about half the soldier's size and who looks in the direction of the soldier's hands, obviously straining hard to imitate the casual pose, holding his hands in his pockets.[72] The wish of the boy to imitate an adult and his comically visible effort at trying so hard to appear relaxed seem to be reciprocated by the wish of the soldier to be imitable and cool, to instruct with his body posture.

Toxi (Elfie Fiegert) and her adoptive mother, Gertrud Fiegert. Ca. 1952. *Photo by Berthold Fischer.*
Süddeutsche Zeitung photo 647217/reference 60139099.

April 24, 1946

Elfie, the daughter of an African American G.I. and a German woman, is born in Freising and placed in an orphanage. In 1948, she is adopted by Fritz and Gertrud Fiegert, a Silesian refugee couple now living in Markt Schwaben, Bavaria, who lost their own two-year-old child during the expulsion. In 1952, Elfie stars in the film Toxi, *popularizing the story of occupation children and their possible adoption*

The Race Problem in the House on Lilac Road

Occupation Children and the Film *Toxi*

Ich möcht' so gern nach Hause geh'n, ay - ay - ay.

Die Heimat möcht' ich wiederseh'n, ay - ay - ay - ay.

Ich find' allein nicht einen Schritt, ay - ay - ay.

Wer hat mich lieb und nimmt mich mit? Ay - ay - ay.

Ich bin so verlassen und hör' kein liebes Wort,

So fremd sind die Gassen. Warum kann ich nicht fort?

Kannniemand denn mein Herz versteh'n, ay - ay - ay?

Ich möcht' so gern nach Hause geh'n, ay - ay - ay.

— Bruno Balz, "Toxi-Lied"

In the postwar years, illegitimate birth still carried a stigma for mother and child in Germany: only in the course of the 1960s did the legal and cultural landscape undergo a dramatic change in this matter.[1] Abortion (the choice Koeppen's Carla and Habe's Eva want to make) was illegal, expensive when it could be obtained, and dangerous when performed in secrecy. Getting married when one was pregnant (in what was called a *Notheirat,* an emergency marriage) often was the best possible course of action for a woman to avoid public and intrafamilial shame, even if the

husband-to-be was not the father-to-be. This was not, however, an option readily available to women who were about to give birth to children who were likely to look recognizably different, and the easily perceivable difference of darker skin color was, of course, a prime example.[2] German women could not file paternity suits against American or any Allied soldiers before Germany regained sovereignty, and the U.S. Army evinced no interest in dealing with children of American soldiers and German women. Giving birth secretly, and letting German state welfare and adoption agencies, with their network of orphanages and foster parents, take care of the child, thus became a relatively frequent outcome, generating political worries about public costs.[3] As an additional consideration, while there were many difficulties in the process of legalizing any alliance resulting from fraternization, especially in the immediate postwar period, the official obstacles to interracial marriages between black American soldiers and German women were of a completely different order as far as U.S. Army regulations were concerned (as seen in Habe's and Smith's novels). As observers noted, when it came to issues like miscegenation, the army had a distinctly Southern feeling to it.[4]

The fate of an estimated three to four thousand children born between 1946 and 1953 of German mothers and black American fathers thus became an issue that dominated discussions of fraternization.[5] Especially once the first cohort of *Mischlingskinder* became more publicly visible and began to enter schools around Easter 1952, the question of what the best future would be for these children was widely debated by the West German parliament, in the press, by educators, and in contemporary scholarship.[6] Should the education of these children be considered a German or an international issue? What could be done to help them in difficult family situations and in the educational system? Should some special classes or separate boarding schools be created for them, or should they be integrated with all other children? German political institutions and educators overwhelmingly viewed it as a German issue and favored integrated schooling, although they also advocated some special preparation of educators. African American newspapers and magazines tended to favor adoption by black American families, and they published long lists of children looking for homes, lists which included the mothers' full names and addresses.[7] Later on, stories of a few successful adoptions by African American parents appeared.[8] An early American journalistic study of six hundred

children in the American zone, published in *Survey* in 1949, included four photographs of German mothers with their children and provided charts, which indicated that most of the mothers were single, the bulk of support for the children came from the mothers' employment or from the mothers' parents, but a very significant source of support originated with welfare agencies and charitable organizations.[9] A 1954 Neue Deutsche Wochenschau newsreel clip showed an idyllic children's village in Imst, Austria, full of orphans and occupation children, making the institutionalization of the children with orphans and abandoned children look attractive.[10]

Looking at the Race Problem with Different Eyes

A German film released on August 15, 1952, addressed this set of issues memorably and made Elfie Fiegert an instant star. It takes its title, *Toxi*, from the name of an occupation child, the daughter of a black G.I. and a meanwhile deceased German woman, and its plot is dominated by the question of what might be the best course of action to take in the matter of this representative child.[11] A German middle-class family has to decide whether the sweet, polite, and well-mannered girl should be kept in their house or placed in an orphanage, taken in or handed over to the police. The themes of shame, illegitimacy, and race are all sounded in the movie, but eventually everything is resolved and the family decides to keep Toxi—before suddenly, in a surprise ending, Toxi's father arrives to take her to America.

Toxi is a family movie and a tearjerker; it also features a heartrending scene in the Kinderheim Nordland, a German orphanage. As *Der Spiegel* reported at the time, the film was originally produced by REAL-Film, but because the left-leaning producer Wolfgang Koppel had difficulties getting the needed partial funding guarantee for the filming from the German Interior Ministry (usually given out routinely), he sold the project at a very late stage to the production company Fono-Film in Hamburg, and it was distributed by Allianz-Film. The relatively young but experienced director was Robert A. Stemmle, who had made postwar headlines when his *Berliner Ballade*, a film about a returning veteran trying to find his way, was exhibited at the Venice Biennale in 1949. Peter Franke and Maria Osten-Sacken wrote the story and, together with Stemmle, the

screenplay for *Toxi*. Edited by Alice Ludwig, the black-and-white film ultimately had fewer scene cuts and thus longer camera takes than was common in those years.[12]

Elfie Fiegert was selected from among a large number of occupation children who auditioned to play the title role; a five-and-a-half-year-old, mixed-race *Besatzungskind*, she joined a cast of mostly experienced adult German actors, though there were no superstars among them. The film was released with much fanfare; the publicity, which focused on the character of Toxi and the children she was meant to represent, included numerous events with American G.I.s and German orphans. In materials given to journalists as well as in the reviews that those journalists published, the film story of Toxi and the life story of Elfie were often merged, and it is telling that while the credits list the other actors' first and last names, they identify the star of the film not as Elfie Fiegert but only as Toxi. The Allianz-Film publicity material states that Toxi overcomes the obstacle of prejudice and that the film's purpose is "to move the audience, with humor, toward understanding and love for all Toxis."[13]

Early in the film, Toxi is left at the doorstep of the Roses, a bourgeois Hamburg family, by her own German grandmother, Frau Berstel (played by Lotte Brackebusch). Berstel formerly worked as a housekeeper for the Roses, but her daughter has died, and when she has to go to the hospital to get an eye operation, she simply does not know what to do about her grandchild Toxi. She leaves the child secretly at the front door at Fliederweg 11 (for, in an apparent attempt at establishing a floral theme, the Rose family lives at Lilac Road) because she fears that the Roses are still upset that she left her job without giving notice, but she hopes that the family will take good care of Toxi. The viewers see Frau Berstel drop off the child, but the Roses have no idea from where she came, and they think at first that Toxi, who enters with a small bunch of flowers and recites a poem, is a surprise for Grandmother Helene Rose (Johanna Hofer), who is celebrating her fiftieth birthday that Saturday evening, and whose sister-in-law, Wally (Elisabeth Flickenschildt), had promised a surprise when she left the house earlier. Soon they see the girl's little suitcase and her belongings, however, and they realize that she must have been abandoned outside their home.

Three generations clash in the debate about what do to with Toxi: Grandfather Gustav Rose (Paul Bildt) and his wife, Helene; their daugh-

Toxi: "Das Rassenproblem." Herta Rose (Ingeborg Körner), Robert Peters (Rainer Penkert), Theodor Jenrich (Wilfried Seyferth), and Grandfather Rose (Paul Bildt). *DVD screenshot.*

ters Charlotte (Carola Höhn), married to the pharmaceutical company owner Dr. Theodor Jenrich (Wilfried Seyferth), and Herta (Ingeborg Körner), in love with the advertising designer and graphic artist Robert Peters (Rainer Penkert); and finally the Jenrich kids, Ilse and Susi.

Son-in-law Theodor Jenrich turns out to be the most vocal opponent to an adoption scheme and refuses, on the principle of difference in skin color, to let Toxi stay in the three-generation house. Theodor's thinking is openly racist, though he at first approaches the topic by indirection: "I don't wish Toxi to play with my children tomorrow. . . . She could have a contagious disease."[14] (The verdict of the family physician, Dr. Carsten, is that Toxi really is healthy but that Susi, the younger Jenrich child, is still recovering from a case of whooping cough.) When Grandfather Rose tells Theodor that having an additional child in the family would be a problem only if there weren't anything to eat, Theodor has to get more explicit, and he soon sounds like an unreformed Nazi: "I mean the race problem" ("Ich meine das Rassenproblem").[15]

An embarrassed pause follows for about eight painful seconds, the camera cutting four times in silence from one group of tense adult faces to the next, their eyes wide open and expressing utmost concern. The viewer is

thus confronted with a strange cinematic move reflective of the scene's tension: four two-second-short and sharply cut segments in a film that ordinarily has longer takes and often uses fade-out, fade-in transitions. The scene is all the more effective since, as in much of the camera work by Igor Oberberg for this film, adults are viewed from a low angle, resembling a child's perspective, and are therefore seen with dramatically intensified, silent-movie-like facial expressions in front of ceilings, lamps, or the upper parts of doors and walls, creating an expressionist effect.

It is this heavily charged silent moment that carries the weight of everything that is not spoken but that is implicitly associated with the Nazi past. Finally, Grandfather Rose's response comes as a relief: "Of course, that still exists. But I believe we have learned to look at it with different eyes." ("Natürlich gibt es das noch. Aber ich glaube, wir haben gelernt, es mit anderen Augen anzusehen.")[16] This reference to having learned to rethink the recent past and to look at the race problem with different eyes may represent a faint trace of reeducation in the film.[17] In case the audience was in any doubt, the movie thus announces that this is one of its key scenes and that the race problem is its central theme.

Theodor's explicit reference to the "race problem" causes fearful silence and embarrassment, all the more so because there are guests present in the house. The family lawyer Übelhack (Ernst Waldow) is there, as is his wife (Erika von Thellmann)—who seems primarily concerned about the child's illegitimacy ("It's a child of shame," she says), a theme that otherwise remains undeveloped. Also present is Herta's not-yet-fiancé, Robert, whose tempestuous departure at the end of this scene signals the potential for conflict in Theodor's position. Implied in this scene is a clear trajectory from the past to the present, and the desire for tolerance toward and acceptance of people of darker color is articulated in terms of the need to reject Theodor's residual and no longer tolerable prejudice. The film's method of working toward greater tolerance by attacking racial prejudice, not by dramatizing difference, seemed to be in conformity with then-current educational concepts as they were articulated both by postwar intercultural educators in the United States and in German pedagogic publications like *Maxi, unser Negerbub*, a book issued by the German Society for Christian-Jewish Cooperation that caused much of a stir among educators in the early 1950s.[18]

Theodor's pat prejudice must have been anti-Semitism, originally; however, it is never identified as such. In fact, there is no sense of a deeper historical or political past in the film, and Doctor Carsten's toast for Helene's fiftieth birthday reviews her life strictly in the realms of the family and of the postwar period. The two silent close-ups of Grandfather Rose and Theodor facing each other emphasize that their different points of view mark the central conflict of the film, that the younger Theodor represents the wrong-headed views of an unspecified past and that the older Grandfather Rose has the forward-looking attitude.

This key moment was a scene that the scriptwriters wrestled with, for it was repeatedly revised, as the various scripts of the film demonstrate with numerous inserted emendations that yield two completely different versions with intermediary adjustments. In what seems to be the original version, Theodor simply refuses to say what bothers him about Toxi's presence in the house, so that race remains unmentioned, except when Camilla Jenrich (either a typographical error for Charlotte or another relative of Theodor's who was later dropped from the script) brings it up in a context in which it intensifies the shame of illegitimacy: "The mother of this child has thrown herself away and at a Negro. . . . It is a child of shame."[19] Interestingly, then, originally it may have been Grandfather Rose's older daughter who explicitly named the double obstacle that Toxi's racial origin and presumed illegitimacy represent to integration into the German family. If Camilla Jenrich was really meant to be the same figure as Charlotte, she also underwent a character change from explicitly voicing Theodor's position to playing a far more subdued role.

In the next version it is Grandfather Rose who has to name the *Rassenproblem*, first encouraging Theodor to speak up and then chiding him for living in the wrong era, being narrow-minded, and still harboring racial prejudices ("Rassenvoreingenommenheiten"):

Grandfather Rose: What do you see differently? What problem do you mean? Well?

Theodor is silent.

Grandfather Rose: Why don't you say it. You only talk around it. You mean the race problem?

Theodor is silent again.

Grandfather Rose: Come on, you are still bringing that up today!

Theodor: Dear Papa-in-law. You know, we do not agree on some of our viewpoints.

Grandfather Rose: So what? You are indeed still so narrow-minded, I almost said.

Theodor: Call it narrow-minded if you want. In my opinion, each species belongs to its own kind.

Grandfather Rose: Theodor, please! Must you still bring up racial prejudice? Tell me, which time period are you living in?[20]

Despite Grandfather Rose's taunting, Theodor keeps silent—until he feels that he has to object to his father-in-law's accusation that he is "borniert" (perhaps best rendered as "arrogantly narrow-minded"), and comes up with the racial maxim that the same species belong together (*Nach meiner Meinung gehört Art zu Art*—a phrase that echoes the Nazi emphasis on "Artgleichheit" that Carl Schmitt had endorsed in 1934): Grandfather Rose rightly repudiates it as racial prejudice. In this version the silence is still only Theodor's silence, and Grandfather Rose not only names the race problem but is also quite judgmental in accusing his son-in-law of being a narrow-minded bigot in front of the family and the guests.

In the drafts of the script there are crossed out sentences and revisions of pretty much every character's comments in this scene; the compromise that emerged in the final version, the one seen in the film, makes Theodor himself affirm his own "principle," as it is called, and makes the Grandfather's rebuke milder. Charlotte, the Roses' older daughter and Theodor's wife, is now silenced by the scriptwriters rather than by other characters, something that becomes quite apparent in the movie since there is too long an audible pause after her incomplete sentence ("One moment, Papa, I . . .") before Theodor ostensibly "interrupts" her. What may originally have been her comment is now voiced in weakened form by the lawyer's wife, Frau Übelhack, an outsider to the Rose family.[21]

Where Is Home?

As visualized by the film, the options that the family members debate are articulated only theoretically. Despite disagreements within the extended family, the house on Lilac Road has already clearly emerged as semiutopian. The Roses are not poor: Grandfather Rose invented some pharma-

ceuticals and made money from patents; Theodor is not a terribly successful producer and would love to get a financial injection from the wealthy but difficult spinster Aunt Wally, but the multigenerational family lives well and manages to employ a cook and a maid. The publicity materials call the family "patrician," and they do enjoy the company of doctors and lawyers. The house is spacious at a time when that was rare in Germany, and the family doctor proclaims in his birthday toast for Helene that the family may rejoice at being in a position that no housing authority can interfere with (the *Wohnungsamt* assigned living spaces to refugee families in houses that were considered to have spare rooms after the war), and that no intruders (*Eindringlinge*) have to be feared any more. Is Toxi (who is first seen outside the house just when the word *Eindringlinge* is spoken inside) such an intruder, or can she be integrated into the happy home where most of the film is set? The mood of 1945 has disappeared—or has been covered over—as the film *Toxi* presents the viewer with a flowery road in an apparently undamaged, or completely restored, city and focuses on a bourgeois family that does not have to mourn any human losses, can enjoy freedom from want, and has to confront only the possibility of adopting a child as a test that the race problem can be looked at with new postwar eyes.

One alternative to adoption that the movie mentions but does not act on is police arrest followed by assignment to social services. The police inspector Plaukart (Willy Maertens), who comes to investigate the matter of Toxi, is simply too kind a figure. However, the film does visualize Toxi in one of the city's orphanages after Grandfather Rose suffers a heart attack and gives in to Theodor. And near the end of the film, when Theodor tries to bring Toxi back to the orphanage but loses her, we see her walking around in the big city all day until a pseudofamily of circus entertainers picks her up with the intention to abduct and exploit her. These are scary alternatives indeed to being welcome in the home of the Roses.

A stark counterimage to the family home is the Kinderheim Nordland, the orphanage. Though it is a clean, well-lighted place, and the supervisor (Katharina Brauren) and nurse (Gertrud Prey) seem caring and professional, it still comes across as the embodiment of collective homelessness. There are about twenty-four children in the playroom, many of them mixed-race, grouped around three round tables, and at the Grandfather's visit, a full children's chorus sings, "Ich möcht so gern nach Hause gehn" (I would like so much to go home), the song that, we are told by one

Toxi: **Kinderheim Nordland, with Grandfather Rose (Paul Bildt) and Toxi (Elfie Fiegert).** *DVD screenshot.*

of the children, they learned from the mixed-race girl Tabita but that became widely known simply as *Toxi-Lied* (Toxi song):

> I would like so much to go home, aye, aye, aye,
> Would like to see my homeland again, aye, aye, aye.
> Alone I cannot find my way, aye, aye, aye,
> Who'll like me and take me along, aye, aye, aye?
> I am so alone, don't hear a loving word,
> So strange are the alleys. Why can't I go away?
> Can no one understand my heart, aye, aye, aye?
> I would like so much to go home, aye, aye, aye.

Michael Jary composed this song for the film with a text by Bruno Balz that Toxi sings another time, incongruously during a Three Kings pageant with the Jenrich children. The complete tune is heard fully orchestrated as a kind of overture during the credits, and its motifs recur orchestrally in other peak moments of the film and at its ending.[22]

Where *is* the children's home? Where is Toxi's *zu Hause?* The film, embodied and intensified by this song, asks its viewers this question—a

question particularly poignant at a time when home, *Heimat*, was problematic to millions of Germans. The story of the Fiegert family appealed particularly to the large refugee population in postwar Germany: Silesian expellees from Breslau who had lost a child, their home, and the movie theatre where Fritz Fiegert had worked as a projectionist, they had found a new home in rural Bavaria and adopted the girl who would become famous as Toxi. The journalistic accounts of the Fiegerts' story thus resonated with other postwar sagas of reconstituted families. After the loss of her own child Gertrud Fiegert reportedly underwent depression, and a doctor suggested: "What you need is someone to take care of again! Then your depression will subside!" When she saw Elfie "lying so sadly" in the "little institutional bed" of the orphanage, she thought, "Why not a moor child! She surely doesn't have an easy time of it and will need much love and someone to help her."[23] Elfie Fiegert/Toxi was thus represented as suited to heal the adoptive mother's depression caused by a loss, and particularly so despite (or because of?) her difference.

Is a child's difference in skin color really as important as Theodor believes? In order to address this question, the filmmakers, publicists, and reviewers of the early 1950s loved to focus on skin color in all kinds of ways—some good, some not so good. Together with Toxi, the Jenrich children read "Die Geschichte von den schwarzen Buben" (The story of the inky boys) in the famous (and scary) nineteenth-century children's book *Struwwelpeter*, the episode in which Santa Claus dips three mischievous German children in ink as punishment for making fun of a blackamoor, thus turning them blacker than the Moorish child. [*When I was a small child my mother recited to me and made me memorize the entire* Struwwelpeter, *which is written in verse.*] On the way to the orphanage, a white boy sticks out his tongue at Toxi, in clear reaction to her difference in color, which she reciprocates by sticking out her tongue three times. Inspired by Toxi, Herta's friend, Robert, starts a chocolate advertising campaign with a Moorish theme—from the realm of the imagination somewhere in between Sarotti chocolate and *Imitation of Life*.[24]

It seems to take on significance later on that the Jenrich children yearn for chocolate at the very beginning of the movie. Ilse and Susi are also most welcoming toward Toxi and accept her enthusiastically, like a sister, but at Susi's birthday party Toxi is the target of some of the other children's prejudices, is excluded by one slightly older and particularly racist

girl from playing with the others, from eating the birthday cake, and from touching a toy, and is also subjected to that girl's heartless comment: "You don't need a *Mohrenkopf*, you have one yourself." ("Du brauchst ja keinen Mohrenkopf, Du hast ja selber einen.") Mohrenkopf, literally meaning "moor's head," was a popular chocolate-covered marshmallow that was also known in the 1950s as *Negerkuss* (Negro kiss) and is now called *Schokoladenkuss*. This exclusion and the meanness of the remark make Toxi leave the party, sit on the stairs, and cry.

The theme of the consumption of chocolates and other sweets was enthusiastically picked up in the intense press coverage of the film, and the scrapbook in the Stemmle Archive contains numerous headlines of articles as well as photographs and stories associating Toxi with *Mohrenköpfe* and chocolate bars and ascribing not only to the character but also to the actress an unusually great appetite for sweets.[25] The press kits included the cameraman Igor Oberberg's story that he needed to find a second Mohrenkopf that matched the color of the first one he had given Toxi to eat during the shooting of a scene. Yet it proved hard to find another exact color match, so that he ended up buying 120 *Mohrenköpfe*—of which Elfie Fiegert supposedly ate twelve!

Toxi is clearly a "sweet" girl, and soon viewers guess that it is only a question of time until Toxi will be accepted in the Roses' home. Theodor's opposition to Toxi is easily overcome by her lack of guile, her pure goodness, her politeness. And indeed, the film shows Jenrich's conversion. Hard-hearted bigot though he appears to be at the beginning, he does have a conscience, and he realizes that he has come to like Toxi so much that he would find it hard not to have her in the house anymore: he changes, as the publicity folder for journalists put it, "from Saul to Paul."[26] It is significant that Jenrich's conversion occurs during the time he spends alone with Toxi. In her company he suddenly loses his backache and learns that he, too, can look at the "race problem" with new eyes and can recognize Toxi as a human being and not as a racial abstraction.[27] In a sequence that seems to literalize lines from the Toxi song ("Alone I cannot find my way," or "So strange are the alleys"), Toxi gets lost in the city of Hamburg, surprisingly shown in long sequences without any visible ruins anywhere, she ends up with circus entertainers who virtually try to kidnap her, and she sings the *Toxi-Lied* another time in their wagon. Ironically, it is Jenrich who is searching for her desperately and who is visibly happy and relieved

to find her with the help of the efficient police and to bring her back home at the end of a long and worrisome day. Now that the melodrama seems to have run its course, all obstacles have been overcome, and the badness in Theodor has been removed, we expect an extended scene of a happy family integration with Toxi, like a multigenerational Christmas party—which the pageant of the Three Magi that the children perform for the adults promises, with Susi, at her own request, in blackface as the Moorish king, and with Toxi in whiteface.

A Deus ex Machina Ending

Near the end of the movie, then, everyone expects Toxi to become a full part of the Rose family—the only exception being Wally, the wealthy and haughty sister of Grandfather Rose, from whose money the family is now independent since Grandfather Rose is selling some of his patents to make Theodor's firm solvent again. It therefore comes as a sharp surprise to viewers, and as a jarring experience to every member of the Rose and Jenrich family, when Toxi's tall black father James R. Spencer (Al Hoosman) suddenly rings the doorbell (exactly at the word "Mohrenland" in the Three Magi pageant) and comes into the house together with Toxi's grandmother, Frau Berstel. He speaks English, strangely identifies himself as Toxi's father by displaying an American passport, and says that he has searched for Toxi everywhere and is so happy to have found her. No dramatic exchange between foster family and blood father or between blood grandmother and blood father emerges, as one might have expected at this moment. It is interesting that the original script let Theodor Jenrich articulate an emotional opposition to Toxi's departure with a true convert's zeal: "That will not do." But the shooting script no longer lets Theodor voice that sentiment and has only Grandfather Rose, ever a representative of the reality principle, tell his ex-racist son-in-law: "I would have liked to do something for one of these children. Given one a home. But now the real father has come. There is nothing we can do about that. No, no, Theodor. Even though we'll be missing her."[28] (In the film, this direct address to Theodor was also omitted.) We must accept that Spencer (who operates a gas station, Frau Berstel reports) will now take Toxi with him to America. BANG!

The Rose residence is threatening to feel empty with Toxi's imminent departure. Can Toxi really go away just when everyone, the film's audience

Toxi: **Daddy and Toxi. James R. Spencer (Al Hoosman) and Toxi (Elfie Fiegert).** *DVD screenshot.*

included, so much wants her to stay with the Roses in the house on Lilac Road? The film says yes, and Toxi, still in whiteface from the pageant, tells her daddy that the face paint will come off—and, as if to prove (rather unconvincingly) that America is her real home, she starts counting in English (with a strong German accent) until the crescendo of the orchestral Toxi-song motif makes her voice inaudible and leads to the surprisingly quick appearance of the capital letters ENDE on the screen.

Of course, viewers may realize at this point that in the text of the Toxi-song "Ich möcht' so gern nach Hause geh'n," this "going home" may not just refer to a child being found after getting lost alone in a big city; but it may also imply that Toxi—and, by extension, children like her—cannot ever feel at home in Germany: "So fremd sind die Gassen. Warum kann ich nicht fort?" (So strange are the alleys. Why can't I get away?). Can Toxi have a home in Germany or is her natural home elsewhere? It is strange that the question of whether or not Toxi is adopted by the Rose family, which made up much of the drama and the meaning of the film and constituted the center of Theodor's happy conversion experience, is so abruptly dropped at the end, literally in the last three minutes of the film, without much warning.[29] (Meanwhile, all subplots are resolved:

Grandfather Rose and Theodor are fully reconciled; Theodor's conversion will be durable, and the Jenrichs' finances will be on a firmer footing; Robert's advertising campaign will obviously flourish, and he and Herta will undoubtedly get married; the kind police inspector Plaukart and the new cook, Anna, seem to be getting along cozily; Frau Berstel's operation has gone well; and so forth.) One also wonders whether America will live up to the expectation of being Toxi's real home—where language, people, and streets will surely be strange to her, not to mention Jim Crow practices of the early 1950s.

Some contemporary reviewers and the later secondary literature complained about the deus ex machina quality of this ending and voiced dissatisfaction with the way the film's serious issue was derailed by it. Most notably, Arianna Giachi complained in 1952 that the film was philistine kitsch that only played with the audience's sentiments and that even the family's final decision to keep Toxi has no serious consequences because of the sudden reappearance of her father.[30] In 1982 Rosemarie Lester found the solution of the problems "cheap" in that "the chic brown *deus ex machina* relieves the chic white patrician family finally of any responsibility to act."[31] In 1999, Leroy T. Hopkins judged the film to be the result of a "wedding of pity, melodrama and a total ignorance of the social implications of race" and noted that the "problem of dealing with Toxi's otherness on a level other than that of an emotional response to a nonthreatening child is removed by the arrival of her father, deus ex machina, to take her with him. The problem of dealing with an adult Toxi who might marry into the family is thus avoided."[32] And in 2005, Yara-Colette Lemke Muniz de Faria argued that the film's attempt to decrease prejudices in the German population failed because of its simplification and falsification of problems. "As solution to the problem, Toxi's father appears and takes her 'home.' Toxi, already taken in by a German family, will not remain in Germany. In making that choice the biological connection to a father who is a complete stranger to her is less decisive than the conviction that this child 'naturally' belongs to her black father, is better off living with black people, and 'properly' should live there and not in Germany."[33] The ending of the film with a G.I.'s withdrawal from German society also neatly synchronized with the return of German sovereignty and the new possibility of paternity suits against American soldiers.[34]

Since the ending has been so central to ideological critiques of the movie, it is worth following Angelica Fenner's lead, for she has shown that the final film version eliminated an additionally planned sequence that still appeared in the shooting script in which Grandfather Rose goes back to the Kinderheim and adopts the mixed-race girl Tabita, who had taught the other children the Toxi song, who loved to rip off buttons, and to whom Toxi had surrendered many of her own buttons. In the original script, this ending included no new dialog and was a short, three-page addition to a 224-page text. It shows Toxi giving Grandfather Rose a "butterfly kiss" with her eyelashes, as she has done before, but this time as a final good-bye. This is followed by a view of the empty house, the door of the Kinderheim opening, and Grandfather Rose emerging, holding hands with Tabita who is once again trying to rip off a button from his overcoat. Grandfather Rose reaches into his pocket, pulls out a whole handful of buttons, and gives them to Tabita who is jumping with joy at such bounty—as the orchestral Toxi song motif returns and the camera swerves to the window of the Kinderheim where the noses of the other children are pressed against the window pane and the word ENDE appears above them.[35]

Whether this last scene was sacrificed because of time and financial constraints after the transfer of the project from Real- to Fono-Film or whether the cut was made as the result of Stemmle's decision or a story conference late in the game, the effect of the ending would have been rather different had the Tabita plot been added to the released film. Its surprise might have been somewhat mitigated simply by giving viewers more film time to digest the news that Toxi would be going home to America (where, of course, she has never been). Then the Tabita ending would have invited a more explicit strengthening of the general adoption theme that went beyond the acceptance of Toxi alone. Of course, the longer ending might also have tempted audiences to think of Toxi/Tabita generically rather than as specific children who are characterized rather differently in the film, Tabita being mischievous, hungry for buttons, and ready to tear them off people's clothes, and Toxi being such a model of polite behavior. One also wonders whether the audience would be more readily mobilized toward the film's issue of racial difference and integration by ending with the loss one feels at Toxi's departure or by the prospect that another child can quickly be found among the *Besatzungskinder* to take Toxi's place.

Does a viewer react more strongly to the representation of an absence or of a real possibility, to a specific promise that is withdrawn or to one that is fulfilled by a substitution? In any event, the ending of the film *Toxi* with the surprising arrival of the child's real father is another version of the dream of a G.I. father coming true.

In criticizing the film, it seems futile to belabor the many stereotypical associations with chocolate that *Toxi* articulates and provokes. The Roses' maid's exclamation "ein Schokoladenmädchen"—with the same sense of surprise that a black market customer expresses in Billy Wilder's *A Foreign Affair* (the subject of the next chapter) when he shouts, "eine Schokoladentorte"—voices not only a colonial cliché but also a desire for chocolate as a particularly precious delicacy in the postwar years. It is more remarkable that Stemmle's film (in contrast to the mixed-race Louise in Hans Habe's novel *Walk in Darkness*) represents Toxi not as the child of a daughter in the German family that is at the center. She is not the real grandchild of Grandfather Rose and she is not Theodor's niece—a plot choice that is inadvertently highlighted by Toxi's calling everyone by kin names, like "Großpapa" or "Onkel Theodor." Although mixed alliances were not that uncommon at the time, and were, in fact, part of the very reason that the film was made, Toxi's mother never appears, not even in Toxi's memories, and we learn only of the cold fact of her death. Toxi answers a question about her with the brief statement that she is "with the heavenly father." The laconic one-liner by Frau Berstel is no more informative: "Meine Tochter ist gestorben. . . . Ich muss ihm [Toxi's Vater] schreiben, dass meine Tochter tot ist" (My daughter died I'll have to write him [Toxi's father] that my daughter is dead). And in case the viewers' sympathy with or curiosity about Toxi's mother should be raised by this fleeting remark amidst other woeful Berstel news, Anna responds with a comment that seems as inappropriate as it is likely to make the audience self-conscious that they are watching a form of fiction: "Manchmal ist das Leben wirklich wie ein Roman" (Sometimes life really is like a novel). The film lets Toxi's mother be dead for an unexplained reason and for a contradictory time period—Frau Berstel makes it sound as though it has just happened, but Toxi seems to have no memories of her mother to share, making one think that she must have died quite some time before the action of the film sets in. Could her butterfly kiss be a subdued trace of an otherwise suppressed maternal presence in her life?[36]

By having the mother dead, the film avoids directing the viewers' imagination toward the union that led to Toxi's birth, which seems (very vaguely) imaginable only in the working-class milieu of the Berstels, and even there, the actual mother cannot be shown, or fully remembered, as it seems.[37] The notion that a young German middle-class woman could be allied with a black soldier seems so unthinkable that the younger Rose daughter, Herta, can only laugh out loud when she finds out that her Aunt Wally assumes that Herta must be Toxi's mother: after all, Herta has worked for the Americans (though Hamburg was in the British zone) and knows English. Laughing off the possibility of real kinship of a mixed-race child with an allegorical German patrician family would seem to make the adoption theme more plausible but would from the outset identify what were after all children of German mothers not as family members but only as possible objects of familial adoption.[38]

In that respect, it is interesting to consider the reportage on the film in American Negro weeklies, which showed Elfie Fiegert flanked by Al Hoosman and Ingeborg Körner (the film's Herta) with such a vague plot summary that it simply invited viewing the three as a family: "Al Hoosman, Los Angeles heavyweight boxer, who is now a resident of Frankfurt, Germany, is shown with German actress Ingeborg K[ö]rner and Elfie Fiegert who plays the title role in 'Toxi,' a German film in which ex-bruiser Hoosman is the male star. The story depicts the life of a German Negro girl. Little Elfie is the daughter of an American Negro GI and a German fraulein. The photo was made when Hoosman and fellow players gave a reception for 50 German orphans on the occasion of the film's premiere."[39] What the *Baltimore Afro-American* and the *Norfolk Journal and Guide* obliquely implied as a possibility was, however, what the film actually deemed to be outside the realm of representability.[40] The price Toxi has to pay for the film's plot choice, is that she is, indeed, a motherless child, a long way from home.

Since it has often been noted that the movie was supposed to help increase German tolerance toward colored people, it is remarkable that not even Elfie Fiegert seems to have benefited from the film *Toxi*. Despite all the popular attention she received in 1952, she played only one more major role, then had a few bit parts before her career as an actress came to a halt—despite the claim in the publicity materials accompanying *Toxi* that she was a natural actress and the prediction that she would have a great career.[41]

Yet another critique could be voiced. By directing the audience (and many reviewers and later critics) to think about mixed-race children in terms of adoption rather than of real family membership, by defining the problem of integrating a super-German, clean, polite, and Christian—but not completely white-skinned—girl into a German middle-class family as a racial problem, *Toxi* also distracts from a clearer view of the society into which Toxi, the innocent occupation child, is to be integrated. When one thinks of the tally of the Bundestag in 1950 (when 53 of 403 members of parliament were ex-Nazis) and wonders about the reconstruction of the German film industry after World War II, one is tempted to take a closer look at the whole Realfilm/Fono-Film crew that participated in creating *Toxi*.[42] With the help of the Internet Movie Data Base, the continuity from the Nazi period to the early Federal Republic becomes instantly and easily recognizable. The director Robert Adolf Stemmle (1903–73) became an UFA director in 1935 and made such Nazi films as *Quax, der Bruchpilot* (1941) and *Der Mann, der Sherlock Holmes war* (The Man Who Was Sherlock Holmes, 1937), in which Paul Bildt (in *Toxi*, Grandfather Rose) played Sir Arthur Conan Doyle and Ernst Waldow (in *Toxi*, Tante Wally's old flame Übelhack) had the part of a hotel detective. The Russian-born cameraman Igor Oberberg, whose work was highlighted with his dramatic upward shots of the "race problem" scene in *Toxi*, started his German film career in 1939 with *Kongo-Express* and made such movies as *G.P.U.* (The Red Terror, 1942) and *Die unvollkommene Liebe* (Imperfect Love, 1940), in which Paul Bildt and Erika von Thellmann (*Toxi*'s Frau Übelhack) played parts. In another Nazi film, *Rembrandt*, edited by *Toxi*'s editor Alice Ludwig, Wilfried Seyferth (in *Toxi*, Theodor Jenrich), Erika von Thellmann and Elisabeth Flickenschildt (Tante Wally) appeared together; in *Madame Bovary* (1937), Paul Bildt and Katharina Brauren (the director of the orphanage) could be seen together; *Ein Mann mit Grundsätzen* (A Man with Principles, 1943) was written by Maria von der Osten-Sacken (who, having shed the "von der," also co-authored the script for *Toxi*), and Ernst Waldow (Übelhack) was among the actors. In fact, among the actors of the older generation, only Willy Maertens (the police inspector) and Lotte Brackebusch (Frau Berstel) were genuine "postwar" actors; most of the others knew each other from films in the Nazi period.

The composer of the Toxi song "Ich möcht so gern nach Hause gehen" was Michael Jary, who contributed the music for thirty Nazi films, among them such Zarah Leander wartime hits as "Ich weiß, es wird einmal ein Wunder gescheh'n" and "Davon geht die Welt nicht unter" ("I know, a miracle will be happening" and "The world won't go under from this," both in the 1942 film *Die große Liebe*), and both songs were extremely popular as *Durchhaltelieder*, perseverance songs that reaffirmed and strengthened the German war effort after the Allied bombing had started. The lyrics for both of these songs were written by Bruno Balz, who also penned the words for the Toxi song. Paul Bildt, the actor playing the humane Grandfather Rose who suggests that his son-in-law look at the racial problem with new eyes, acted not only in *Die große Liebe* (as an unfriendly head waiter) but also played the more important part of the rector in the outrageous 1945 Nazi propaganda film *Kolberg*. And director Stemmle shot the film *Am seidenen Faden* (1938), described in the secondary literature as an anti-Semitically toned propaganda film in which Paul Bildt (Grandfather Rose) plays the banker Brogelmann and Wilfried Seyferth (in *Toxi*, Theodor Jenrich) appears as a salesperson of the Hellwerth company.[43]

One wonders whether in the key scene in *Toxi*, when Herta defends Toxi by saying "the child can't be blamed; such a child is innocent," one could say the same things about the adult actors. One also wonders whether there must not have been an implicit acknowledgment of the earlier Stemmle films and of the widely-shared Nazi past in some of the actors' off-screen interaction during the filming of *Toxi*. However one wants to interpret the ending, there is no doubt that the film family in which Toxi's integration is presented as a serious problem because of Toxi's difference in color has itself deep and extended roots in National Socialist film history, roots that remain unnamed. Does tolerance toward a darker-skinned child redeem German society of its legacy of anti-Semitism and genocide, does it resolve the Rassenproblem? Contemplating these palpable continuities with Nazi Germany one is almost tempted to think of the Rose family speaking the famous chant from the 1932 horror film *Freaks*: "Gobble, gobble, one of us, we accept her!"

As one stares into this abyss, one finds that there is yet a deeper sense of horror embedded in it, making it glib to cast individual aspersions on people who lived and worked in a state in which basic human rights were

suspended for twelve years, for whom "the state of exception" was a tyrannical reality. Thus Bruno Balz (1902–88) was reportedly arrested for homosexuality by the Gestapo and tortured in 1941; as such, even though he had written the texts of the songs for the Nazi propaganda film *Die große Liebe*, songs famously sung by Zarah Leander that most Germans would have recognized in the 1940s (and remembered in the early 1950s), his name could not appear in the credits. Michael Jary (1906–88), born Jarczyk in Upper Silesia, whose compositional style was attacked by Nazis in 1933, helped Balz get out of Gestapo arrest.[44] About Paul Bildt (1885–1957), the man who played Grandfather Rose, we know that he was endangered as "jüdisch versippt": he had married Henriette Friedländer (1885–1945), a Jewish actress whose stage name was Lotte Frei, on November 27, 1928, and remained married to her throughout the entire Nazi period. In 1938, the *Reichsfilmkammer* added this racial information to Bildt's secret file under the heading "Marriages with Jews and Jewesses as reason for dismissal, with a list of actors and actresses (Albers to Wüst)" and ending with the instruction that this information must neither be shared with Bildt nor copied or photocopied.[45] Hence Bildt, in the crosshair of racial purity surveillance, apparently tried to protect his wife and their daughter, Eva, through his active film work, which included participating in propaganda films like *Kolberg*. Bildt's biographer writes that Henriette Bildt died of cancer on March 6, 1945. Upon the arrival of the Russian army in Berlin in April, Bildt and his daughter wanted to commit suicide together and took an overdose of Veronal. She died; he survived.[46] There may be other haunting Nazi and postwar stories in the backgrounds of further participants. Tales of the 1940s!

Alternatives to *Toxi?*

Before condemning and completely dismissing the film in hindsight—it is so easy to write an ideological critique and so hard to create art and criticism more fully expressive of utopian possibilities—one has to marvel at the fact that the film was made at all, and also that it was the only one made in Germany, or the United States, for that matter, to make the story of occupation children a central theme.[47] It also departed markedly from some of the more outrageous ways of discussing mixed-race children at the same time.

[*For what it is worth, I saw the film at age nine, shortly after it was released and, as a result of seeing it, wanted my parents to adopt a child just like Toxi. We were, like the Fiegerts, Silesian refugees, which may have enhanced my identification with the movie, and the fact that we were living in one single rented room at the time did not stop me from wishing to have an adopted sibling. The film program that I kept for many years gave the film the subtitle "Die Geschichte eines Mulattenkindes." And of the hundreds of films I saw before turning fourteen, Toxi was one of which I have retained unusually strong memories, having also never forgotten the Toxi-Lied.*

To stress what makes Toxi distinctive I might also mention that one of my early recollections is of a Rosenmontagszug, *a carnival parade, in Mainz, in the French zone of occupation. I believe it was the first carnival after World War II. There was a float of* Schwellköpp, *people with gigantically enlarged headmasks, representing a family: a black father in military uniform, a white mother in a dress, and some children, one checkered, one speckled (gesprenkelt), and another one striped black and white. I was absolutely mystified by this aspect of the parade, which was meant to be humorous (it was carnival, after all), and perhaps here lies a deep origin of my interest in interracial family symbolism. When I wrote to the Stadtarchiv and Fastnachtsmuseum in Mainz, hoping that there might be a photograph of this particular float, I was told that there was none. However, in researching this chapter, I was prompted by a footnote in the book* Farbe bekennen *to examine a West German parliamentary debate from 1952 in which the future of mixed-race children was discussed, at times quite troublingly. And there I found a Christian Democratic member of parliament, Frau Dr. Luise Rehling, arguing that this was a German question, and that while it was important to direct the German public's attention to this issue, it was "completely unacceptable to direct public attention to it in the way it happened in a city where one could see during carnival a Rose Monday float with the inscription 'Made in Germany.' On it stood German children, made up as Mulattoes. Such a thing one can hardly describe as mere tastelessness." Here another Christian Democratic member of parliament, Margarete Gröwel, interjected: "Incredible!"[48] By comparison to such contemporary public representations in Germany,* Toxi *was, indeed, a breath of fresh air.*]

With all the critiques she launched, Rosemarie Lester still asked her readers to keep in mind at the end that it was "really important in 1952 to place a larger-than-life 'colored occupation child' in the center of public attention."[49] And public attention the film did get. *Toxi* was among the ten

most popular West German films of the year 1952; it ranked eighth among nearly five hundred German and foreign competitors released that year.[50] While there were a few critical voices among the reviewers, some pointing out that the stories of the children Toxi was meant to represent were beset with so many more serious problems, the response was over-whelmingly positive, generating even a *Spiegel* cover story for Robert Stemmle.[51] Marie Nejar (the singer known by the name Leila Negra who recorded the *Toxi-Lied*) wrote in her memoirs that the true story of Elfie Fiegert (whom the older Negra met) would have made a better film but she still found the film acceptable for its time and added that it probably prevented a few people from expressing their less tolerant views in pub-lic.[52] As a symbolic figure derived from a 1952 film and with a name whose origin has never been explained, Toxi has remained amazingly present—whether in the plural form of "all Toxis" that we saw being used to refer to occupation children generally or in other echoes. Thus the 1992 novel *Afra* by Eva Demski traces the story of a postwar occupation child from rural Bavaria through the decades, and at some point she is referred to as Toxi by a couple from the city, and more allusions to the film follow that are not explained—so that the author must have assumed that German readers in the 1990s were still familiar with the figure Robert Stemmle's film had created four decades earlier.[53]

It is perhaps also worth noting that contemporary American reactions seemed to have been divided along the color line: the *New York Times* no-tices of *Toxi* were a brief plot summary of the film about a "poignant" subject and a more critical, equally brief comment on the film's dealing "with an important problem in a somewhat heavy-handed manner" so that it "can only be described as corny at times."[54] By contrast, the African American press gave lavishly illustrated, detailed, and appreciative plot summaries and reports on *Toxi* with much emphasis on Al Hoosman and Elfie Fiegert.[55] (Of course, American films of the postwar period typically used white actors to play the roles of mixed-race characters.) An Ameri-can showing of the film in the Christmas season 1953 was announced in the *Norfolk Journal and Guide*.[56] The *Amsterdam News* mentioned "hand-some heavyweight" Hoosman and applauded Fiegert for being a "beautiful and loveable child with great acting ability," praising *Toxi* for "portraying the plight of the 'occupation children' without fathers . . . with finesse and a touch of poignancy" and summing up that *Toxi* was "the story of children's

love for each other transcending color lines."[57] The *Baltimore Afro-American* devoted a full front page to a photo montage of scenes from the film and a very detailed account of the plot under the headlines "Brown Baby Film is a Hit" and "Toxi: The Story of a War Baby Nobody Wanted Is Cheered in German Theatres," reprinting more or less the entire Allianz-Film-publicity-generated plot summary. On the page on which the long article concluded, accompanied by a photograph of Elfie Fiegert, the paper called attention to German orphans "getting a helping hand of sweets from Airman James Clukies, 2nd Radio Squadron" at a party in Darmstadt "for German orphans in connection with the new film. U.S. soldiers were escorts for the tots."[58]

Like so many tales of the 1940s, the story of *Toxi* was hardly a story documenting the success of the Allied occupation but rather a melodrama of one of the problems the occupation had helped to create. The connection of *Toxi* with the issue of adoption remained in the public debate, and while it may be doubtful whether there was an uptick of German adoptions of occupation children following the release of *Toxi*, the discussion of that topic intensified on both sides of the Atlantic, all the more so since Al Hoosman, inspired by his role as Toxi's father, took up the cause and became widely known in Germany and the U.S. for his campaign to find foster parents to adopt German occupation children and orphans.[59] He launched this campaign at first on his own, but after getting much publicity for smuggling the colored girl Rosemary Kubik out of East Germany, he managed to receive West German governmental support in 1958. He founded Hilfe für farbige und elternlose Kinder, an organization to help colored and parentless children.[60] Hoosman remained in West Germany and appeared in a few more films, including the occupation melodrama *Town without Pity* (1961). He died in 1968 and is buried in München. One may well say then in conclusion that the film *Toxi* changed at least one person's life.

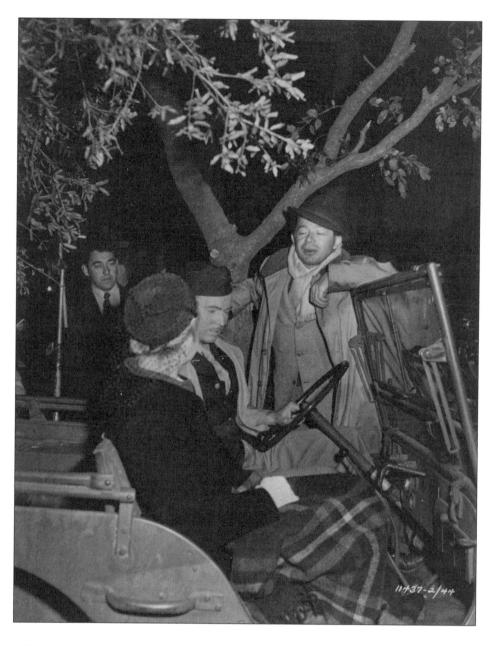

Billy Wilder on the set of *A Foreign Affair.* *Paramount publicity photograph at Margaret Herrick Library,*
11437-2/44, © Universal Pictures/UniversalClips.com.

August 20, 1948 / May 6, 1977

A Paramount film comedy set in postwar Berlin is released in the United States and, twenty-nine years later, shown for the first time in Germany

Heil, Johnny

Billy Wilder's *A Foreign Affair*; or,
The Denazification of Erika von Schlütow

Amidst the ruins of Berlin
Trees are in bloom as they have never been
Sometimes at night you feel in all your sorrow
A perfume as of a sweet tomorrow
That's when you realize at last
They won't return
The phantoms of the past
A brand new spring is to begin
Out of the ruins of Berlin

—Friedrich Holländer, "The Ruins of Berlin"

The Berlin entertainer Erika von Schlütow is a loose woman, compromised by her past. At 11:00 A.M., she is still in bed in her ruined apartment and lets her derrière cover the U.S. Army stencil on the blanket she has procured by fraternizing with Captain John Pringle. When John asks about her mismatched pajamas—"How the heck does anybody lose the top of the one and the bottom of the other?"—Erika wisecracks, "Johnny, you didn't know the Nazi party," as if it had been some kind of pajama party. In the Lorelei, the nightclub of ill repute where Erika performs, she raises "her silken buttocks to the piano." "A Rhine maiden, a Valkyrie—but a maiden who had gone off the deep end, and a Valkyrie who had ridden the

wrong way," she was an "active Nazi from 1935 until the end of the war" and wears "a dress that must have been pillaged from Schiaparelli the first day the Nazis took over Paris."

When the Iowa congresswoman Phoebe Frost, who has come to Berlin on a congressional committee investigating the morale of American troops feels manipulated by Erika, she asks bitterly, "What is this? Munich all over again?" Erika is not just a woman, then, but an allegory of postwar Germany, deeply compromised by its Nazi past. At times, John's attraction to Erika seems to be fired up by such associations. Her kisses make "his young . . . heart reverberate like the brass section playing the Overture to Tannhaeuser," and having admitted to her that he cleared her Nazi files with his own signature, John asks, "How about a kiss now, you Beast of Belsen?" That term, "Beast of Belsen," circulated widely in reference to the Bergen-Belsen concentration camp commandant Josef Kramer and the sadistic female camp guard, Irma Grese, both of whom were sentenced to death and executed in 1945.[1]

A Valkyrie Who Has Ridden the Wrong Way?

For audiences familiar with Erika von Schlütow from Billy Wilder's film *A Foreign Affair,* this portrait of her seems wildly incongruous, for this is Erika as she appeared only in an earlier story treatment and in a precensorship script.[2] In later stages all these passages were deleted, and in Wilder's film John Pringle addresses Erika not as "Beast of Belsen" but as "gorgeous booby-trap," which he follows up with a shout of delight, "Ya-hoo!" Eisenhower had reportedly referred to European prostitutes as "booby traps," and added: "More men were knocked out by this variety than by the real article."[3] In short, Erika's German allegory changed from a scandalous and opportunistic Nazi whom John can happily leave for an American woman to an irresistibly attractive femme fatale who simply had, and still has, to make some compromises.

What accounts for this dramatic transformation? In 1945, Billy Wilder had proposed "Propaganda through Entertainment" to the Information Control Division (ICD) of the American Military Government, arguing that the novelty of showing newsreels and documentaries to German audiences had worn off and offering to make an "entertainment film" instead that could be "a very special love story, cleverly devised to help us

sell a few ideological items."[4] What did he have in mind, and how does it relate to the film that emerged from this proposal? Which "ideological items" did the 1948 movie ultimately sell?

We can find some answers in story lines proposed, considered, and discarded, remnants of Paramount-owned plots, fresh materials, revisions, and concessions made to censorship requests—a confusing array of sources that have left residual traces in the film. This genesis also makes it difficult to date the time of the action with any precision. The film was proposed in August 1945 and released in August 1948, and its time frame seems to move freely within that three-year span. A reference to "Empire Day" would seem to establish May 24 as the date of arrival of the delegation that stays in Berlin only for a short time. The very active pursuit of the American denazification campaign, a reference to the Nürnberg trials (which started in November 1945), and the fact that the end of the ban on fraternization seems to be recent would point to some time in 1946. Yet there is the sense of a longer time frame: John has not had home leave for four years, the occupation seems to have been in place for quite some time, and Plummer, the colonel in charge of the congressional delegation, says that the first free Berlin elections had been held—and that was on October 20, 1946—so one has to think more of 1947. An indirect allusion to the Marshall Plan, first articulated June 5, 1947, would date the time of the action even later. However, the American-Russian joviality does not yet have a Cold War feeling to it, and the black market is in full swing so that it probably is not yet 1948, just before the introduction of the D-Mark and the subsequent Russian blockade of Berlin that would change everything.

An Alternative to Suicide

Wilder's original plot outline—"a very simple story of an American G.I. stationed here with the occupational troops and a German . . . Frau [whose] husband, an Oberleutnant in the Luftwaffe, has been killed in action over Tunisia"—was, he explained to the ICD, inspired by a chance encounter in Berlin with a woman clearing rubble on Kurfürstendamm in August 1945 (mentioned in my Introduction). "I had thrown away a cigarette and she had picked up the butt," Wilder wrote, and a conversation ensued in which the woman said casually that she would turn on the gas,

once it was working again, but not light it. "Why? Because we Germans have nothing to live for any more." Wilder responded, "If you call living for Hitler a life, I guess you are right," then offered her a brand new Lucky Strike that she did not accept. Instead, she went back to clearing rubble. This encounter with despair inspired Wilder to make the proposal to shoot his film. "Right here in this piece of dialogue is the theme of the picture, and here is the simple ending I want to arrive at: when the gas finally is turned on our German Frau strikes a match to cook her dinner, a few measly potatoes I grant you—but now that a few facts have dawned on her she has 'something new to live for.' This is what the film should state (in Eisenhower's words): 'That we are not here to degrade the German people but to make it impossible to wage war'—and in the end 'let us give them a little hope to redeem themselves in the eyes of the world.'"[5]

Whether Wilder's proposal to film the story of a depressed German war widow could be turned into an Eisenhower-inspired contribution to "Propaganda through Entertainment" is questionable. It seems more in keeping with Billy Wilder's extraordinary ability to create bittersweet film comedies as a way of fending off thoughts of suicide or death. When the project ultimately turned into a Paramount film, Wilder's old friend, Erich Pommer, extended his help.[6] Pommer was the erstwhile producer of Josef von Sternberg's 1930 film *The Blue Angel* (starring Marlene Dietrich) and of Robert Siodmak's 1931 Berlin film *Der Mann, der seinen Mörder sucht* (A Man in Search of His Murderer), for which Wilder had served as a scriptwriter, and he was now the Film Production Control Officer of the ICD, a position he had apparently assumed at Wilder's recommendation.[7]

Billy Wilder was born in 1906 into the Jewish family of Maksimilian and Eugenia Wildar in Sucha, a Galician village near Kraków (which was then Austrian), went to school in Vienna, and wrote scripts for, and then directed, several films in Berlin, one in Paris, and many more in the United States. He was not yet forty and at the peak of his Hollywood career at Paramount, in the wake of the success of *Double Indemnity* (1944), and after *The Lost Weekend* (1945) had received four Oscars.[8] It was easy for a friend in the ICD to accept a proposal by such a distinguished Hollywood director.

Wilder left for Europe the day after VE Day and worked for the Film, Theatre, and Music Control Section of the Psychological Warfare Divi-

sion. He was confronted with the horrors of the recent past in different ways. Most important, he tried to find out what had happened to his own mother (his father had died in Berlin in 1927, well before the Nazi ascent to power), yet only managed to learn that she had perished. Details emerged much later: she was deported to the concentration camp Plaszów-Kraków in 1943 at age fifty-eight and was murdered either there or after a transport to Auschwitz; his stepfather and grandmother were also killed.[9] Wilder participated in the denazification effort, interviewing filmmakers and actors in Bad Homburg, among them Werner Krauss who had starred in the anti-Semitic film *Jud Süß*, and he proposed not only the filming of a topical comedy but also recommended (with little success) the reconstruction of the German film industry.[10] Wilder edited down the horrifying concentration camp documentary *Die Todesmühlen/Death Mills*, a version of which was shown to numerous German audiences in 1946. It includes footage of camps, of barely surviving victims, and of masses of corpses as well as of Germans reacting with horror and shame to Allied-enforced visits to liberated camps.[11] Wilder also flew with a cameraman over the destroyed and devastated city of Berlin—the city where his career as filmmaker had begun—and found that it now "looked like the end of the world."[12] Yet against such grim backgrounds, Wilder still wanted to create a comedy.

From *Love in the Air* to *Operation Candybar*

Paramount owned an undated comic story treatment called *Love in the Air*, written by Irwin Shaw and David Shaw.[13] It is a silly wartime plot that takes the old yarn of a sailor with a girl in every port literally into the air—and is remarkably different from Wilder's sketched proposal of 1945.[14] The hero is Jasper McKay in the Air Transport Command in Prestwick, Scotland. He has an Iowa fiancée named Leona but wants to visit the various girls he has met in the course of the war, in Rome, Paris, Moscow, Frankfurt, Cairo, and Sydney to make sure that marrying Leona would be the best choice for him. His colonel assigns him to a "Representative Kinnicut, of the United States Congress, assimilated rank of Major General, who is making a tour of army installations throughout the world" (5). It turns out that Kinnicut is a congress*woman*, and after visits to Jasper's girlfriends all over the world, he finds out that not one of "his" girls still really wants him, not even his fiancée Leona, to whom the congresswoman

flies him last. Telling him off, Leona shouts at McKay that the war has made him coarse: "Maybe you can get away with stuff like that in front of soldiers and female congressmen," but not with a "decent American girl." Angrily, Jasper blames the congresswoman for having "ruined six marriages" for him. "I'm without a woman now . . . and you're the cause," he tells her. The script ends with Representative Kinnicut's sly reply to Jasper McKay. "Well . . . not exactly completely without one . . . ," implying a possible match between McKay and Kinnicut. This tale of an airman's ineffectual and self-defeating Don Juanism that is cured by a scheming congresswoman gave Wilder little more than the motif of a womanizing soldier's choice among home girl, foreign girls, and congresswoman.

The next stage was a third-person prose treatment written by Billy Wilder, Charles Brackett, and Robert Harari, already titled *A Foreign Affair* and dated May 31, 1947.[15] (Robert Harari's name also appears in the film's credits for adaptation.) Here the outline of the later film and even some dialogue bits that would be used are already present. The central constellation of John, torn between the "beautifully molded" Erika, who performs in the Lorelei, and the "maidenly" Phoebe is also there. Since Erika sings "Falling in Love Again," the Friedrich Holländer song from *The Blue Angel* (1930) that is forever associated with Marlene Dietrich, one already imagines her in that role—except that, as has already become clear, this earlier Erika is far less sympathetic than she would turn out to be in the film. Given Erika's allegorical role, it is also significant that the concluding scene here is a sham *wedding* of John and Erika staged by the army in a ruined church in order to lure her high-ranking Nazi consort, Otto von Birgel, out of hiding.

The prose treatment's Erika, "wise by now" and ever an opportunist, seeks her luck in a car with Russian officers and asks them to take her to the Russian zone, for "no one can like the Americans. They are swine. They make me clean up the Berlin streets" (46). But the Russians promise to take her to a labor camp in Stalingrad, and the Americans arrest Birgel. This leaves little ambiguity at the end, as John returns to America with Phoebe. His relationship with Erika was merely a fling that can be ended without regrets; and her affection for him was purely self-serving. Readers of this version don't feel sad at all that the Russians intend to make Erika work hard in Stalingrad. Although John does not get any final lines to say so, it seems that he'll probably be happy with Phoebe at the end.[16]

The German everywoman Erika does not offer an inviting alternative or future, for she is fickle: her alliance with the harbinger of American democracy may be nothing more than an interlude between a totalitarian past and another totalitarian future. This glum allegorization of Germany was disrupted only in the final stages of the film project.

Some time between May and November 1947, Billy Wilder and Charles Brackett must have decided to add complexity to Erika's character, and thereby more ambiguity and life to the love triangle of the plot. The transformation that Erika's character underwent from the prose treatment to the later scripts parallels the change in American attitudes toward Germany from a more punitive posture to a more collaborative one (signaled by the 1947 Marshall Plan), as the inklings of the coming Cold War made for new alliances—which did, however, not at all affect Wilder's portrayal of the Russians in the film as genial drunkards and black market dupes rather than as potential military antagonists.[17] (The threatening Russians in the four-power-occupied Vienna of Carol Reed's *The Third Man*, released in August 1949, just one year after *A Foreign Affair*, seem to come from a different epoch: they are relentless in their menacing pursuit of the forced repatriation of the beautiful Anna Schmidt [Alida Valli], who, in Graham Greene's original script was an Estonian displaced person who could now be claimed as a Soviet citizen, but whom the film transformed into a citizen of Czechoslovakia.)[18]

It was also in the summer of 1947 that Wilder was able to sign up Marlene Dietrich, whom he had always wanted for the part of Erika, and for whom Friedrich Holländer would write the songs—as he had done in *The Blue Angel*. Apparently, Wilder went to see Dietrich with some mock-up footage of actress June Havoc (who had appeared in Elia Kazan's *Gentleman's Agreement*) playing Erika's part and innocently asked Dietrich for advice—until she agreed with him that this role could only be played by her.[19] In her own autobiography, Dietrich remembered the encounter in Paris somewhat differently: Billy Wilder had already called her, and she had declined to play a Nazi woman. But when he came to Paris to see her in order to persuade her to accept, she found that it was simply impossible to resist him.[20] Wilder told one of his biographers, "She was so much against the Nazis that at first she didn't like playing someone who had slept with one. I said, 'Marlene, you're an actress. I want you to play a part, not join the Nazi party.'"[21]

The next stage was a scenic version, *Operation Candybar* (*A Foreign Affair*), authored by Wilder, Brackett, and Richard L. Breen and dated November 20, 1947. It marks an intermediate phase toward the film, with numerous stage directions taken directly from the story treatment, but already listing the final cast of actors and the titles of Dietrich's three memorable songs, "Black Market," "Illusions," and "The Ruins of Berlin."[22] It was this version that was submitted to Stephen S. Jackson at the industry's self-censoring Production Code Administration, and the PCA reacted vigilantly that the material presented "a very serious problem" and would have to be brought to the attention of the president of the PCA.[23] While the "characterization of the members of the Congressional Committee and of the members of the American Army of Occupation" was the center of the complaint, the PCA also deemed that the "portrayal of the Congresswoman, Phoebe Frost, getting drunk in a public night club of poor reputation, hanging from the ceiling and being arrested and carted off to jail in a police van" violated the Production Code's stipulation that "the history, institutions, prominent people and citizenry of all nations shall be represented fairly." Furthermore, the PCA took issue specifically with the "over-emphasis on illicit sex," which seemed "to run through most of the script" and was especially prominent in the relationship between Captain Pringle and Erika. This overemphasis needed to be "eliminated" in order to make approval of the film possible. Finally, "the portrayal of wholesale and universal activities in the black market on the part of occupation personnel" also constituted a code violation. A meticulously detailed listing of more than two dozen specifically objectionable sequences in the script followed, more than twenty of them considered "overly sex suggestive" or too much focused on "lust and excessive passion."[24] The letter ended with the invitation to resubmit the changed script and with the stern pronouncement that "final judgment will be based on the finished picture."

Billy Wilder's Paramount team must have gone through these requests very carefully, for a few substantial changes were indeed made. Jackson had specifically demanded that the dialogue sequence about the mismatched pajamas be omitted, insisting that "at all times Erika must be fully clothed," and the matching handwritten marginal annotation to this scene in *Operation Candybar* reads: "This guy just walks in while she is in bed, and it is O.K. with her!" Marlene Dietrich remembered a censor actually appear-

ing on the set and prohibiting her sitting next to John on the bed in the shooting of the scene. And indeed, in the filmed version of *A Foreign Affair*, Erika is no longer lying in bed when John arrives, wears some kind of a bathrobe instead of her controversially mismatched sleepwear, and is brushing her teeth—but their "lustful and passionate attitude" is unmistakable nonetheless.[25] In fact, the sequence that follows reportedly even upset Brackett, who did not like the idea of "a woman spitting lovingly in a man's face," and when Wilder told him, "that's just how a broad is, if she really likes the guy. We show how close they are—physically," Brackett (who was what was then called a confirmed bachelor) reportedly responded, "You're sick, Billy! Sick!"[26]

While the action of the PCA did prompt many of the changes between *Operation Candybar* and the Censorship and Release Dialogue Scripts of April 24 and May 20, 1948, neither the sexual innuendo nor the political bite was substantially diminished in the revising process, and Wilder managed to leave much objectionable material in script and film. Furthermore, there are changes in the script that make apparently harmless scenes somewhat more titillating, though what one actually sees on screen would not have to be different. For example, in the precensorship version, a short take is described as follows: "A GERMAN NURSE, WHEELING A BABY CARRIAGE DOWN THE STREET As the baby's parents are American, the carriage is decorated with two small American flags." In the postcensorship version one reads, "LONG SHOT German girl wheeling baby carriage which is decorated with two American flags." The visual suggestion that this must be the illegitimate baby of an American soldier (rather than the child of American parents accompanied by a German nurse) is strengthened in the revised script, then, and no one would be able to believe any longer in the rationale offered by the precensorship script when reviewing this scene.[27]

Wilder and Brackett also came up with a whole number of new and funny twists at the postcensorship stage. In a scene where Phoebe searches for the von Schlütow file and John starts to kiss her in order to hide Erika's file from her, Phoebe originally recites the Constitution (which caused no concern to the censors) in her attempt at filibustering the amorous-seeming captain. In the final version, it is Longfellow's "Midnight Ride of Paul Revere," with its dramatic opening, "Listen." They also added John's response to Erika's kiss, "Gently, baby. It's Mother's Day."[28] On the whole, the revising only made the dialogues funnier.

There is another rather intriguing (though discarded) plot possibility that Wilder mentioned in an interview he gave four decades after making the film: apparently he had thought of a "stronger version" of the story line that he proposed to Charles Brackett: "What I wanted to do was that not only is Captain Pringle in the American army, he was also Jewish. *That* is going to really *cement* it, you know. The American lieutenant with whom Dietrich is having an affair, and is going to marry, is Jewish. 'What? She's going to marry a . . . !' That picture I would have loved to make. But then we chickened out. [*Smiles.*] And we just made him an American."[29] Needless to say this discarded plot possibility (which Wilder also apparently would have ended with a *real* marriage of Nazi-implicated Erika and Jewish John) would have created a somewhat different film. This anecdote throws light on the fact that race is absent as a theme. Though concentration camps and gas chambers are mentioned in the film, amazingly in a comic context, there is no direct allusion to Jews or to Nazi genocidal anti-Semitism, and there is also no representation of any black G.I.s anywhere in Wilder's Berlin.[30]

The Film

When the picture was finally completed under the title *A Foreign Affair* and officially released on August 20, 1948 (after July premieres in New York and Los Angeles), it bore very little resemblance to Wilder's original proposal to the ICD. The desperate German rubble *Frau* had become an entertainer who is anything but suicidal. She has not been married and widowed, but now has a jealous Gestapo-officer ex-boyfriend who has gone underground.[31] The simple German-American love story was transformed into an intricate postwar triangle, with the American officer of dubious morality torn between a sensuous German and a respectable American woman, both of whom want him. Pretty much all that was left from the story of the German lieutenant's suicidal widow was now in Colonel Plummer's brief statement in one of his addresses to the congressional delegation: "I remember the first day the gas works started operating again. There were a hundred sixty suicides in Berlin alone. That was ten months ago. Today they take a match and light the gas and boil themselves some potatoes. Not many potatoes, mind you. There is still a lot of hunger. But there is a new will to live."[32] (Plummer, played by Millard

Mitchell, also lectures the congressional delegation about other accomplishments of the occupation: "We had to take four million displaced persons and return them to their homes. That's a little hard, if you don't have a home to start with." And during a tour through Berlin, he shows the delegation German youngsters playing baseball and explains that they were mean but, "we're trying to make kids out of them again. We had to kick the goosestep out of them and cure them of blind disobedience and teach them to beef at the referee, and if they feel like stealing, make sure it's second base.")[33]

In the film *A Foreign Affair*, Captain John Pringle—played by John Lund, after Wilder failed to get Clark Gable for the part—is shown, a nylon stocking for his German sweetheart Erika von Schlütow dangling from his pocket, receiving a birthday cake from his Iowa girlfriend, Dusty (a faint trace of Jasper's Iowa fiancée, Leona, from *Love in the Air*). The cake gets delivered by congresswoman Phoebe Frost (played by Jean Arthur), who is part of the committee that flies into Tempelhof airport. Phoebe is shocked at the extent of fraternization she witnesses; and she herself pretends to be a *Fräulein* and permits the two G.I.s Joe and Mike to pick her up and take her to the Lorelei nightclub, where Dietrich sings the "Black Market" song. John attempts to save Erika from a denazification trial, and Phoebe tries to find the American protector of the Nazi entertainer—unable to imagine that it could be "her" Johnny. Erika is a sophisticated and charming woman whose involvement in the Nazi party becomes clearer to John only later; Phoebe is a plain-looking, uptight, puritanical politician at the beginning who discovers a more romantic and aesthetic (but also foolish) side in herself only with John and amidst the ruins of Berlin.[34] Phoebe's softening from an ideologically hard-hearted and sexually repressed Republican politician to a bleary-eyed romantic has reminded viewers of Ernst Lubitsch's *Ninotchka* (1939)—which is to say that Wilder's female representative of American democracy is as stuck-up as was Lubitsch's female embodiment of Soviet ideology.[35] Will John stay with his forbidden erotic German lover Erika or will he follow the Republican congresswoman? Wilder's final film version offers the plot twist that John, on explicit orders from Colonel Plummer, has to *pretend* to continue being enamored by Erika in order to smoke out Erika's former (and extremely

jealous) lover Birgel: "the love commando," as Colonel Plummer calls John's dangerous mission, marking him as a target.[36]

The mission is successful, and Birgel gets killed in a scene in the Lorelei that substituted for the earlier story treatment's sham church wedding: it is also the last musical number, with Marlene Dietrich singing "The Ruins of Berlin." John may be headed toward a more serious relationship with Phoebe after the end of the movie—even though one of the "romantic" things he tells Phoebe along the way is that now that he's met her he knows how he'll cast his next *absentee* ballot. He is, in his own and quite believable words, "just a hit-and-run boy," not the marrying kind, and one can hardly imagine him back in Iowa with all the urban sophistication he has acquired—though Phoebe, too, has changed in her few days in Berlin (not as dramatically and completely, however, as did Ninotchka, and Jean Arthur, whom Dietrich called that "funny little woman with that terrible American twang," is no Greta Garbo).[37] The scene that triggers Phoebe's transformation is the kiss John gives her as he tries to keep her from finding Erika's Nazi file, which Phoebe first searches for under "S" and then under "V" for "von Schlütow"—or, as John puts it in an aside, "V, as in vindictive" (the script adding that he drops Phoebe's coat "in disgust").

At the end, Erika is arrested by two young M.P.s who, after she adjusts her stockings and shows her beautiful legs to them, are so enthusiastic escorting her that Colonel Plummer sends two more soldiers to guard the guards—but who really knows what Marlene Dietrich's charm cannot accomplish with however many guards?[38] So ends the story of a complex and somewhat unresolved love triangle (for, as did Wilder at times when talking about the movie, the viewer thinks of John and Erika as the romantic couple, not of John and Phoebe). Wilder clearly shows sympathy for Colonel Plummer, the symbol of democracy and reeducation, but also for the lively and beautiful Erika von Schlütow, who lives in a ruin—and who is, after all, also always Marlene Dietrich, the glamorous antifascist wartime entertainer of U.S. troops and well-known recipient of the Medal of Freedom (1947), who is only reluctantly playing a former Nazi.[39] Furthermore, she is such an attractive and sympathetic actress that it's almost impossible not to identify with her.

The formal open-endedness of the romantic plot is driven home by the publicity that accompanied the film's release. A Paramount cartoon reportedly stated: "Jean Arthur: The People's Choice in IOWA. Marlene

Dietrich: The Army's Choice in BERLIN."[40] And there was a poster made of a two-column ad that reads

MEET JOHN-NEE
He can't decide
between a
Fraulein with a Chassis . . .
and an Ioway
Lassie!

Other ideas for the film's promotion included "legs contests"—in which contestants were to be judged for legs that most resemble Dietrich's—and a campaign to inspire department stores or specialty shops to place a small card in every package of nylons that they sell, saying "Marlene Dietrich flatters nylons in 'A Foreign Affair.'" Apparently, nothing the "Ioway lassie" wore or was seemed equally publicity worthy. The Paramount publicity photograph that serves as frontispiece to this chapter shows Billy Wilder giving specific directions. It has the telling inscription, "Director Billy Wilder explains the reaction he wants to Jean Arthur and John Lund, seated in jeep. Instinctively, Billy's face indicates the sought expression as much as his words do." And what a sour face Wilder is making in this photograph for press release! Wilder also wrote a note to Dietrich on July 12, 1948, addressed "Sweetheart," asking her, "Do you think we should send this to Jean Arthur" (probably referring to a press notice that was favorable to Dietrich).[41]

The previews seemed to be willfully misleading in suggesting that *A Foreign Affair* was about some international intrigue and showing a series of witnesses of different nationalities in various capital cities who attest that the movie is "very funny." Hence the first showings must have yielded some surprises. When *A Foreign Affair* was released, one would have expected skeptical reactions from reviewers and audiences to a plotline that hardly seemed "devised to help us sell a few ideological items" and to an only sparingly revised script that had so worried the industry's self-censoring agency. The critical literature makes mention of a supposedly negative official reaction by the army and Congress, yet all these comments lack a credible source citation, and no records have been found to document either a worried response by the army or a congressional debate

about the film.[42] It is possible that such references go back to two sentences in Bosley Crowther's wholly positive *New York Times* review: "Congress may not like this picture. . . . And even the Department of the Army may find it a shade embarrassing," for Brackett and Wilder "are here making light of regulations and the gravity of officialdom in a smoothly sophisticated and slyly sardonic way." But apparently neither Congress nor the army ever reacted, and the film opened to uniformly enthusiastic reviews.[43]

Only one critic, the film editor and member of the Screen Writers' Guild, Herbert G. Luft, published an attack on Billy Wilder's whole "decadent" œuvre in an academic journal, expressing his particular dislike for Wilder's "unhealthy boulevard witticism" in *A Foreign Affair*. Luft specifically complained about the movie's easygoing attitude toward Nazis, "seen as double-crossers, yet drawn with much charm and noblesse, living in an atmosphere of comparative ease, with a romantic façade covering up a decade of mass murders. Those praising the guts of the story didn't see the malefic travesty." Charles Brackett felt the need to respond and refute the diatribe point by point: "The Berlin woman, played by Marlene Dietrich, was such a complete heavy that some humanization of her character became necessary. Therefore she was given a scene which explained what made her tick. I suppose that is what makes Mr. Luft describe her as 'drawn with much charm and noblesse.' About the audience's reaction to her, I can only report that she ended by going to a labor camp, amid the delighted laughter of American audiences. Apparently to Mr. Luft it was a wistful and romantic exit."[44] (Brackett seems to draw here on the earlier ending of the script.) The denazification of Erika von Schlütow, the process by which former Nazis got reeducated by Allied procedures and trials, is not really represented in the film; instead, one can say that the *character* of Erika von Schlütow had been denazified by virtue of the various plot transformations from scripts to the film. In any event, the dialogue between Brackett and Luft took place four years after the release of the film and sharply contrasted with its positive reception in 1948.

However, in a revealing 1953 letter to the editor of the *Quarterly of Film Radio and Television*, in which the exchange between Luft and Brackett had been published, Marshall Plan film producer Stuart Schulberg described how, after a viewing of *A Foreign Affair* in Berlin, Pommer and the Military Government's Screening Committee had deemed and then ruled

the film unsuitable for German audiences. Schulberg writes, "(On the face of it, this picture seemed to have everything: Wilder, Dietrich, and Berlin. One almost expected to see the old UFA trade-mark in the main title.) And I also remember how, as the reels rolled by, our disappointment turned into resentment and our resentment into disgust. Perhaps we were all too close to the situation; we certainly lacked Wilder's happy-go-lucky perspective. But straining our objectivity to the breaking point, we could not excuse a director who played the ruins for laughs, cast Military Government officers as comics, and rang in the Nazis for an extra boff."[45]

Though Schulberg's view was not shared by the German reviewer in *Der Abend*, who considered the movie brave and a spiritual Care package that would make even the German ruins laugh, and though there were other German reviews in 1948 that mentioned a possible German release, Schulberg was associated with the Motion Picture Export Association of America, and apparently as a result of his intervention, the movie was not exhibited in Germany until May 6, 1977.[46] [*I saw the film for the first time at the Berliner Filmfestspiele 1980, as part of a Billy Wilder retrospective, in an audience roaring with laughter, and I was surprised by what had been kept from me for all these years.*]

More representative than Schulberg of the general attitude at the time was Ernest Hemingway who, on July 1, 1950, sent Marlene Dietrich an advance copy of his novel *Across the River and into the Trees* and wrote her in one of the many, many letters they exchanged, with his characteristic punctuation: "Think you will like book . Have really worked on it . If you like it one half as much as I liked you in A Foreign Affair I'll be happy ."[47] Hemingway knew, loved, and admired Marlene Dietrich, of course, but one can find many additional reasons why reviewers and audiences generally also liked the film.

The Ruins of Berlin, Black Market, and Illusions

What made the movie visually stunning was Wilder's extensive use of footage actually filmed in ruined Berlin (where Wilder had returned in 1947 for outdoor shooting), as promised by the credit line: "A large part of this picture was photographed in Berlin."[48] From the introductory sequence showing ravaged Berlin from the air and the black market scene at Brandenburg Gate, to John's jeep ride to Erika's apartment and the delegation's

guided tour up to the last car ride to the Lorelei, the haunting omnipresence of the ruins of Berlin contributes greatly to the effect of the film. The work by director of photography Charles Lang and editor Doane Harrison was simply excellent.

Since much of the rest of film was actually shot at the Paramount Studios, where sets of the Lorelei (inspired by Berlin's Femina Bar) and of Erika's dramatically ruined apartment had been built, the illusion that one is always in Berlin was largely created with the help of the most advanced process-shooting technique then available. Using the services of specialists like Farciot Edouart, who had won two Oscars for his skill, helped to integrate the clearly focused rear-projection footage rather seamlessly into the film and suggested realism rather than artifice.[49]

The technique is so natural in *A Foreign Affair* that the presence of the ruins seems to affect characters and action. The scene in which Phoebe and John are watching the made-up Nazi newsreel that Billy Wilder meticulously re-created to show Erika next to Hitler (and which employs essentially the same apparatus as process shooting) creates a vague visual echo of the rear-projection footage and a momentary illusion of simultaneity of occupation presence and Nazi past, calling attention to the technique in the manner of romantic irony, as if this sequence were a self-conscious comment on the film's employment of process shooting.[50] The weird humor of the newsreel scene is strengthened by the fact that the Hitler actor looks, as a French reviewer of the film pointed out, more like Charlie Chaplin's funny incarnation than like the somber original.[51]

The beginning of *A Foreign Affair* specifically echoes *Triumph of the Will*, Leni Riefenstahl's propaganda film on the Nürnberg Nazi Party rally of 1934—another one of Wilder's sly jokes. In both films, a plane arrives from above the clouds and casts its shadow over a city: Riefenstahl's sun-aglow Nürnberg with its castle and a wide promenade on which uniformed men are marching, Wilder's ruinscape of Berlin, the shadow of the aircraft even evoking the memory of a bomber plane. The plane lands to a reception (the over-the-top *heil*ing of the Nazi crowd, and the small military band for Wilder), and lets its passengers descend a gangway, Riefenstahl's Hitler with swastika band on his left arm, Wilder's congressional delegation with their identifying US flag bands on their left arms.[52] In Wilder's Nazi newsreel, a critic found, Erika also seems to be made up to look like Riefenstahl, another visual gag.[53] With his penchant for black humor,

A Foreign Affair: **Screening the Nazi newsreel.** *DVD screenshot.*

Wilder also shows a helmeted Prussian statue from behind, with the Nazi propaganda inscription "Der Sieg ist uns gewiss" (Our victory is assured) still painted on it—in a completely devastated area near the black market at Brandenburg Gate.

A Foreign Affair is also a film in which aural effects make a significant difference. Most importantly, it is very rich musically. Friedrich Holländer's three songs, all performed by Marlene Dietrich, are not only high points of the movie, but the songs are visually and textually integrated into the film, from the overture to the closing notes. Motifs from Holländer's songs echo throughout the film, and the lyrics of his songs resonate with visual elements and with sections of the dialogue. Thus porcelain figures appear on the black market before one hears the "Black Market" song's line "You want my porcelain figure?"

The universal exchangeability that Holländer's black market song so vividly demonstrates is driven home almost to excess by Billy Wilder, who keeps reminding viewers that anything and anybody can be traded in. Thus Phoebe carries the big birthday cake from John's girlfriend Dusty from Iowa to Berlin, and the inscription of it—the film offers a very close view of the wording "I LOVE YOU I LOVE YOU I LOVE YOU DUSTY"—embarrasses Phoebe who has moved over for a better view and

says, "I beg your pardon. I didn't know it was so personal." Yet cakes only appear to symbolize the unique "personal" relationship of two individuals, for John quickly exchanges the cake at the black market—where it is greeted with a loud incredulous exclamation, "Eine Schokoladentorte!"— for a mattress. Then John brings the mattress to Erika, transforming Dusty's long-distance birthday greeting and love token, delivered by the Republican congresswoman, into a means of having more comfort with Erika in bed. After Erika tells Phoebe that she causes her to be disappointed in the appearance of American women ("I see you do not believe in lipstick. And what a curious way to do your hair. Or rather, not to do it"), Phoebe (as she later tells John) exchanges her typewriter, the instrument with which she might be expected to write her report on the morale of the troops, for an evening gown at the black market and pays six extra typewriter ribbons for a pair of elegant shoes. The fraternizing G.I.s show Phoebe a candy bar that they hope will be in exchange for sexual favors, and Phoebe plays along with them, posing as a German girl with the implausible name "Gretchen Gesundheit." Russian soldiers at the black market trade ridiculously high sums of dollars for a Mickey Mouse watch, and the Lorelei serves champagne in exchange for cigarettes.[54]

Human beings can undergo metamorphoses as easily as if they were objects. Erika has changed from a Nazi entertainer to a singer for Allied troops and has exchanged her Gestapo fiancé Otto Birgel for the American fraternizer John Pringle; Phoebe gets transformed in the course of the film from a prim and repressed congresswoman to a woman who is willing to take some risks in love, for which she seems ready to surrender her political rigidity. Phoebe's first visit to the Lorelei is as a raincoat-wearing undercover Republican investigator who wants to smell out the "moral malaria" in Berlin; her second visit is as John's smartly dressed date who wants to enjoy their last evening in what John confirms is the "best sewer" in Berlin. Hence John's exchanging Dusty for Erika and Erika for Phoebe is simply part of the general instability of the exchange system that is in place in Billy Wilder's film—which makes any resolution of John's love plot illusory. In fact, the story of all the plot transformations from the German lieutenant widow's romance to *Love in the Air* to *Operation Candybar* to *A Foreign Affair* to Wilder's contemplated Jewish G.I. story seem to offer additional evidence not only of the exchangeability of objects and people but also of the infinite malleability and open-endedness of plot lines.

A Foreign Affair: **Phoebe Frost (Jean Arthur) in the briefing room.** *DVD screenshot.*

When Phoebe with her braided blond hair—she has already posed as "Gretchen" at this point—is seen in front of a map of Germany reacting to Colonel Plummer's briefing, the viewer may wonder whether *she* is the real German allegory, rather then than glamorous Erika who sports an international Hollywood look. Phoebe also passes as a German girl a second time, when the Lorelei is raided, and Erika gets her out of the hands of the police claiming that Phoebe is her country cousin. The "Black Market" song, with composer Holländer at the piano, illuminates a general human condition of exchangeability, with many a double entendre pointing to the central object of exchange, Marlene Dietrich herself.[55]

> Black market
> Laces for the missus, chewing gum for kisses
> Black market
> Cuckoo clocks and bangles, thousand little angles,
> Come and see my little music box today.
> Price? Only six cartons,
> Want to hear it play?
> Black market

A Foreign Affair: **Erika von Schlütow (Marlene Dietrich) singing "Black Market" with Friedrich Holländer at piano.** *DVD screenshot.*

Mink and microscope for liverwurst and soap.
Browse around, I've got so many toys
Don't be bashful, step up boys.

You like my first edition
It's yours—that's how I am—
A simple definition:
You take art, I take Spam.
To you for your K-ration
Compassion—and maybe
An inkling, a twinkling of real sympathy.
I'm selling out. Take all I've got.
Ambitions, convictions, the works, why not?
Enjoy these goods
For boy, these goods—are *hot*.[56]

John lights a cigarette and puts it in his mouth as he watches Erika sing; Erika casually takes it from John, puffs, strolls back to the stage, and then puts the lit cigarette between the lips of the pianist (played by Holländer himself), continuing the theme of exchangeability in creating a strange

A Foreign Affair: **Erika von Schlütow (Marlene Dietrich) passes cigarette to Friedrich Holländer.** *DVD screenshot.*

visual triangle of two men and a woman united by the same cigarette, the universal currency at the Lorelei and at the black market, the hub of the movie's (and of postwar Germany's) exchange system.[57]

The other two Holländer songs are just as seamlessly integrated. Phoebe says that she is not "in the mood for laughs," and John asks Phoebe what she does "for laughs and tears" some time before Erika sings "Illusions" with such wonderful lines as

> Want to buy some illusions?
> Slightly used. Just like new
> Such romantic illusions
> And they're all about you.
> I sell them all for a penny.
> They make pretty souvenirs
> Take my lovely illusions
> Some for laughs
> Some for tears . . .

At this moment the focus of the camera switches from Erika (who just hums another stanza in the background) to Phoebe, blissfully tipsy, visibly

A Foreign Affair: **John Pringle (John Lund) and Phoebe Frost (Jean Arthur),
with Erika von Schlütow (Marlene Dietrich) in mirror.** *DVD screenshot.*

enamored, and making duplicitous John so uncomfortable that he begs
Phoebe to stop building him up.

During the last stanza of the song, a shot shows John and Phoebe at
table, while Erika is "reflected in mirror, moving toward them, followed
by violinist." Erika's crisp and brightly lit reflection comes between
Johnny and Phoebe and serves as a reminder of Phoebe's romantic illu-
sions. (The central plot triangle is driven home in many single frames
with John, Erika, and Phoebe.)[58] The tune of "Illusions" can be heard
again when John takes Phoebe home to her billet and she is at her most
enamored.

The movie ends with the third Holländer song, "The Ruins of Ber-
lin," which speaks of the subdued hope for a new beginning: "A brand
new spring is to begin / Out of the ruins of Berlin." Of course, the
viewer has seen plenty of ruins by that point in the movie. The song is
also quatrolingual and thus makes audible the four-power status of the
occupied German capital.[59] Wilder was adamant about letting the film
have a naturally multilingual ambience: "The film should be made in just
one version, the Americans speaking English and broken German, the
Germans speaking German and broken English, the Russians speaking
Russian, etc."[60]

All three Holländer songs reinforce central themes of the film: black market, lost illusions, and the ruins of Berlin. And all three also allude to, and transform into a postwar world, Marlene Dietrich's earlier Holländer repertoire from *The Blue Angel*. The fact that Holländer himself sits at the piano in the Lorelei calls further attention to the importance of his music for the film. One almost senses a longing by Wilder, Holländer, and Dietrich for a past that had so brutally ended when the Nazis took power, enhancing the melancholy one feels under all the comedy and sarcasm. That dry and at times mournful humor also pervades Holländer's autobiography, which contains many stories about Wilder and Dietrich, but mentions only in passing that Holländer wrote text and music for Dietrich's songs in *A Foreign Affair* after a depressing return trip to Germany, during which he "visited not only friends and ruins, but also Dachau."[61]

Holländer's musical score for *A Foreign Affair* uses many other musical themes beyond the three Dietrich songs. There are military marches and the repeated Russian song "Polyushko, polye" (Meadowland), a Red Army favorite accompanied by much horselike tongue-clicking. There is Phoebe's campaign song, "We Are from Ioway," which she performs after two G.I.s play "Deep in the Heart of Texas." John whistles "Shine on, Harvest Moon," the song associated with Phoebe, when he visits Erika's apartment the second time, an ironic comment on his state of mind, creating an acoustic sense of the love triangle; later Erika whistles the tune at Phoebe when she tries to make her give up John.[62]

A wonderful musical gag is the candybar number, which literalizes the popular song "Daisy Bell" ("Daisy, Daisy, give me your answer true . . .") when the two G.I.s Mike and Joe invite Phoebe for a fraternization ride "on a bicycle built for two"—as if the tandem had materialized visually, had stepped out of the song—and with a raunchier text accompanying it, "Fraulein, Fraulein, / willst Du ein Candy bar. / Schön, fein, Fraulein. / You like G.I.s, nicht wahr?" One has to remember in this scene, too, that *Operation Candybar* was one of the working titles for *A Foreign Affair*.[63]

The most extended musical joke may be John's ride from the black market to Erika's apartment. Wilder lets John, who has just exchanged Dusty's birthday cake for a mattress, drive to Erika in a jeep (called "kidney killer," a common nickname at the time for the vehicle because of its tough suspension system without shock absorbers); the ride goes through the rear-projected and quite overwhelmingly depressing ruins of Berlin—but

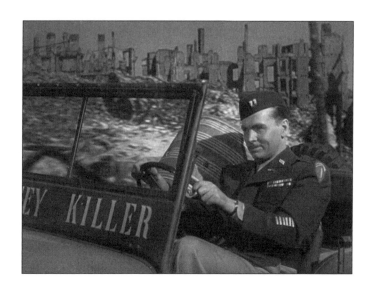

A Foreign Affair: **John Pringle (John Lund) in his jeep, with mattress.**
DVD screenshot.

Wilder set this sequence to the incongruously cheery musical background music of Richard Rodgers and Lorenz Hart's song "Isn't It Romantic?"[64] Wilder may have been parodying Rouben Mamoulian's famous opening of *Love me Tonigh*t (1932), casting John Lund in the role of Maurice Chevalier, Marlene Dietrich in Jeanette MacDonald's part, and offering ruined Berlin as a substitute for romantic Paris.[65] (One of several perspectival camera views fittingly has the ruin of the Kaiser Wilhelm Memorial Church as its mock-Parisian vanishing point.) Yet it is hard to imagine a more inappropriate juxtaposition than that between amorous John with his mattress sticking out of the jeep and the devastated streets through which he is driving in long takes, and the equally inappropriate but catchy love song enhances this incongruity. John then whistles the opening bars of "Isn't It Romantic" while Erika brushes her teeth. It is sequences like these that have earned Wilder the reputation of being cynical. Originally, the script had John whistling "Ach, du lieber Augustin," a mischievous German children's song about a boy who has lost everything—and it would rub in the devastation the viewer has just seen outside and now sees inside Erika's apartment, whereas "Isn't It Romantic" speaks to the sexual energy John feels toward Erika, even (and perhaps especially) "amidst the ruins of Berlin." In his interview film with Billy Wilder, *Billy How Did You*

Do It? (1992), Volker Schlöndorff suggested that there was an intentional "counterpoint" between music and visual footage in this scene, but Wilder claimed that he used the tune here and in some of his later movies simply because Paramount owned the rights to it. And indeed, Wilder's *Sabrina* (1954) is awash in several renditions of "Isn't It Romantic?"

The Happiest Pair in Hollywood

Comic visual and sound effects make *A Foreign Affair* a rich cinematic experience, but it is the wit of the script (written by Wilder and Charles Brackett—known as the "happiest pair in Hollywood" at the time, though they were to part ways soon after *A Foreign Affair*) that makes the film unforgettably funny.[66] The effect of much of the humor is that *A Foreign Affair* makes a joke not only of Nazi pretensions but also of all the clichés and cant of American military occupation, of provincial moral indignation at fraternization, and especially of Allied righteousness about reeducation and denazification. The conversations among the various congressmen poke fun at their political differences and posturing, in view of all the devastation they are surrounded by. To Texas congressman Giffin the Berlin ruins look "like packrats been gnawing at a hunk of old mouldy Roquefort cheese" and "like chicken innards at fryin' time"—a ludicrous extension of the repertoire of ruin metaphors circulating in the postwar period.[67] Black humor about ruins is, in fact, pervasive in the film. When New Hampshire congressman Pennecott observes Berlin children playing baseball surrounded by ruins he says cheerily, "One thing they don't have to worry about around here . . . breaking windows." Plummer states that in Berlin there is "rubble of all kinds, mineral, vegetable, animal." And Erika wisecracks to Phoebe: "Let's go up to my apartment. It's only a few ruins away from here." (This line was rewritten and perfected from "My apartment's just around the corner" in the earlier prose treatment of *A Foreign Affair*.) Congressman Salvatore from the Bronx (modeled on Vito Marcantonio) insists on recognizing Russian artillery contribution to the destruction of Berlin (as if that were a commendable accomplishment) and objects to dollar diplomacy in an apparent allusion to the Marshall Plan: "If you give a hungry man a loaf of bread, that's democracy. If you leave the wrapper on, it's imperialism!"

Both Phoebe and Erika contribute to some hilarious dialogues. "I wonder what holds up that dress," Phoebe says when she sees Erika strapless in the Nazi newsreel; John responds: "Must be that German willpower." Phoebe's local pride in Iowa is lambasted repeatedly. "Sixty-two percent Republican, thank you," is how she answers John's initial question, "How is good old Iowa?" Later Phoebe talks about changes in her state: "And we had the lowest juvenile delinquency rate in this country, till two months ago." She responds, as might only a politician so entranced by statistics that she is blind to the human story behind numbers: "A little boy in Des Moines took a blow-torch to his grandmother and we fell clear down to sixteenth place. It was so humiliating."[68] John says to Phoebe, "You're not a Nazi. Don't tell me it's subversive to kiss a Republican," and later, "I don't even know your first name, congresswoman, darling." Phoebe wears the dress she bought at the black market pinned up high, and John comments, "It *is* kinda high. What is it, a turtle-neck evening gown?" And when she asks him, after he has fixed the dress by taking out the pins, "John, where did you learn so much about women's clothes," his response is, "My mother wore women's clothes." Erika sneers at Phoebe's black market dress: "Oh, it's stunning. But haven't you got it on backwards?" When Erika is arrested, she tries to flirt with "that wonderful" Colonel Plummer (as she tells him), but after playing along with it ("Only most of the time they call me 'delicious'"), he tells her off: "Miss von Schluetow, I've become a grandfather today. Let's not be silly." (This must have been doubly amusing to the 1948 audience, since Millard Mitchell was actually two years younger than Marlene Dietrich, and the birth of her grandson J. Michael Riva that same year had earned Dietrich the popular epithet, "the world's most glamorous grandmother," and a photograph of her on the cover of *Life* famously carried the caption "Grandmother Dietrich.")[69] Even in that scene, there is a little glimmer of Marlene's resourcefulness, daring, and verve that, together with the humor given to her character generally, makes Erika, despite her seemingly unprincipled flirtatiousness with Plummer and with the M.P.s, a more sympathetic figure—and certainly much more so than was the earlier conception of Erika von Schlütow's character who was headed for forced labor at Stalingrad.

As if echoing the old cliché that journalists like Drew Middleton had used, John says piously to Phoebe "Now, that we won the war, we must not lose the peace."[70] This comes at the beginning of the movie and is

supposed to explain why John does not want a home leave—when in fact it is, of course, his affair with Erika that makes him want to stay in Berlin. Alluding to John's affair with Erika, Plummer tells him: "I know you were among the first ten men to cross the Remagen Bridge. I also know why you were in such a hurry." And Plummer muses more generally: "Sometimes I wonder if it isn't an awful waste of money to import eleven thousand ping-pong tables for the recreation of you young men."

A Comedy of Denazification

The result is that the movie is extraordinarily balanced (which is why reviewers could find it more realistic and convincing than the heavier melodramas of the occupation which appeared at the same time, like *Berlin Express*). Wilder managed to accomplish this by keeping John relatively characterless (Dietrich called John Lund a "petrified piece of wood"), as an occupying Everyman very much attracted erotically to Erika while seemingly ready to settle with Phoebe (with whom the most intimate scenes include a kiss she makes impossible for a while by reciting Longfellow and improbably whistling "Shine on, Harvest Moon"—a tepid antithesis to Erika's full-bodied songs and even to the urgent orchestral rendition of "Isn't It Romantic").[71]

On the one hand, the film supports Plummer's wisecracking and grandfatherly smart approach to reeducation, and Millard Mitchell embodies the figure excellently, both in his jokes at the expense of Germany's Nazi past and in his good-humored devotion to reconstruction and helping establish democracy. His speech to the congressional delegation is the heart of this side of *A Foreign Affair*. "When we moved into Germany, we found a country of open graves and closed hearts," he says. "We had to eliminate things that breed political unrest and military aggression. We've tried to make them free men and give them some dignity." Finally: "We have helped them to start a free press and institute parliamentary government. They've just had their first free election in fourteen years. It had been so long they didn't know what to do with it. It was like handing the village drunk a glass of water. What I want to point out is, that it's a tough, thankless, lonely job. We're trying to lick it as well as we can."[72] This is the official OMGUS line that Plummer successfully humanizes in *A Foreign Affair*.

A Foreign Affair: **John Pringle (John Lund) in denazification office with Herr Maier (Richard Ryen) and Gerhardt (Ted Cottle).** *DVD screenshot.*

On the other hand, there is, apart from such speeches, not much filmic evidence of things changing much for the better under occupation. The waiter at the Lorelei bows deeply when ex-Gestapo officer Birgel shows up—as if the Nazis could return to power any time.

And the single scene in which we see John at work in his denazification office inspires little confidence in the success of that effort and provides only another occasion for black humor. A father and his son take deep bows when they leave (correcting their first impulse of clacking their heels), but the issue is that the little boy Gerhardt Maier keeps drawing swastikas all over the neighborhood. The father grabs the chalk away from the boy and says to John, "I will break his arm!" The following dialogue ensues:

> *John:* Herr Maier, we've dissolved the Gestapo.
> *Maier:* [He shakes his finger at boy.] No food, Bürschchen. (Little boy.) I will lock him into a dark room . . . into . . .
> *John:* Why not just shove him in a gas chamber?
> *Maier:* Yes, Herr Kapitän.
> *John:* Listen, Bub, we've done away with concentration camps. Now, you just take him around to a G.Y.A., one of our German Youth

Clubs. Some baseball and a little less heel clicking is what he
needs . . .

Maier: Yes, Herr Kapitän.

As they leave, Maier is seen from behind with a chalked swastika on his
back.[73] This scene makes the authoritarian father ridiculous, for he is
comically recognizable as an authority-loving Nazi, even as he tries to
erase his son's swastikas and wishes to please the new authority of the
Americans. Little Gerhardt's disturbed and vaguely surrealistic chalk
performance seems more sympathetic than the clichéd conduct of an
authoritarian father. In hindsight, one could even see in Gerhardt the
anticipation of the 1968 generation's many absurd (and sometimes will-
fully childlike) rituals of holding a Nazi mirror to the elder genera-
tions. Of course, John, who wields authority over Gerhardt's father,
and the American soldiers who teach German children how to play
baseball also play relaxed and child-friendly paternal (or avuncular)
roles as they work toward "a little less heel clicking" in German youth.
Still, this scene does not exactly instill much confidence in the process
of denazification of adults or in the growth of a politically responsible
democratic youth.

In any event, the film's dominant focus on John and Erika as an alle-
gorical enactment of an American-German encounter during the occupa-
tion makes political goals seem like a joke, a mere pretext for sexual ban-
ter. Colonel Plummer may tell the congressional committee that the
army is bringing democracy to Germany, but what the viewer sees is John
bringing a mattress to Erika, and the dialogue that follows is an excellent
example of the satirical approach the movie takes to the themes of denazi-
fication and reeducation.

Erika: Where did you get it?

John: A friend of mine baked it. [An allusion to his having exchanged
his American girl friend Dusty's birthday cake for the mattress.]
Only you're not going to get it. Should I care whether you sleep
or not?

Erika: Johnny, for fifteen years we haven't slept in Germany. First it
was Hitler screaming on the radio, then the war of nerves, then
the victory celebrations, then the bombing and all the furniture

A Foreign Affair: "Heil Johnny." Erika von Schlütow (Marlene Dietrich) and John Pringle (John Lund). *DVD screenshot.*

burned. See . . . (SOUND OF SPRINGS) That one I hate worst. Give me that mattress, Johnny.

John: No mattress will help you sleep. What you Germans need is a better conscience.

Erika: I have a good conscience. I have a new Fuehrer now. You! Heil, Johnny.

She raises her hand and rests it on his shoulder.[74]

[The frame at this moment shows a nice parallel between Marlene Dietrich and the baroque *putti* on the wall.]

John: You heil me once more and I'll knock your teeth in.

Erika: You'll bruise your lips.

John: Why don't I choke you a little or break you in two, or build a fire under you, you blonde witch.[75]

As they are about to kiss, they are arrested by knock on door. . . .

Erika: Who's that?

John: With my luck, it's Eisenhower.

If this is the sequence Brackett was thinking of when he defended the characterization of Erika against Herbert Luft's attack, the scene also shows that in *A Foreign Affair,* the military harbinger of American-style

democracy seems to be acting out, with his object of "reeducation," a rather kinky fantasy in what Wilder called a "crackling relationship."[76]

All sides of the political debate are presented with comic verve, and at the end the viewer has to decide what the film does not. In thinking about the American occupation of Germany after World War II, is it really Plummer's "We have helped them to start a free press and institute parliamentary government" or Erika's "Heil, Johnny" that best defines the moment? In its very inconclusiveness, *A Foreign Affair* cuts through the ideological rhetoric of occupation politics and tells a "very special love story," indeed. Perhaps Billy Wilder's motto for this film could already have been the one that made the ending of his *Some Like It Hot* so unforgettable, the line Wilder also was to choose for his tombstone: "Nobody's perfect."

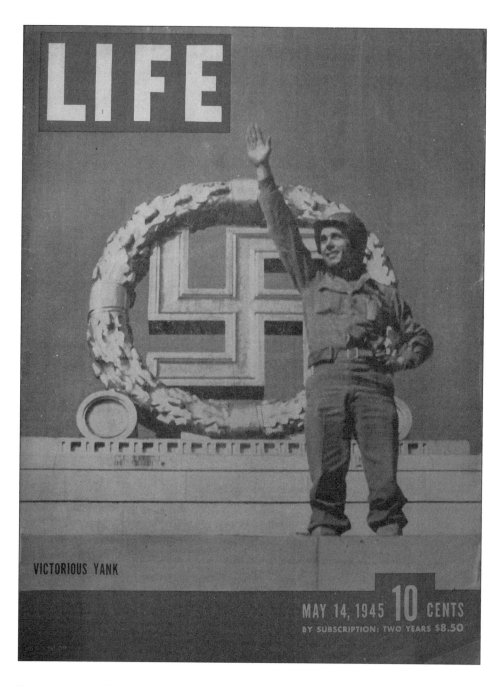

Victorious Yank. *Photo by Robert Capa, as it appeared on the cover of* Life, *May 14, 1945. Magnum/Robert Capa@ International Center of Photography, Robert Capa, Image Reference BOB1945012W00003/ICP717 (PAR 77084).*

Coda

Comic Relief?

Despair was more than just a temptation for many who lived through the 1940s in Central Europe, and traumatic memories would linger for decades to come. Was there a postwar angel of hope and forgiveness who could help sinners, sufferers, witnesses, and observers of the period achieve triumph over despair? The stress of experiencing the world of the 1940s created the wish to somehow overcome the haunting remnants of Nazism and to leave the horrors of these experiences behind—even experiences that may have come indirectly, from seeing photographs and documentaries or from reading stories and hearing reports. Throughout this book, we have seen how the events of the 1940s not only directly affected many people but also cast their indirect shadows onto writers, photographers, and artists of the period, making for aesthetic shifts and reorientations. After World War II Wolfgang Koeppen became a modernist in literature, Werner Bischof turned away from photographic abstraction and toward documenting human suffering, and Gerhard Gronefeld came to embrace art photography. After seeing Bergen-Belsen, George Rodger vowed he would give up war photography and William Congdon, who had drawn charcoals of the camp, started engaging in action painting. Martha Gellhorn wrote a Dachau novel, and from afar, her illustrator William Pachner abandoned his cheery cartoons and colorful advertising work and switched to a somber style in gray tones. The activist publisher Victor Gollancz, who had warned of the Nazis' anti-Semitism in the 1930s and tried to rouse world opinion to intervene into the Holocaust in the 1940s, in the postwar years published extensive pleas to evoke compassion for German suffering and to restrain the self-righteousness of the

Allies. The forties were a period of many an aesthetic and thematic turnaround.

Was there also a turn toward humor? Billy Wilder and Friedrich Holländer were not the only ones who, after going through a darker stage—Wilder editing *Death Mills* and Holländer visiting Dachau—reacted with a reassertion of irony, with such broad comic strategies, in fact, that (as we saw) a critic could consider *A Foreign Affair* a completely unacceptable "malefic travesty." Jokes may not have been abundant in the immediate postwar years, but they certainly existed, with targets of laughter going in all kinds of directions and with quite a bit of black humor inserted into them. A British postwar story has it that two Tommies are walking around the ruined city of Hamburg when, to their absolute surprise, they hear what sounds like the noise of industrial machinery from nearby. Could the Germans already have rebuilt a factory, the soldiers wonder. Yet as they approach the source of the sound they only see a long row of people passing along bricks from a mound of rubble to a lorry. Since each person in the line says "dankeschön" when receiving a brick and "bitteschön" when giving it to the next person, the chorus of the many voices declaiming "dankeschön—bitteschön—dankeschön—bitteschön" sounds like machinery.[1] A Jewish D.P. joke from postwar Bavaria needs a preliminary explanation since it includes as reference to Philipp Auerbach, a German Jewish survivor who had obtained the complex position of state commissioner for racially, religiously, and politically persecuted people, a position that made him powerful but also vulnerable.[2]

> On the Orient Express, two Jews from Munich, a German and a Pole, found themselves sharing the rare luxury of one of the sleeping compartments which in those days could only be obtained through pull. The Pole asked his companion, "How in the world did *you* manage a sleeper?" The German replied, "Philipp Auerbach! . . . And *you?* "Why," answered the Pole, confidently taking a package of cigarettes out of his pocket, "Philip Morris!"[3]

The black market power of cigarettes trumps the "pull" of the commissioner. And we have already regarded the versions of the Berlin saying, "Rather a Russki on the belly than an Ami on the head," that Erich Kästner and *A Woman in Berlin* reported in 1945.[4]

National Socialism—like all forms of totalitarianism—took itself very seriously and compelled its subjects and subject nations with deadly power to take it very seriously, too, and to perform a kind of emphatic collaborative conformity that was induced by the fear of violence. Its code of conduct with heel-clicking and fascist salutes, with ending each letter with "Heil Hitler!" which made some party members add an exclamation mark even after the word *Lebenslauf!* on their C.V.s, simply invited comic deflation, especially once the Nazis had been defeated. In *A Foreign Affair*, the scene in the denazification office functions like a comedy routine in this manner, with Gerhardt's father continuing to move in the angular military manner, even toward his own son. Marlene Dietrich's "Heil, Johnny" gesture also repeats and thereby parodies and makes ridiculous the Hitler salute—while adding a bit of double-edged humor to the situation of fraternization. One can find many such uses of repetition-with-a-comic-difference and of a broader comedy in postwar Germany, often with a touch of black humor. Though they may have been solicited and read primarily as endorsements of victory, they still seem to have a slightly different effect from those raw gestures of victorious superiority that Victor Gollancz targeted for his criticism; in fact, they seem to approach the quality of a ritual of exorcism hidden in the form of a gag.

The most widely disseminated example of such a gag was the cover of *Life* magazine of May 14, 1945, the first issue readers could buy after VE Day. It showed the Virginian G.I., Hubert Strickland, doing the Hitler salute in front of a gigantic swastika.[5] Margaret Bourke-White related the story of how this cover photograph came about: *Life* had cabled all photographers "to strive for a cover picture that would symbolize victory over political tyranny," and Robert Capa rose to the occasion when he asked his jeep driver to pose for him under that huge swastika at the Nürnberg party rally ground: "It was a natural thing for the driver to raise his hand in a mock 'Heil,' and for Capa to take a couple of shots against the mammoth shrapnel-battered swastika." Bourke-White thought that the photograph "expressed everything: the vast stadium once consecrated to all we were fighting against, its Nazi symbols scarred by our bombs and shells; the tired, victorious doughboy; and even the suggestion of a gag in that imitation of a 'Heil'—a GI gag at the moment of victory. There is an indefinable mood that suffuses all fine pictures; this one had what a Victory

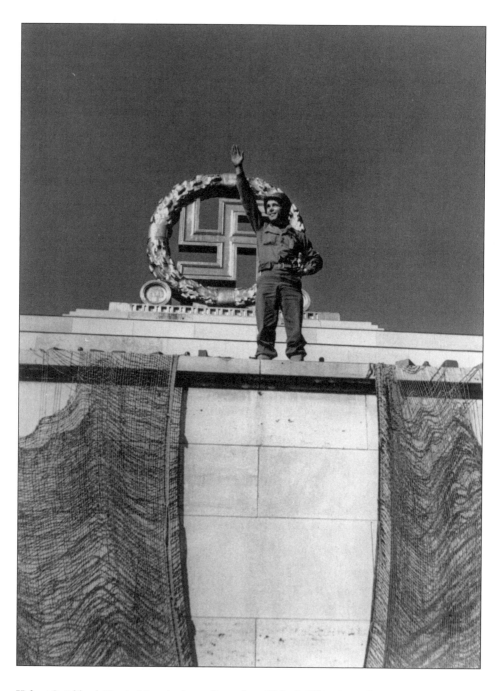

Hubert Strickland, Capa's driver, in the stadium where Hitler held his Nazi rallies. Nürnberg, April 20,
1945. *Photo by Robert Capa. Magnum/Robert Capa@International Center of Photography, Robert Capa, Image Refer-*
ence BOB1945012W00003/ICP717 (PAR 77084).

cover required."[6] The capsule description of the photograph in the front matter of the issue of *Life* similarly stated that, serving in a unit that had captured Nürnberg, Strickland had "just made history" but now "proceeded to mock it. In a stadium where Hitler had often stood, he raised his right hand and, with a burlesque Nazi salute, proclaimed a GI's razzing epitaph on Hitlerism."[7] This gesture, disseminated by the cropped, slightly rotated, and retouched version of the photograph on the *Life* magazine cover (see the figure facing the opening page of this chapter), became widely popular and was imitated by numerous other G.I.s who posed for photographs on Hitler's tribune even after the huge swastika had been exploded by the U.S. Army.[8]

In 1945 Lee Miller and David Scherman went to Hitler's huge apartment on the third floor of Prinzregentenplatz 16 in München and found Hitler's bathtub enjoyable. "Before taking turns in the large tiled tub, they set the scene for the series of photos that mark the occasion. In the best of these, Lee's pensive, almost unreadable expression as she reaches to scrub her shoulder contrasts oddly with the objects around her, which look like props. On the rim of the bath, a photograph of Hitler surveys the scene; a classical statue of a woman stares back at him." This is how Miller's biographer describes this deliberately staged scene in an extended interpretation of the ironies in the photograph that places Miller between Hitler and the Venus statuette "whose raised right arm echoes her own." Among other photographs Scherman took was one of a G.I. reading *Mein Kampf* on Hitler's bed.[9]

What for Miller and Scherman were mere props for taking photographs, were desirable souvenirs for which Allied visitors were soon hunting in Hitler's apartment, as Bourke-White reported it: "It was an unprecedented experience for me to be guided through a souvenir's paradise like Adolf's apartment by an officer in the Military Government. But the place had been gone over so thoroughly by the 42nd Division that only the heaviest of its movable objects remained."[10]

Gags, burlesque salutes, mockeries of history, visits to sites strongly associated with Hitler where one can let oneself be photographed and wish for souvenirs—were these all mere gestures of victorious derision or expressions of black humor, of laughter on edge, of a wish to forget that was immediately recognized as impossible, as the very acts of repetition themselves demonstrated?

Gertrude Stein stands with a group of U.S. soldiers as they all smile and point into the distance, shortly after the end of World War II in Berchtesgaden, location of Adolf Hitler's home, Obersalzberg. **July 20, 1945.** *Photo by U.S. Army/Getty Images/Time & Life, 719999159.*

When Gertrude Stein and Alice B. Toklas visited Germany in 1945, the characteristically enigmatic Stein literally covered all these elements when she wrote up the visit for *Life* magazine in her unmistakable style: "We all did Hitler's pose on Hitler's balcony in Berchtesgaden," the caption of the photograph reads in *Life*—though Stein and the soldiers do *not* do a Hitler salute but merely point in the same direction in a way that resembles a Hitler salute: she thus engaged in an act of comic near-repetition that is intensified by the fact that it is a collective gesture. Stein's own text makes clear the fascination with comically overcoming the legacy of the past:

> And off we went to Hitler. That was exciting. It was exciting to be there, the other houses were bombed but Hitler's was not it was burned but not down and there we were in that big window where Hitler dominated the world a bunch of GIs just gay and happy. It re-

ally was the first time I saw our boys really gay and careless, really forgetting their burdens and just being foolish kids, climbing up and around and on top, while Miss Toklas and I sat comfortably and at home on garden chairs on Hitler's balcony. It was funny, it was completely funny, it was more than funny it was absurd and yet so natural. We all got together and pointed as Hitler had pointed but mostly we just sat while they climbed around. And then they began to hunt souvenirs, they found photographs and some X-ray photographs that they were convinced were taken of Hitler's arm after the attempt on his life. What I wanted was a radiator, Hitler did have splendid radiators, and there was one all alone which nobody seemed to notice, but a radiator a large radiator, what could I do with it, they asked, put it on a terrace and grow flowers over it, I said, but our courage was not equal to the weight of it and we sadly left it behind us. After we had played around till it was late off we went, down the hills and that day was over, it was a wonderful day.[11]

Stein's approach was that she parodied the parodies, exaggerated the wish for a souvenir absurdly by choosing a truly odd one, too bulky to be transported, but one that by becoming a base for growing flowers would embody the wish for renewal—a wish that her ironic style yet undercuts. Indeed: "It was funny, it was completely funny, it was more than funny it was absurd and yet so natural"—and now "that day was over."

Stein put her ironic recipe on reeducation right in the odd subtitle of her essay. It reads: "Germans should learn to be disobedient and GIs should not like them no they shouldn't." The explanation comes in a conversation Stein had about reeducation with General Osborne. She proclaimed:

There is only one thing to be done and that is to teach them disobedience, as long as they are obedient so long sooner or later they will be ordered around by a bad man and there will be trouble. Teach them disobedience, . . . make every German child know that it is its duty at least once a day to do its good deed and not believe something its father says or its teacher tells them, confuse their minds, get their minds confused, and perhaps then they will be disobedient and the world will be at peace. (56)[12]

Near the end of the essay Stein expresses her anger at G.I.s who "admitted that they liked the Germans better than the other Europeans." "Of course you do," Stein says, beginning a tirade that starts with the point that Germans "flatter you and they obey you" and that on July 4 "they will all be putting up our flag . . . and all you big babies will just be flattered to death, literally to death . . . because you will have to fight again" (58). As Julia Faisst put it, for "Stein, a prime dealer in disobedient narration and confusing diction, disobedience equals confusion, and confusion equals peace."[13]

Stein may have had a point, for not only were Germans hoisting the Stars and Stripes, but Berliners, for example, literally stitched together American flags, and all Allied flags, right after the war. Thus the anonymous diarist of *A Woman in Berlin* describes a woman on June 2, 1945, who was

> sewing together red and white stripes on a sewing-machine. I then watched her cutting circles out of some white material, afterwards scalloping them into stars: the Stars and Stripes—she's making an American flag. . . . It's a difficult flag for a German seamstress, difficult in color, even more so in design. How simple the Russian flag by comparison! All one has to do is unstitch the black and white swastika design from an old Nazi flag (which every unbombed house is sure to have), then sew a yellow hammer and sickle in the top left-hand corner of the background.[14]

One of Margaret Bourke-White Berlin photographs, "Brother and sister in Berlin: The flags are home-made," shows two children in front of a completely ruined building on which four flags representing the four occupying powers have been mounted, flags that have clearly been recycled in the manner *Woman in Berlin* described.[15] Such flags are perceived as somewhat comic: they, too, speak of repetition with a difference, but though seemingly cheering the new order they, like palimpsests, cannot completely erase the traces of the old, for "occasionally one can still see the dark circle from which the white piece of material with the black swastika has been unstitched."[16]

One has reason to doubt whether General Osborne followed Stein's suggestion or whether the G.I.s minded her advice. Still, it would seem that a spirit of disobedience did reemerge in Germany when the National

Socialist state of siege was ended. Even though public criticism of Allied policies and of the Allied Military Government was prohibited, it was in jokes of the 1940s that one could hear a note of criticism and disapproval, even of the Allies. Stig Dagerman does devote a section of his report to humor. In Hamburg he observed a man who used the performance of selling a newly invented potato peeler as a comic way of criticizing the low calorie allocations: for his instrument can produce the thinnest possible peels—thus preserving more of each precious potato. Dagerman comments: "No one is likely to satisfy his hunger by joking about it, even in Hamburg, but to be able to laugh at it provides an entertaining form of forgetfulness which the people of this hungry land are seldom willing to forgo."[17] In a similar vein, a fish salesman puts a notice in his window that reads, "Imagine raising the fish rations now when we're *so* short of wrapping paper" (27).

Could black humor be an effective secular way of fending off the devils of despair or make them at least hide under the bed for a while? Recently returned to Berlin from Italy, a wounded German ex-soldier who gets forty-five marks a month from the government, "enough for seven cigarettes," and who now lives with a Polish woman who lost her husband at Auschwitz and lost two of her children on the road from Poland to Berlin in the chaos of 1945, tells Stig Dagerman an explicitly critical joke about the four occupying powers in Berlin. They, he says, "rule over a pond and each has his own goldfish. The Russian catches his goldfish and eats it up. The Frenchman catches his and throws it away after pulling off the beautiful fins. The American stuffs his and sends it home to the USA as a souvenir. The Englishman behaves most strangely of all: he catches his fish, holds it in his hand and caresses it to death" (49). Perhaps Gertrude Stein would have been happy, or confused, had she heard this joke.

Afterword

When I first turned toward the undertaking that has now resulted in this book, I expected to write an account of the American occupation of Germany and the dissemination of American culture in Western Europe after World War II. It was meant as a project that would be partly informed by, but not include specific references to, my own first encounters with America in postwar Germany: smiling black soldiers with their casual body poses; music on the radio; jeeps speeding by; and first experiences with chewing gum, a form of nonfood John Kouwenhoven once said could only have been invented in America, as it embodies process rather than result. I intended to explore what has fascinated a German boy about America, fascinated me to such an extent that I would spend half a century examining American culture as a student and scholar. At some point I imagined that each chapter might center on an American-German encounter, and perhaps I even expected something along the lines of what Orm Øverland calls a "homemaking myth," suggesting a compatibility or symbolic merger of selected German and American motifs. And it promised to become a rather cheery study. At some point Lindsay Waters, my editor, urged me to include occasional personal recollections in the text so as to make this fully *my* book, a suggestion I followed in a few asides and that I am now continuing to follow in this afterword.

As I became more deeply engaged in the postwar sources some surprises awaited me. An encounter that I initially believed to be between an American photographer and a German boy turned out to be more haunting as the encounter between a British photographer and a Dutch Jewish boy that it was in reality. The mood was often darker than I had known,

remembered, or expected; in fact, it came as a surprise to me how gloomy the expectations for the future were, not only on the side of the defeated, but also on the side of the victors. Another surprise was the extent to which information about the atrocities—about what would later be called the Holocaust—was disseminated right away and in all available media in the immediate postwar period, generating the persistent question of how to react to the enormity of the horrors committed in World War II in Germany's name that were beginning to be revealed in full and visually documented. Dachau, Buchenwald, Bergen-Belsen, and other camps were frequently mentioned. The diaries of 1945, and the changes some of them underwent for publication, made apparent the continuing search for an adequate human response to these revelations.

Living in Central Europe after World War II meant living in a vast graveyard. George Rodger's Bergen-Belsen photograph suggests as much visually. Though my examination of it was driven by a wish to imagine as precisely as possible the moment at which it was taken and to find out as much as I possibly could about the photographer and his subject, I was, of course, also identifying with the boy in that picture. I was dressed like him when I was his age, in sweaters, knee pants, and leather shoes, and I could also see myself in him in the abstract, or allegorically, squinting, but looking forward, away from murder, death and frightening forms of violence, stories of which have accompanied me from an early age. A horrifying sense of the very recent past and dark forebodings concerning the future did not help to make more palatable the early postwar years that were characterized by food and housing shortages, life in ruins, and forced mass expulsions. Yet somehow the mood and the material conditions did change, more quickly than one might have thought possible in the mid-1940s, and new German postfascist beginnings did become a reality.

My last chapter and the coda focused on one way the temptation of despair could be fended off, by black humor and by ridiculing what had been the common rituals of an immensely powerful dictatorship: such black-humor strategies persisted into the comic counterrituals of the '68 generation in some of which I also took part. It was well after 1968 that I first saw Billy Wilder's *A Foreign Affair*, after I had seen Mel Brooks's *The Producers*, both films that so excellently and, I believe, effectively, approached fascism and its legacy with the means of comedy, following in the path that Ernst Lubitsch had cleared with his wartime comedy *To Be or Not To Be*. Some of

Tony Vaccaro's photographs were also animated by an at times more melancholy form of humor with distinctly pacifist undertones, Erich Kästner's hetaera story was a comic way of dealing with the bombing experience, and *A Woman in Berlin* gave room even to the shocking topic of rape humor. Still, black humor was not the only antidote to the gloomy world of the 1940s.

The very popularity in the postwar period of Georges Bernanos that ultimately let me choose his phrase "the temptation of despair" as the title of this book also speaks to the religious revival that postwar West Germany experienced. After all, the traditional remedy against the temptation of despair was to reaffirm one's faith in God. The teacher quoted in Chapter One who witnessed the Easter-time arrival of the first American tank in his village expressed his reaction with the Christian metaphor of the Resurrection, the woman in Berlin wonders whether she can still call herself "Christian," and Toxi prays before sitting down to eat or going to sleep. The new postwar emphasis on religion was apparent also in Kurt Ihlenfeld's novel, where the central figure is a Lutheran minister, and the lieutenant's last hope is in God; in one of Gerhart Pohl's short stories, Wanda prays to the crucifixion. It was the Society for Christian-Jewish Cooperation that worked toward the acceptance and integration of mixed-race occupation children in postwar Germany. The religious revival did help to give rise to a new sense of hopefulness and to reassert old and tried ethical maxims that the Nazis had striven so hard to do away with. It also gave churches a central role in West German society. Socialists, too, were a strong force in the immediate postwar years and were given to look forward toward building up a new Germany, even though the Stalinist dictatorship that was constructed in the Russian zone of occupation soon dampened any enthusiasm for communism in the areas of Germany where free elections could be held. Still, the two biggest parties to emerge in postwar West Germany adopted some socialist ideas, and one put the adjective "Christian" right in its name. Socialists and some Christians could also see their postwar hopes as a continuation of their antifascist past, as many of them had suffered in concentration camps.

At the same time, it was impossible to ignore how quickly some former Nazis also became active again, aided by the Cold War. This became apparent to me when I approached *Toxi* with the eyes of a scholar, a film that had deeply affected me when I was nine years old but that now began to appear

as a demonstration of the restoration of the Nazi film industry in postwar West Germany—until, upon even closer scrutiny I saw how some participants in the Nazi propaganda machine could also themselves be victims, people who had been held hostage by a regime that ruled with the suspension of basic human rights, a state of exception that lasted for more than twelve years.

For some time I have been puzzled by contemporary scholars, both in the United States and in Europe, who seem to be enchanted by Carl Schmitt who famously defined sovereignty as the ability to declare the state of exception. Schmitt was more than an accidental Nazi, published explicitly anti-Semitic essays in the 1930s, was petty enough then to remove positive references to Jewish scholars from his pre-Nazi publications, and remained rather unapologetic after the war. I became deeply interested when I came across the German Jewish émigré scholar Karl Loewenstein who tried in vain to bring Schmitt to trial in 1945. Their diverging paths and their relationship—as the reader has seen, Schmitt even recorded a dream about Loewenstein—became an opportunity to juxtapose liberal and authoritarian theories of the state and to examine the emergence of the concept of a democracy that would be militant enough to defend itself against its declared enemies. Like many others who approached the difficult task of "denazification" with some idealism, Loewenstein also pondered the various possibilities of excluding real Nazis from positions of political power in the postwar world, a necessary step toward the new democratic beginnings.

General Lucius D. Clay, who was appointed Eisenhower's deputy in 1945 and then served as military governor from 1947 to 1949, offered a balanced assessment near the end of his memoir *Decision in Berlin*, which chronicles his work in the Military Government: "We cannot and should not forget the destruction Hitler brought to the world, nor the potential cruelty which led to concentration camps and mass exterminations. We cannot forgive the German people for permitting such things to happen. However, we must remember that the people in a police state have little to say and their moral and spiritual qualities deteriorate rapidly."[1] This, together with Clay's hope for German unification and reintegration into "the family of European nations," is a good indication of his distance from revenge fantasies like the one Martha Gellhorn's Jacob Levy acts out, different also from the tone of some of the reports about Germans in *Life*

("the world, seeing their suffering, finds it hard to feel sorry for them"), and from the initial platform of the punitive occupation blueprint JCS-1067 (of which Clay was very critical). The story of the American occupation was a story of heterogeneous competing tendencies. This is quite a normal fact in a democratic society that can be sensitive to press reports, as is illustrated by the Harrison report on the dismal situation of Jewish postwar D.P.s, with a good number of them interned for years in former concentration camps. Harrison's request to treat "Jews as Jews" also makes this document a part of the prehistory of what became affirmative action.

Having been drawn to topics of migration for much of my life, I also realized in the course of this project how intertwined my own life had been with these themes. My parents, aunts, uncles, and older cousins told stories after stories about Silesia, though many of them would never be able to return even for just a visit in their lifetimes, and my mother superimposed the topography of Breslau onto that of Frankfurt, where she lived from 1953 until her death in 1994. Breslau was a city, the landmarks of which I heard mentioned all my life, yet it is a city, now called Wrocław, that I saw for the first time consciously only when I had turned sixty. Researching literature about the postwar refugees also brought along its surprises. In Germany, a public critique of the expulsions and of the bombing of residential cities has had its natural home on the right of the political spectrum, the left accusing such critique as a sneaky way for a country of perpetrators to claim victim status by whining about the postwar expulsions so as to be silent about German wartime atrocities, or else in order to "balance an account" (the phrase used by the author of *A Woman in Berlin*).[2] Yet the best German literary treatments of the expulsions that I read do include specific and extended references to the Shoah and German war crimes, in part as an explanatory background to the new events of 1945.[3] I also did not know that American liberal postwar reports (as well as Swedish and British socialist voices) were so sympathetic toward the expellees (mostly women, children, and older people) and toward the misery of those who had to live in ruins. The postwar books by Victor Gollancz and Stig Dagerman, the report in the Christian magazine *America*, the work of the members of the Committee against Mass Expulsion in New York, and the declaration of the World Council of Churches were particularly striking to me—also as they document the value of freedom of the

press—and some of them might perhaps still be of interest in Germany today.[4] The intensely humane concern of such efforts to affect public opinion in Western countries contrasted sharply with the propagandistic pamphlets American soldiers received, instructing them to "avoid the pitfalls of sentimentalism," for "making us feel sorry for them is one of the few weapons the 'little' Germans have left," or promising the soldiers: "You'll see plenty of ruins, but you will not have to live in them."[5] Still, it seems that the army had a hard time convincing soldiers of assuming a punitive attitude, as the blatant failure to maintain a fraternization ban and contemporary press reports about the reluctance of soldiers to accept the propaganda they were given suggest.[6]

As I mentioned in an aside, in my childhood I experienced many kindnesses from American soldiers, especially but not only from African Americans. Yet until I read the sources for this book I had not fully known how deeply the Jim Crow regime affected the details of their lives while they were stationed in Germany. Neither had it occurred to me before reading Kay Boyle's "Home" and Kurt Vonnegut's "D.P." that the occupation of Germany permitted black soldiers to play a paternal role toward German children, kinder and more generous than the general part American soldiers were believed to perform after 1945, namely (in the words of Bertram Schaffner, a neuropsychiatrist who participated in the denazification of Germany) that of a "strict but benevolent father, returning home to punish bad children for their misbehavior and to reestablish the accepted order of the family."[7] It seems plausible to me that the large-scale experience of black soldiers in Germany was an element in the growth of the civil rights consciousness in the United States.[8]

Examples of positive experience with Americans were numerous in my family. One of my aunts received a Care package and gave us the mysterious egg powder that was included in it. One afternoon, soldiers showed us children the inside of the requisitioned house in which they lived, an abode of what was, for children, a near-utopian messiness and that had a working pianola in it, and they gave us white bread. Later I watched Marshall Plan films and went to the Amerikahaus in Frankfurt. One of my cousins married a G.I. from Alabama and another cousin worked for the U.S. Army, then went to Texas for a number of years. Like the boy trying to assume a casual pose next to that naturally casual G.I. in Tony Vaccaro's photograph, I also practiced and ultimately learned

to assume casual body postures, probably though from models in Hollywood movies.

I was never confronted with any charge of collective guilt, although it did not take anyone from the outside to make me feel German shame and guilt. Like the boy who looks at the poster documenting atrocities in the photograph that opens Chapter Three, I stared at many similar photographs when I was in middle school and was a Catholic boy scout. German illustrated magazines reprinted images of the Nazi years regularly in the 1950s, and I clipped out dozens of them and made an album that included images of the Warsaw uprising and of a skeletal figure at Auschwitz as well as a pamphlet about the July 20, 1944, attempt to assassinate Hitler. One of the very first political demonstrations in which I participated was against Globke and Oberländer, ex-Nazis whom Adenauer had appointed in his government. Later I attended some sessions of the Auschwitz trial in Frankfurt. As someone who grew up where and when I did, I could not but have a lifelong passionate engagement with early postwar life and with the horrors of the war that preceded it.

However, this book, despite its few autobiographical asides, makes no claims of authority because "I was there." While I saw *Toxi* as a nine-year-old child, I did not see most of the photographs and did not read most of the texts I wrote about until I started working on this book. Reading and rereading texts from the war years to the early 1950s, watching and rewatching films from the period, and looking at countless photographs again and again became the method with which I could settle on a manageable number of texts, films, and images to include for discussion in this book. Some of them are extremely well known, but many have received scant scholarly attention: there is, for example, very little secondary literature on Gellhorn's *Point of No Return*, Hans Habe's *Walk in Darkness*, or on Vonnegut's "D.P.," and even less on Pohl's short stories, Ihlenfeld's novel, or Ursula von Kardorff's published diary.

As I mentioned in the introduction, I was drawn to some of these works because they appealed to me as a scholar in the humanities: they conveyed a rich "inward" sense of the cultural moment I had chosen to focus on. When I used the term *inward*, I did not mean to refer to an inner private sphere, as distinguished from the public realm of politics, something that the German word *Innerlichkeit* has suggested at times. I also never meant to imply that a Swedish report on postwar Germany or a British photo-

graph taken there were somehow "outward." Instead, what I was after in the works I studied was what might get lost in quick generalizations, bullet-point summaries, or abstract debates. In all parts of this book I have therefore attempted to stay close to the sources, quote extensively from texts, and examine exemplary photographs and films at very close range, not as thematic exhibits and illustrations of conclusions I had arrived at earlier, but as aesthetic objects that make a moment or an issue come to life in such a way that it stays with the reader and viewer beyond any single maxim or conclusion that could be drawn from them. This also meant engaging with the writers and artists together with their metaphors and images, with the contemporary reception, and sometimes even with plot-lines that seemed implied but were aborted in a given work. I can only hope that showing the struggles and hesitations at the stages of composition of a film script, the cropping and captioning of a photograph, or the revisions of the text of a diary did come across to the reader as an effort to respect the dynamic quality of the forms I examined and to understand aesthetic modes of expression themselves as an active part in the historical process and not just as a reflection of it. A famous quip has it that poetry is what gets lost in translation. My attempt in this book has been to hover on what would get lost in a summary.

Notes

Introduction

1. The *Oxford English Dictionary* cites Reuben Hatch's book *Bible-Servitude Re-Examined: With Special Reference to Pro-Slavery Interpretations and Infidel Objections* (Cincinnati: Applegate, 1862), 243, as the first instance of the word *nation-building*, where it is associated with the rise of human selfishness resulting in the creation of chattel slavery; the next occurrence is in a journal article from 1913 referring to "the moving forces of the constructive nation-building of the American people." Yet a Google Ngram curve for the word shows a steep increase of its employment only in the years from 1958 to 1972 and from 1985 to 2000.

2. Franz Oppenhoff, the mayor of Aachen installed by the Americans in October 1944, was assassinated on March 21, 1945, in what was believed to be a Werwolf action, but research in East German archives led Volker Koop to the conclusion that the assassination was an SS operation. See his book *Himmlers letztes Aufgebot: Die NS-Organisation "Werwolf"* (Köln: Böhlau, 2008), 122–36. Similarly, the spectacularly brutal assassination of sixteen people collaborating with the Americans in Bavaria, the so-called "Penzberger Mordnacht" of April 28, 1945, may have actually been planned by the SS. Members of the occupying forces appear not to have been targeted.

3. This is a marked contrast to the situation in Japan.

4. See Timothy Snyder, *Bloodlands: Europe between Hitler and Stalin* (New York: Basic Books, 2010); and Keith Lowe, *Savage Continent: Europe in the Aftermath of World War I* (Oxford: Oxford University Press, 2012).

5. Franz Neumann, "Military Government and the Revival of Democracy in Germany," *Columbia Journal of International Affairs* 2 (1948): 4.

6. See Norman M. Naimark, *The Russians in Germany: A History of the Soviet Zone of Occupation, 1945–1949* (Cambridge, MA: The Belknap Press of Harvard University Press, 1995). See also Anonyma, *Eine Frau in Berlin: Tagebuch-Aufzeichnungen vom 20. April bis 22. Juni 1945* (2003; repr. München: btb-Verlag, 2005), discussed in Chapter One.

7. I am citing these examples more or less randomly to stand for such a vast array of shorthand capital letters used in the 1940s that several scholarly books about the period include long lists of acronyms. However, in case the reader wonders, HJ stands for Hitlerjugend; BdM for Bund deutscher Mädchen, the Nazi youth organizations for boys and girls; and GYA was the German Youth Association of the U.S. Army, which engaged youngsters in sports activities after the war. OKW was the Oberkommando der Wehrmacht, the Supreme German Army Command, SHAEF the Supreme Headquarters Allied Expeditionary Forces, and USAREUR the United States Army Europe.

8. Richard L. Merritt, *Democracy Imposed: U.S. Occupation Policy and the German Public, 1945–1949* (New Haven: Yale University Press, 1995), 260.

9. The document is included in Hajo Holborn, *American Military Government: Its Organziation and Policies* (Washington, DC: Infantry Journal Press, 1947), 157–72. The quoted passages are on 159 (4.b and 4.c). Part II of the directive instructed the commander-in-chief of U.S. Forces of Occupation: "Except as may be necessary to carry out these objectives, you will take no steps (a) looking toward the economic rehabilitation of Germany, or (b) designed to maintain or strengthen the German economy" (164). See also http://usa .usembassy.de/etexts/ga3-450426.pdf, accessed March 1, 2013. One of the odd ironies of the JCS-1067 was that this first real blueprint for the American occupation was classified and remained secret because it contained a large list of people who were to be arrested; it was made public on October 17, 1945. By then parts of the JCS-1067 had been incorporated into the Potsdam Agreement. General Lucius D. Clay was critical of the JCS-1067 and found that it "contemplated a Carthaginian peace which dominated our operations in Germany during the early months of the occupation," but was fortunately so general in nature that "the degree of its application was left to the judgment of the military governor." Clay, *Decision in Germany* (Garden City, NY: Doubleday, 1950), 19.

10. Nicholas Watson, "Despair," in Brian Cummings and James Simpson, eds., *Cultural Reformations: Medieval and Renaissance in Literary History*, Oxford Twenty-First Century Approaches to Literature (London: Oxford University Press, 2010), 342–57, an authoritative and exhaustive treatment of the theological and historical background of the notion in the Middle Ages and the early modern period.

11. Giorgio Agamben, *Stanzas: Word and Phantasm in Western Culture*, trans. Ronald L. Martinez (Minneapolis: University of Minnesota Press, 1993), 3. Quoting Cassian's long warning against the dangers of the "midday demon," Agamben comments that the patristic description seems "to have furnished the model for modern literature in the grips of its own *mal de siècle*" (14n4).

12. *Ars moriendi, Desperatio: Versuchung durch Verzweiflung*, Cod. Pal. germ. 34, fol. 118v, XV c. Heidelberg / Universitätsbibliothek. Friedrich Joseph Adam Bartsch, *Die Kupferstichsammlung der K. K. Hofbibliothek in Wien: In einer Auswahl ihrer merkwürdigsten Bilder* (Wien: Braumüller, 1854). Images of

"Temptation by Despair" and "Triumph over Despair" are at ARTstor 8075.1475/651.

13. The lure of suicide also had a longstanding history. Thus a seventeenth-century melancholy woman confessed to experiencing the "very great temptations" of destroying herself after giving birth to a child, so much so that she often took a knife in her hand to do it and feared being alone—until after the loss of another child she was freed of her thoughts of desperation by God's great mercy, and she was able to pray and found solace in scriptures. E.C., "The Temptation of Despair," in Patricia M. Crawford and Laura Gowing, eds., *Women's Worlds in Seventeenth-Century England* (London: Routledge, 2000), 276. Source: Vavasor Powell, *Spiritual Experiences of Sundry Believers*, 2nd ed. (1652), 25–27.

14. Robert Brasillach, a French fascist writer who was executed as an intellectual collaborator in 1945, published an in-depth essay on Bernanos in 1944 under the title, "Georges Bernanos ou la tentation du désespoir," in *Les quatre jeudis: images d'avant guerre* (1944; repr. Paris: Les sept couleurs, 1951): 257–74. Georges Bernanos, *Die Sonne Satans*, trans. Friedrich Burschell and Jakob Hegner (Hamburg: rororo 16, 1950). In an essay on Gertrud von le Fort's postwar writing, Joël Pottier invokes Bernanos's phrase to characterize le Fort's lyrical diary of the years 1933 to 1945. In Frank-Lothar Kroll, ed., *Flucht und Vertreibung in der Literatur nach 1945* (Berlin: Gebr. Mann Verlag, 1997), 147.

15. Gerhard Hirschfeld and Irina Renz, eds., *"Vormittags die ersten Amerikaner": Stimmen und Bilder vom Kriegsende 1945* (Stuttgart: Kleist-Cotta, 2005), 93.

16. Ed Sikov, *On Sunset Boulevard: The Life and Times of Billy Wilder* (New York: Hyperion, 1998), 248–49.

17. A Google Ngram even shows a sharp increase of uses of the word *Selbstmord* (suicide) from 1941 to 1948. Percy Knauth's essay on "The German People" in *Life*, May 7, 1945, 69–76, begins with the story of the suicide on March 25 of Helmut Lotz and his family in Frankfurt.

18. The many photographs of this scene that are now also readily available at various internet sites seem to have helped to make these suicides rallying events for the extreme right. Lisso appears to have followed the example of Mayor Alfred Freyberg who also killed his wife and daughter and himself as the Americans were arriving in Leipzig. In Bourke-White's section "Death Seemed the Only Escape," she mentions that she was urged by Bill Walten of *Life* magazine to run to Leipzig's city hall: "The whole inside of it is like Madam T[u]ssaud's wax-works." She follows this with a half-page description of the scene, including the bottle of Pyrimal with which the Lissos had killed themselves. See *"Dear Fatherland, Rest Quietly": A Report on the Collapse of Hitler's "Thousand Years"* (New York: Simon and Schuster, 1946), 49–50. Some of Bourke-White's photographs appeared in the photo-essay "Suicides: Nazis Go Down to Defeat in a Wave of 'Selbstmord,'" *Life*, May 14, 1945, 32–33. See also Vicki Goldberg, *Margaret Bourke-White* (New York: Harper & Row, 1986), 292–93. Bourke-White took another photograph from a very high position. Whereas Bourke-White featured Lisso's

party membership card under his elbow, Lee Miller shot the scene after placing a highly visible portrait of Hitler against the doorpost. Someone also must have moved Lisso's body into a more upright position on the extremely dusty table, so that his elbow now rests next to a pack of cigarettes and matches and not on the party card. Miller "photographed the mother and the daughter as if asleep, then moved close to the daughter, who seems to swoon luxuriously across the leather sofa." Carolyn Burke, *Lee Miller: A Life* (New York: Knopf, 2005), 254. Burke mentions the resemblance of Miller and Lisso's daughter as well as another "little known shot from the Leipzig sequence" that shows a U.S. Army photographer shooting the scene. A brief film is at http://www.youtube.com/watch?v=ozwJ3Xog9sw, accessed March 1, 2013. Not only high-ranking Nazi officials or Germans fearful of the arrival of the Allies committed suicide, but also many others did, as the last, full-page photograph in the "Suicides" photo-essay in *Life* also suggests.

19. Thomas Dodd, in Christopher J. Dodd, with Lary Bloom, *Letters from Nuremberg: My Father's Narrative of a Quest for Justice* (New York: Crown Publishing, 2007), 98. Dodd goes on, however, to complain particularly about the conduct of the French colored troops and "the vicious butchery of some Russians." Later on he affirms his own hatred of anti-Semitism but expresses the wish that "the Jews would stay away from this trial—for their own sake" because he believes that the staff is "about seventy-five percent Jewish" (135).

20. Heinrich Hauser, *The German Talks Back*, Intr. and annot. Hans J. Morgenthau (New York: Henry Holt, 1945), 110.

21. This partly resembled Secretary of the Treasury Henry Morgenthau Jr.'s 1944 proposal for a totally deindustrialized postwar Germany.

22. Quoted in Theo Sommer, *1945: Die Biographie eines Jahres* (Hamburg: Rowohlt, 2005), 263.

23. Quoted in Atina Grossmann, *Jews, Germans, and Allies: Close Encounters in Occupied Germany* (Princeton, NJ: Princeton University Press, 2007), 157. In another speech of June 10, 1945, Grinberg said, "We belong to those who were gassed, hung, tormented and tortured to death in the concentration camps! . . . We are not alive . . . we are dead!" And he ended his short speech as follows: "We are free now, but we do not know how to begin our free but unfortunate lives. It seems to us that for the time mankind does not comprehend what we have gone through and what we have experienced during this period of time. And it seems to us, that we shall not be understood in [the] future. We have forgotten how to laugh, we cannot cry any more, we do not comprehend our freedom yet, and this because we are still among our dead comrades. Let us rise and stand silent to commemorate our dead." At http://www.jewishvirtuallibrary.org/jsource/Holocaust/GrinbergSpeech .html, accessed March 1, 2013.

24. William Ebenstein, *The German Record: A Political Portrait* (New York: Farrar & Rinehart, 1945), 307–8.

25. John Dos Passos, "Americans Are Losing the Victory in Europe: Destitute Nations Feel that the US Has Failed Them," *Life*, January 7, 1946, 23, 24.

26. Drew Middleton, "Failure in Germany," *Collier's*, February 9, 1946, 12, 13.

27. Anne O'Hare McCormick's original article "Abroad: American Responsibility in Germany," *New York Times*, November 18, 1946, 20. This report received some renewed attention when it was invoked by U.S. president George W. Bush in the context of worries about Iraq after the American invasion of the country. In his nomination speech at the Republican Convention in 2004, Bush alluded to this *New York Times* article and concluded, to applause from the audience: "Fortunately, we had a resolute president named Truman, who, with the American people, persevered, knowing that a new democracy at the center of Europe would lead to stability and peace. And because that generation of Americans held firm in the cause of liberty, we live in a better and safer world today." See http://www.washingtonpost.com/wp-dyn/articles/A57466-2004Sep2.html, accessed March 1, 2013. In her column "Amnesia in the Garden" (Op-Ed, *New York Times*, Sunday, September 5, 2004, Week in Review, 9), Maureen Dowd pursued the lead and found that "Bush distorted the columnist's dispatch."

28. Karl Loewenstein, "Autocracy versus Democracy in Contemporary Europe, I," *American Political Science Review* 29, no. 4 (August 1935): 571–93, here 582; "Autocracy versus Democracy in Contemporary Europe, II," *American Political Science Review* 29, no. 5 (October 1935): 755–84, here 776; and *Political Reconstruction* (New York: Macmillan, 1946), 337.

29. Franz Neumann, "Military Government and the Revival of Democracy in Germany," *Columbia Journal of International Affairs* 2 (1948): 3–20, here 4 and 5.

30. William Gardner Smith, *Last of the Conquerors* (1948; repr. Chatham, NJ: Chatham Bookseller, 1973), 104.

31. Repr. in *Essays in Understanding 1930–1954*, ed. Jerome Kohn (New York: Harcourt Brace, 1994), 248–69, here 268–69.

32. Ian Buruma suggests that it was Franz Neumann who, with the backing of Lucius D. Clay, "helped to devise the notorious *Fragebogen* (questionnaire)" that was used for denazification. Ian Buruma, *Year Zero: A History of 1945* (New York: Penguin Press, 2013), 177.

1. Between the No Longer and the Not Yet

I am grateful to several institutions at which I presented very early and preliminary versions of this section and a few small other parts of this project and to the members of the various audiences who made helpful suggestions, among them Marc Dolan and Richard McCoy at the Graduate Center of the City University of New York; M. Lynn Weiss at William and Mary College; Frank Kelleter at the Georg-August-Universität Göttingen (who also kindly published a German version of that paper in an essay collection); Henry Wonham at the University of Oregon; Frederick Aldama at Ohio State University; Rafia Zafar, William Paul, Gerald Early, and Lynne Tatlock at Washington University St. Louis; Mohsen Mostafavi at Cornell University; and Christa Buschendorf, Berndt Ostendorf,

Herwig Friedl, Heike Paul, and Udo Hebel at the meeting of the German Society for American Studies in the I. G. Farben Building in Frankfurt, formerly the seat of the Military Government and now the Johann Wolfgang Goethe-Universität Frankfurt. Christa Buschendorf and Astrid Franke published my talk in *Transatlantic Negotiations* (2007).

1. The figure that opens this chapter comes from Tony Vaccaro, who locates the scene in Calbe, though the akg website identifies the town as nearby Barby. In a lecture at Harvard on November 9, 2006, Vaccaro said that the photograph was taken about a hundred miles from Berlin. Tony Vaccaro, *Entering Germany, 1944–1949*, ed. Michael Konze (New York: Taschen, 2001), 46.

2. Wolfgang Fritz Haug offered a cogent criticism of the evasive terms used in lectures at German universities to name the end of World War II; see his *Der hilflose Antifaschismus: Zur Kritik der Vorlesungsreihen über Wissenschaft und NS an deutschen Universitäten* (Frankfurt: Suhrkamp, 1967).

3. Walter Kempowski, *Das Echolot. Abgesang '45: Ein kollektives Tagebuch*, 2nd. ed. (München: btb-Verlag, 2007). This 450-page volume covering the period from April 20 to May 9, 1945, is the last volume of Kempowski's massive enterprise to collect thousands of diaries, letters, photographs, and recollections of the war years and to reproduce them in strict chronological order. The preceding four volumes, *Das Echolot. Fuga furiosa*, record sources from January 12 to February 12, 1945, in more than 3,300 pages. See also Gerhard Hirschfeld and Irina Renz, eds., *"Vormittags die ersten Amerikaner": Stimmen und Bilder vom Kriegsende 1945* (Stuttgart: Klett-Cotta, 2005); Hermann Glaser, *1945: Ein Lesebuch* (Frankfurt: Fischer, 1995); Werner Filmer and Heribert Schwan, eds., *Besiegt, befreit . . . : Zeitzeugen erinnern sich an das Kriegsende 1945* (München: Bertelsmann, 1995). The vogue of such books is also a result of the fiftieth and sixtieth anniversaries of the end of the war. Their danger, of condensing lives to that one moment, is obvious.

4. Ernst Schneider, handwritten diary, 199–200, Stadtarchiv Kronberg im Taunus.

5. Pfarrer [Richard] Keuyk, "Der Einmarsch der Amerikaner in Oberhöchstadt am 29. März 1945," undated typescript, Stadtarchiv Kronberg im Taunus.

6. David P. Boder, *I Did Not Interview the Dead* (Urbana: University of Illinois Press, 1949), 21–22. (See also web site with recordings of interviewees at http://voices.iit.edu.) In his book publication, Boder changed the names slightly, turning Anna Kaletska into Anna Kovitzka. The recording is at http://voices.iit.edu/interviewee?doc=kaletskaA, reel 2 (spool 165) from 33:34 to 35:34.

7. Videorecorded slide lecture by Tony Vaccaro at Harvard University, November 9, 2006.

8. The teacher Schneider's diary registers numerous lawless acts in his area in a general situation of want: a murder, brazen robberies, and black market activities turn the resurrection experience of liberation into a nightmare, and on May 20, he writes: "These are hard times! There is neither gas nor

electric light. No newspaper appears, no mail service exists. The railroads do not run; and the telephones do not work. Nobody is permitted to go further than 6km from town."

9. See Walter O. Weyrauch, "The Experience of Lawlessness," *New Criminal Law Review* 10, no. 3 (summer 2007): 415–40.

10. Volker Koop, *Himmlers letztes Aufgebot: Die NS-Organisation "Werwolf"* (Köln: Böhlau, 2008), 154.

11. Ursula von Kardorff, *Berliner Aufzeichnungen 1942–1945: Unter Verwendung der Original-Tagebücher neu herausgegeben von Peter Hartl* (München: C. H. Beck, 1992), 311–12 (my trans.). The 1961 English-language version of the book was translated by by Ewan Butler and published under the title *Diary of a Nightmare: Berlin, 1942–1945* (London: Rupert Hart-Davis, 1965).

12. Erhard Schütz suggests that Kardorff published journalism in support of the Nazi war effort (Durchhalte-Artikel). See his "Introduction" in *Handbuch Nachkriegskultur: Literatur, Sachbuch und Film in Deutschland (1945–1962)*, eds. Elena Agazzi and Erhard Schütz (Berlin: de Gruyter, 2013), 65.

13. This is the explanation Kardorff gave in the opening page to her 1976 expanded and illustrated edition of *Berliner Aufzeichnungen 1942–1945: Erweiterte und bebilderte Neuausgabe* (München: Nymphenburger Verlagsbuchhandlung, 1976), 5–6.

14. Though there was a concentration camp at Oranienburg, it was closed in 1934. The published diary may have erroneously taken Oranienburg from a list of places around the Berlin that had been bombed, and made that the name of the concentration camp. Kardorff may also have been thinking of the camp at nearby Sachsenhausen which, however, was liberated by Russian soldiers only on April 22, 1945, two days after the date of Kardorff's journal entry.

15. Erich Kästner, *Notabene 45: Ein Tagebuch* (1961; repr. Berlin: Cecilie Dressler Verlag, n.d.), 144.

16. *Splitter und Balken: Publizistik*, eds. Hans Sarkowicz and Franz Josef Görtz, *Werke*, vol. 6 (München: Carl Hanser, 1998), 837. Sarkowicz's critical edition makes it easy to compare the differing texts. See also Heinz-Peter Preußer, "Wie baut man ein zweites Ich? Erich Kästner als Überlebender des Dritten Reiches und sein *Notabene 45*," in Preußer and Helmut Schmitz, eds., *Autobiografie und historische Krisenerfahrung* (Heidelberg: Winter Universitätsverlag, 2010), esp. 92.

17. 12.2.45, *Notabene*, 31–32. Here the typed transcript of the diary (T) is identical with the version published in *Notabene 45* (T 7, Literaturarchiv Marbach). As we shall see, a similar saying was also reported twice in the anonymously published book, *A Woman in Berlin* (1954; New York: Ballantine Books, 1957), 23: "Rather a Russki on the belly than an Ami on the head."

18. "Berliner Hetärengespräch 1943: Nach Tagebuchaufzeichnungen," *Die kleine Freiheit: Chansons und Prosa 1949–1952* (1959; repr. München: dtv, 1999), 89–93. The editor of the critical edition mentions that there is actually no corresponding note in Kästner's diaries.

19. The inmates had liberated themselves on April 11.

20. T 46.

21. In February 1946, after seeing the documentary film *Die Todesmühlen*, a version of which Billy Wilder had edited, Kästner wrote the essay "Wert oder Unwert des Menschen," in which he described the varied reactions of viewers: "Most of them do not speak. They go home in silence. Others come out and seem pale; turning their faces to the sky, they say 'look, it's snowing.' Others mumble 'Propaganda! American propaganda.'" Quoted in her own translation by Dagmar Barnouw, *Germany 1945: Views of War and Violence* (Bloomington: Indiana University Press, 1996), 2, from Erich Kästner, *Gesammelte Schriften: Vermischte Beiträge* (Zürich: Atrium, 1959), 62–63.

22. Referring to the Allies, and especially the Americans, as "Pharisees," seemed, for the Anglo-Irish observer James Stern, to have indicated an unreconstructed Nazi attitude. See *The Hidden Damage* (New York: Harcourt, Brace, 1947), 127, quoted in Chapter Three. This last entry, beginning with "the 'other' German," was much expanded for publication, and the original diary was much less rhetorical.

23. Kempowski, *Das Echolot. Abgesang '45*, 371. Abschrift in Kempowski Archiv Nartum, Signatur Kempowski Biographiearchiv 3770. Wolfgang Soergel was born on October 29, 1919, in Chemnitz and became a medical doctor, published fiction writer, and essayist after the war. See http://www.stadtbibliothek-chemnitz.de/autorenlexikon/pmwiki.php?n=Autor.WolfgangSoergel, accessed August 10, 2012. Thanks to Maren Horn, Akademie der Künste Berlin.

24. Reprinted in Hirschfeld and Renz, *"Vormittags die ersten Amerikaner,"* 124–25. See also Udo von Alvensleben's diary, *Lauter Abschiede: Tagebuch im Kriege*, ed. Harald von Koenigswald (Frankfurt/M: Propyläen, 1971), 449: "How harmless does the defeat in World War I compare to this now! . . . The pain has been anticipated and burned up."

25. Hirschfeld and Renz, *"Vormittags die ersten Amerikaner,"* 135.

26. Helen Dann Stringer, ed., *Letters of Love and War: A World War II Correspondence* (Syracuse, NY: Syracuse University Press, 1997), 245.

27. Edgar Allan Poe, *Poetry and Tales*, ed. Patrick F. Quinn (New York: Library of America, 1984), 432–48, here 442.

28. *A Woman in Berlin*, translated by James Stern (1954; repr. New York: Ballantine Books, 1957), which reportedly sold half a million copies. I shall generally be quoting by giving the date of the entry in the text and indicating the page numbers in the footnotes: the reference before the slash refers to Stern's English translation, after the slash to the German version, as cited from Anonyma, *Eine Frau in Berlin: Tagebuch-Aufzeichnungen vom 20. April bis 22. Juni 1945* (München: btb-Verlag, 2005); "n.t." means that the passage was not translated in the first American edition, "m.t." indicates my own translation, for in some cases I offer my own translation of the German text and occasionally indicate the German original in notes. In a few instances I shall also refer to the new English translation by Philip Boehm, *A Woman in Berlin: Eight Weeks in the Conquered City: A Diary* (New York: Picador, 2005), with a foreword by Hans Magnus Enzensberger and an introduction by

Antony Beevor. The British mass market edition published by Ace Books had a somewhat different cover design from the one Ballantine Books used and pitched the book as follows: "When the Russians ravaged Berlin, one woman—trapped and helpless—made this record of her personal ordeal."

The Anglo-Irish writer and translator James Stern was in Germany immediately after World War II and in 1947 published *The Hidden Damage* about his experience (see Chapter Three). Stern is an at times whimsical translator: for example, he inserts lines from T. S. Eliot's *Waste Land* about Mrs. Porter and her daughter (May 27, 178) to render an untranslatable German bawdy folk song.

29. Berlin was the city that Kästner and Kardorff fled, and the narrator of *A Woman in Berlin* quickly, perhaps enviously, mentions a landlord who similarly took off from Berlin for western Germany and was "already American" (April 20, 1945). "The landlord . . . has 'demoted' himself to Bad Ems and is already American" (13/15).

30. The numerical estimates are enormous, and rapes were extensively documented for the Russian conquest of East Prussia, Pomerania, Silesia, and the entire territory of East Germany. One scholar concludes that "rape became a part of the social history of the Soviet zone in ways unknown to the Western zones." Norman M. Naimark, *The Russians in the Soviet Zone of Occupation, 1945–1949* (Cambridge, MA: The Belknap Press of Harvard University Press, 1995), 106–7.

31. To my knowledge, the only Russian diary that has been published about the Battle of Berlin (though only in a German translation by Anja Lutter and Hartmut Schröder of selections from the original Russian manuscript) is by Vladimir Natanovich Gel'fand, *Deutschland-Tagebuch 1945–1946: Aufzeichnungen eines Rotarmisten* (2005; Berlin: Aufbau-Verlag, 2008). Its entry from April 25–27, 1945, describes a German woman who has been raped by twenty Russian soldiers, asks Gel'fand for help, and invites him to sleep with her (78–80). The somewhat self-centered Gel'fand who was twenty-two years old at the end of the war also includes episodes of consensual sex with German women in his diary (e.g., June 24, 1945), and the published text reproduces photographs of Gel'fand with German girlfriends and love letters from them (picture insert between 192 and 193). Alexander Solzhenitsyn, *Prussian Nights: A Poem*, bilingual edition with translation by Robert Conquest (New York: Farrar, Straus and Giroux, 1977), 48–51, 68–69. The Russian version of the poem, *Prusskie nochi*, was copyrighted in 1974. Naimark, *Russians in the Soviet Zone*, 73, quotes some lines from Solzhenitsyn as does Wikipedia (http://en.wikipedia.org/wiki/Prussian_Nights). Conquest calls attention to the leitmotif of a romantic air by Spanish composer Sarasate "as the persistent voice of conscienceless temptation, accompanying the wartime urges to self-indulgent destructiveness and sensuality" (109).

32. Nikolai Nikolaevich Nikulin, *Vospominaniya o voine* (Sankt Peterburg: Izdatel'stvo Gos. Ermitazha, 2007), chapters 14, 17, 18, 10, and 20, available at http://www.belousenko.com/books/nikulin/nikulin_vojna.htm. Among the comic episodes are the Russian soldiers' disposal of a Hitler bust they

find in the Kaulsdorf school where they are housed and a talking parrot who shouts "Heil Hitler" at the Russian victory celebration. Nikulin's own reflective role and vivid style of narration in an unusually candid book would make this an excellent work to compare and juxtapose with *A Woman in Berlin*.

33. October 25, 1948. My trans. from Bertolt Brecht, *Arbeitsjournal. Zweiter Band*, ed. Werner Hecht (Frankfurt: Suhrkamp Werkausgabe, Supplementband, 1974), 527. The original text uses no upper cases. Naimark, *Russians in the Soviet Zone*, quotes Brecht, 105–6. In his postwar poetry, Brecht directed his protest more against the Americans and the West. See, for example, "Der anachronistische Zug oder Freiheit und Democracy," a parade of criminals and ex-Nazis, or "Stolz," the poem expressing the speaker's pride that whereas bourgeois daughters were for sale to G.I.s, enslaved Russian women were not. *Gesammelte Werke* 10 (Frankfurt: Suhrkamp, 1967), 940 and 943ff.

34. I am following Janet Halley's suggestion of differentiating unknown author and palpable narrator in this case. See Janet Halley, "Rape in Berlin: Reconsidering the Criminalisation of Rape in the International Law of Armed Conflict" *Melbourne Journal of International Law* 9.1 (2008): 78–124, at http://austlii.edu.au/au/journals/MelbJIL/2008/3.html. She writes: "I assume that this *Diary* is a literary artefact. . . . I offer here a reading of the Woman, not as an actual individual woman living in Berlin in 1945 but as our *narrator*—as the person introduced by this actual author to *represent* the fall of Berlin from an *imagined* point of view. I read the text *as text*" (88–89). Halley's close reading of the book is most detailed, nuanced, and compelling, and I am drawing on some of her findings throughout this chapter. I am also grateful to Janet Halley for a long conversation about this book. See 24/29, 203/272–73.

35. The Horace quotation (19/23) from the Roman Odes 3.3: 7–8, meaning "even if the entire globe should crumble, the fragments will hit him unafraid," was also cited in the Nazi period by the political philosopher Karl Haushofer in his *Weltpolitik von heute*. (See Julia Hell, "Katechon: Carl Schmitt's Imperial Theology and the Ruins of the Future," *Germanic Review* 84, no. 4 [2009]: 283–26; here 307.) The biblical "noli timere" (16/19) means "don't fear." See 187, 208, 74, in the new German edition.

36. The epigraph was omitted, without an explanation, in the 2003 German edition. Oddly, it is Leontes's cuckoldry passage from I.ii.281–95:

> There have been,
> Or I am much deceived, cuckolds ere now.
> And many a man there is, even at this present,
> Now, while I speak this, holds his wife by the arm,
> That little thinks she has been sluiced in 's absence
> And his pond fish'd by his next neighbour, by
> Sir Smile, his neighbour. . . .
> It is a bawdy planet, that will strike

Where 'tis predominant; and 'tis powerful, think it,
From east, west, north and south: be it concluded,
No barricado for a belly. . . .

Re. Wittenberg theses, see 23n.t./28; re. Pushkin, see 75/97; re. *Polikushka*, see 203/272; for secret nickname, see 83/108.

37. For Nietzsche's maxim, see 41/52. She uses it again on May 23 (170/227). For *Shadow-Line: A Confession*, see 140/187; for her observations re. *Decline of the West*, see 66/86 and 202/270.

38. 11/12.

39. 179/239.

40. For her plans for a publishing venture, see 167–68/224 and June 4 (191/256). Goethe is mentioned twice by name, May 29 (181/243) and June 10 (197/264); on May 11, Herr Pauli is identified with Mephistopheles as "the spirit who always denies" / "Geist, der stets verneint" (138/185); on May 29 the little girl Gerti recites memorized poetry, quotes the somber end of (Goethe's second) "Wanderers Nachtlied," "Wait, O wait—soon you too shall rest" / "warte nur balde—ruhest auch du" and comments, "with a sigh: 'If only we'd come that far'" (181/243). The text of the major's enchanting song, May 2, "Bleib, verweile doch, du Schöne mein" / "Stay, linger, my lovely one" (n.t./117) also sounds like a bungled allusion to Faust's wish for the moment to last.

41. 127/168; she states that "the ironic remark" was made by a Russian travel companion during her time in the Soviet Union and agrees that "we Germans are not a nation of partisans."

42. Echoes of the Richardsonian tradition of the epistolary novel are manifest in the development of subplots—for example, the widow loses her late husband's pearl (May 8, the day of German surrender), searches for it (May 14), and finally finds it (May 20, Pentecost Sunday)—and in the rhetoric of immediacy in representing the writing process, the narrator interrupting her own sentences, saying "no, crossed out . . ." (April 21), "halt" (April 26), or "wait a minute" (May 6) whereas most ordinary diarists would simply have made the emendation. This mode of writing is an artifice employed, for example, in Edgar Allan Poe's "MS Found in a Bottle." The drama-like structure is enhanced by theatrical metaphors and similes like the April 26 observation during the looting of a wine cellar that the exit beckoned "like a brightly lit stage" (37/47) or the April 27 comparison of the baker's pained scream with the work of a seasoned actor (46–47/60). Júlia Garraio, "Höhlenbewohner: Die Erfahrung des totalen Krieges im Tagebuch *Eine Frau in Berlin*," *Publikationen der Gesellschaft für interkulturelle Germanistik* 15 (2011): 209–24, offers a nuanced reading of the book she sees structured around notions of decline and rebirth, and the Russians are actually associated with rebirth and new beginnings.

43. 17/19.

44. 180/241.

45. 9/9.

46. Jens Bisky, "Wenn Jungen Weltgeschichte spielen, haben Mädchen stumme Rollen," *Süddeutsche Zeitung* (September 24, 2003), is a much-discussed article in which Bisky questioned the authenticity of the book and proposed the otherwise little known Marta Hillers as author. His article is also available at http://www.arlindo-correia.com/eine_frau_in _berlin.html, accessed March 1, 2013. Daniela Puplinkhuisen, "A Short Footnote on the Decline of the West: The Interplay of Collective Memory and Female Perspective in Anonyma's *Eine Frau in Berlin*," *LiLi: Zeitschrift für Literaturwissenschaft und Linguistik* 39, no. 155 (September 2009): 148–61, here 153. Puplinkhuisen sketches a comparison with Hamsun's *Hunger* and offers a very careful literary analysis of Anonyma's text, on which I am drawing here.

47. This beginning invites a comparison with Kurt Ihlenfeld's novel *Wintergewitter* (1951; repr. Bertelsmann-Lesering, 1958) in which the sound of the Russian artillery, misinterpreted by a young boy as a winter thunderstorm, provides the frightening background to a novel of fear simply in anticipation of the arrival of the Russian troops; the novel ends before the troops get to the small East German town through which fleeing refugees pass (see Chapter Three of this book).

48. See, for example, 63, 72, 82, 119, 120, and 176 in the German edition.

49. 9/9 and 10/10.

50. For "Poor words . . . ," see m.t./175; for story of a redhead, see 113–14/149–50.

51. For "syncope," see 16/19; for "violent dactyl," see n.t./89. See also April 30 (72/94), and May 8 (123/162). Re. *fama*, "Die *Fama*. Bei dem Wort hab ich mir stets eine verhüllte, murmelnde Frauengestalt vorgestellt. Das Gerücht. Wir nähren uns davon. In Urzeiten haben die Menschen alle Meldungen und Begebenheiten von dieser *Fama* bezogen" (whole paragraph missing/123).

52. "Wir leben in Kitschromanen und Kolportage" (91/118). She repeats the last word on June 13, when she sees one of the first Russian films that is shown in Berlin (201/270).

53. See Puplinkhuisen, "A Short Footnote," for examples of most of these devices in *A Woman in Berlin*.

54. 63/82.

55. 115 m.t./151. On May 19, she writes, with a less striking metaphor: "We exist without newspapers, without any clear idea of the time, live by the sun like flowers" (160/213).

56. The word *Uhr* (clock, watch, o'clock) probably appears more than a hundred times in the German text.

57. 41/52.

58. For example, there is another gruesome double picture at the end of the entry for June 1 (187/250).

59. 129/171.

60. N.t.121/159. The phrase "stiller Schläfer" may allude to the poem "Wein' nicht, ich bin dir gut" by Johanna Ambrosius (1854–1939).

61. 200/268. It is also another example of synesthesia.

62. Religious references to angels, manna, Christ's parable, and praying are abundant, and even makeshift crosses on graves in the book are more than "two pieces of wood tied together with string," making the narrator feel that her throat is contracting and leading her to ask: "Why are we so affected by the sign of the Cross, even if we can no longer call ourselves Christians?" (May 9, 130/171). On May 11, she describes the opportunistic alternation from loud approval to shouts for punishment (of Nazis): "The '*Hosanna Crucifige*' is constantly repeating itself" (138/185). The authorial comment Marek quotes in his introduction mentions a "crown of thorns" (7/283). The April 27 passage of her imagined division into a body she leaves below and an angel-like self that rises (quoted below) could have been inspired by the image of "Triumph over Despair" (see the Introduction in this book). The review of the book in *Booklist*, November 1, 1954, 104, describes *A Woman in Berlin* as a record of Berliners who were "subject to fears, privations, and despair of the conquered."

63. 46–47/60.

64. 139/186. Veronal, a sedative, was often used for suicide in the period.

65. Wedding ring in underpants, 24/29; vox populi folk sayings, "Lieber ein Russki auf'm Bauch als ein Ami auf'm Kopf" (23/28), explained on April 26 (/52), and repeated, with a slight variation, on May 26 (176/236). Kästner's version from *Notabene 45* (32), "Better a Russian on your belly than a broken house on your head!" is cited above.

66. 49/63–64.

67. 88 m.t./115.

68. 106/140.

69. See 106/140, n.t./166, 134/179, and 204/274. Halley, "Rape in Berlin," 108, writes: "If her rapes had been 'the absolute worst', her national solidarity with the defeated German soldiers would have remained intact and Gerd would not have been repelled. If instead she and the other women took some of the rapes lightly, even in jest, as one among many harms of war, they became 'shameless', 'disgust[ing]', and . . . nationally *disloyal*."

70. 126/166. See Beevor, "Introduction," xix. The German phrase "nach all den gestiefelten Gästen" reminds the reader of the Perrault/Tieck fairy tale "Der gestiefelte Kater" (Puss in Boots), and the otherwise relatively rare adjective "gestiefelt" appears two more times in the German text.

71. 63/83.

72. 83 m.t. /108.

73. 253. Stern's translation uses the circumlocution, "we managed to be quite gay and competed with one another in telling our raping experiences" (189), and Philip Boehm renders it as "rapish wit" (237). She mentions the "business of rape" (*Schändungsbetrieb*) on May 24 (173/231) when she mocks the official term "compulsory intercourse" (*Zwangsverkehr*), and on May 16 (154/206) she speaks about such new coinages as "sleeping food into the house" (*anschlafen*) and "rape shoes" (*Schändungsschuhe*). All but one of the references to the word *Schändungshumor* in Google Books come from *Eine Frau in Berlin*; the exception is a book review of Margret Boveri's *Tage des*

Überlebens in *Spiegel* (October 7, 1968), published nine years after the first publication of *Eine Frau in Berlin*, which had received a review in *Spiegel* (March 30, 1960) that highlighted the word, in quotation marks.

74. Puplinkhuisen, "A Short Footnote," focuses on, and Garraio develops further, the expressly female point of view of *A Woman in Berlin*. A new sense of postwar gender relations and a critique of German men are articulated many times in the book. For example, the narrator writes on April 22 that returning soldiers are no longer men (22/27) and on May 8 that a new word has to be found to substitute for "masculine" (127–28/168); on April 24 she states that women in this war can no longer just be good angels for men (30/37), though men still like to act as though they were the only ones who had been in the war and want to tell stories about it to women who are supposed to shut up (May 8, 124/163); on April 26 she finds that the male-dominated Nazi ideology of strong men and the myth of men altogether are tottering (40/51).

75. On May 3, she wonders whether she should consider herself a whore now that she lives from her body and received victuals for surrendering it to the major (98/128–29). See Weyrauch's pertinent comments on prostitution as part of an exchange system in the interim period of lawlessness. "The Experience of Lawlessness," 421.

76. 97/128.

77. See Halley, "Rape in Berlin, 103, commenting that, according to Woman at least, the major "*hasn't* raped her—not ever, not even once. Surrounded by coercion of the most acute and inescapable kind, our protagonist understands that she and the major comforted each other by having sex. And pretty good sex."

78. 120/158. The narrator again mocks the encroachment of the kitschy novel style on human experience when she must listen to the "magazine story about love and fidelity" that the mistress (and former secretary) of an apparently high-ranking Nazi who has been arrested tells her: "Something like our love, he used to say to me, I've never seen before. Ours must be a very great love." To the narrator's ears this sounds atrocious, like the cheapest movies and romances, and the fact that this woman sheds a tear does not help. The entry ends with a sarcastic marginal addition from July 1945 that this woman was the first "in this house to have an Ami—a cook with a pot-belly and fat neck who spends his time lugging in supplies of food" (160/214). One wonders what the book's author thought about the American paperback headline, "A woman's night-by-night account of how the Russians ravaged a city—and its women."

79. As Halley, "Rape in Berlin," has stressed, the narrator does react with tears of emotion, not to rape as such but to being evicted from the apartment she has shared with the widow and Herr Pauli and to hearing Beethoven on the radio after concentration camp revelations.

80. 48/62.

81. 55/72.

82. 54/70–71.

83. 56/73.
84. 56/73. Saliva, spit, can, of course, be generally humiliating (April 30) and disgusting (May 1), connected with the strong general aversion to spit and snot that she reports having (May 28), even more so than to excrement, but her revulsion from it is also a deflection from rape as such. See 77/101, 80/104, and n.t./240. Is it also allegorically connected with the national malaise that she must swallow? See June 6: "All I can see is that we Germans are in the ditch, have become a colony, are at the mercy of all the winds. Well, there's nothing I can do, I'll just have to swallow it and steer my little ship through it all" (194/261). On the other hand, the women are collectively able to "spit out" (*das Erlittene auszuspeien*, as the German original has it), that is, to get rid of their suffering by airing it to each other (122/161).
85. I am following Halley, "Rape in Berlin," 101, closely here. This episode in the book will remind the Americanist of the turning point in Harriet Jacobs's *Incidents in the Life of a Slave Girl* (1861), the moment when she decides to seek the protection of an unmarried white man to escape the advances of her married owner.
86. 66/86. She uses the word *Unflat*, closer to "excrement."
87. 25/31.
88. 110/145. Doris Peel, "Holocaust's Aftermath," *Saturday Review*, October 30, 1954, 23, admires the "capacity of the writer in the very thick of her ordeal to concede to the violators the basic humanity of the violated." "There are no heroes and heroines." See also Naimark, *Russians in the Soviet Zone*, picture insert following p. 140, "Russian soldiers were noted for their indulgent behavior toward German children."
89. Beevor, "Introduction," xix–xx.
90. She shows that the narrator considers the rape of a virgin worse than other rapes, that one Russian sees rape as almost a national duty in revenge for what Germans had done to his sister, whereas a Russian officer looks at it as just the "sort of thing" that happens in war.
91. 159/212–13.
92. In the introduction to the first English translation, Marek quotes a remark the author made to him in 1947: "None of the victims will be able to wear their suffering like a crown of thorns. . . . I for one am convinced that what happened balanced an account" (7/283). This somewhat opaque remark has been much cited and commented on. The same phrase was used in Klaus L. Berghahn's review essay on Dagmar Barnouw's book *1945:* "[A]fter showing the unbelievable crimes committed by Germans in the concentration camps, she [Barnouw] documents the suffering of the defeated Germans, which could be interpreted as a balancing of accounts or, even worse, as a blurring of the difference between perpetrators and victims." Berghahn, "German Misery—1945: A Revision," *Monatshefte* 91, no. 3 (fall 1999): 414–23, 420.
93. "Introduction," xix.
94. Ann Stringer, "The 'Ivans' in Berlin," *New York Herald Tribune Book Review*, December 5, 1954, 4. The former war correspondent Stringer, who is identified as having co-written a postwar book on *German Faces* with her husband,

also praises *A Woman in Berlin* for being "remarkably controlled" and considers it neither fiction nor propaganda, but "brutal fact."

95. This was especially the case in the context of the Cold War. Thus Karoline von Oppen and Stefan Wolff write: "Russian soldiers raping German women became a prominent symbol for the rape of the German nation by the Soviet Union." "From the Margins to the Centre? The Discourse on Expellees and Victimhood in Germany," *Germans as Victims: Remembering the Past in Contemporary Germany*, ed. Bill Niven (Basingstoke: Palgrave Macmillan, 2006), 210–24, here 213.

96. Anonyma, *Eine Frau in Berlin*, foreword 1959 (München: btb-Verlag, 2005), 6. This preface is not included in either of the two English translations. It is a claim that the 2003 edition weakened to "a gray fate shared by masses of uncounted women" ("ein graues Massenschicksal ungezählter Frauen"). Jennifer Redman, "*Eine Frau in Berlin:* Diary as History or Fiction of the Self?" *Colloquia Germanica* 41, no. 3 (2008): 193–210, raises very good questions in response to this preface: "Who is authorized to speak for all? Can a diarist represent the experience of anyone beyond herself? Does a diary count as history when the 'facts' it contains cannot be verified because the diarist's identity is unknown?" (195).

97. 122/161.

98. When she speaks of the "cadaver of Berlin" (May 10), she furthermore asks the reader to imagine the city in analogy to a dead human body.

99. 152/203.

100. 111/146.

101. 111/146–47.

102. 179/239.

103. 189/253.

104. 203/273.

105. 156 (May 17).

106. 132/175–76, 188/252. See also the photograph, "Brother and sister in Berlin: The flags are home-made," in Margaret Bourke-White, *Dear Fatherland Rest Quietly*, picture insert between 166 and 167, and the Coda of this book.

107. "Nowadays the anxiously hidden 'non-Aryans' are heavily underlined in the family trees and produced with pride" (May 21), 163/217. Re. July 20 comment, 159/212. By contrast Brecht was rooting for Hitler against the Junker conspirators: "For who if not him [Hitler] will exterminate this band of criminals?" he asks rhetorically in his July 21, 1944, entry of the *Arbeitsjournal*, 426.

108. 141–43/189–91.

109. Only in the first edition, 296, and translation, 207, not in new edition or translation. Bisky's criticism that the afterword by Marek uses as different abbreviation for rape, "VG" (for *Vergewaltigung*) from the text of the book which has it as "Schdg." (for *Schändung*) is probably due to the fact that the translator of Marek's comments (which were not included in the 1959 edition) chose one German word for rape without knowing that the text used

another one. However, at least my 1957 preface by Marek did not mention "rp." or any other abbreviation for rape.

110. 10/12.

111. See, for example, pages 12, 19, 20, 42, 45. 70, 72, 78, 105, 148, 149, 150, 151, 155, 244, and 247 in the German edition.

112. Trans. Boehm, 261. "Ob Gerd noch an mich denkt? Vielleicht finden wir doch wieder zueinander" (277).

113. Enzensberger's foreword mentions that the typed ms. consisted of "121 pages of gray war-issue paper" but makes no mention of the writing on the back of these pages. "Foreword," *A Woman in Berlin*, trans. Boehm, x. Excerpts from Kempowski's short authentication of the diary, "Gutachten zur Authentizität des Tagebuchs der Anonyma: Unverwechselbarer Ton," were published in *Frankfurter Allgemeine Zeitung*, January 20, 2004, 35. Kempowski did notice differences between the original three handwritten notebooks and the 121-page typescript but saw no evidence that Marek or anyone else may have had a hand in writing it. See the web at http://www.arlindo-correia .com/eine_frau_in_berlin.html. Kempowski's own *Echolot: Abgesang '45* includes excerpts from her entries of April 25 and April 30 (185–86 and 295).

114. My trans./184.

115. 137/183. After the insertion of the Paris episode the theme of opportunism returns, as if it had been interrupted by an insertion.

116. 183. There are several more passages in the book in which the narrator asks questions, e.g., "Were we brave?" (omitted in first English translation /45), "Can I be going out of my mind?" (54/71), or "What will happen tomorrow?" (71/93). In the second English translation by Philip Boehm, the passage is rendered as: "What about me? Was I for . . . or against? What's clear is that I was there, that I breathed what was in the air, and it affected all of us, even if we didn't want it to" (168).

117. "Foreword," *A Woman in Berlin*, trans. Boehm, xii. For the 1954 American edition the author reportedly had agreed with Marek "to change the names of people in the book and eliminate certain revealing details" (x).

118. "Introduction," *A Woman in Berlin*, trans. Boehm, xv. The foreword to the 1959 German edition mentions the 1954 translation without any reference to its incompleteness.

119. I noticed another small passage in the first English translation that is missing in the German original. For May 18, James Stern's translation reads: "Intellectual workers of secondary importance are given Card II; perhaps I'll have a chance to slip in there *if I'm able to find a job in a publishing house or as a designer*" (243–44 in 1954 edition). The passage I italicized does not appear in any of the German versions (224, 1st ed.; 210, btb-Verlag reprint). Though inconsequential, this is another case of the "incomplete" translation containing more text than the complete original.

It might be worthwhile to do a line-by-line comparison of the 1959 and the 2003 editions as well as of the 1954 and 2005 English translations. Of course, it would have been ideal to undertake a scholarly comparison of all

editions against the original manuscript. However, my letters to Kurt Marek's widow and my e-mail to his son, requesting to see the manuscript, or a scan of a part of it, have remained unanswered. Neither the Stern Papers at the University of Maryland nor the Stern Archive at the British Library contains any documents offering contexts for his work as translator of *A Woman in Berlin*, though Stern must have seen a manuscript of the text that was to appear in print in German only five year later.

120. Writers know that readers may include contemporaries who will read the diary (often only the relevant entries) mostly to learn how they are represented in it.

2. Malevolent Rectangles of Spectral Horror

I am deeply indebted to Karen Maandag and to Jinx Rodger for their extraordinary kindness and generosity in countless e-mails, in providing me with sources and research leads, and for extending invitations to visit them in their homes. This essay could not have been written had I not visited the Maandags in December 2008 and been able to speak with Silvia Springer, Henk Poncin, and Herman Hennnik Monkan. I am also grateful to my research assistant Anna Acosta, who helped me track down a number of sources, and to Maarten van Gageldonk, Joanne van der Woude, and Pascale LaFountain, who kindly translated a newspaper article and a segment of a recorded interview for me. E-mail exchanges with my colleague Robin Kelsey and with Elfriede Schulz from the Bergen-Belsen Foundation, and comments by Alide Cagidemetrio, Liam Kennedy, Don Pease, and members of the Clinton Institute Summer Seminar were truly helpful as were those by Christoph Irmscher, Jennifer Fleissner, Sarah Withers, and other members of the Americanist Colloquium at Indiana University; by Norma E. Cantú, Bridget Drinka, and Steven Kellman at the University of Texas at San Antonio; by Alan Trachtenberg and Laura Wexler at Yale University; by René Kok, Hans de Vries, Tilly de Groot, and members of the audience at the Netherlands Institute for War Documentation in Amsterdam; by Britta Waldschmidt-Nelson, Stefanie Schäfer, Amin Ahmad, Jerry Z. Muller, and other members of the audience at the German Historical Institute in Washington, DC; and by Tatyana Venediktova, Yuri Stulov, and members of the audience at Lomonosov Moscow State University. Finally, I am also indebted to the late Dagmar Barnouw, whose book *Ansichten von Deutschland (1945)* alerted me to the photo-essays in *Life*.

1. *Life*, May 7, 1945, 32. According to *Life: The First Decade, 1936–1945* (Boston: New York Graphic Society, 1979), 169, "Rodger captioned his film with a description of what he and the Allied soldiers found at the camp," which is followed by an excerpt from the story that was published in *Time*, April 30, 1945. The *Boston Globe*'s report on the liberation of Bergen-Belsen drew a similar contrast: "I saw the living beside the dead . . . I saw children walking about in this hell." Quoted in Carolyn Burke, *Lee Miller: A Life* (New York: Alfred A. Knopf, 2005), 253.

2. Dwight D. Eisenhower, *Crusade in Europe* (Garden City, NY: Doubleday, 1948), 408–9. A photograph of Eisenhower at Ohrdruf is at http://www .scrapbookpages.com/Ohrdruf/Ohrdruf01.html (accessed March 1, 2013), and his letter and telegram are available in digitized form at the Eisenhower Presidential Library, available at http://www.eisenhower.archives.gov/ (accessed December 26, 2008).

3. See the Jewish Virtual Library, "U.S. Army and the Holocaust," at http:// www.jewishvirtuallibrary.org/jsource/judaica/ejud_0002_0020_0_20242 .html, accessed March 1, 2013. In a typed report of April [no day given], 1945, that British lieutenant (later General Sir) Michael Gow sent to his mother, he found that he would always remember his visit to the newly liberated concentration camp Belsen, because it made clear to him "what we have been,—and are still—fighting against" and because it assured him that "the lives of many friends lost" had been "worth while." Gow also drew a schematic map of the camp. Original is included in Michael Gow private papers, Imperial War Museum, London. A partial German translation dated April 20, 1945, appears in Walter Kempowski, *Das Echolot: Abgesang '45* (München: btb, 2007), 90.

4. Robert Capa did not participate in photographing liberated concentration camps because they "were swarming with photographers, and every new picture of horror served only to diminish the total effect." Richard Whelan, *Robert Capa: A Biography* (New York: Alfred A. Knopf, 1985), 235.

5. Susan Sontag, *On Photography* (1977; repr. New York: Farrar, Straus and Giroux, 1990), 20. One such photograph may also have inspired Randall Jarrell's 1955 poem, "A Camp in the Prussian Forest." See Randall Jarrell, *The Complete Poems* (New York: Farrar, Straus and Giroux, 1969), 167–68.

6. Chaim Potok, *In the Beginning* (New York: Alfred A. Knopf, 1975), 419, 428; qtd. in Carol Naggar, *George Rodger: An Adventure in Photography, 1908–1995* (Syracuse, NY: Syracuse University Press, 2003), 142–43. Some photographs, Ariella Azoulay writes, are, "of necessity, the product of an encounter—even a violent one—between a photographer, a photographed subject, and a camera, an encounter whose involuntary traces in the photograph transform the latter into a document that is not the creation of an individual and can never belong to any one person or narrative exclusively. The photograph is out there, an object in the world, and anyone, always (at least in principle), can pull at one of its threads and trace it in such a way as to reopen the image and renegotiate what it shows, possibly even completely overturning what was seen in it before." Ariella Azoulay, *The Civil Contract of Photography*, transl. Rela Mazali and Ruvik Danieli (New York: Zone Books, 2008), 13.

7. In the issue of *Life* (May 28, 1945), Jane C. Fales from Rochester suggested that the atrocity photographs be "blown up to mural size and that they be used to adorn the walls of the room in which the peace conferences which shall determine the fate of Germany are held." Geane Sutherland from Oakland, the mother of an American prisoner of war who died at the age of eighteen in a German camp, considered the publication of such pictures

"important" to show the world "that these things were not dreamed up by newsmen but actually happened." They will help convince people how cruel "were the German guards of these prisons." She continued: "The pictures are hard to take—they tear your heart out, I know, and make you so mad you can't see. That's what they're supposed to do, to keep us there pitching until the end of this war. If my son could stand a German camp for three months I can stand looking at pictures which tell the truth, so that his death may be avenged properly." Harry Clatfelter from Peoria suggested rerunning "those pictures in 1965 . . . on the 20th anniversary of V-E Day. We are such a forgetful people!" Robert M. Rosse from Hutchinson, Kansas, drew on his experience of witnessing the Japanese atrocities in China and told the editors of *Life:* "Your pictures on German atrocities are excellent for their stark realism and also very timely, for I am afraid that too many Americans are inclined to be skeptical about reports of both German and Japanese brutality." Though the "cold truth" may seem "nauseating," *Life* is to be encouraged to "continue to print such revealing articles that will make the U.S. realize that 'seeing is believing.'" On the opposing side was only one letter by Alan Schutz from St. John's College in Annapolis who protested the "publication of such atrocity pictures as being detrimental to clear thinking about peace." Though the facts are well known, "how can right reason prevail at any gathering where emotions have been aroused, emotions that distort perspective and goals and present personal revenge as the only satisfactory means to peace?" None of the published letters commented specifically on any individual photograph in the photo-essay.

8. In the interview with Rodger included in Marie-Anne Matard-Bonucci and Édouard Lynch, eds., *La libération des camps et le retour des déportés* (Bruxelles: éditions Complexe, 1995), 94, however, the photographer said that he knew "nothing, absolutely nothing" about the camps before his arrival at Bergen-Belsen.

9. Matard-Bonucci and Lynch, eds., *La libération des camps*, 94. The initial assumption that a dead person must be asleep also appeared in *A Woman in Berlin.*

10. Quoted in *George Rodger: Photographic Voyager and the Beginnings of Magnum* (Petaluma, CA: Barry Singer Gallery, 1999), 2.

11. Qtd. in Naggar, *George Rodger,* 136. Naggar's comment on the first series of Rodger's photographs, shot in 35mm, which included the photograph of the small boy, is perceptive: "It must be admitted that his Belsen pictures are beautiful," she writes, and that series "was an extraordinary sequence of overviews of the camp, its surroundings, and the dead lying beneath the trees. The images' hushed, contemplative spirit conveys the otherworldly silence of the camp, the silence that follows calamity. The photographs are strangely peaceful. Their detached stance and classic composition make them stronger than any dramatic close-up could be. . . . Yet it is the very beauty of his pictures that makes them so profoundly disturbing." (Naggar, *George Rodger,* 139.)

12. Robin Kelsey, "Photography, Chance, and *The Pencil of Nature*," in Robin Kelsey and Blake Stimson, eds., *The Meaning of Photography* (Williamstown, MA: Clark Art Institute, 2008), 15–33. *Arrangement* for Kelsey is "the program or general intention that informs the production of the photograph as a picture. A desirable arrangement makes us inclined to take *this* photograph and not some other." And *interruptant* is "an accidental detail or formal relation that addresses the viewer as if from the photograph itself and swerves attention away from the arrangement" (17). Kelsey proposes these terms as alternatives to Roland Barthes's *studium* and *punctum*. In the Vaccaro photograph of the American tank in Paderborn the fuel cap that seems to be missing may be seen as such an interruptant. (Tony Vaccaro, *Entering Germany, 1944–1949* [New York: Taschen, 2001], 46; see my brief discussion of his photograph in Chapter One.)

13. Arno Widmann, review of *Die großen LIFE-Fotografen*, in "Die Bücherkolumne," December 10, 2004, at http://www.perlentaucher.de/artikel/1982.html, accessed March 1, 2013.

14. Andrea Holzherr and Isabel Siben, eds., *George Rodger on the Road, 1940–1949: From the Diaries of a Photographer and Adventurer* (Ostfildern: Hatje Cantz, 2009), 12.

15. "Il n'avait aucune objection à se laisser photographier. Il a même été très coopératif." Matard-Bonucci and Lynch, eds., *La libération des camps*, 98. In a Russian blog, Rodger was reported to have said in an interview that he had not spoken with that boy in 1945 and did not know from where he had come or where he was going. See Stepnoi_volk and alexandre75 at http://www.liveinternet.ru/search/?q=%C1%E5%EB%FC%E7%E5%ED, accessed December 12, 2008. Yet in the source cited, *La libération des camps*, Rodger said that he was solitary and had talked to very few German prisoners (97), and he also specified that he did not really talk much about everything the boy had gone through (98)—but he was referring to their later reunion.

16. For Rodger's self-critical comments on "nice photographic composition," see, for example, the 1977 interview in Paul Hill and Thomas Cooper, eds., *Dialogue with Photography* (New York: Farrar, Straus, Giroux, 1979), 60.

17. The caption of the photograph of the German children on 70–71 begins as follows: "German children watch as Ninth Army jeeps enter their wrecked village. Putting his hands over his ears, one small boy shuts out the noise that comes with being conquered."

18. It is a sad historical irony that the "image of the German concentration camps as the worst element of National Socialism is an illusion," as Timothy Snyder argued. "In the early months of 1945, as the German state collapsed, the chiefly non-Jewish prisoners in the SS concentration camp system were dying in large numbers. . . . Some of the starving victims were captured on film by the British and the Americans. These images led west Europeans and Americans toward erroneous conclusions about the German system. The concentration camps did kill hundreds of thousands of people at the end of the war, but they were not (in contrast to the death facilities) designed for immediate mass killing. . . . The German policy to kill all the Jews of

Europe was implemented not in the concentration camps but over pits, in gas vans, and at the death facilities at Chelmno, Belzec, Sobibor, Treblinka, Majdanek, and Auschwitz." *Bloodlands: Europe between Hitler and Stalin* (New York: Basic Books, 2010), 394. For example, whereas "Belsen" was mentioned 236 times in the *New York Times* between 1940 and 1960, "Treblinka" appeared only 18 times. In the mid-1940s, Dachau, Buchenwald, and Bergen-Belsen suggested the kind of horror in the Western press that the killing centers in the East would acquire only later on.

19. Margaret Bourke-White, *"Dear Fatherland, Rest Quietly": A Report on the Collapse of Hitler's "Thousand Years"* (New York: Simon and Schuster, 1946), picture insert between 38 and 39.

20. Lee Miller, "Germans Are Like This," *Vogue* (New York), June 1945, 102–3, 192; reproduced in Mark Haworth-Booth, *Lee Miller* (catalog for Lee Miller exhibition at the Jeu de Paume) (Paris: Hazan, 2008), 190–91. See also Burke, *Miller*, 265.

21. See Sybil Milton, "The Camera as Weapon: Documentary Photography and the Holocaust," at http://motlc.wiesenthal.com/site/pp.asp?c=gvKVLcMVIuG&b=394975, accessed March 1, 2013, referring to National Archives, Washington, DC: Audiovisual Stills Branch, RG 238: U.S. Chief of Counsel for the Prosecution of Axis Criminality; and RG 218: Combined Chiefs of Staff, War Crimes (000.5). The *Times of India*, September 22, 1945, 7, reported under the headline "Belsen Horror Films Shown to Accused" that lengthy documentary footage was projected at the Belsen trial but that, unlike Irma Grese, Josef Kramer remained "unmoved," even when he himself appeared on the screen. In his essay on the documentary film *Death Mills/Die Todesmühlen*, Erich Kästner mentions that some of the defendants at Nürnberg preferred to turn their heads away when the film was shown. See "Wert und Unwert des Menschen," *Die Neue Zeitung*, February 2, 1946, reprinted in *Der tägliche Kram: Chansons und Prosa, 1945–1948* (Zürich: Atrium Verlag, 1949), 70–75, here 73. According to Sandra Schulberg, lecture at Harvard Law School (November 17, 2011), although Robert H. Jackson, the chief American prosecutor, was skeptical of using film as evidence, two documentary films were shown at the Nürnberg Trial, *The Nazi Plan* on December 13, 1945, and *Nazi Concentration Camps* on December 29, 1945. Jeffrey Shandler, *While America Watches: Televising the Holocaust* (New York: Oxford University Press, 1999), discusses the projection of *Nazi Concentration Camps* early in the Nürnberg tribunal (75–76) as well as of documentary footage at the trial (112); Shandler also calls attention to Homer Bigart's report, "Eichmann Is Unmoved in Court As Judges Pale at Death Films: Nazi, Seeing Movies for Second Time, Sits Calmly as Allied Documentaries Show Concentration-Camp Horrors," *New York Times*, June 9, 1961, 16. Bigart wrote that Eichmann sat through eighty minutes of filmed horror . . . without flinching or batting an eye. . . . The man who said he could not bear the sight of blood . . . was the very model of composure." See also Tony Kushner, "From 'This Belsen Business' to 'Shoah Business': History, Memory and Heritage, 1945–2005," in Suzanne Bardgett and David

Cesarani, eds., *Belsen 1945: New Historical Perspectives* (London: Vallentine Mitchell, published in association with the Imperial War Museum, 2006), 189–216, here 193; and Lawrence Douglas, *The Memory of Judgment: Making Law and History in the Trials of the Holocaust* (New Haven, CT: Yale University Press, 2001): 56–63, 100–101, with a photograph of the moment in the Eichmann trial at which the documentary was projected.

22. Edith Wyschogrod, *An Ethics of Remembering: History, Heterology, and the Nameless Others* (Chicago: University of Chicago Press, 1998), 141–142. Wyschogrod continues: "Or, they may link this photograph to other visual artifacts, perhaps provide a historical context for the liberation of the camps. Yet so long as the boy in his uncanny flight is permitted to break into the narrative of what is depicted, the child's face becomes the escape route for an unsayability that seeps into the visual image and contests any narrative articulation of what the camera captures, a world where death and life are virtually indistinguishable."

23. Dagmar Barnouw, *Ansichten von Deutschland (1945): Krieg und Gewalt in der zeitgenössischen Photographie* (Basel, Frankfurt: Stroemfeld/Nexus, 1997), 186, 189. See also the slightly different English version, Dagmar Barnouw, *Germany 1945: Views of War and Violence* (1996; repr. Bloomington: University of Indiana Press, 2008), 79: "The solitary figure of that child suggests not so much German denial of guilt or shame—understandably a much repeated concern of *Life* and America during these months—but numbness, an inability to understand the meanings of what is shown to him."

24. The photograph has been reproduced numerous times, including in *Life Goes to War: A Picture History of World War II* (Boston: Little, Brown, 1977); *Life: The First Decade, 1936–1945* (Boston: New York Graphic Society, 1979); *Life Sixty Years: A 60th Anniversary Celebration, 1936–1996* (New York, Boston: Time-Life Books, 1996), 169; *Life: Our Century in Pictures*, ed. Richard B. Stolley (Boston: Little Brown, 1999), 203; and *Die großen LIFE-Photographen: Die Photo-Enzyklopädie des 20. Jahrhunderts* (München: Schirmer und Mosel Verlag, 2004). It was reproduced as a full page in both the German and the English editions of Dagmar Barnouw's book about 1945. Captioned "Concentration Camp Bergen-Belsen shortly after the liberation on April 15, 1945," it serves as double-page frontispiece, to the section "Liberation" in Erik Somers and René Kok, eds. *Jewish Displaced Persons in Camp Bergen-Belsen, 1945–1950: The Unique Photo Album of Zippy Orlin* (Zwolle: Waanders, 2003; Netherlands Center for War Documentation in cooperation with United States Holocaust Memorial Museum), 16–17. According to Joelle Sedlmeyer at Getty Images, the "image is used all the time" and "is currently licensed to museums, retail books, broadcasting and documentaries, and numerous magazines around the world." E-mail "#50605938," June 20, 2011.

25. Tony Judt, *Postwar: A History of Europe since 1945* (New York: Penguin Press, 2005), facing 238.

26. One of Bourke-White's photographs showing two women walking by a charred corpse by the barbed wire of a camp, with expressions of horror in

faces held up by hands in gestures resembling Munch's *Scream*, would seem to indicate the reaction in which the boy was found wanting, yet it is captioned "Hausfraus at Leipzig-Mochau: bleak is the heart and bleak the future." Bourke-White, *"Dear Fatherland,"* facing 39.

27. Dagmar Barnouw, e-mail "Research Questions" (March 28, 2008). See "The History of the Bergen-Belsen Camp" at http://www.bergenbelsen.de /en/, accessed March 1, 2013. The destruction of the barracks by flame-throwers was documented by British military photographs available in the Imperial War Museum. The remaining buildings became a camp for Displaced Persons from 1945 to 1950 in which, after May 1946, only Jewish D.P.s were housed, the camp population peaking in August 1946 to over eleven thousand. See Somers and Kok, eds., *Jewish Displaced Persons*, 20–21, 42–55, and passim.

28. Azoulay, *Civil Contract of Photography*, 18. Azoulay also writes: "The photographed person's gaze seriously undermines the perception that practices of photography and watching photographs taken in disastrous conditions can be described and conceptualized as separate from the witnessed situation" (20).

29. Wyschogrod, *Ethics*, 141–142.

30. If one superimposed the *Life* image onto a 35 cm-wide print of the photograph as now disseminated by Getty, one would see about a 7.4 cm crop on the right and a 2.6 cm cut on the left.

31. Holzherr and Siben, eds., *George Rodger on the Road*, 12.

32. The 1995 print, reportedly from the original negative, was published in Klaus Honnef and Ursula Breymayer, eds., *Ende und Anfang: Photographen in Deutschland um 1945* (Berlin: Katalog zur Ausstellung des Deutschen Historischen Museums vom 19. Mai bis 29. August 1995), 137. The same unretouched version of the image appeared in Clément Chéroux, ed. *Mémoire des camps: photographies des camps de concentration et d'extermination nazis, 1933–1999* (Paris: Marval, 2001), 143. Ursula Breymayer, e-mail "George Rodger" (August 1, 2011) replied to an inquiry about the 1995 print, informing me that the German Historical Museum does not have a negative, but that Magnum had prepared the prints for the catalog. Yet Magnum does not own that negative either (Matt Murphy, e-mail "Inquiry concerning a Holocaust photo from George Rodger," July 30, 2012).

33. In the Getty image, several of the figures who are covered in the *Life* version are exposed, but the dress on the body closest to the viewer is longer now and hides the nakedness. My attempt to get an answer from Getty Images about the three versions of the photograph only yielded the response that the *Life* image had been "cropped in a little to fit the magazine page" and that, for Getty, "photo manipulations are not permitted without permission from Time Life." E-mail "#50605938," July 19, 2011, from Joelle Sedlmeyer.

34. See http://www.gettyimages.com, image #50605938, accessed December 13, 2008. At my suggestion, Getty Images changed this errata-rich caption in

July 2011, for Bergen-Belsen was not an extermination camp and the date of the photograph was April 20, not May 20, 1945 (accessed March 1, 2013). The *Life* photograph archive, scanned by Google and accessible at Google Books, identifies the picture as "Young German boy walking down dirt road lined w. corpses of hundreds of prisoners who died of starvation nr. Bergen Belsen extermination camp." The 1977 caption in *Life Goes to War* reads: "A boy walks past corpses at Bergen-Belsen. GIs could not comprehend the Germans' unconcern with the existence of the death camps" (unpaginated). The United States Holocaust Memorial Museum Photo Archives gives the photograph (Image File #75713) the caption "A young German boy walks past the bodies of prisoners that are laid out on the side of a road in the newly liberated Bergen-Belsen concentration camp" and adds "Original caption reads: 'Dead lying by the side of one of the roads in the camp. They die like this in the thousands. There are piles of them among the pine trees. The SS guards gave them neither food nor water. When they became so weak they no longer walk they just lay down and died, wherever they were.'" E-mail Judith Cohen, "United States Holocaust Memorial Museum Worksheet 75713," May 14, 2012. See also the following caption at http://geese68 .wordpress.com/photography-war-some-pictures-mayshould-cause-upset/, accessed April 17, 2008: "A German child averts his gaze from the lines of hundreds of corpses awaiting removal for burial. This image was taken shortly after the defeat of Germany and the child in refusing to look at the bodies echoes the actions of many adult Germans. The corpses are victims of the Bergen-Belsen concentration camp, 1945."

35. In *Humanity and Inhumanity: The Photographic Journey of George Rodger,* text by Bruce Bernard, picture research by Peter Marlow in association with Magnum Photos (London: Phaidon, 1994). The accompanying text reads "1945, Belsen. A Dutch Jewish boy walks through the camp." One year later, Honnef and Breymayer, eds., *Ende und Anfang,* 137, gave the print made in the same year from the negative the caption "Ein jüdischer Junge läuft durch das Konzentrationslager Bergen-Belsen. Mitte April 1945" and the accompanying text on George Rodger provides more contextual details. In 1998, Wyschogrod, *Ethics,* 142 and 263n56 identified the "Jewish youth" as "the Belgian Jew Sieg Maandag [who] survived the dying after the liberation of the camp by the British army." See also http://israel.skynetblogs .be/post/3102033/pour-un-devoir-de-memoire-car-aujourd-hui-cer, accessed March 29, 2008 (the caption this blog uses for the photograph translates to "Sieg Maandag, a young Jewish survivor, walking on a path lined by corpses at Bergen-Belsen around the 20th of April, 1945").

36. Naggar, *George Rodger,* 137. This version appears to be, again, that of the new print made from the old negative.

37. Honnef and Breymayer, eds., *Ende und Anfang,* 202, write, drawing on an interview with George Rodger: "Eines der Bilder, die er im Konzentrationslager von Bergen-Belsen machte, zeigt einen kleinen Jungen, der auf der Lagerstraße in einem Kiefernwald dem Photographen entgegengeht und

den Kopf von der Frühlingssonne abwendet. Aber er wendet den Blick auch von den halbnackten Leichen der Ermordeten, die am Straßenrand aufgereiht liegen. Dieser Junge, der belgische Jude Sieg Maandag, überstand auch das Sterben, das nach der Befreiung durch die britische Armee weiterging."

38. Clément Chéroux, ed. *Mémoire des camps*, 39. The context is an interview with George Rodger, excerpted from Matard-Bonucci and Lynch's 1995 interview in *La libération des camps*.

39. In recent years, the image has circulated very widely. There are various European sites selling prints and posters of the photograph. See http://eu .art.com/asp/display_artist-asp/_/crid–8900/George_Rodger.htm and http:// www.allposters.it/-sp/Young-German-Boy-Walking-Down-Dirt-Road -Lined-with-Corpses-Bergen-Belsen-Extermination-Camp-Posters _i4256432_.htm, both accessed December 28, 2008. A blog on a 2008 Russian website mentioned before also reproduced the photograph. See http:// www.liveinternet.ru/search/?q=%C1%E5%EB%FC%E7%E5%ED, accessed December 12, 2008. See also the sites http://crazys.info/page,1,2,1280315746 -koncentracionnyjlagerbergenbelzen.html?cstart=2&newsid=1280315746 &news_page=1, http://mazunchik.livejournal.com/28737.html, http://mojai storia.blogspot.it/2012/10/blog-post.html, and http://nazadvgsvg.ru/viewtopic .php?id=961, accessed May 8, 2013, all of which show the photograph.

40. On May 18, 1993, he gave a tape-recorded interview in Amsterdam (in English) to Thomas Rahe of the Bergen-Belsen Memorial Foundation (also present was Ronald Abram). Sieg Maandag Interview, Audio-Interview 99, Stiftung niedersächsische Gedenkstätten, Gedenkstätte Bergen-Belsen. On May 18, 1995, the newspaper *De Telegraaf* published "De Lijdensweg van een Joods Jongetje: Omdat het moét, vertelt Sieg Maandag over zijn gruwelijke tijd in het concentratiekamp," a long, detailed story by Yvonne Laudy, based on an interview, with many direct quotations by Sieg Maandag (T23). On September 1, 1995, Maandag granted an interview (in Dutch) to the Shoah Foundation, conducted by Roos Elkerbout and videotaped by Mirjam Vogt.

41. Hetty Verolme, *The Children of Belsen* (2000, under title *The Children's House of Belsen* [repr. London: Politico's, 2004]). Alexandra-Eileen Wenck, *Zwischen Menschenhandel und "Endlösung": Das Konzentrationslager Bergen-Belsen* (Paderborn: Ferdinand Schöningh, 2000), is an extraordinarily well-researched study. Other recent books are Joanne Reilly, *Belsen: The Liberation of a Concentration Camp* (London: Routledge, 1998); and Ben Shephard, *After Daybreak: The Liberation of Belsen, 1945* (London: Jonathan Cape, 2005).

42. *De Telegraaf*, May 18, 1995. I am grateful to Karen Maandag for giving me a copy of this newspaper and to Maarten van Gageldonk for translating the article. Further biographical details are taken from the various interviews Maandag gave in the 1990s mentioned above.

43. See the detailed account "Der deutsch-amerikanische Austausch," in Wenck, *Zwischen Menschenhandel*, 238–48.

44. See Wenck, *Zwischen Menschenhandel*, 264–67.

45. The complete letter is quoted in Wenck, *Zwischen Menschenhandel*, 355–57. In depositions Kramer made in British and French interrogations he men-

tioned a growth from fifteen thousand internees in December 1944 to a temporary maximum of seventy-five thousand, leveling off to sixty thousand by April. He also states that his request was turned down and that he was ordered from Berlin "to keep the camp open to receive transports coming from the East, fever or no fever." Extract from a statement of May 22, 1945, Wiener Library 2312 D 008 and copy of a statement made by Josef Kramer on July 23, 1945, to an officer of the French War Crimes Liaison Group attached HQ 21 Army Gp. WL 1446 D 41. An early testimony of the last three months in the concentration camp by Fela Nichthauser, a Belsen survivor, was recorded by David P. Boder in 1946. See http://voices.iit.edu/interviewee?doc=nichthauserF and Boder, *Die Toten habe ich nicht befragt* (Heidelberg: Universitätsverlag Winter, 2011), 272–77.

46. Wenck, *Zwischen Menschenhandel*, 381–382.

47. *Life*, May 7, 1945, 37. Rodger's photographs from Belsen are available at Getty Images; those of the British Army Film and Photography Unit (AFPU) are at the Imperial War Museum in London, under "The Liberation of Bergen-Belsen Concentration Camp, April 1945," and include a photograph (#BU004025) taken by the No. 5 Army Film & Photographic Unit (Sgt. Harry Oakes and Lt. Alan Wilson); the content of that photograph is described as follows: "British troops stand guard as German SS troops are made to load the bodies of the dead onto a lorry for transport to mass graves." Numerous children and several nurses can be seen in the background looking on.

48. Upon liberation, on April 18 and 21, 1945, Esther Werkendam was interviewed by British radio journalist Patrick Gordon Walker for the BBC. Excerpts of the interview appear in Verolme's book, *Children's House of Belsen*, ix–xi, with a reference to the transcripts in the BBC archives, available at http://www.bbc.co.uk/archive/holocaust/5136.shtml?page=txt, accessed March 1, 2013. A sound recording of Richard Dimbleby's BBC April 15, 1945, news story about the liberation of Belsen is at http://news.bbc.co.uk/2/hi/in_depth/4445811.stm; and one of Patrick Gordon Walker's report is at http://dbellel.blogspot.com/2007/09/sound-portraits-bergen-belsen.html and http://www.isracast.com/article.aspx?id=766, both accessed March 1, 2013. Jonathan Martin's 2003 BBC documentary *The Men Who Liberated Belsen* is also available online at http://www.youtube.com/watch?v=Qu_wsre TnzY, accessed March 1, 2013.

49. George Rodger mentioned in an interview that he had his uniform tailored at Savile Row, with American insignia on his left and British on his right sleeve, permitting him to join different armies. Matard-Bonucci and Lynch, eds., *Libération des camps*, 95.

50. E-mail "Zwei Namen" (April 17, 2008) from Elfriede Schulz, Stiftung niedersächsische Gedenkstätten, Gedenkstätte Bergen-Belsen, Anne-Frank-Platz, D-29303 Lohheide. On the "Star Camp" and the "Women's Camp," see http://www.bergenbelsen.de/en/karte/1944/#1, accessed April 10, 2008, and Verolme, *Children's House of Belsen*, 100. See also Luba Tryszynska-Frederick, as told to Michelle Roehm McCann, *Luba: The Angel of Bergen-Belsen*

(Berkeley, CA: Tricycle Press, 2003), and http://books.google.com/books ?id=STl3UEb2X7wC&pg=PT55&dq=Luba+Tryszynska-Frederick&sig=82 P6vvtqqfKvLLcqpHkH0Ryzb7Y, accessed March 1, 2013. This account was vehemently disputed by Coby Lubliner, who proposes that Ada Bimko (Hadassah Rosensaft) was responsible for taking care of the children in the Kinderbaracke. See his "Memories of a Coal Child," http://www.ce.berkeley.edu/~coby/essays/coalchild.htm, accessed March 1, 2013. In Wenck, *Zwischen Menschenhandel*, 262 and 267, the Dutch couple Osiasz and Helene Birnbaum, who were deported with their own children to Belsen on February 2, 1944, are credited with caring for the diamond children in the Waisenhaus.

51. Patrick Gordon Walker's script, "Belsen Concentration Camp: Facts and Thoughts," is reproduced in "Lesser-Known BBC Broadcasts: The Scripts," in Suzanne Bardgett and David Cesarani, eds., *Belsen 1945: New Historical Perspectives* (London and Portland, OR: Vallentine Mitchell, published in association with the Imperial War Museum, 2006), 137–52. The program is archived at http://www.bbc.co.uk/archive/holocaust/5111.shtml and was broadcast on May 27, 1945. The end of the transcript, reproduced in *Belsen 1945*, 141, and corrected against the soundtrack at the BBC website, reads as follows:

> There was a children's block—where orphaned children (that is, children whose parents had been gassed and burned) were looked after by self-appointed foster mothers—looked after with unbelievable tenderness amidst starvation.
>
> The children said they would like to sing. I took them as far away from the corpses as I could—fifty yards, perhaps—and there, near the barbed wire fence amidst pines and young birch trees, they sang for me and for the world outside.
>
> Here are a dozen Russian children—from nine to fourteen—singing a Partisan song that they remembered from before their captivity.
>
> DISC: DBU 63284 .. disc 8 .. band 1 (28 seconds)
>
> And here are some Dutch boys and girls about the same age. They were being looked after by a Russian woman. They are singing a song in honor of the British liberators, who had given these little children a chance to live out their full lives: 'The English—long may they live in glory!'
>
> DUSC DBU 63284 .. disc 8 .. band 2 (25 seconds)

52. In the Imperial War Museum there are several photographs of children (none seems to portray or include Sieg Maandag), so that British war photographers may well have given a friendly call to the children to come to have a "liberation photograph" taken after they had been washed and dressed in new clothes.

53. Bergen-Belsen Memorial Foundation, Sieg Maandag interview, Audio-Interview 99 (cited earlier).

54. Jinx Rodger, e-mail "Young Belsen boy" (March 28, 2008). See also Honnef and Breymayer, eds., *Ende und Anfang*, 202; and Peter Sager, "Jenseits von

Bergen-Belsen: George Rodger," in *Augen des Jahrhunderts: Begegnungen mit Fotografen* (Regensburg: Lindinger+Schmid, 1998), 182.

55. Sieg's cousin Sylvia Springer-Groen, who was also in Belsen with her family and was deported from there with her parents to a camp near Leipzig, commented more than sixty years later that the Red Cross is the only charity she would not give anything to.

56. Photographs of Tryszynska-Frederick and the reunion are included in *The Children of Belsen*, picture insert between 164 and 165.

57. I am grateful to Karen Maandag for giving me a copy of this poem. Luba Tryszynska was a witness in the Belsen trial and testified that "when woman internees gathering herbs fell behind," camp guard Irma Grese "set her dog on them" (http://www.ess.uwe.ac.uk/WCC/belsen4.htm, part IV, 35; website set up by Stuart.Stein@uwe.ac.uk, accessed December 12, 2008).

58. A photograph of Sergeant Richard Leatherbarrow with former women camp inmates (Imperial War Museum HU 48482) shows one woman in a dress very much like that worn by one woman in the background of the Rodger photograph and a second woman whose facial features resemble Luba's.

59. Karen Maandag, e-mail "Sieg Maandag," April 15, 2008, and letter February 20, 2009; Jinx Rodger, e-mail "Young Belsen boy," March 28, 2008. Karen Maandag explains that Becht and Bromett "had a difference of opinion on the intention of the film, which only took shape after many of the scenes had already been shot. They ended up going to court and the judge, after hearing both parties, decided that they both had legal rights" and ruled "that they would have to find a way to work together to finish the project. This was never realized and the project ended in a stalemate."

60. The photographs all credit George Rodger in the back, but according to Jinx Rodger, all the photographs of the reunion were taken by George Becht, for a planned publication that never happened. Karen Maandag kindly provided me with high-resolution scans of these original photographs.

61. Naggar, *George Rodger*, 140.

62. Hill and Cooper, *Dialogue with Photography*, 59–60. See also: "This natural instinct as a photographer is always to take good pictures, at the right exposure, with a good composition. But it shocked me that I was still trying to do this when my subjects were dead bodies. I realized there must be something wrong with me. Otherwise I would have recoiled from taking them at all." At http://www.thephotoforum.com/forum/archive/index.php/t-23834.html, accessed March 3, 2013. In another interview, Rodger made similar comments: Sager, "Jenseits von Bergen-Belsen," 181. See also Sager, "Jenseits von Afrika," *Die Zeit*, March 10, 1995, http://www.zeit.de/1995/11/Jenseits _von_Afrika?page=2, accessed March 1, 2013.

63. Hill and Cooper, *Dialogue with Photography*, 59. This decision distinguishes George Rodger from Margaret Bourke-White who went on after World War II to take horrifying atrocity photographs of the Indian partition in 1947. The Swiss photographer Werner Bischof's trajectory went in the opposite direction: having started as a specialized nature and technical

photographer, his work in ruined postwar Germany focused his career on documenting human suffering around the world from then on.

64. Holzherr and Siben, eds., *George Rodger on the Road*, 37–38.

65. Hill and Cooper, *Dialogue with Photography*, 69.

66. Ibid., 70.

67. Sager, "Jenseits von Bergen-Belsen," 181–82. The British Army recorded 12,453 deaths by May 15, 1945. See Joanne Reilly, *Belsen: The Liberation of a Concentration Camp* (London: Routledge, 1998), 82.

3. After Dachau

1. For the source of the epigraph, see United States Strategic Bombing Survey, *The Effects of Strategic Bombing on German Morale*, vol. 2 (Washington, DC: Government Printing Office, 1946), 28–35, here 33.

2. An *Esquire* cartoon of 1940 shows the arrival of an enormous French army unit of more than one hundred soldiers in a town, where two busty women look out of a hotel window and one says what serves as caption to the image, "What's worrying me is how we are going to feed them." By contrast, "Maternitá" (1943), and "The Truck" (1944) demonstrate the somber themes to which Pachner turned during the war, the former showing, against a background of ruins, a mournful female figure in a melancholy pose next to small boy with his head bowed down, and the latter representing a deportation of prisoners toward a burning town. For the development of his artwork, see the exhibition catalogs *William Pachner Affirmations, 1936–1986* (Tampa, FL: Tampa Museum of Art, 1987) and Kenneth Donahue, *William Pachner* (New York: American Federation of Arts, 1959).

3. Martha Gellhorn, "Dachau: Experimental Murder," *Collier's* June 23, 1945, 16, 28, 30; here 30. The editors of *Collier's* chose a version of the first sentence in this excerpt as caption above Pachner's illustration. Lee Miller took a gruesome photograph of an SS guard killed upon the liberation of Dachau.

4. See Richard Whelan, *Robert Capa: A Biography* (New York: Alfred A. Knopf, 1985), 148–50, 228.

5. Letter to Betsy Drake, January 15, 1972. *Selected Letters of Martha Gellhorn*, ed. Caroline Moorehead (New York: Henry Holt, 2006), 378. As Moorehead writes, seeing Dachau just a few days after the American troops had liberated the concentration camp on April 29, 1945, changed Gellhorn, as "'a darkness' entered her spirit. The article she wrote for *Collier's* was despairing" (175).

6. For a full reading in this manner, see Laura Nazimek, "An Undiscovered Jewish American Novel: Martha Gellhorn's *Point of No Return*," *Studies in American Jewish Literature* 20 (2001): 69–80. Levy is at first confused when he learns that "the prisoners were not Jews, or anyhow not all of them were Jews" (304), but finds that though "they did not make the war because of Dachau . . . in the end, they reached it. And the S.S. guards were there, piled up dead in a mound; and their dogs were dead. So the war was a good thing" (305).

7. Martha Gellhorn, *Point of No Return* (Lincoln: University of Nebraska Press, 1995), 290.

8. Nazimek, "An Undiscovered Jewish American Novel," 70, erroneously writes that Levy kills three German *soldiers*. The brief and dismissive *New Yorker* review of the novel is more accurate in stating that the hero "deliberately runs down and kills three German civilians after paying a post-hostilities visit to Dachau." The verdict: "Strikingly minor." *New Yorker,* October 9, 1948, 129.

9. The text of the earlier edition under the title *The Wine of Astonishment* (New York: Bantam Books, 1949), 221, is identical here, though in the previously cited passage it reads "My mother" instead of "Momma" (220).

10. *Manifestoes of Surrealism,* translated by Richard Seaver and Helen R. Lane (Ann Arbor: University of Michigan Press, 1969), 125.

11. Frantz Fanon, "On Violence," in *The Wretched of the Earth* (French orig. 1961), new translation by Richard Philcox (New York: Grove Press, 2004), 51. See also Fanon's comments: "To the expression: 'All natives are the same,' the colonized reply: 'All colonists are the same'" (49). "The work of the colonized is to imagine every possible method for annihilating the colonist" (50). And: "For the colonized, life can only materialize from the rotting cadaver of the colonist" (50). In her subtle reading of Gellhorn's novel, Phyllis Lassner writes: "Levy embodies a generalized and continuous history of Jewish persecution and survival, but his amorphous sense of Jewish identity is given shape as being indelibly outlined and resistant to choices he might make outside it." And: "In the aftermath, as the military dismisses Levy's crime and therefore destabilizes any sense of absolute justice for it and for the war itself, Levy's indelible Jewish identity is made to embrace a unified if disturbing ethical meaning that sets a foundation for waging war and peace." See her "'Camp Follower of Catastrophe': Martha Gellhorn's World War II Challenge to the Modernist War," *Modern Fiction Studies* 44, no. 3 (1998): 792–812; here 807, 808.

12. This phrasing resembles the proto-existentialist self-affirmation of Bigger Thomas at the end of Richard Wright's novel *Native Son* (1940).

13. See Leah Garrett, "Young Lions: Jewish American War Fiction of 1948," paper delivered at Harvard University, October 17, 2012. Garrett's interesting work about Jewish American war novels from 1948 shows that Gellhorn was part of a trend of representing the experience of seeing concentration camps as a "'type scene' that delineates the moment when the Jewish soldier must reckon with his particular status" and that the six authors Garrett examined reject any fuller or more positive expression of Jewishness and rather create characters who, like Jacob Levy "merely exemplified the struggle against antisemitism."

14. James Agee, "Films," *The Nation* 160, no. 20 (May 19, 1945): 579. Dagmar Barnouw, *Germany 1945: Views of War and Violence* (1996; repr. Bloomington: University of Indiana Press, 2008), 8–9, cites other passages from this remarkable essay.

15. See also Victor Gollancz's worried comment on a speech given by Field Marshal Viscount Montgomery: "'The German food-cuts have come to

stay,' he is reported to have said. 'We will keep them at 1,000 calories (Britons get 2,800). They gave the inmates of Belsen only 800.' These words reveal—they could not have revealed more clearly if they had been spoken for the purpose—the moral crisis with which western civilisation is faced." Gollancz, *Our Threatened Values* (London: Victor Gollancz, 1946), 7. Reinhold Niebuhr reviewed Gollancz's book quite favorably in "The Forgotten Human Being," *The Nation*, February 28, 1948, 245–47.

16. In a 1956 letter to Diana Cooper, Gellhorn commented briefly on Agee's death in the context of an awkward moment in a social dinner conversation when the guests "wanted, or thought they wanted, to talk about Jim Agee, a young man recently dead, and a man Tom [*Time* editor Thomas Matthews, then Gellhorn's husband] really knew (a man apparently impossible to know) and really loved. And Tom felt about that (Ivan saying, 'Didn't you adore him?') the way I always and furiously feel when people who don't know and didn't really feel it, speak about my sacred deads. I freeze and I hate the speakers and I always want to say, 'Never heard of the fella' in order to shut them up for good." Caroline Moorehead, ed. *The Letters of Martha Gellhorn* (London: Chatto & Windus, 2006), 259–60.

17. See the discussions of Stig Dagerman and Victor Gollancz below. The approach Agee took, though it was tougher, also resembled that of Erich Kästner, who articulated the difficulty of writing a cohesive "review" of the film *Die Todesmühlen/Death Mills* for *Die Neue Zeitung* and instead produced an article pondering the petty details surrounding the atrocities, the psychology of perpetrators, the nature of terror, and the audience's varied reactions to the film which, "fortunately, was prohibited for children." Kästner reported that most viewers of *Death Mills* leave the theater and walk home in silence. "Others are pale when they exit, look at the sky, and say: 'Look, it's snowing.' Still others mumble: 'Propaganda! American propaganda! Propaganda before! Propaganda now!'" This makes Kästner wonder: "Do they mean propaganda on the basis of true facts? Then why do their voices sound so remonstrative when they say 'propaganda'? Should one not have shown them the truth?" Kästner concluded his ruminations with his own way of wishing for a differentiation that would make it possible to think of Germans not only as perpetrators but also as victims: "We Germans are not likely to forget how many million human beings were killed in these camps. And the rest of the world should every now and then remember how many Germans were killed in them." Erich Kästner, "Wert und Unwert des Menschen," *Die Neue Zeitung*, February 2, 1946; reprinted in *Der tägliche Kram: Chansons und Prosa, 1945–1948* (Zürich: Atrium Verlag, 1949), 70–75, here 75.

18. *The Hidden Damage* (New York: Harcourt, Brace, 1947), 79–81. The Bundesarchiv does have at least one such poster (Plakat 004-005-009) from the Soviet zone with the caption "Buchenwald klagt an," produced by the Communist Party in Zwickau.

19. Bundesarchiv Koblenz, Bundesbildstelle, Plak 004-005-005; Imperial War Museum, London, EA 71580; both reproduced in Jürgen Engert, ed., *Die*

wirren Jahre: Deutschland 1945–1948 (Berlin: Argon, 1996), 34, 35; the poster was also reproduced in James Stern, *Die unsichtbaren Trümmer: Eine Reise im besetzten Deutschland 1945* (Berlin: Eichborn Verlag, 2004), 386–87, the abridged German translation of *The Hidden Damage* (1947), published and marketed in Germany in the wake of the success of *A Woman in Berlin*, which Stern translated for its first publication in 1954. My efforts to learn more about the context in which the photograph of the boy was taken and perhaps to identify him remained fruitless. The helpful archivists in the Landesarchiv Baden-Württemberg and the Stadtarchiv Bad Mergentheim mentioned that the photograph is not part of their archives, that it was shown as part of a lecture in Bad Mergentheim, but that no identification of the boy resulted from that. Claudia Wieland, e-mail "Anfrage betr. Foto Bad Mergentheim 1945," March 25, 2013; and Christine Schmidt, e-mail "Anfrage wegen einer Fotografie aus dem Jahr 1945," April 16, 2013.

At the Imperial War Museum in London one can inspect photographs of the adult populations of whole towns who are being taken by British soldiers and German policemen to see atrocity photographs and films. Barnouw, *Germany 1945*, includes photographs from the U.S. Holocaust Museum, some of which show young boys and girls looking at atrocity photographs or entering film theaters to view a documentary on Belsen and Buchenwald (Fig. 1.2 and 1.3, pp. 9 and 10). Alan Bennett remembered seeing such a film as a youngster in Britain: "There were cries of horror in the cinema, though my recollection is that Mam and Dad were much more upset than my brother and me. Still, Belsen was not a name one ever forgot and became a place of horror long before Auschwitz." Alan Bennett, "Seeing Stars," *London Review of Books* 24, no. 1 (January 3, 2002): 12–16. (Some American audiences also reacted strongly. The article "Atlanta GI Sees Horrors of German Prison Camp" was accompanied by a photograph of an Atlanta audience watching Signal Corps newsreels of Nazi concentration camps. The caption states, "One man closes his eyes to shut out a horrible scene; a youth bites his fingernails; all look on with intense revulsion." *Atlanta Constitution*, May 13, 1945, 10A.)

20. The tape-recorded reactions by German officers in British captivity to being forced to view a concentration camp film in June 1945 ranged from the fear that these atrocities might be the only thing about the thousand-year *Reich* that will be remembered for a thousand years ("Yes, we are disgraced for all time," another officer agrees) to an argument about whether or not the bombing of Dresden can be compared to "this slow, intentional, systematic murder." Sönke Neitzel, *Abgehört: Deutsche Generäle in britischer Kriegsgefangenschaft 1942–1945* (Berlin: List-Taschenbuch, 2007), 313–15.

21. Ursula von Kardorff, *Berliner Aufzeichnungen 1942–1945: Unter Verwendung der Original-Tagebücher neu herausgegeben von Peter Hartl* (München: C. H. Beck, 1992), 334 (June 25, 1945) and 330 (June 5, 1945).

22. See, for example, Charles E. Egan, "All Reich to See Camp Atrocities: Allies Will Billboard in Each Community to Teach Germans They Have Guilt," *New York Times*, April 24, 1945, 6.

23. *Hidden Damage*, 127. When Stern near the end of his trip hears an educated woman in Frankfurt explain that locals call the American headquarters in the former IG Farben building "Das Pharisäerghetto" (The Ghetto of the Pharisees), he realizes that he has been talking to Nazis, "the Real Enemy," is reminded of a most poisonous snake he once saw hiding in an African tree, and concludes that these unrepentant though now slightly embarrassed Nazi women were still just as dangerous as a nest of snakes. Heidrun Kämper, *Der Schulddiskurs der frühen Nachkriegszeit: Ein Beitrag zur Geschichte des sprachlichen Umbruchs nach 1945* (Berlin: de Gruyter, 2005), offers a detailed analysis of the semantic management of guilt after World War II by victims, perpetrators, and nonperpetrators.

24. In letters to Charles Henry Miller of May 16, 1979, and February 21, 1983, James Stern identifies the "Merwyn" of *Hidden Damage* as "Wystan." Charles Miller–W. H. Auden Papers, Special Collections Library, University of Michigan.

25. U.S. Strategic Bombing Survey, *The Effects of Strategic Bombing*, vol. 1, Appendix A, 109–31, offers the methodology, the list of questions, and some sample answers. In his letter to Charles Henry Miller of February 21, 1983, Stern mentioned the stupidity of those questions.

26. Alfred Döblin, *Destiny's Journey*, ed. Edgar Pässler, transl. Edna McCown (New York: Paragon House, 1992), 293, 294. For the German original, see *Schicksalsreise: Bericht und Bekenntnis* (Frankfurt am Main: Josef Knecht, 1949), 429, 430.

27. Interview with Tony Vaccaro, May 9, 2006.

28. David Brion Davis, "The Americanized Mannheim of 1945–1946," in William E. Leuchtenburg, ed., *American Places: Encounters with History, A Celebration of Sheldon Meyer* (Oxford: Oxford University Press, 2000), 78–91, here 80–81.

29. Hugo Hartung, *Schlesien 1944/45: Aufzeichnungen und Tagebücher* (1956; repr. München: dtv, 1976), 100.

30. Zelda Popkin, *Small Victory* (New York: Lippincott, 1947), 14–15.

31. Vicki Goldberg, *Margaret Bourke-White* (New York: Harper & Row, 1986), 292.

32. Stig Dagerman, *German Autumn*, transl. Robin Fulton Macpherson, with an introduction by Mark Kurlansky, (1988; repr. Minneapolis: University of Minnesota Press, 2011), 24–25.

33. John Dos Passos, "Land of the Fragebogen," *Tour of Duty* (1946; repr. Westport, CT: Greenwood Press, 1974), 244.

34. Döblin, *Destiny's Journey*, 308, 306; *Schicksalsreise*, 451, 449.

35. Max Frisch, *Sketchbook 1946–1949*, transl. Geoffrey Skelton (New York: Harcourt Brace Jovanovich, 1977), 15. For the original, see *Tagebuch 1946–1949* (1950; repr. Frankfurt: Suhrkamp Verlag, 1963), 29–30. The early parts of this diary were first published in 1947 under the title *Tagebuch mit Marion*.

36. *Sketchbook 1946–1949*, 21–22. For the original, see *Tagebuch 1946–1949*, 38. Frisch's mentioning of grass and dandelion is echoed almost verbatim in

Svetlana Boym's thoughtful essay "Ruinophilia: Appreciation of Ruins," in which she writes that "instead of marveling at grand projects and utopian designs, we begin to notice weeds and dandelions in the crevices of the stones." *Atlas of Transformation*, at http://monumenttotransformation.org /atlas-of-transformation/html/r/ruinophilia/ruinophilia-appreciation-of -ruins-svetlana-boym.html, accessed January 30, 2013.

37. Erich Kästner, ". . . und dann fuhr ich nach Dresden," *Die Neue Zeitung*, September 30, 1946, unpag. [Kunstbeilage]. Reprinted in *Gesammelte Schriften*, vol. 5 (Köln: Kiepenheuer und Witsch, 1959), 82–86.

38. Dagerman, *German Autumn*, 20–21. Dagerman's report first appeared in individual essays in the Swedish newspaper *Expressen*, in book form under the title *Tysk Höst: Reseskildring* (Stockholm: Norstedt, 1947).

39. Gertrude Stein, "Off We All Went to See Germany," *Life*, August 6, 1945, 54–58, here: 54.

40. Stein, "Off We All Went," 54, 56, and 57. The photograph, apparently taken amidst the rubble of Frankfurt's Fahrgasse, carried the odd caption: "In Frankfort ruins, Miss Stein was greeted by a GI who began to quote her poetry. She was the first civilian American woman people of Frankfort had seen since the war ended" (56). It appears as though a few months after the arrival of the Americans, Frankfurt's ruins had already become part of a common U.S. Army-guided sightseeing tour through the destroyed old city.

41. Dagerman, *German Autumn*, 20.

42. See Boym's essay "Ruinophilia": "The uncanny anthropomorphism of ruins was discovered as early as the 16th century in scenes from the anatomic theater, where the dissection of the human body took place against the backdrop of classical ruins."

43. Döblin, *Destiny's Journey*, 310; *Schicksalsreise*, 453.

44. "Die Ruine" (1919), Engl. transl. "The Ruin," *Essays on Sociology, Philosophy, and Aesthetics*, ed. Kurt H. Wolff (New York: Harper and Row, 1965), 259–66. "Nature has transformed the work of art into material for her own expression, as she had previously served as material for art" (262). Simmel argues that, unlike other damaged works of art—paintings that have lost their colors, statues with mutilated legs, or ancient texts in which lines and passages are missing—a ruin is not merely a diminished work, because what has disappeared and has been destroyed has also been reinhabited by the growing forces of nature, so that a new and particular unity is formed out of what is still left of art and what has already turned into nature."

45. Margaret Bourke-White, *"Dear Fatherland, Rest Quietly": A Report on the Collapse of Hitler's "Thousand Years"* (New York: Simon and Schuster, 1946), picture insert between 86 and 87; text 41, 77, 82–85.

46. Working with such motifs was so common among photographers from different countries that it would probably be impossible to identify a photographer's nationality on the basis of these types of ruin photographs.

47. Kochmann was born in Heidelberg in 1916, and his photographic archive is at the Institut für Stadtgeschichte Frankfurt. Reproduced with caption "Römerberg von Osten, May 9, 1947," in Helmut Nordmeyer, *Hurra, wir*

leben noch! Frankfurt a.M. nach 1945: Fotografien von Fred Kochmann 1945–1948 (Institut für Stadtgeschichte Frankfurt; Gudensberg-Gleichen: Wartberg Verlag, 2001), 14–15.

48. Weinrother, "Postzustellung in den mit Trümmern bedeckten Straßen Kreuzbergs," Bildarchiv Preußischer Kulturbesitz, reproduced in Barnouw, *Germany 1945*, 172; "A destroyed street in Hamburg," AKG-images/Ullstein-Bild AKG_417832, file reference 2-G56-B1-1945-32"; Werner Bischof, *After the War*, with a foreword by Miriam Mafai (Washington, DC: Smithsonian Institution Press, 1997), image 9 "Freiburg, 1945"—also reproduced as the cover art of Tony Judt, *Postwar: A History of Europe since 1945* (New York: Penguin Press, 2005); Ray D'Addario, "Blick von der Rotschmiedgasse zur Unteren Talgasse," *Nürnberg damals—heute* (Nürnberg: Verlag Nürnberger Presse, 1997), 40; Hagel, Archiv der Stadt Pforzheim, reproduced in Barnouw, *Germany 1945*, 67. Victor Gollancz, *In Darkest Germany* (London: Victor Gollancz, 1947), plate 55, "High Street, Düren."

49. Cf. Boym's point in "Ruinophilia" about earlier ruin paintings: "It is not by chance that many 17th- and 18th-century paintings of ruins presented them as porous architecture; ruins appear as *vedute*, gateways to the landscape, elaborate man-made frames that mediated between history and nature, between architecture and the elements, the inside and outside of dwellings."

50. Dagerman, *German Autumn*, 22.

51. This photo is also found in Tony Vaccaro, *Entering Germany, 1944–1949*, ed. Michael Konze (New York: Taschen, 2001), 127, where it is titled "Woman who refused to leave her bombed-out apartment."

52. Interview with Tony Vaccaro, May 9, 2006.

53. Werner Bischof, *After the War*, images 3, "Friedrichshafen, Germany, 1945" and 6, "Freiburg, 1945" (unpaginated); VI; diary extracts, ix–x; letter to his father cited in editor's foreword, viii.

54. Nordmeyer, *Hurra wir leben noch*, 15.

55. "Ruins," *German Autumn*, 20.

56. Robert Capa, "Hohenzollernplatz" and "Berlin, Sommer 1945," *Sommertage, Friedenstage: Berlin 1945* (Berlin-Kreuzberg: Dirk Nishen, 1986), 14, 30. Another Capa photograph, "Hohenzollernplatz: Kinder wühlen in wertlos gewordenen Bezugsscheinen," 12, shows two boys playing with valueless ration cards on a mound of rubble.

57. "Kinder spielen mit Schutt aus den Ruinen." Bildarchiv Preußischer Kulturbesitz, Sign. WII 535a, reproduced in Barnouw, *Germany 1945*, 165.

58. Reproduced in Barnouw, *Germany 1945*, 137; Barnouw offers an imaginative reading of that photograph on 136.

59. David Brion Davis, "World War II and Memory," *Journal of American History* 77 (September 1990): 580–87, here 582.

60. Vaccaro, *Entering Germany*, 128–29. The text accompanying this image reads: "At first this young boy was as serious as any other young man. However, as soon as he took the three loaves of bread he had purchased into his arms, he suddenly became one big smile."

61. *German Autumn*, 117. Dagerman continues: "At another exhibition the commonest motif was not ruins but the heads of smashed classical statues lying on the ground with the Mona-Lisa smile of defeat. 'But when I paint ruins,' says the painter in Hannover, 'I do that because they are beautiful and not because they are ruins. There are masses of ugly houses which have become things of beauty after the bombing. The museum in Hannover really looks quite passable as a ruin, especially when the sun breaks through the shattered roof.'"

62. Frisch, *Sketchbook 1946–1949*, 22; *Tagebuch 1946–1949*, 38. See also Carl Zuckmayer's essay "Germany's Lost Youth," *Life*, September 15, 1947, 124–26, 128, 130, 132, 135–36, 138, accompanied by strong photographs.

63. Döblin, *Destiny's Journey*, 289.

64. Dagerman, *German Autumn*, 31–32.

65. Hans Habe expressed his critique of the Allied requisitioning policy colorfully in *Our Love Affair with Germany* (New York: Putnam, 1953).

66. Gollancz, *Our Threatened Values*, 22, 26. A visual equivalent of this report can be found in two facing pages of *Life*, May 6, 1946, 28–29, on the left a lavish dinner at the fine restaurant El Morocco (whose butcher is portrayed behind a mountain of meats) under the heading, "New York: Dinner Is 2,000 Calories," and on the right the corresponding headline "Brunswick: Dinner Is 600 Calories," at Echternkeller, a Braunschweig inn whose proprietor is shown bringing in the modest supplies in a simple cart he pushes through the ruined city.

67. Gollancz published the book *The Yellow Spot: The Outlawing of Half a Million Human Beings; a Collection of Facts and Documents Relating to Three Years Persecution of German Jews, Derived Chiefly from National Socialist Sources, Very Carefully Assembled by a Group of Investigators* as early as 1936, and he authored and published in early 1943 *"Let my people go": Some Practical Proposals for Dealing with Hitler's Massacre of the Jews and an Appeal to the British Public*.

68. Though the figures Gollancz cites for various illnesses were probably exaggerated and though some of the sources he relied on have been considered problematic, the individual encounters he reports and documents were sufficient to affect public opinion and occupation policy in Britain. See John Farquharson, "'Emotional but Influential': Victor Gollancz, Richard Stokes, and the British Zone of Germany, 1945–49," *Journal of Contemporary History* 22, no. 3 (July 1987): 501–19. *In Darkest Germany* was dedicated to Erwin Stadthagen who died in 1949 while under arrest in a corruption investigation. See "Personalien," *Spiegel*, April 2, 1949, 18.

69. *Our Threatened Values*, 41–45, citing Sheila Grant Duff in the *Manchester Guardian* of October 26, 1945, and G.E.R. Gedye in *The Daily Herald* of October 9, 1945.

70. *Our Threatened Values*, 104–5, citing the Lübeck correspondent in the *Manchester Guardian* of March 10, 1946.

71. *In Darkest Germany*, 54–56 and 81.

72. George Orwell, "Politics and the English Language," *Horizon* 13, no. 75 (April 1946): 252–65, here 261. Orwell writes: "In our time, political speech and writing are largely the defense of the indefensible. . . . Thus political language has to consist largely of euphemism, question-begging and sheer cloudy vagueness. . . . Millions of peasants are robbed of their farms and sent trudging along the roads with no more than they can carry: this is called *transfer of population* or *rectification of frontiers.*"

73. An excellent historical account delineating the ideological origins in Allied thinking is Detlef Brandes, *Der Weg zur Vertreibung 1938–1945: Pläne und Entscheidungen zum "Transfer" der Deutschen aus der Tschechoslowakei und aus Polen,* 2nd ed. (2001; repr. München: R. Oldenbourg, 2005). The belief in the desirability of ethnic homogeneity affected not only the transfers of Germans, but also the forced expulsion of 5 million Poles from the eastern third of the country (which became part of the Soviet Union pretty close to the demarcation line that the Hitler-Stalin agreement had drawn in Poland); and several other countries underwent processes that aimed at ethnic cleansing and at establishing more homogeneous countries than had been in existence in Central Europe. It also included the repatriation of Polish Jews who had escaped to and survived in the Soviet Union, and when they found themselves quite unwelcome in the new Poland, their move to the British and the American zones of Germany.

74. "Hordes Now Rove Poland, Going Home," *Washington Post,* October 21, 1945, B1.

75. Ernst Schneider, handwritten diary, 220 (1950), Stadtarchiv Kronberg im Taunus.

76. See Eva Hahn and Hans Henning Hahn, *Die Vertreibung im deutschen Erinnern: Legenden, Mythen, Geschichte* (Paderborn: Ferdinand Schöningh, 2010), 666. On pp. 39–40 the Hahns present printed sources that offer figures ranging from 3 million to more than 20 million. Rainer Schulze, "Forced Migrations of German Populations during and after the Second World War: History and Memory," in Jessica Reinisch and Elizabeth White, eds. *The Disentanglement of Populations: Migration, Expulsion and Displacement in Post-War Europe, 1944–49* (Basingstoke, UK: Palgrave Macmillan, 2011), 51–70, gives the figure of 12–14 million people who were affected and of 2 million deaths. Chauncy D. Harris and Gabriele Wülker, "The Refugee Problem of Germany," *Economic Geography* 29, no. 1 (January 1953): 10–25, suggest an estimated total number of 12.48 million expellees, based on 1950 German census figures.

77. Eva Hahn and Hans Henning Hahn offer a good overview of the issue in "Flucht and Vertreibung," in Etienne François and Hagen Schulze, eds. *Deutsche Erinnerungsorte: Eine Auswahl* (München: C. H. Beck, 2005), 332–50. See also the Hahns' fuller study, *Die Vertreibung im deutschen Erinnern,* in which they call particular attention to Victor Gollancz as an author who is now too little read (374).

78. Daniel de Luce, "Poland Seeks Settlers but Evicts Germans," *Chicago Tribune,* August 25, 1945, 9, writing from Pomerania, noted the paradox that

the newly Polish province expected 1.9 million new Polish settlers to come from now Russian Eastern Poland, though only 100,000 had actually arrived; similarly, 4.2 million new arrivals were needed in Silesia, and all along Germans were being evicted. See also "500,000 Poles Resettled: Upper Silesia Now 'Saturated,' Government Spokesman Says," *New York Times*, June 24, 1945, 12; "Czechs Ask Haste in Exiling 2,000,000: Officials Tell British of Peril in Waiting Till Homes for Sudetens are Found," *New York Times*, September 6, 1945, 7; "Britain Asks Big 4 to Warn Poland: Wants U.S., Russia, France to Join Her in Protest," *New York Times*, October 11, 1945, 7; Sydney Gruson, "Deportations of German Add to Europe's Troubles: Allies, Having Taken Care of Millions of 'Displaced Persons,' Try to Stop Them," *New York Times*, November 18, 1945, 67; Anne O'Hare McCormick, "Abroad: Problem of Places for the Refugees," *New York Times*, November 13, 1946, 24. Joseph E. Evans, "Mass Expulsions: Twelve Million Shunted into a Smaller Germany from the East Create Vast Social and Economic Problems," *Wall Street Journal*, July 23, 1947, 4, called attention to the curious fact that the mass expulsions coincided with the "victorious Allies . . . trying a group of men in Nuremberg for certain crimes, among them mass removals of populations." An exception to the general trend is "Covered Wagon Trail Leads Home for These Germans," *New York Times*, September 6, 1945, 10, two photographs of a refugee trek of women and children who are moving back to Silesia from Czechoslovakia: "Irony of their trek back is that Silesia, their home area, is now in Polish hands and under Russian domination."

79. See, for example, these pieces from the *Times of India*, "One Million Refugees Entering Austria: Plea to Allies," October 16, 1945, 5; "German Refugee Streams: Millions May Die," October 27, 7; and "Germans' Expulsion to British Zone: Mr. Bevin Seeks Clarification," November 6, 1945, 4.

80. Louis M. Lyons, "Lyons in Czechoslovakia—Czechs Take Harsh Revenge on Sudetenland Germans," *Boston Daily Globe*, August 20, 1945, 2.

81. Larry Rue, "Fail to Harden Troops against German People: GIs Bitter on Army's Hate Propaganda," *Chicago Daily Tribune*, September 30, 1945, 7. The British paper Rue quotes is the *Weekly Tribune* ("a Labor organ . . . formerly edited by Aneurin Bevan"): "What is happening now after the defeat of Germany and the collapse of fascism everywhere is nothing less than the transformation of a large part of Germany, as well as Austria, into one huge Belsen."

82. *Life*, October 15, 1945, 107–15. Representative examples of McCombe's broader range of photography from the 1940s appeared in *Menschen erleiden Geschichte: Das Gesicht Europas von der Themse bis zur Weichsel, 1943–1946* (Zürich: Atlantis-Verlag, 1947). See also http://5b4.blogspot.it/2008/04 /menschen-erleiden-geschichte-by-leonard.html, accessed March 1, 2013. Barnouw, *Germany 1945*, 101–8, discusses McCombe's reportage at length and calls attention to the fact that the report was preceded by the editors' warning to refrain from empathizing.

83. *Life*, November 5, 1945, 6. Other readers' letters published in response to this essay were divided between compassion and vindictiveness. On the one

hand, Ensign John Henry Holt wrote from San Francisco that he lost his faith in American democracy and wondered what he had been fighting for after reading the article; Mrs. J. H. Eidson from Sweetwater, Texas, found that the "careful selection of pictures depicts the aftermath of war in all its horror and degradation, from the innocent babies to the helpless old people"; and Carl B. Montgomery, an ex-prisoner of war from Asheville, North Carolina, thought that the "picture of the German woman with her ankles split open, sitting almost prayerfully in the Stettiner Station, must be included as one of the half-dozen great photos of this war." On the other hand, several letters from New York City refused empathy: J. W. Lowey whose family in Czechoslovakia was killed by Hitler's assassins remembered seeing the faces of those displaced Germans before when they were "screaming and bellowing at their idol, 'Heil Hitler! *Wir danken unsrem Führer!*" Manuel Komroff wrote in response to the photograph of the refugee girl who had been raped: "Where was your photographer when the girls of Poland, Greece, Holland and all the other lands were raped?" And Mary Reve commented that she "gloated over them. May they continue to suffer long and hard for the monstrous crimes they inflicted on the rest of Europe" (4, 6).

84. The Sanders photo was first published in the photo-essay "Wives in Germany," *Life*, May 17, 1946, 55–57, here 55.

85. "Death March from Silesia," *America*, November 17, 1945, 176–78.

86. "Death March from Silesia," 177–78. On the situation in Görlitz in 1945 and the postwar years see also Markus Lammert, *Die Stadt der Vertriebenen—Görlitz 1945–1953* (Görlitz: Verlag der Oberlausitzischen Gesellschaft der Wissenschaften, 2012). (Beiheft 10 zum Neuen Lausitzischen Magazin.)

87. Robert Jungk, "Aus einem Totenland," *Die Weltwoche* 13, 627 (November 16, 1945), repr. in *Spiegel-special* 2/2002. "Die Flucht der Deutschen," at http://www.spiegel.de/spiegel/spiegelspecial/d-22937254.html.

88. "Church Council Warns against Vengeful Peace: Victors Urged to Alter Their Outlook," *Chicago Daily Tribune*, February 26, 1946, 9.

89. "The Land of the Dead: Study of the Deportations from Eastern Germany," Committee against Mass Expulsion, New York, February 23, 1947. Among the others who signed the introduction were the radical Alfred Bingham; William Henry Chamberlain, a journalist and historian of the Russian Revolution; George S. Counts, an educational historian at Teachers College; radio commentator H. V. Kaltenborn; author, philanthropist, and theatrical figure Francis Neilson; lawyer, civic leader, and writer Eustace Seligman; reformer, socialist, and pacifist Norman Thomas; and Massachusetts labor leader Robert J. Watt. I shall be quoting from the copy in the Harvard University Library. A scan is also available at http://babel.hathitrust.org/cgi/pt?id=wu.89048887236;page=root;view=image;size=100;seq=1.

90. "Land of the Dead," 29, 30, 32.

91. "Expulsion Plans Imperil 20,000,000: Committee Here Asks Action to Ease Suffering in Shifts in Eastern Europe," *New York Times*, February 24, 1947, 12.

92. "Help for DP's: IRO Cannot Aid Some Groups It Is Pointed Out," Letters to the Times, *New York Times*, July 20, 1947, E8. Signed by Thomas, La-Farge, Holmes, and Emmet as well as by Sidney Hook (who was not among those who had signed the introduction to the pamphlet), the letter also takes the opportunity to call attention to the pamphlet and to reiterate its central findings. On the IRO, see the 1946 Constitution of the International Refugee Organization, "Part II: Persons Who Will Not Be the Concern of the Organization":

> 4. Persons of German ethnic origin, whether German nationals or members of German minorities in other countries, who:
> (a) Have been or may be transferred to Germany from other countries;
> (b) Have been, during the second world war, evacuated from Germany to other countries;
> (c) Have fled from, or into, Germany, or from their places of residence into countries other than Germany in order to avoid falling into the hands of Allied armies.

Collection of International Instruments and Legal Texts Concerning Refugees and Others of Concern to UNHCR (Geneva, Switzerland: United Nations High Commissioner for Refugees, [2007]), 63. Schulze, "Forced Migrations," 57, also writes that the Allies prohibited the creation of German refugee organizations and instructed German authorities to devise policies toward the integration of expellees in the receiving areas.

93. The topic of the expulsions became a prominent preoccupation for the political Right in West Germany and the memory of them has remained intensely controversial in postunification Germany. The German critical Left has generally suspected that speaking about the refugee experience was only a way of avoiding to speak about Auschwitz, and, for understandable reasons, any comparisons with Nazi policies (as Gollancz or the Emmet group drew them) have been taboo in Germany.

94. I have probably not searched in the right places, but have found no American work of literature from the period that centers on the expellees and the refugees of the 1940s. Louis Ferdinand Helbig, *Der ungeheure Verlust: Flucht und Vertreibung in der deutschsprachigen Belletristik der Nachkriegszeit* (Wiesbaden: Otto Harrassowitz, 1988), offers a comprehensive account of the German literature on the expulsions, from which I have selected Ihlenfeld and Pohl. Apart from Helbig there appears to be relatively little scholarship from the past half century about these two writers.

95. This strategy is diametrically opposed to the aesthetic choice made by the anonymous author of *A Woman in Berlin*, especially in that book's second section.

96. This is also the case in works like Elisabeth Langgässer's 1946 short story "Glück haben," a dramatic account that a deranged woman gives of her life to a frame narrator.

97. "Death March from Silesia," 178.

98. Kurt Ihlenfeld, *Wintergewitter* (1951; repr. Gütersloh: Bertelsmann Leser-ing, 1958). See, for example, *verändert* (9), *verschwunden* (9), *Veränderungen* (24, 27), *verschwindet* (52); *verschwinden* (53); *verschwand* (72), *versank* (73), *Alles verschwindet allmählich* (93); *jetzt ist er [the train] weg* (103); *alle zerstreut* (107); *einfach auswischen* (108); *am liebsten schnell verschwinden* (109); *daß das hier ein Ende hat* (145); *Das Ende ist da, wir erleben es jetzt* (257). Among the biblical passages invoked are Micah 2:10, "Ihr müßt davon, ihr sollt nicht hier bleiben" / "Arise ye, and depart; for this is not your rest" (127), and Isa-iah 32:13, "Denn es werden auf dem Acker meines Volkes Dornen und Hecken wachsen, dazu über allen Häusern der Freude in der fröhlichen Stadt" / "Upon the land of my people shall come up thorns and briers; yea, upon all the houses of joy in the joyous city" (283–84). Also, the painting that hangs over the minister's wife's desk is not one representing a Last Sup-per, but Wilhelm Steinhausen's serious and somber *Aufbruch vom Abend-mahl* (1874), which shows Jesus and eleven disciples in the process of leaving the room where they have eaten and going out into the dark night (70). For a general assessment of Ihlenfeld and Gerhart Pohl, see H. M. Waidson, *The Modern German Novel: A Mid-Twentieth Century Survey* (Oxford: Oxford University Press, 1959), 25–27.

99. *Wintergewitter*, 227, 228.

100. Ibid., 170. It is one of the strengths of the novel that the minister ponders on the full force of words like *capitulate* (207) and *deserter* (212). Conversely, in the last, the lieutenant's section, the word *tank* (*Panzer*) is often avoided in favor of circumlocutions like "iron vault," "wagon" (462, 466), "iron cage" (463), "iron mountain," "box," or "coffin" (472).

101. *Wintergewitter*, 172.

102. See Karina Berger, "Expulsion Novels of the 1950s: More Than Meets the Eye?" in Stuart Taberner and Karina Berger, eds., *Germans as Victims in the Literary Fiction of the Berlin Republic* (Rochester, NY: Camden House, 2009), 42–55. Berger called attention to the fact that fiction about the expulsion was mistakenly suspected of highlighting Germans only as victims and stresses the episodes concerning Herr von Schindler as well as that of the female concentration camp prisoners. Yet she adds: "However, the narrative does not provide specific, or more explicit, details about the Holocaust" (46). The immensely helpful *Handbuch Nachkriegskultur: Literatur, Sachbuch und Film in Deutschland (1945-1962)*, eds. Elena Agazzi and Erhard Schütz (Berlin: de Gruyter, 2013), includes briefer comments on Ihlenfeld's novel (248, 336).

103. *Wintergewitter*, 466, 467.

104. Ibid., 480.

105. The lieutenant's paradox parallels Dagerman's cited description of those Germans he considered "ruins."

106. Gerhart Pohl, *Wieviel Mörder gibt es jetzt?* (Berlin: Lettner-Verlag, 1953), 7–11. Further references to this collection are given parenthetically. A sec-ond edition of this short story collection appeared under the title *Engels-masken* (Berlin: Lettner-Verlag, 1954).

107. The 1942 date for this postwar story given in the 1953 edition is clearly erroneous, and the earlier printing, with illustrations, in Pohl's collection *Zwischen gestern und morgen* (Berlin: Chronos Verlag, 1947) has the more plausibly dated heading "Wolfshau—Wilcza Porçba, Sommer 1947."

108. *Friederike: Singspiel in drei Akten* (Berlin: Crescendo Theaterverlag, 1928). A 1929 recording with Richard Tauber as Goethe is at http://www.youtube .com/watch?v=2PYRl_f9v7I, accessed November 6, 2013.

109. Pohl may have modeled this response on Zalman Grinberg's 1945 addresses to Jewish survivors: "Hitler lost all the battles on all the fronts, except the battle against defenceless and unarmed men, women and children! He won the war against the European Jews.

 Indeed, he was helped by the German nation. However, we do not want revenge. If we took revenge, it would mean that we would fall to those moral and spiritual depths in which the German people have been lost for the last ten years.

 We are not able to murder women and children! We are not able to burn millions of people! We are not able to starve hundreds of thousands!" At http://www.jewishvirtuallibrary.org/jsource/Holocaust/GrinbergSpeech .html.

110. The typescript of the story in the Gerhart Pohl-Archiv, Akademie der Künste Berlin, dated September 18, 1950, 7, shows the deletion of a generalizing passage stating that "so many then needed a retouching of their identity cards for the most diverse reasons."

111. In the typescript, p. 6, after the mentioning of the renaming of streets (p. 40, bottom, of the published edition), a sentence was deleted that generalizes that it was "the same change of signs" though "the signified remained— the street, the apartment, and hopefully also Marian's mother, dear old Mrs. Nowakowska."

112. Pohl's story could be read against the background of Gregor Thum's study *Uprooted: How Breslau Became Wrocław during the Century of Expulsions*, transl. Tom Lampert and Allison Brown (Princeton, NJ: Princeton University Press, 2011). Thum describes the need for mythicizing history, as the history or Breslau, now Wrocław, had to be written anew, analyzes the Polonization of the names of towns, streets, and people, and presents the situation of abandoned German cemeteries in major cities such as Wrocław, where a few years after the war "criminals often sought hiding places in the undergrowth and in the open tombs" (283).

113. "Die Erde und die Toten," second version, typescript with handwritten changes, dated September 18, 1950, 19. Akademie der Künste Berlin. My thanks to Sabine Wolf.

114. Frisch, *Sketchbook 1946–1949*, 22; *Tagebuch 1946–1949*, 38–39.

115. Gerald Daniel Cohen, *In War's Wake: Europe's Displaced Persons in the Postwar Order* (Oxford: Oxford University Press, 2012), 5, cites a figure of "eight million civilians in Germany" at the end of the war: "foreign workers, slave laborers, prisoners of war, and liberated concentration camp inmates." These "displaced persons" (the term an American coinage first cited in the

Oxford English Dictionary from the *Saturday Evening Post* of July 14, 1944) were quickly returned to their homelands, "forcibly and often tragically in the case of Soviet nationals reluctant to repatriate to the USSR."

116. Atina Grossmann, *Jews, Germans, and Allies: Close Encounters in Occupied Germany* (Princeton, NJ: Princeton University Press, 2007), 122–23, also mentions threatening and harassing policies toward Jews in early postwar Poland.

117. "Tide of 'DP's' Ebbs, 70% Repatriated: Of 6,500,000 Allied Prisoners and 'Slaves' Once in Reich Only 2,000,000 Remain," *New York Times*, August 30, 1945, 10. By late 1945 only about 1.2 million remained under the care of UNRRA. A *New York Times* story of November 1945 mentioned the successful repatriation of 5,243,000 people who had been uprooted by German authorities during World War II, among them more than 2 million to the Soviet Union, 1.5 million to France, and half a million to Italy. All but about half a million who were considered "non-repatriable" were to be repatriated within a year after Germany's capitulation. See Sydney Gruson, "Deportations of Germans Add to Europe's Troubles," *New York Times*, November 18, 1945, 67.

118. "Red Traitors' Dachau Suicide Described as 'Inhuman' Orgy," *Stars and Stripes*, Germany edition, January 23, 1946.

119. Wolfgang Jacobmeyer, *Vom Zwangsarbeiter zum heimatlosen Ausländer: Die Displaced Persons in Westdeutschland, 1945–1951* (Göttingen: Vandenhoeck & Ruprecht, 1985), 133–34.

120. The full text of the report appeared in the *New York Times*, September 30, 1945, and is available at http://www.ushmm.org/museum/exhibit/online/dp /resourc1.htm and at http://www.jewishvirtuallibrary.org/jsource/Holo caust/truman_on_harrison.html, both accessed March 1, 2013. Grossmann, *Jews, Germans, and Allies*, 138–41, offers an excellent discussion of the Harrison Report, on parts of which I draw here.

121. This novel form of articulating a particular group's need to be recognized as a group would seem to belong to the prehistory of what became later known as "Affirmative Action."

122. Grossmann, *Jews, Germans, and Allies*, 141.

123. Many of the photographs are reprinted with various texts, including an essay by Orlin, in Erik Somers and René Kok, eds., *Jewish Displaced Persons in Camp Bergen-Belsen, 1945–1950: The Unique Photo Album of Zippy Orlin* (Zwolle: Waanders, 2003).

124. Jacqueline Giere and Rachel Salamander, eds., *Ein Leben aufs neu: Das Robinson-Album. DP Lager: Juden auf deutschem Boden 1945–1948* (Wien: Brandstätter, 1995), 11.

125. Giere, *Ein Leben aufs neu*, 84. The handwritten inscription accompanying this and four other photographs of demonstrations in the original album reads: "The UNRRA camps were a blessing in the first few months only . . . because of the troubled international politics the D.P. had to stay in the new-form post war camps, long after the war ended. Already in winter 1946 everybody wanted to get out and to eat his own bread." Reproduced in ibid., 114.

126. For example, the serious expressions on the men's faces at a wedding photograph is noteworthy as is the fact that several of the guests look directly at the camera (in ibid., 78–79). Testimonies by witnesses from the D.P. camps mention that children who were named after people who had been murdered had difficulties assuming the place of an idealized precursor (a social worker); other children had themselves lost close relatives in the Holocaust so that any other loss seemed trivial, which diminished the capacity for other feelings (ibid., 53).

127. David P. Boder, *I Did Not Interview the Dead* (Urbana: University of Illinois Press, 1949). German edition; *Die Toten habe ich nicht befragt* (Heidelberg: Universitätsverlag Winter, 2011). Most recordings have been digitized, transcribed, and translated at the Voices of the Holocaust website, http://voices.iit.edu.

128. This is obviously the case with his interviews of Holocaust survivors from different countries: The interview with Fania Freilich, for example, includes an account of the 1942 mass deportations of Jews in Paris to the Vélodrome d'hiver and to Drancy. But Boder also recorded Mennonites and Catholics, asked several interviewees to sing songs for him, and one of the interviews is with Judah Golen who explains to Boder that he has come to Germany from Palestine to organize a group of fifteen others to do cultural work in various D.P. camps, teaching Hebrew and preparing the D.P.s for emigration to Palestine. See http://voices.iit.edu/interview?doc=golenJ&display=golenJ_en.

129. Boder's term seems quite compatible with Ihlenfeld's description of Herr von Schindel's *Vereinsamung* as part of the persecution.

130. Zelda Popkin, *Open Every Door* (New York: E. P. Dutton, 1956), 243. Further page references are given parenthetically, with the identifier "O."

131. This scene contrasts sharply with an episode in William Gardner Smith's *Last of the Conquerors* (1948). There an old man begs the black G.I. Hayes Dawkins for a cigarette and is at first ignored. After hearing an upsetting anti-Semitic tirade by an American captain, however, Dawkins gives the man a half-empty pack of cigarettes (100, 106). Collecting cigarette butts is, of course, connected to the fact that the cigarette served as currency in postwar Germany, so that tobacco in any form meant wealth; and Popkin gives a particularly detailed account of its value. According to her, one could buy a watch in Zurich for a carton of cigarettes, then sell it in Berlin to a Russian for $300; otherwise a carton of Camels fetched $100, Pall Mall Kings $125: "more tabac" (S 160). In Berlin in 1945, film director Billy Wilder bought a George Grosz painting for a carton of cigarettes (Ed Sikov, *On Sunset Boulevard: The Life and Times of Billy Wilder* [New York: Hyperion, 1998], 250); and his film *A Foreign Affair* shows the black market, exchanges with cigarettes, and a man picking up a cigarette butt. Long before he wrote his bestselling Mafia book *The Godfather* (1969) Mario Puzo published his first novel *Dark Arena* (1955) about the time of occupation in Germany, and criminal racketeering and black market dealings play a central role in it; according to Puzo, an abortion could be had for half a carton of cigarettes.

132. *Small Victory* (New York: Lippincott, 1947), 30. Further references in the text, preceded by "S."

133. A passage in Hans Habe's novel *Off Limits* offers a dramatic counterpoint to this scene, as Habe describes, amidst black market activities of Displaced Persons in München, "an UNRRA official, a gray-haired woman, American in appearance, in a blue uniform and rimless glasses, the typical missionary who hastens from mission station to mission station, partly to bring humanity to others and partly to escape from her own loneliness, . . . standing helplessly amidst the turmoil, still with a benign and charitable smile, unable to understand that the needy had become speculators, that alms had become an object of barter, and that her own mission had become a farce." *Off Limits*, transl. Ewald Osers (New York: Frederick Fell, 1956), 128.

134. Grossman, *Jews, Germans, and Allies*, 220, states that more than five hundred young D.P.s attended German universities, mostly in such fields as medicine, dentistry, and engineering.

135. Zelda Popkin Papers, Howard Gottlieb Archival Research Center, Boston University.

4. Dilemmas of Denazification

I am grateful to my colleague Philip Fisher who talked with me at length about Carl Schmitt and to Oliver Simons who commented on a draft of this chapter. George Blaustein and Maggie Gram read this chapter and made very helpful suggestions. Heike Paul gave me the opportunity to present an earlier version of parts of this chapter at a conference on reeducation at the Friedrich-Alexander-Universität Erlangen-Nürnberg, and I am grateful to her, Rainer Huhle, and to the other conference participants for comments and suggestions.

1. Ralf Hansen, "Im Schatten des Leviathan," http://www.jurawelt.com/liter atur/rechtssoziologie/2015, accessed March 7, 2011.

2. *Der Wert des Staates und die Bedeutung des Einzelnen* (Tübingen: J. C. B. Mohr/P. Siebeck, 1914).

3. See Giorgio Agamben, *Homo Sacer* (Torino: Einaudi, 1995); Engl. transl. Daniel Heller-Roazen, *Homo Sacer: Sovereign Power and Bare Life*, (Stanford, CA: Stanford University Press, 1998), and *Telos* issues 71, 72, and 139, for example. See also Michael Hardt and Antonio Negri, *Empire* (Cambridge, MA: Harvard University Press, 2000). The fact that Walter Benjamin corresponded with Schmitt has been of much interest to the Left. See Michael Rumpf, "Radikale Theologie: Benjamins Beziehung zu Carl Schmitt," in *Walter Benjamin: Zeitgenosse der Moderne*, ed. Peter Gebhardt et al. (Kronberg: Scriptor, 1976), 37–50; and Horst Bredekamp, "From Walter Benjamin to Carl Schmitt, via Thomas Hobbes," *Critical Inquiry* 25, no. 2 (winter 1999): 247–66. On Schmitt's three readings of Benjamin, see Jürgen Thaler, "Fabelhaft! Genial! Großartig! Herrlich! Carl Schmitt als Leser von Benjamins *Ursprung des deutschen Trauerspiels:* Ein Streifzug durch die Annotationen

und Marginalien," *Frankfurter Allgemeine Zeitung*, August 17, 2011, N4. By contrast, see Herbert Marcuse, "Der Kampf gegen den Liberalismus in der totalitären Staatsauffassung," *Zeitschrift für Sozialforschung* 3 (1934): 161–95. Alfons Söllner, "'Kronjurist des Dritten Reiches': Das Bild Carl Schmitts in den Schriften der Emigranten," *Jahrbuch für Antisemitismusforschung* 1 (1992): 191–216, offers an indispensable survey of critical analyses by authors like Karl Löwith, Otto Kirchheimer, Franz Neumann, and Herbert Marcuse. Ellen Kennedy, "Carl Schmitt and the Frankfurt School," *Telos* 71 (spring 1987): 37–66, stresses intellectual affinities of antiliberal thinking between Schmitt and the Frankfurt School, despite obvious political differences and shows that 1933 was the turning point toward open hostility. Benno Gerhard Teschke, "Fatal Attraction: A Critique of Carl Schmitt's International Political and Legal Theory," *International Theory* 3, no. 2 (2011): 179–227, proceeds from the paradox that Schmitt has provided "an analytical vocabulary to simultaneously conceptualize and criticize, *inter alia*, the ongoing US-imperial turn and its 'war on terror' after 9/11," an unexpected convergence "between the neo-Conservative Right and the post-Marxist Left" (179) toward a historical understanding of the political baggage that Schmitt's thought carries.

4. Literature on Carl Schmitt is vast, and Peter C. Caldwell, "Controversies over Carl Schmitt: A Review of Recent Literature," *Journal of Modern History* 77 (June 2005): 357–87, offers a balanced survey of recent Schmitt studies. I have here drawn extensively on Reinhard Mehring, *Carl Schmitt: Aufstieg und Fall: Eine Biographie* (München: C. H. Beck, 2009), an excellent critical biographical study.

5. *Volk und Parlament nach der Staatstheorie der französischen Nationalversammlung von 1789: Studien zur Dogmengeschichte der unmittelbaren Volksgesetzgebung* (München: Drei Masken Verlag, 1922).

6. *Erscheinungsformen der Verfassungsänderung: Verfassungsrechtsdogmatische Untersuchungen zu Artikel 76 der Reichsverfassung* (Tübingen: J. C. B. Mohr, 1931).

7. For the biographical information and the discussion on the following pages I have relied on Mehring's work as well as on Markus Lang, *Karl Loewenstein: Transatlantischer Denker der Politik* (Stuttgart: Steiner, 2007), an intellectual biography and assessment, and Robert Chr. van Ooyen, "Ein moderner Klassiker der Verfassungstheorie: Karl Loewenstein," *Zeitschrift für Politik* 51 (2004): 68–86.

8. *Die Diktatur: Von den Anfängen des modernen Souveränitätsgedankens bis zum proletarischen Klassenkampf*, 4th ed. (1921; Berlin: Duncker & Humblot, 1978), 22, 23.

9. *Politische Theologie: Vier Kapitel zur Lehre von der Souveränität*, 3rd ed. (1922; Berlin: Duncker & Humblot, 1979), 20: "Souverän ist, wer über den Ausnahmezustand entscheidet. . . . Der Ausnahmezustand offenbart das Wesen der staatlichen Autorität am klarsten. Hier sondert sich die Entscheidung von der Rechtsnorm."

10. *Politische Theologie*, 22. For a far more nuanced deliberation of Schmitt's notion of the exception in connection with his relationship to Benjamin, see

Samuel Weber, "Taking Exception to Decision: Walter Benjamin and Carl Schmitt," *Diacritics* 22, no. 3–4 (autumn–winter 1992): 5–18.

11. For the concept of the political, see *Der Begriff des Politischen: Text von 1932 mit einem Vorwort und drei Corollarien* (Berlin: Duncker & Humblot, 1963), 194. For the distinction between friend and enemy, see *Frieden oder Pazifismus? Arbeiten zum Völkerrecht und zur internationalen Politik 1924–1978*, ed. Günter Maschke (Berlin: Duncker & Humblot, 2005), quoted in Mehring, *Schmitt*, 207–8.

12. Mehring, *Schmitt*, 207–8.

13. Loewenstein, *Verfassungslehre*, 4th ed. (Tübingen: J. C. B. Mohr, 2000), 37, the German translation by Rüdiger Boerner of *Political Power and the Governmental Process* (Chicago: University of Chicago Press, 1957).

14. Loewenstein, *Political Power*, 319; cf. *Verfassungslehre*, 337.

15. Loewenstein, *Political Power*, 22–24, 34–36; cf. *Verfassungslehre*, 38–39.

16. Loewenstein, *Political Reconstruction* (New York: Macmillan, 1946), 2, quoting Jefferson's letter to Peregrine Fitzhugh, 23 February 1978, *The Writings of Thomas Jefferson: Correspondence*, ed. Henry Augustine Washington (New York: J. C. Riker, 1854), 218.

17. Loewenstein, *Political Reconstruction*, 351.

18. Loewenstein, *Political Power*, 4. "Against the Shadow of the Leviathan," 384.

19. Letter from Carl Schmitt to Karl Loewenstein, April 29, 1925, Karl Loewenstein Papers, Amherst College Archives & Special Collections.

20. Loewenstein, *Minderheitsregierung in Großbritannien: Verfassungsrechtliche Untersuchungen zur neuesten Entwicklung des britischen Parlamentarismus* (München: J. Schweitzer, 1925), 1; Schmitt, *Die Rheinlande als Objekt internationaler Politik* (Köln: Verlag der rhenischen Zentrumspartei, 1935). Schmitt, *Die geistesgeschichtliche Lage des heutigen Parlamentarismus* (Berlin: Duncker & Humblot, 1926); Loewenstein mistitles Schmitt's essay *Die geistesgeschichtlichen Grundlagen des Parlamentarismus*. Schmitt, *Verfassungslehre* (München: Duncker & Humblot, 1928), 323n1. See also Joseph W. Bendersky, "Carl Schmitt's Path to Nuremberg: A Sixty-Year Assessment," *Telos* 139 (2007), 6–34, here 10.

21. These articles guaranteed fundamental personal rights, including the right not to be arrested without due cause (114); the inviolability of one's residence (115); the punishability of an action only on the basis of prior laws that make the action punishable (116); the right to secrecy of mail, telegraph, phone and other communication (117); the right to freedom of expression (118), to peaceful assembly (123), and to form political associations (124); and the right to hold property and to be protected against expropriation (153).

22. English translation from Heinrich Oppenheimer, *The Constitution of the German Republic* (London: Stevens and Sons, 1923), 230–31.

23. Schmitt, *Verfassungslehre* (München: Duncker & Humblot, 1928), as cited by Mehring, *Schmitt*, 217.

24. *Verfassungsrechtliche Aufsätze aus den Jahren 1924–1954* (Berlin: Duncker & Humblot, 1958), 307–45, cited in Mehring, *Schmitt*, 286.

25. Mehring, *Schmitt*, 286, quoting a "Nachbemerkung zum Neudruck von *Legalität und* Legitimität" in *Verfassungsrechtliche Aufsätze*, 345.

26. *Erscheinungsformen der Verfassungsänderung: Verfassungsrechtsdogmatische Untersuchungen zu Artikel 76 der Reichsverfassung* (Tübingen: J.C.B. Mohr, 1931). See Bendersky, "Carl Schmitt's Path to Nuremberg," 10. Markus Lang, "Politikwissenschaft als 'amerikanisierte' Staatswissenschaft. Zur politischen Intention der Amerikastudien von Karl Loewenstein," in Michael Dreyer, Markus Kaim, and Markus Lang, eds., *Amerikaforschung in Deutschland: Themen und Institutionen der Politikwissenschaft nach 1945* (Stuttgart: Franz Steiner Verlag, 2004), 137–60, here 152, called attention to the specific critique of Schmitt that appears in Loewenstein's *Erscheinungsformen der Verfassungsänderung*, vii.

27. Carl Schmitt, *Tagebücher 1930–1934* (Berlin: Akademie-Verlag, 2010), 114, June 4, 1931.

28. See Loewenstein, "Zur Verfassungsmäßigkeit der Notverordnungen von Juli und August 1931," in "Aus der Praxis des Staatsrechts," *Archiv des öffentlichen Rechts* N.F. 21 (1932): 124–58.

29. William Ebenstein, *The German Record: A Political Portrait* (New York: Farrar & Rinehart, 1945), 214.

30. Loewenstein, *Verfassungslehre*, 226–27.

31. *Tagebücher 1930–1934*, 356. The dream starts with "a horribly ordinary, dirty and cheap whore."

32. Raphael Gross, *Carl Schmitt und die Juden: Eine deutsche Rechtslehre* (Frankfurt: Suhrkamp, 2005), 60, erroneously cites March 1 as the day Schmitt joined the party, but Mehring dates it correctly. In his diaries, Schmitt mentions the idea of joining the party earlier in 1933, but his entry on April 27, 1933, states that Schmitt tried to join the NSDAP in (Köln-)Lindenthal that day, which was not the appropriate branch, and that he therefore had to go to Braunsfeld in the afternoon where he was finally accepted after some to and fro, then bought a party badge (that he is wearing in the photograph reproduced in this chapter). See *Tagebücher 1930–1934*, 287. Schmitt's membership card in the Berlin Document Center microfilm at the National Archives has the date of May 1, 1933.

33. The editors of the *Tagebücher 1930 bis 1934* list the seventy members of the Staatsrat (295–96n1476), among whom Schmitt appears to have been the only university professor. Schmitt spoke with Minister Alexander Schneider "nicely" about the March law of Hitler's empowerment (272), was involved in advising the legislation of the 2. Gleichschaltungsgesetz, April 7, 1933, the abolition of the federal structure (276–78), and was particularly impressed by Göring who, in a few minutes resolved all problems by saying the Reich chancellor, not the Reich president is the president of the German State (277).

34. Carl Schmitt, *Antworten in Nürnberg*, ed. Helmut Quaritsch (Berlin: Duncker & Humblot, 2000), 65; further shortened references to "Quaritsch, *Antworten*."

35. Carl Schmitt, "Nationalsozialismus und Rechtsstaat," *Juristische Wochen-schrift* 63, no. 12–13 (March 24 and 31, 1934): 713–19, here 714. See also Mehring, *Schmitt*, 340–44, 347. Mehring emphasizes the paradox that Schmitt transfigured the destruction of legality into a constructive achievement (347).

36. Schmitt, "Nationalsozialismus und Rechtsstaat," 715, 716; Schmitt explicitly offered *Dux* as opposed to *Lex* in his definition of the new legal order (715). Mehring, *Schmitt*, 343, relates Schmitt's use of "Artgleichheit" in *Staat, Bewegung, Volk: Die Dreigliederung der politischen Einheit* (Hamburg: Hanseatische Verlagsanstalt, 1933).

37. "Der Führer schützt das Recht," *Deutsche Juristen-Zeitung* 39 (August 1, 1934): 946–50, here 947, 948.

38. Ibid., 949.

39. See Gross, *Carl Schmitt und die Juden*, here especially pp. 42–134. Cf. *Carl Schmitt and the Jews: The "Jewish Question," the Holocaust, and German Legal Theory*, trans. Joel Golb (Madison: University of Wisconsin Press, 2007). By contrast, Joseph W. Bendersky, *Carl Schmitt: Theorist for the Reich* (Princeton, NJ: Princeton University Press, 1983), 227, states that before Schmitt "joined the NSDAP there was not the slightest anti-Semitic note in any of his writings or personal relationships." Schmitt's diaries around 1933 sound venomous anti-Semitic sentiments almost daily; see Carl Schmitt, *Tage-bücher 1930–1934.*

40. "Die Verfassung der Freiheit," *Deutsche Juristen-Zeitung* 40 (1935): 1133–35.

41. Ibid., 1135. The *New York Times* reported on Schmitt's article in "Berlin Works Out Anti-Jewish Rules," October 2, 1935, 6.

42. "Die deutsche Rechtswissenschaft im Kampf gegen den jüdischen Geist," *Deutsche Juristen-Zeitung* 41 (October 15, 1936): 1193–99. See Gross, *Carl Schmitt und die Juden*, 120–34, and Mehring, *Schmitt*, 372–78, for detailed assessments of the conference and the volume that resulted from it.

43. See Mehring, *Schmitt*, 677n139.

44. "Die deutsche Rechtswissenschaft," 1195.

45. Ibid., 1195–96.

46. This is not my satirical summary, for Schmitt really asked: "Wie war es möglich, daß ein deutscher Mann aus dem Wuppertal dem Juden Marx so völlig verfiel?" (1198).

47. Mehring, *Schmitt*, 361.

48. "Eine peinliche Ehrenrettung," *Das schwarze Korps* (December 3, 1936): 14; and "Es wird immer noch peinlicher," *Das schwarze Korps* (December 10, 1936): 2. See also Thomas O. Beebee, "Carl Schmitt's Myth of Benito Cereno," *Seminar: A Journal of Germanic Studies* 4, no. 2 (May 2006): 114–34, here 120. Alfred Rosenberg had attacked Schmitt for his use of the term *total state* in the *Völkischer Beobachter* of January 1, 1934.

49. Sicherheitsdienst des RFSS [Reichsführer SS, Heinrich Himmler] SD-Hauptamt, file P.A. 651c, Archiv des Instituts für Zeitgeschichte, microfilm at Wiener Library, London, 505 MF Doc 54/Reel 4/46. The microfilm begins with a biographical sketch that mocks Schmitt for his first marriage

and keeps pointing out his Jewish connections and anti-Hitler views in the Weimar years. Since the frames are unnumbered I have followed the numbering of the SD documents that are available online at http://carl-schmitt -studien.blogspot.com/2008/05/sicherheitsdienst-des-rfss-sd-hauptamt .html (accessed March 1, 2013).

50. *Das Judentum in der Rechtswissenschaft: Ansprachen, Vorträge und Ergebnisse der Reichsgruppe Hochschullehrer des NSRB am 3. und 4. Oktober 1936* (Berlin: Deutscher Rechts-Verlag, 1936).

51. Waldemar Gurian's letters from exile and Herbert Marcuse's book review of a 1933 revision of Schmitt's *Der Begriff des Politischen* had publicly called attention to small textual changes Schmitt made when republishing his earlier writings after 1933. (See Mehring, *Schmitt*, 378–80.) It may be odd to point this out, but the research the SS undertook of pre- and post-1933 editions of Schmitt's work was more thorough and more damaging than the background work that must have been done for the ill-prepared questions Kempner asked Schmitt at Nürnberg. Thus, an SD surveillance letter from December 14 requested the acquisition of all of Schmitt's publications in their various editions "in order to determine exactly the changes" in his thinking (a telegram of the same day specifying Schmitt's relationship to Catholicism, to the Jews, and to the Weimar politicians Papen, Brüning, and Schleicher). By contrast, Kempner quoted only one single passage from Schmitt's writing and probably did not know that Schmitt had eliminated laudatory references to Jews in his earlier books that he republished after Hitler had taken power.

52. *Völkerrechtliche Großraumordnung mit Interventionsverbot für raumfremde Mächte: Ein Beitrag zum Reichsbegriff im Völkerrecht*, 3rd ed. (1939; repr. Berlin: Deutscher Rechtsverlag, 1941). The title is difficult to translate; the English version of it is Karl Loewenstein's.

53. The British *Daily Mail* reported on Schmitt's essay as follows: "Just as President Monroe insisted on 'America for the Americans', Herr Hitler insists on 'Central Europe for the Central Europeans'. Germany considers herself the leading nation in this sphere, just as the United States claims to be the leading nation in the Americas. Herr Hitler, it is believed, will soon give it the world as his justification for Germany's relentless expansion." Quoted in Carl Schmitt, *Staat, Großraum, Nomos: Arbeiten aus den Jahren 1916–1969*, ed. Günter Maschke (Berlin: Duncker & Humblot, 1995), 347.

54. This treaty, dividing Poland between Germany and Russia and assigning Lithuania to the Soviet sphere of influence, also provided for the repatriation of Germans from the Soviet Union and of Russians from Germany. It could be considered a model for the ideal of greater ethnic homogeneity in Europe that the Yalta and Potsdam agreements continued to adhere to.

55. *Völkerrechtliche Großraumordnung*, 3rd ed., 53.

56. Ibid., 49.

57. Ibid., 45.

58. Ibid., 4th. ed. (1941), 63; repr. in Schmitt, *Staat, Großraum, Nomos*, ed. Maschke, 318. See Gross, *Carl Schmitt und die Juden*, 345.

59. "Law in the Third Reich," *Yale Law Journal* 45, no. 5 (March 1936): 779–815; here 811.

60. Ibid., 811n117. See also other references to Schmitt at 782n6, 803n88.

61. The epithet for Schmitt, "Kronjurist des Dritten Reiches," was coined by Waldemar Gurian in 1934 and became a leitmotif in the German emigrant press (see Alfons Söllner, "Kronjurist des Dritten Reiches," 191). It also appeared in *Deutschland-Berichte der Sozialdemokratischen Partei Deutschlands* (Sopade), vol. 1 (1934; repr. Frankfurt: Verlag Petra Nettelbeck, 1980), 366. Loewenstein may have been the first to use the phrase in English, for Google Books cites references starting only in 1942.

62. "Law in the Third Reich," 796.

63. See Edmund Spevack, *Allied Control and German Freedom: American Political and Ideological Influences on the Framing of the West German Basic Law (Grundgesetz)* (Münster: LIT-Verlag, 2001), 212–14. Max Lerner employed the term in the title of his book, *It Is Later Than You Think: The Need for a Militant Democracy* (New York: Viking Press, 1938) and explains that he took the adjective "militant" from William James (103); Frederic Clemson Howe had used the term in *The City, the Hope of Democracy* as early as 1905; and Markus Lang, "Politikwissenschaft als 'amerikanisierte,'" 152n65, mentions that Hugo Preuß (1860–1925) had also used the term "streitbare Demokratie."

64. "Militant Democracy and Fundamental Rights I," *American Political Science Review* 31, no. 3 (June 1937): 417–32; here 430–31; Part II, *American Political Science Review* 31, no. 4 (August 1937): 638–58.

65. *University of Chicago Law Review* 4, no. 4 (June 1937): 537–74; here 542n13.

66. According to Bendersky, "Carl Schmitt's Path to Nuremberg," 9, Schmitt was briefly questioned by the Russians in Berlin in April 1945, then released.

67. Schmitt, *Ex Captivitate Salus: Erfahrungen der Zeit 1945 / 47*, 2nd ed. (1950; repr. Berlin: Duncker & Humblot, 2002), 10–11. Gross, *Carl Schmitt und die Juden*, 347–48, suggests that the title *Ex Captivitate Salus* was an intentional allusion to, and departure from, the Gospel of St. John in the Vulgate's version, "Salus ex Iudaeis" (John 4:22).

68. Loewenstein, *Political Power*, 385; Schmitt, *Ex Captivitate Salus*, 25–33.

69. Ibid., 35. As we have seen, Kurt W. Marek, the editor of *A Woman in Berlin*, read that diary in the light of the same Poe story. Schmitt also repeatedly (and rather self-servingly) identified with Benito Cereno from Herman Melville's eponymous 1855 novella, the disempowered Chilean captain held captive by slave rebels and forced by them to act as if he were still in command.

70. He was then moved to the internment camp Lichterfelde-Süd (Wismarer Str. at Teltowkanal), and finally to a Civilian Detention Camp at Wannsee (Königstr./Endestr.). See Mehring, *Schmitt*, 442–44; Quaritsch, *Antworten*, 12.

71. See OMGUS–Legal Division–"Library of Professor Carl Schmitt", October 10, 1945. Loewenstein Papers, Box 46, Folder 46, Amherst College Archives & Special Collections; Mehring, *Carl Schmitt*, 694n18.

72. Quaritsch, *Antworten*, 51–114; and "The 'Fourth' (Second) Interrogation of Carl Schmitt at Nuremberg," *Telos* 139 (2007): 35–43. The versions included in Robert M. W. Kempner, *Das Dritte Reich im Kreuzverhör* (1969; repr. München: F. A. Herbig, 2005) were criticized for inaccuracies by Quaritsch, *Antworten*, 42–47. See also Piet Tommissen, "Bemerkungen zum Verhör Carl Schmitts durch Ossip K. Flechtheim," Anhang II to *Schmittiana* II, ed. Piet Tommissen (Brussels: K. de Rooms, 1990): 142–48, an attempt to evaluate three different accounts of Flechtheim's interrogation.

73. Quaritsch, *Antworten*, 53. The German original of three interrogations was published by Claus-Dietrich Wieland in *Zeitschrift für Sozialgeschichte des 20. und 21. Jahrhunderts* 1–2 (1987): 109–22; and reprinted in Friedhelm Kröll, *Das Verhör: Carl Schmitt in Nürnberg* (Nürnberg: Bildungszentrum Stadt Nürnberg, 1995), 233–47.

74. Quaritsch, *Antworten*, 54.

75. Ibid., 55.

76. *Telos* 139 (2007): 39.

77. Quaritsch, *Antworten*, 60.

78. Ibid., 65.

79. Loewenstein, Office Diary, August 14, 1945. Private Diary, August 16, 1945. Both in Loewenstein Papers, Box 46, Folder 1, Amherst College Archives & Special Collections.

80. Loewenstein, Office Diary, August 15 and 16, 1945.

81. Ibid., August 23, 1945.

82. Ibid., November 9 and November 13, 1945. Loewenstein Papers, Box 46, Folder 1, Amherst College Archives & Special Collections.

83. Loewenstein quotes from memory, for he substitutes "entscheidet" by "gebietet." OMGUS–Legal Division–"Observations on Personality and Work of Professor Carl Schmitt," 1, 2. November 14, 1945. Loewenstein Papers, Box 46, Folder 46, Amherst College Archives & Special Collections.

84. "Observations on Personality and Work of Professor Carl Schmitt," 2.

85. Ibid., 3.

86. Ibid., 4.

87. OMGUS–Legal Division–"Library of Professor Carl Schmitt," October 10, 1945, 2. Loewenstein Papers, Box 46, Folder 46, Amherst College Archives & Special Collections.

88. Schmitt knew at least three of the Nürnberg defendants well: Hermann Göring, Hans Frank, and Wilhelm Frick.

89. "Not a permanent status," quoted by Mehring, *Schmitt*, 457; *Glossarium: Aufzeichnungen der Jahre 1947–1951* (Berlin: Duncker & Humblot, 1991), 70.

90. Mehring, *Schmitt*, 525.

91. *Das internationalrechtliche Verbrechen des Angriffskriegs und der Grundsatz 'Nullum crimen, nulla poena sine lege,'* ed. Helmut Quaritsch (Berlin: Duncker & Humblot, 1994), 23, cited in Mehring, *Schmitt*, 440–41. William E. Scheuerman, *Carl Schmitt: The End of Law* (Lanham, MD: Rowman and Littlefield, 1999), 178, cites postwar instances in which Schmitt criticized retroactive legislation.

92. "Der Feind ist unsre eigne Frage als Gestalt." *Ex Captivitate Salus*, 90. See Theodor Däubler, *"Sang an Palermo,"* in *Hymne an Italien*, 2nd ed. (Leipzig: Insel-Verlag, 1919), 57–69. Schmitt had a long-standing interest in Däubler and published a study of his *Nordlicht* in 1916.

93. *Carl Schmitt–Ludwig Feuchtwanger, Briefwechsel 1918–1935*, ed. Rolf Rieß, pref. Edgar J. Feuchtwanger (Berlin: Duncker & Humblot, 2007). See Feuchtwanger's unanswered letter of July 23, 1935, 397–98, and editor's afterword, 401. See also Schmitt's *Tagebücher 1930 bis 1934*, 275 and 282.

94. *Glossarium*, 34–35.

95. Ibid., 18; also cited in Mehring, *Schmitt*, 461.

96. *Glossarium*, 264. Henry Morgenthau, Jr., was the U.S. treasury secretary who proposed turning Germany into an agricultural state after the war; William Ebenstein, already quoted twice in this book, was an Austrian legal scholar who emigrated to the United States in 1936 and published such books as *Die rechtsphilosophische Schule der reinen Rechtslehre* (1938), *The Nazi State* (1943), and *The German Record* (1945). Ebenstein included Schmitt's essay "The Concept of the Political" in his collection *Modern Political Thought: The Great Issues* (New York: Holt, Rinehart, and Winston, 1960).

97. Justus Fürstenau, *Entnazifizierung. Ein Kapitel deutscher Nachkriegspolitik* (Luchterhand: Neuwied and Berlin, 1969), 227. Translation: German Historical Institute staff.

98. HQ US Group Control Council (Germany)–Legal Division–Justice Ministry Branch–"Basic Problems of the Denazification of the Legal Profession," unpublished ms., September 14, 1945, ad 11. Loewenstein Papers, Box 46, Folder 17, Amherst College Archives & Special Collections.

99. On the "vintage" method, see OMGUS–Legal Division: Denazification Memoranda, Notes, Directives–"Denazification Policy," unpublished brief to the Director of the Legal Division, dated November 30, 1945, 5–6. Loewenstein Papers, Box 46, Folder 20, Amherst College Archives & Special Collections. For separating active party members from "*Kartei*-Genossen," see "Denazification Policy," 2.

100. "Basic Problems of the Denazification of the Legal Profession," ad 6 (Dr. Lahusen).

101. "Reconstruction of the Administration of Justice in American-Occupied Germany," *Harvard Law Review* 61 (1948): 419–67, here 448.

102. "Law and the Legislative Process in Occupied Germany," *Yale Law Journal* 57, no. 6 (April 1948): 1003.

103. See http://www.wienerlibrary.co.uk/Search-document-collection?item=532, accessed March 1, 2013.

5. Are You Occupied Territory?

1. Roi Ottley, "No Schwarze Allergy," in *No Green Pastures: The Negro in Europe Today* (1951; repr. London: John Murray, 1952), 139.

2. Edith S. Sampson, letter to the U.S. High Commissioner in Germany, John J. McCloy on December 27, 1951. Cited by David Braden Posner, "Afro-America in West German Perspective, 1945–1966" (Ph.D. Diss., Yale University, 1997), 60, from National Archives, Record Group 496, Box 17.

3. Matthias Reiß, *"Die Schwarzen waren unsere Freunde": Deutsche Kriegsgefangene in der amerikanischen Gesellschaft 1942–1946* (Paderborn: Ferdinand Schöningh, 2002), 215–30.

4. Samuel A. Stouffer, Shirley A. Star, and Robin M. Williams, Jr., "Negro Soldiers" in Stouffer, *The American Soldier, I. Adjustment During Army Life* (Princeton: Princeton University Press, 1949), 494–97; also quoted in Reiß, *Die Schwarzen waren unsere Freunde*, 197 and 197n22.

5. African American physician Charles Drew pioneered the development of blood banks. According to the National Institute of Health's U.S. National Library of Medicine website, "In January 1941, Drew became the assistant director of a pilot program for a national blood banking system, jointly sponsored by the National Research Council and the American Red Cross. The success of the subsequent nationwide project was tarnished by the Armed Forces' initial exclusion of African-American donors, and later their segregation of blood donations. Throughout the war, Drew criticized these policies as unscientific and insulting to African-American citizens" (http://www.nlm.nih.gov/news/charles_drew.html, accessed November 1, 2013).

6. For an early scholarly account, see L. D. Reddick, "The Negro Policy of the American Army since World War II," *Journal of Negro History* 38, no. 2 (April 1953): 194–215.

7. Walter White, *A Man Called White* (New York: Viking Press, 1948), 251; Hanson W. Baldwin, "Segregation in the Army: Gen. Bradley's View is Held to Put Morale above Compulsory Change," *New York Times*, August 8, 1948, 51. Walter White responded vigorously with "Segregation in the Army: Policy Believed Extending Sectional Pattern to the National Level," letter to the *New York Times*, August 17, 1948, 20. See Maria Höhn and Martin Klimke, *A Breath of Freedom: The Civil Rights Struggle, African American GIs, and Germany* (New York: Palgrave Macmillan, 2010), 75.

8. The 7 percent figure comes from a 1956 report of the Historical Division in the U.S. headquarters cited in Maria Höhn, *GIs and Fräuleins: The German-American Encounter in 1950s West Germany* (Chapel Hill: University of North Carolina Press, 2002), 95.

9. The figures of 351,602 white and 51,082 Negro soldiers appear in "Segregation under Siege." Report by Marcus H. Ray, Civilian Aide addressed to Secretary of War, Robert P. Patterson, dated July 18, 1946. In *Blacks in the United States Armed Forces: Basic Documents*, eds. Morris J. MacGregor and Bernard C. Nalty, vol. 8 (Wilmington, DE: Scholarly Resources, 1977), 68.

10. New York bureau editor Edgar T. Rouzeau, "Black America Wars on Double Front for High Stakes," *Pittsburgh Courier*, February 7, 1942, 5.

11. "Nazi Atrocity Film Recalls Horror of Sikeston Lynching," *Chicago Defender*, August 18, 1945, 6. Such photographs were also displayed in Georgia.

12. George S. Schuyler, "Views and Reviews," *Pittsburgh Courier*, January 19, 1946, 7.

13. "The Negro Congress," *Chicago Defender*, June 15, 1946, 14.

14. John Robert Badger, "The Nuremberg Trials," *Chicago Defender*, September 7, 1946, 15.

15. "U.S., Britain Ignore Racial Crimes, But Nuernberg Trials Mold Pattern of 'Collective Guilt' Principle," *Pittsburgh Courier*, October 19, 1946, 17.

16. W. E. B. Du Bois, "An Appeal to the World: A Statement on the Denial of Human Rights to Minorities in the Case of Citizens of Negro Descent in the United States of America and an Appeal to the United Nations for Redress," W. E. B. Du Bois Papers No. 01490 (1947), Du Bois Papers, 35-2-807, microfilm series 9, reel 86. See http://www.library.umass.edu/spcoll/ead/mums312.html. See also Du Bois, "I Return to the NAACP," *Autobiography* (New York: International Publishers, 1968), 326–29; and White, *A Man Called White*, 358–59.

17. Du Bois, "An Appeal to the World."

18. Louis Wirth and Herbert Goldhamer, "Legal Restrictions on Negro-White Intermarriage," in Otto Klineberg ed., *Characteristics of the American Negro* (New York: Harper, 1944), 363.

19. Gunnar Myrdal, *An American Dilemma: The Negro Problem and Modern Democracy* (New York: Harper and Brothers, 1944), 58–59, 62, 587.

20. Höhn and Klimke, *A Breath of Freedom*, 62. See also the website "The Civil Rights Struggle, African-American GIs, and Germany" at http://www.aacvr -germany.org/, accessed March 1, 2013.

21. *Rassenschande was* a term coined in analogy to *Blutschande*, literally "blood shame" or incest. The Nürnberg laws of 1935 ("Gesetz zum Schutze des deutschen Blutes und der deutschen Ehre") prohibited interracial sex and marriage between Aryans and non-Aryans.

22. Negroes are members of an unworthy (lower) race yes: 30% no: 59%
Jews should not have the same rights as those belonging to the Aryan race yes: 33% no: 62%
Extermination of the Jews and Poles and other non-Aryans was . . . necessary for the security of Germans yes: 37% no: 59%
Source: Richard L. Merritt, *Democracy Imposed: U.S. Occupation Policy and the German Public, 1945–1949* (New Haven, CT: Yale University Press, 1995), 95, table 4.1.

23. "The German Appraisal of the Allied Forces in West Germany: With Recommendations for Improved Citizen Soldier Relations" (U.S. High Commissioner for Germany, Office of Public Affairs, Reactions Analysis Staff, 1952), 57.

24. The best study is LeRoy S. Hodges, Jr., *Portrait of an Expatriate: William Gardner Smith, Writer* (Westport, CT: Greenwood Press, 1985), with a biographical sketch and an extensive bibliography of Smith's books, articles, and journalism, interviews, and obituaries, as well as of the secondary literature. Unfortunately, Smith's Papers, to which Hodges had access, have meanwhile been lost.

25. William Gardner Smith, *Last of the Conquerors* (New York: Farrar, Straus: 1948). I am quoting from the 1973 reprint of the novel (Chatham, NJ: Chatham Bookseller, 1973), which follows the pagination of the first edition.

26. "Bishop Walls Blasts Army German Jim Crow Policy," *Chicago Defender*, November 1, 1947, 7, also cited in Höhn and Klimke, *A Breath of Freedom*, 55.

27. "Song of Girls and GI's," *Ebony* 1, no. 11 (October 1946): 10–11; and Baltimore *Afro-American*, November 9, 1946, 20. The Baltimore *Afro-American* photograph is reproduced in Timothy L. Schroer, *Recasting Race after World War II: Germans and African Americans in American-Occupied Germany* (Boulder: University Press of Colorado, 2007), 134. Schroer also reproduces the Army Signal Corps photograph of the black soldiers guarding Ohlendorf, 78. See also Annette Brauerhoch, *"Fräuleins" and GIs: Geschichte und Filmgeschichte* (Frankfurt: Stroemfeld, 2006), 194.

28. I am grateful to Kimberley L. Phillips for emphasizing this inconsistency in her excellent analysis of Smith's novel, " 'And We Return Trembling': Black Writers and the Postwar Jim Crow Military" (2006) unpublished paper, partly incorporated into her study, *War! What Is It Good For? Black Freedom Struggles and the U.S. Military from World War II to Iraq* (Chapel Hill: University of North Carolina Press, 2012).

29. Bill Smith, "Negroes in Germany Set Styles until Nazis Started Hate Drive," *Pittsburgh Courier*, September 7, 1946, 13; Martha Stark, "My 13 Years under the Nazi Terror: Amazing, True Life Story of a Negro Girl in Germany Who Fought Hitler, and Won," *Pittsburgh Courier*, May 7, 1949, 1. Sequels in *Pittsburgh Courier*, May 14, 1949, 1; May 21, 1949), 1; May 28, 1949, 1; June 5, 1949, 6; June 11, 1949, 12; June 18, 1949, 7; June 25, 1949, and July 2, 1949. In *Last of the Conquerors*, Hayes is also deeply interested in the colored entertainer Lela, and about two hundred other colored people living in Berlin are mentioned (92–93).

30. Among the works discussed in this chapter, only Smith makes mention of the Russian rapes.

31. Smith's prose here may also remind the reader of Vardaman's style in Faulkner's *As I Lay Dying*. Robert Bone, *The Negro Novel in America* (New Haven: Yale University Press, 1958), 177, faults the novel, written by a twenty-two-year-old author, for its "immature" style, "an occasional attempt at stream-of-consciousness . . . grafted upon a basic journalese," finding Ilse's "pidgin English (reminiscent of Hemingway's stylistic debacle in *For Whom the Bell Tolls*) . . . especially distracting."

32. Bill Smith, "Half of Tan GIs Leaving Germany," *Pittsburgh Courier*, December 21, 1946, 1; "Innocent Soldier Goes on Rampage; Kills 1, Wounds 3," *Pittsburgh Courier*, January 25, 1947: 22; "Segregation Dogs Soldiers in Europe," *Pittsburgh Courier*, October 24, 1947, 1, a critique of General Joseph T. McNarney's Report. See also Smith's articles "Crack QM Outfit 'Best in Berlin,'" *Pittsburgh Courier*, July 27, 1946, 30; "Few GIs Eager to Return to States," *Pittsburgh Courier*, February 22, 1947, 1; "American Prejudice Rampant in Germany," *Pittsburgh Courier*, March 1, 1947, 13;

33. Carl Milton Hughes, *The Negro Novelist: A Discussion of the Writings of American Negro Novelists* (New York: Citadel Press, 1953), 100. Hughes, 231–32, also gives excerpts from reviews in the *New Republic*, the *Crisis*, *America*, the *Atlantic Monthly*, and the *New York Herald Tribune*. See also Petra Goedde's brief discussion of the novel in *GIs and Germans: Culture, Gender, and Foreign Relations, 1945–1949* (New Haven, CT: Yale University Press, 2003), 110–11; and Gerri Bates's "Images of European Women in William Gardner Smith's *Last of the Conquerors* and *The Stone Face*," *MAWA Review* 6, no. 2 (1991): 1–4.

34. G. F. Eckstein [pseudonym for C. L. R. James], "Two Young American Writers," *Fourth International* 11, no. 2 (March–April 1950): 53–56. The review compares Norman Mailer's *The Naked and the Dead* and Smith's novel, with further comments on Melville's *Benito Cereno.*

35. David Dempsey, "American Dilemma, Army Model," *New York Times Book Review* September 5, 1948, 6. Hodges, *Portrait of an Expatriate*, 17–18, cites excerpts of reviews from the *Chicago Sun Times* (by Jack Conroy) as well as from the *Saturday Review of Literature* and the *Dallas Herald.*

36. One wonders, after November 2008, whether a change in "the visible signs of black sovereignty" that Smith noted in Ghana, "black ministers, heads of corporations, managers of big department stores, customs officials" and, the reader might add, a black president, would have changed the expatriate Smith's view of his native country. See Smith's *Return to Black America* (Englewood Cliffs, NJ: Prentice-Hall, 1970), 96.

37. Gertrude Stein, "Off We All Went to See Germany," *Life*, August 6, 1945, 54–58, here 56.

38. Kay Boyle, "Home," *Harper's*, January 1951, 78-83, quoted from Boyle's *The Smoking Mountain: Stories of Germany during the Occupation* (New York: Knopf, 1968), 149–62, here 151 and 153. *Negro Digest* 9 (August 1951): 53–60, reprinted the entire story with an illustration of the moment when the G.I. meets the boy (52) and a caption characterizing the tale as "a poignant story of a Negro soldier in occupied Germany, and a small boy he befriended" (53). Boyle also published *Generation without Farewell* (New York: Knopf, 1959), a novel of the occupation set in 1948, with a cast of German and American characters.

39. Robert C. Jespersen's full biographical-critical account, "Hans Habe," appeared in John M. Spalek, Joseph Strelka, and Sandra H. Hawrylchak, eds., *Deutsche Exilliteratur seit 1933*, vol. 1, pt. 1 (Bern & München: Francke, 1976), 393–413. See also David McCain McMurray, "Conserving Individual Autonomy in Exile: Hans Habe's Struggle against Totalitarianism," Diss., Vanderbilt University, 2001.

40. Jespersen, "Hans Habe," 405–6.

41. Hans Habe, *Off Limits*, trans. Ewald Osers (New York: Frederick Fell, 1957), 25. See the brief discussion of that document in the introductory chapter.

42. Hans Habe, *Walk in Darkness*, trans. Richard Hanser (New York: Putnam, 1948). Some sentences and passages in the English edition are entirely missing from the German original.

43. *Weg ins Dunkel* (Zürich: Pan-Verlag, 1951). I shall be quoting the paperback reprint (München: Wilhelm Heyne Verlag, 1979).

44. One wonders whether this is an allusion to William Gardner Smith, whose novel of the occupation Habe may have read.

45. However, in her review of the novel, Elizabeth W. Reeves finds that were one to look for flaws, "both the picture of the black marketers and of the German wife could be pointed out as being too coldly and brutally drawn, with a tinge of loathing by the author." "The Novelist's View of Miscegenation," *Journal of Negro Education* 18, no. 2 (spring 1949): 150–52, here 151–52.

46. The German version uses the word *Neger* (163).

47. Washington's most general anti-Semitic utterance does not appear in the German text (179).

48. This whole passage is missing in the German version.

49. See Arsen L. Yakoubian's critique of denazification for making an *attitude* more important than criminal actions—which could be invoked as evidence for the attitude. See his "Western Allied Occupation Policies and Development of German Democracy, 1945–1951" (Ph.D. diss., New York University, 1952), 73–76.

50. Richard Plant, "Washington Roach, Black Marketeer," *New York Times Book Review*, October 10, 1948, 5.

51. Josephine Schuyler, "An Interracial Romance Abroad," *Pittsburgh Courier*, January 22, 1949, 16. According to the translation of it on the inside flap of the dust jacket of the 1977 Walter-Verlag edition, *Ebony* also commented favorably that it was almost a miracle that a white man could have written such a book.

52. "A Look at Books," *Los Angeles Sentinel*, November 18, 1948, 4.

53. J. Saunders Redding, "Book Review," *Baltimore Afro-American*, November 13, 1948, C4A. While Kelsey Guilfoil, "Vital Story of Humanity in Darkness," *Chicago Daily Tribune*, October 10, 1948, E3, gave the novel extensive praise, the *New Yorker*, November 6, 1948, 128, 131, complained about Habe's melodramatic tendencies, and the *San Francisco Chronicle*, January 16, 1949, 20, found the characters weakly drawn, most especially Eva and Father Durant.

54. Erwin Schallert, "'There's a Small Hotel' Hinted for Bolder; 'Walk in Darkness' Readying," *Los Angeles Times*, August 16, 1952, 11.

55. "Off-B'way Play Plot Is GI, German Bride," *New York Amsterdam News*, October 19, 1963, 20. The 1977 Walter-Verlag edition of *Weg ins Dunkel* had a stage photograph on back of the dust jacket. Clarence Williams III (later of *Mod Squad* fame), Barbara Schneider, and Glenn Kezer appeared in the dramatization written by William Hairston and directed by Sidney Walters; the play script can be found in the Hairston Papers at the New York Public Library. See http://www.nypl.org/archives/3678.

56. "Never before has a white man so completely placed himself into the soul of a black man." *Ich stelle mich* (Wien: Desch, 1954), 519; quoted by Robert C. Jespersen, "Hans Habe," 403. John Kitzmiller (1913–1965) was a black American soldier who stayed on in Europe and starred in such films as *Senza*

pietà (1948), a melancholy film about the black G.I. Jerry's innocent affair with the Italian girl Angela (Carla Del Poggio); entrapped by a mafia underworld, they die at the end when Jerry steers the truck they are in down a cliff; based on a story by Federico Fellini and directed by Alberto Lattuada, the film's cast included Giulietta Masina. Kitzmiller also acted in more than forty other films, including the parts of a servant in *Wolves Hunt at Night* (1952) and of Quarrel in the James Bond picture *Dr. No* (1962). The inside flap of the dust jacket of the 1977 Walter-Verlag edition of *Weg ins Dunkel* states that Kitzmiller considered it his life's dream to play the part of Washington Roach.

57. *Tauben im Gras* (1951; repr. Frankfurt: Suhrkamp Taschenbuch 601, 1980); *Pigeons on the Grass*, trans. David Ward (New York: Holmes and Meyer, 1988). I'll here be quoting from the English translation.

58. His two first novels are *Eine unglückliche Liebe* (1934) and *Die Mauer schwankt* (1935) and his early prose is readily available in the volume *Auf dem Phantasieroß: Prosa aus dem Nachlaß*, ed. Alfred Estermann (Frankfurt: Suhrkamp, 2005). The modernist transformation seems to have set in exactly in 1945. An undated story from the early 1950s, "Clemens," 397–99, also represents fraternization and black G.I.s. The episode of Koeppen's buying the expensive first German edition of Ulysses, reading it over a weekend, and returning it to the bookstore for a refund on the following Monday is reported in David Ward's introduction to the translation of *Pigeons on the Grass*, xv.

59. Koeppen published *Jakob Littners Aufzeichnungen aus einem Erdloch* (Frankfurt: Jüdischer Verlag im Suhrkamp Verlag, 1992) under his own name, and as a "Roman," claiming authorship in his introduction. The controversy that this claim generated resulted in the full republication of Jakob Littner, *Mein Weg durch die Nacht*, eds. Roland Ulrich und Reinhard Zachau (Berlin: Metropol, 2002) and in a new 2002 afterword by Alfred Estermann to Suhrkamp's Koeppen text. While disputes about fictionalized Holocaust memoirs are not uncommon, this may be the rare case of an authentic memoir that was claimed by another author as his own fiction. See Jörg Döring's essay on Littner in *Handbuch Nachkriegskultur: Literatur, Sachbuch und Film in Deutschland (1945–1962)*, eds. Elena Agazzi and Erhard Schütz (Berlin: de Gruyter, 2013), 169–72. For a general assessment of Koeppen see Heinrich Detering, "Hecht im Karpfenteich der Nachkriegsliteratur," *Frankfurter Allgemeine Zeitung*, June 24, 2006, 51. A brief sketch about the Holocaust from the 1950s, "Gefangene," *Auf dem Phantasieroß*, 404, seems to be related to Littner's story.

60. Here and in the preceding sentences I am following the reading offered by Chryssoula Kambas, "Ansichten einer Besatzungsmacht: Wolfgang Koeppens Amerika in Jochen Vogt and Alexander Stephan, eds., *Tauben im Gras*," in *Das Amerika der Autoren: Von Kafka bis 09/11* (München: W. Fink, 2006), 180–209, here 188–91. Kambas gives a full account of Koeppen's affinities to Stein.

61. There is an untranslatable pun, "im Zuge der Liquidierung" and while the English translation has "in the course of the liquidation" (66) the phrase "im

Zuge" also means literally "in the train" thus evoking the train transports to killing centers.

62. Carla's desire for an abortion makes her resemble Eva in Habe's *Walk in Darkness*, and the resistance of Koeppen's Washington echoes that of Habe's Washington.

63. Kambas, "Ansichten einer Besatzungsmacht," 206–7, offers an interesting reading of Heinz and the other individualized child character, Ezra.

64. Stanley Craven, "Two Novels by Wolfgang Koeppen: *Tauben im Gras* and *Treibhaus*," *Modern Languages* 51 (1970): 167–72, here 169. See also Dagmar Barnouw, "Melancholy and Enchantment: Wolfgang Koeppen's Anamnesis," *Mosaic* 14, no. 3 (summer 1981): 31–48.

65. Jespersen, "Hans Habe," 410. Habe opposed modernist orthodoxy, and he may be alluding to François Bondy's 1964 quip: "We had better stop behaving as though Kafka never lived and as though Joyce had never written *Ulysses* . . . !" See Bondy's *European Notebooks: New Societies and Old Politics, 1954–1985* (New Brunswick, NJ: Transaction Press, 2005), 67.

66. Another story by Kay Boyle, "The Lost," illustrates this point perfectly. In an American camp for "Unaccompanied Children" young boys, uprooted by the Nazis, then troop followers of the U.S. Army, are waiting for a resolution of their fates—mostly repatriation to their various countries of origin. Janos, a young orphan from "Noverczimki" (perhaps Nove Zamky, Slovakia) who had seen his family killed when the Germans came in, is now Americanized, calls himself Johnny, and hopes to go to America in order to be adopted by Charlie Madden, a black soldier with whom he had become close friends and who has meanwhile returned to Chattanooga. Janos/Johnny has to learn from a woman of the American Relief Team that the color question in the United States makes this impossible: "Maybe in a combat outfit you didn't hear much talk about men being colored or men being white. . . . But over there, back home, in the United States, there's the color question. . . . So if you did get to the States, there wouldn't be any way for you to live with Charlie Madden and if you were cleared for emigration, then it would be better if you went to another family, a white family." See *The Smoking Mountain*, 173–98, here 196–97. The story was first published in *Tomorrow* (1952).

67. Habe, *Off Limits*, 54–55.

68. "D.P.," *Ladies' Home Journal* 70 (August 1953): 26–27, 80–81, 84. The story was reprinted in Vonnegut's *Welcome to the Monkeyhouse: A Collection of Short Works* (1968; repr. New York: Dial Press, 2010), 161–72.

69. The familial language ("sister," "father") dramatically drives home the absence of real family relations for the displaced whose "sisters" are nuns and whose "father" is only a wishful fantasy.

70. Vonnegut's story here alludes to the U.S. policy directive that suggested conferring German citizenship to orphans and foundlings among the D.P. population. See "Clarification of Nationality in Questionable Cases, Particularly Children, of the United Nations," February 4, 1946. Recommendation 4c. stipulates that "all persons within Germany of unknown parentage shall

be, at birth, a national and citizen of Germany unless definitely proved to have acquired nationality and citizenship by reason of birth elsewhere." OMGUS 1945–46, 260/390/41/6 Box 19, 2.

71. See, for example, the photograph "Schwanheim, Saarbrücker Straße, 1945," Institut für Stadtgeschichte S7Z 1945/01.01.12, or the Army Signal Corps photograph 208819-2, reproduced in Dagmar Barnouw, *Germany 1945: Views of War and Violence* (Bloomington: Indian University Press, 2008), 129. See also the photograph of the German child Hans on black New Jersey Corporal Willard Perry's knees in *Ebony* 1, no. 11 (October 1946): 5, accompanying the story, "Germany Meets the Negro Soldier." It is also worth remembering Roberto Rosselini's *Paisà* (on which Klaus Mann worked) in its rendering of a friendship between a black G.I. and an Italian boy; a photograph of G.I.s with Italian children is at http://www.gettyimages.it/detail /3241999/Hulton-Archive.

72. AKG_245553, picture reference: 9-1948-12-0-H1-2, with the note, "Handwritten inscription: 'A GI—A new peer for a German child.'" Tony Vaccaro, *Entering Germany, 1944–1949,* ed. Michael Konze (New York: Taschen, 2001), 99, titled "The German Boy and the G.I." and placed "near Darmstadt." In Koeppen's *Pigeons in the Grass,* the casual pose of having "legs on the table" is refracted through German eyes as the expression of a people lacking seriousness. In Billy Wilder's *A Foreign Affair* Johnny Pringle is seen in an extremely casual pose at the billet, for he "takes off hat and sits on table. He polishes shoes on arm of chair" (4B p. 6, sc. 22). Maria Höhn, *GIs and Fräuleins: The German-American Encounter in 1950s West Germany* (Chapel Hill: University of North Carolina Press, 2002), 81–82, mentions the "much-admired American 'cool casualness' (*Lässigkeit*)" that made German teenagers observe and wish to imitate the G.I.s' "confident see-saw walk." "Walking with hands in pocket, sitting backwards on a chair, putting feet up on a table, all these gestures became a new way to express an informalized habitus that set the younger generation apart from the more inflexible and formal world of their elders."

6. The Race Problem in the House on Lilac Road

I am grateful to Wendy Sutherland and Eric Rentschler for letting me work with digital copies of the film, to Heide Fehrenbach for alerting me to the availability of *Toxi* as a DVD from the DEFA Film Library, and to Regina Hoffmann at the Stiftung Deutsche Kinemathek, Museum für Film und Fernsehen, Berlin, for letting me examine the film scripts and publicity materials that are part of the Nachlass Robert Stemmle. There is to my knowledge no biography of Elfie Fiegert, whose first name is sometimes also spelled "Elfi." Her date and place of birth are mentioned in the Nürnberg *8-Uhr-Blatt* (August 4, 1964). The Baltimore *Afro-American* (January 10, 1953, 22B) gives Fritz as the first name of her adoptive father; Angelica Fenner, "Representing the Afro-German in Early West German Cinema: Robert Stemmle's *Toxi*" (Ph.D Diss., University of Minnesota, 1999),

144, writes that Elfie's foster mother's first name is Gertrud, citing as the source Volker Hoffmann, "Toxi spielt ihr eigenes Leben: ein Film vom Schicksal der Besatzungskinder," *Frankfurter Rundschau*, May 30, 1952. She is portrayed with her adoptive mother in a photograph accompanying the article "Toxi: Ohne Mutti geht es nicht!" *Westfälisches Volksblatt*, October 2, 1956. Fenner offers the most detailed and well-researched reading of the film, its script, and the history of its production and reception in the context of postwar discussions about mixed-race babies, and I am indebted to her scholarship; her dissertation has meanwhile been revised and published as *Race under Reconstruction in German Cinema: Robert Stemmle's Toxi* (Toronto: University of Toronto Press, 2011). *Toxi* is also the subject of Heide Fehrenbach's "Reconstruction in Black and White: The *Toxi* Films," a chapter in her excellent book *Race after Hitler: Black Occupation Children in Postwar Germany and America* (Princeton: Princeton University Press, 2005), 107–31. Briefer treatments appear in Rosemarie K. Lester, *Trivialneger: Das Bild des Schwarzen im westdeutschen Illustriertenroman* (Stuttgart: Akademischer Verlag Hans-Dieter Heinz, 1982), 99–101, Leroy T. Hopkins Jr., "Race, Nationality and Culture: The African Diaspora in Germany," in *Who Is a German? Historical and Modern Perspectives on Africans in Germany* (Baltimore: American Institute for Contemporary German Studies, Johns Hopkins University, 1999), 9–10; and Yara-Colette Lemke Muniz de Faria, *Zwischen Fürsorge und Ausgrenzung: Afrodeutsche "Besatzungskinder" im Nachkriegsdeutschland* (Berlin: Metropol, 2002), 173–78.

1. See Sybille Buske, *Fräulein Mutter und ihr Bastard: Eine Geschichte der Unehelichkeit in Deutschland, 1900–1970* (Göttingen: Wallstein, 2004).

2. Informative discussions of the situation of occupation children can be found in Fehrenbach, Lemke Muniz de Faria, and in May Opitz [Ayim], "Afro-Deutsche nach 1945: Die sogenannten 'Besatzungskinder,'" in Katharina Oguntoye, May Opitz, and Dagmar Schultz, eds., *Farbe bekennen: Afro-deutsche Frauen auf den Spuren ihrer Geschichte*, 2nd ed. (Frankfurt: Fischer, 1992), 85–102.

3. Vernon W. Stone, "German Baby Crop Left by Negro GIs," *Survey* 85 (November 1949): 579–83, a journalistic account based on six hundred cases. Stone is identified as an official court reporter at the Nürnberg War Crimes Trial, later a verbatim reporter on Ralph Bunche's mission to Palestine, and in 1949 a doctoral student at the University of Chicago.

4. Grace Halsell, who had reported from postwar Europe for the *Fort Worth Star*, summarized in *Black/White Sex* (New York: William Morrow, 1972), 144, that Southern officers were intent on "preserving the purity of the white blood." Quoted in Maria Höhn and Martin Klimke, *A Breath of Freedom: The Civil Rights Struggle, African American GIs, and Germany* (New York: Palgrave Macmillan, 2010), 56.

5. The number was often exaggerated in contemporary accounts, some claiming that there were 100,000 mixed-race occupation children, perhaps the result of a confusion of the estimated number of children fathered by all Allied soldiers and German mothers. By 1953 the estimated number was 3,600, by 1959 approximately 6,000. Some press releases for *Toxi* quoted a figure of 30,000. Fenner also reports a statistical survey in 1955 according to

which 4,776 illegitimate children in West Germany were of colored descent ("farbige Abstammung" being a somewhat ambiguous term) in a total of 67,753 registered children who had been born out of wedlock (Fenner, *Race under Reconstruction*, 26).

6. See, for example, "Tan Tots Attend German Schools," *Jet*, July 24, 1952, inside cover and 14–15, 17–19.

7. For example, the series titled "Would You Like to Help One of These 'Brown Babies' in Germany?" *Pittsburgh Courier*, April 20, 1949, 5: May 7, 1949, 2; and May 28, 1949. Reports on brown babies were common in the postwar Negro press; see, for example the *Courier*'s managing editor William G. Nunn's "Brown Babies Need Help," *Pittsburgh Courier*, May 29, 1948, 1; or Ollie Stewart's "New Problem: Ollie Stewart Estimates there are 3,000 Brown Babes in Germany," *Baltimore Afro-American*, July 3, 1948, B6.

8. Lemke Muniz de Faria, *Zwischen Fürsorge und Ausgrenzung*, 85–87, evaluates some news coverage of such adoptions, with a focus on the Chicago teacher Margaret E. Butler who took numerous bureaucratic hurdles in order to adopt two children from Germany.

9. Stone, "German Baby Crop Left by Negro GIs," 579–83. A German parliamentary debate in March 1952 gave 3093 as the total figure of mixed-race children, of whom 1941 lived with their mothers, 388 in the mother's family, and 838 in orphanages, 350 of those without any remaining family contact. Of black fathers, 362 took an interest in and supported the development of their children, 68 of them from outside of Germany. Twenty Negroes found asylum in France and there married the German girls or women. "Was wird aus den 94000 Besatzungskindern?" *Das Parlament* 2, no. 22 (March 19, 1952): 2. R. Sieg, *Mischlingskinder in Westdeutschland* (Baden-Baden: Verlag für Kunst und Wissenschaft, 1955), Beiträge zur Anthropologie, Heft 4, Festschrift für Frédéric Falkenburger, was an German anthropometric study conducted at the University of Mainz, for which a researcher from the Institut für menschliche Stammesgeschichte und Biotypologie took 186 photographs, displaying a remarkable indifference to human subject research ethics; studies like this tended to concur that finding African American adoptive parents and expatriating the children would be a good solution.

10. "Österreich: SOS Kinderdorf Imst," *Neue deutsche Wochenschau* (1954), 46, available at http://www.wochenschau-archiv.de/ (after registering and entering search terms).

11. The origin of the name was neither explained in the publicity materials nor fully accounted for in the secondary literature. The similarity in the way the name sounds to "Topsy" is outweighed by the great difference in character between Toxi and the black child in Harriet Beecher Stowe's *Uncle Tom's Cabin*. Since Theodor Jenrich's company produces "Hytrophoxin," one might think of a chemical or pharmaceutical allusion, but there seems no clue to that in Toxi's role in the film. Might the name just contain the jumbled four letters that are at the center of the word "exotic"? Angelica Fenner also mentions the possibility of an allusion to a Nigerian name, "Toksi" (*Race under Reconstruction*, 236n2).

12. "Die Leute rühren," *Spiegel*, July 23, 1952, 27–30, at http://www.spiegel.de/spiegel/print/d-21112065.html, accessed March 1, 2013.

13. "Aber schließlich überwindet der kleine krausköpfige Kobold den Wall überlebter Anschauungen. Humorvoll um Verständnis und Liebe für alle Toxis zu werben, ist der Sinn dieses Films." Allianz Film GmbH, *Aktuelle Film-Nachrichten* January 3 and August 1, 1952, cited in Lester, *Trivialneger*, 100. Lester points out that Toxi became, for many years, a synonym for "colored occupation child."

14. This sequence of the film is available at http://www.africavenir.org/news-archive/newsdetails/datum/2012/04/15/german-premiere-toxi-oengu-1952-by-robert-stemmle-in-the-framework-of-bebop-2012-black-europe/print.html and at http://www.youtube.com/watch?v=MlPc9fclf5E (accessed March 1, 2013). Theodor's first comment might support an association of the unusual name "Toxi" with "toxic" (that the movie quickly refutes, however, when Dr. Carsten gives Toxi a clean bill of health).

15. Interestingly, the *Spiegel* story about the film made no mention of racism and ascribed the intrafamilial opposition to egotism which is softened by a disarmingly tender child with her mixture of jungle and Bavarian village which makes it, Stemmle said with some irony, a very German film. See "Die Leute rühren," *Spiegel*, July 23, 1952, 27.

16. I am loosely following Heide Fehrenbach's translation of the dialogue in this scene, *Race after Hitler*, 111–12.

17. It also may be an expression of "the firm conviction that the children stood as a racially foreign group in a manner that bore similarities to the earlier framing of the 'Jewish question,'" as Timothy L. Schroer puts it in *Recasting Race after World War II: Germans and African Americans in American-Occupied Germany* (Boulder: University Press of Colorado, 2007), 147, discussing West German debates about mixed-race children.

18. Alfons Simon, *Maxi, unser Negerbub* (Bremen: Eilers & Schünemann, 1952). For the American discussion see, for example, Robert MacIver, ed., *Civilization and Group Relationships* (New York: Harper, 1945); or Robin M. Williams, *The Reduction of Intergroup Tensions* (New York: Social Science Research Council, 1947).

19. Handwritten script in green Leitz folder, p. 50, scene 96. Nachlass Robert Stemmle, Stiftung Deutsche Kinemathek, Museum für Film und Fernsehen, Berlin.

20. Drehbuch 4.4-83/39, 153 CB (typed script), p. 48, scene 67, deleted. Nachlass Robert Stemmle, Stiftung Deutsche Kinemathek, Museum für Film und Fernsehen, Berlin.

21. Herr Übelhack was formerly a suitor of Tante Wally who has hence remained a spinster and refuses to stay for the fiftieth-birthday dinner of her sister-in-law because Übelhack's wife is present.

22. In 1952 the *Toxi-Lied* was also launched as a single on Polydor (Nr. 48785A) and became popular as a 78 rpm record with Austroton (8700 V), sung by Leila Negra who was famous in the young Federal Republic for the nowadays quite incredible-sounding pop song "Mach' nicht so traurige Augen

weil du ein Negerlein bist" (Don't look so sad, just because you are a little Negro). Leila Negra's real name was Marie Nejar, she lived in Germany through the Nazi years, and she published a fascinating autobiography (as told to Regina Carstensen), *Mach nicht so traurige Augen, weil du ein Negerlein bist: Meine Jugend im Dritten Reich* (Hamburg: Rowohlt, 2007).

23. "Filmstoff und Wirklichkeit: Die Geschichte des Negerkindes Toxi," *Film*, Erbach (June 1952), and *Westfalen-Blatt*, December 2, 1952, as cited in her translations in Angelica Fenner, "Reterritorializing Enjoyment in the Adenauer Era: Robert A. Stemmle's *Toxi*," in John E. Davidson and Sabine Hake, eds. *Take Two: Fifties Cinema in Divided Germany* (New York: Berghahn Books, 2007), 166–79, here 171, 172.

24. The movie shows numerous advertisements (among them, for Waldbaur chocolates and Xox cookies) in the background of the outdoor scenes as well as in the Café "Zur süßen Ecke" (at Baumschulenweg), where Toxi demonstrates her passion for sweets and cakes. Since Toxi is said to have a South German accent (she greets the family with "Grüß Gott!", which has a regional flavor), Grandfather Rose at the beginning mentions that there are many children like her in that area of Germany (meaning the American zone); later he shows Toxi a globe and points out the whole big continent on which black people live.

25. As several interpreters have stressed, consuming in general is an important theme in the film, from Robert's role as an advertiser to Herta's putting on Nylons in the scene in which we first see her, to Toxi's walk through Hamburg studying shop windows, to signs for Dujardin and the food cooperative Konsum. See also *Der Abend*, August 4, 1952; and *Der Kurier*, Berlin, September 20, 1952: photographed with Mohrenkopf; "Mohrenköpfe und kleine Negerlein" *Frankfurter Rundschau*, August 15, 1952; "Mohrenköpfe von Toxi," *Hamburger Abendblat*, August 31, 1952; "Mohrenkopf mit Schlagsahne," *Volksblatt*, Berlin Spandau, September 13, 1952: "Ob allerdings das Leben so angcnehm seine Konflikte mit Schlagsahne ausfüllt wie das Schicksal dieses kleinen Mohrenköpfchens . . . ?"; "Der süße Mohrenkopf," *Der Tag*, Berlin, September 13, 1952; "Das Schokoladen-Kind 'Toxi,'" *Nacht-Depesche*, Berlin, September 13, 1952; photographed with chocolate *7-Tage*, August 18, 1952; and *Bild*, September 14, 1952. All in Nachlass Robert Stemmle.

26. See also Fenner, *Race under Reconstruction*, 57.

27. One is almost tempted to ascribe magical healing powers to Toxi, for Theodor's "Hexenschuß" (lumbago) disappears with his change of heart toward her.

28. S. 218/ Sz. 385–86. Nachlass Robert Stemmle.

29. Viewers may remember that Frau Berstel once showed the new housekeeper Anna (Gustl Busch) an English letter that she had received from Toxi's father and that a doctor had translated for her. Incidentally, the film does not emphasize the father's G.I. past but highlights his new status as a gas station operator in the United States.

30. Arianna Giachi, "Adoption im Kinohimmel," *Die Gegenwart*, August 30, 1952, 557–58.

31. "Der schicke, braune *deus ex machina* enthebt die schicke, weiße Patrizier-familie letzten Endes verantwortlichen Handelns," Lester, *Trivialneger*, 101.

32. Hopkins, *Who Is a German?* 9.

33. Lemke Muniz de Faria, *Zwischen Fürsorge und Ausgrenzung*, 176.

34. See Ollie Stewart, "U.S. Soldiers Must Care for Their German Babies: May Be Prosecuted under German Laws," *Baltimore Afro-American*, June 7, 1952, 3.

35. Drehbuch Expl. CB 4.4-83/39, 153: S. 224/114. Bild/ Sz. 404–8 (Toxi says good-bye with a butterfly kiss to Grandpa Rose). Versions of the Tabita ending also appear in the handwritten script in the green Leitz folder and in the script of cameraman Igor Oberberg 4.4-84113.37. See Drehbuch, 225–27, scenes 411–15. Nachlass Robert Stemmle. Fenner's *Race under Reconstruction* includes an English translation of the script for this omitted scene (118–19) and discusses it thoroughly. She wonders whether it was considered "a too radical allegory for sustained integration of this German minority population" (119) and leans toward attributing "a political significance to this omission" (120).

36. The strangely complete absence of Toxi's mother, the general historical amnesia, so palpable in the birthday toast to Grandmother Rose, and the representation of Hamburg as an intact city as if it had never been bombed may add up to suggest the film's cultural blockage to deal with many different legacies from the past, except only the abstract sense of racial prejudice.

37. See Christiane Kuller, "'Sie tragen ihre schwer belastete Herkunft für jeden sichtbar zur Schau': Afrodeutsche 'Besatzungskinder' nach 1945," *Xenopolis: Von der Faszination und Ausgrenzung des Fremden in München*, ed. Angela Koch (Berlin: Metropol, 2005), 324. Drawing on military surveys and early studies, Kuller documents that a considerable number of occupation children had mothers from the better segments of society. The plot choice to let Toxi be motherless also worked like a literalization of Heide Fehrenbach's comment that the biracial children's "pull of blood was never perceived to work in the direction of their white mothers." Fehrenbach, *Race after Hitler*, 228n12. See also Lemke Muniz de Faria, *Zwischen Fürsorge und Ausgrenzung*, 176, arguing that this choice would avoid touching a good part of the audience's prejudices.

38. This is, in terms of fictional kin relations, what Heide Fehrenbach, *Race after Hitler*, 123, describes as the film's preaching (and 1950s German receptivity toward) "racial tolerance" while insisting on "maintaining racial difference."

39. "Stars in Film Story of Negro Girl in Germany," *Norfolk Journal and Guide*, August 30, 1952, A24B. The accompanying article reads: "Al Hoosman, Los Angeles heavyweight boxer, now a resident of Frankfurt, Germany, poses with German actress Ingeborg Koerner and the little girl who plays the title role in 'Toxi.' Hoosman is the male star in the story of the life of a German colored girl. The film premiered in Germany on Aug. 15. The stars played host to 50 German orphans on the occasion." Two similar articles, "U.S. Fighter Becomes Movie Star in Germany," *Philadelphia Tribune*, August 23,

1953, 1; and "U.S. Scrapper Becomes German Movie Star," *Baltimore Afro-American*, August 30, 1952, 15, are accompanied by the same photograph.

40. The appearance of Toxi's blood father makes *Toxi* fully represent an inversion of the typical situation: for social reasons, the mother-child blood relationship was denied representation (the white mothers of mixed-race children could be deemed "socially dead"), and a more typically adoptive relationship with African American foster families was naturalized as the "daddy"-daughter relationship.

41. The blind spots of the film also become apparent when one reads Ika Hügel-Marshall's grim autobiography *Daheim unterwegs: Ein deutsches Leben* (Berlin: Orlanda Frauenverlag, 1998), translated into English by Elizabeth Gaffney as *Invisible Woman: Growing up Black in Germany* (New York: Peter Lang, 2008). Born in 1947, the author belongs to the same cohort as Elfie Fiegert: she spent time in a children's home, and had no trace of her father until she was able to locate him in the 1990s. See also the short autobiographic sketch by Helge Emde (born in Bingen in 1946), "Als 'Besatzungskind' im Nachkriegsdeutschland" and her poem "Der Schrei," in Oguntoye, Opitz, and Schultz, eds., *Farbe bekennen*, 103–13. Thomas Usleber, *Die Farben unter meiner Haut: Autobiographische Aufzeichnungen* (Frankfurt: Brandes und Apsel, 2002) is an autobiographic account by a man of a later generation, born in 1960.

42. "53 Ex-Nazis Hold Bundestag Seats," *New York Times*, May 9, 1950, 6. Also quoted by Arsen L. Yakoubian, "Western Allied Occupation Policies and Development of German Democracy, 1945–1951" (Ph.D. Diss., New York University, 1951), 109. A much later study by Albrecht Kirschner of the Landtag (state parliament) in Hessen showed that among 403 former members who were born before 1928 at least 92 had been members of the NSDAP, 13 of them as party functionaries, 26 had been members of the SA, and 12 of the SS or Waffen-SS. "Hessischer Landtag arbeitet NS-Vergangenheit auf. Studie: Zeitweilig ein Drittel der Abgeordneten ehemalige NSDAP-Mitglieder," *Frankfurter Allgemeine Zeitung*, February 20, 2013, 4.

43. Fenner, "Representing the Afro-German," 30: "His *Mann für Mann* (1939) and *Jungens* (1941) . . . offer a fairly accurate assessment of the proletarian milieu of the times, but they were also produced in the service of national socialism, as was the anti-[S]emitic *Am seidenen Faden* (1938)." The plot of the film centers on the disturbing presence of international financier and World War I profiteer with bad manners, who becomes a moral und financial threat to the Hellwerth family. Fenner, "Representing the Afro-German," 31, writes that in *Toxi* "Stemmle has deployed the same mechanisms for sustaining ideological discourse that were so common within earlier Ufa and Ufi film production of the Nazi era."

44. Hans J. Wulff, "Michael Jary," *Kieler Beiträge zur Filmmusikforschung* 3 (2009): 148–54; Stephen Brockmann, *A Critical History of German Film* (Rochester, NY: Camden House, 2010), 168; Georg Hörmann, "Davon geht die Welt nicht unter," *Musik-, Tanz- und Kunsttherapie* 16, no. 4 (2005): 198–204.

45. Reichsfilmkammer document 2337, carbon copy of letter signed by Dr. Jacob, re: anonymous letter of September 1, 1938, Berlin Document Center microfilm, National Archives.

46. Klaus Riemer, *Paul Bildt*, Theater und Drama, vol. 23 (Berlin: Colloquium Verlag, 1963), 43–44.

47. Seven years later, a grim Japanese film appeared, *Kiku to Isamu*, directed by Tadashi Imai (1959), which focused on two mixed-race Afro-Japanese occupation children: the eleven-year-old Kiku (the allegorical name means chrysanthemum) and her younger brother Isamu who live in the poor area of Tohoku with their grandmother who suffers from backaches. (The mother is dead, probably of tuberculosis.) The children are bullied much worse than Toxi ever was, and the plot possibility of adoption by an American foster family emerges, but is ultimately not realized. See http://hafujapanese.blogspot .com/2010/01/film-kiku-and-isamu.html, accessed March 1, 2013.

48. "Was wird aus den 94000 Besatzungskindern?" *Das Parlament* 2, no. 22 (March 19, 1952): 1–3; here: 2.

49. Lester, *Trivialneger*, 101.

50. Fenner, *Race under Reconstruction*, 122.

51. "Die Leute rühren," *Spiegel*, July 23, 1952, 27–30. The cover portrait had the caption "Ein Quentchen zuviel Schmalz: Regisseur R. A. Stemmle."

52. Nejar, *Mach nicht so traurige Augen*, 208–9.

53. Eva Demski, *Afra: Roman in fünf Bildern* (Frankfurt: Frankfurter Verlagsanstalt, 1992), 150–61. These passages are discussed by Leslie A. Adelson, "Now You See It, Now You Don't: Afro-German Particulars and the Making of a Nation in Eva Demski's *Afra: Roman in fünf Bildern*," *Women in German Yearbook* 12 (1996): 217–31.

54. Jack Raymond, "Observations on the West German Film Scene," *New York Times*, August 10, 1952, X3; and Walter Sullivan, "Film Festivities inside a Strife-Torn Berlin," *New York Times*, July 5, 1953, X3.

55. Articles appeared under such headlines as "Al Hoosman to Star in German-GI Film," *Amsterdam News*, August 16, 1952, 24; "U.S. Scrapper Becomes German Movie Star," *Baltimore Afro-American*, August 30, 1952, 15; "U.S. Fighter Becomes Movie Star in Germany," *Philadelphia Tribune*, August 23, 1952, 1; "Germany's Most Popular Child Movie Star," *Baltimore Afro-American*, January 10, 1953, 22B; or "Stars in Film Story of Negro Girl in Germany," *New Journal and Guide*, August 30, 1952, A24B.

56. *Norfolk Journal and Guide*, December 26, 1953, B4.

57. Betty Granger, "Al Hoosman to Star in German-GI Film," *Amsterdam News*, August 16, 1952, 24.

58. *Baltimore Afro-American*, November 8, 1952, A1 and A11. The connection to the adoption issue goes back to the film's publicity materials, which included this story: "There was that Mrs. Butler from Chicago, a black woman, widowed, and a former teacher. In a magazine she saw images which had been made by a Heidelberg press photographer in a Catholic kindergarten. She—like some other Negro married couples—wanted to adopt these children. She

succeeded, but she had had to fight for three years." Nachlass Robert Stemmle.

59. See Fehrenbach, *Race after Hitler*, 119. Though there were many earlier reports in the black press about brown babies with comments about the obstacles military regulations presented to black soldiers who wanted to get married to white women, the adoption topic increased in the early 1950s. See, for example, "Brown Babies Adopted by Kind German Families," *Jet*, November 1951, 14–17; the cover story "Heinz and Roswitha: Mixed German Youngsters Want to Come to the US: How to Adopt a German War Baby," *Jet*, October 23, 1952; Mabel Grammer, "What to Do about Adopting War Babies," *Baltimore Afro-American*, March 7, 1953, 22E; "War Babies Romp in New U.S. Home," *Baltimore Afro-American*, March 14, 1953, 22E; "Brown Babies Get Americanized," *Jet*, May 21, 1953; and "Brown Babies Find New Homes," *Jet*, October 8, 1953.

60. See, for example, "U.S. Ex-Boxer Founds German 'Brown Baby' Agency," *Jet*, July 10, 1958, 60; and "He Adopted 5,000 Babies," *Sepia*, January 1960, 57–60.

7. Heil, Johnny

I am grateful to Ed Sikov, Ralph Willett, William Paul and to my research assistants Julia Lee and Kelsey LeBuffe for their suggestions and their help in tracing and procuring sources. Several members of the audience at Washington University St. Louis and Indiana University made very good suggestions when I presented earlier versions of this chapter. I worked with the Universal Cinema Classics DVD 825 814 4 11(UK version, 2008). The script of the film is available at http://www.cswap.com/1948/A_Foreign_Affair, accessed March 1, 2013.

1. Kramer and Grese were photographed by George Rodger in 1945. John Willoughby, "The Sexual Behavior of American GIs during the Early Years of the Occupation of Germany," *The Journal of Military History* 62, no. 1 (1998): 155–74, here 171, mentions such then common terms as "fraternazi" and "furlein" to describe fraternizing women with a Nazi past, but the association with a camp commander seems exceptionally strong. However, in his divorce proceedings Wilder also acknowledged sarcastically that "good wife Marilyn is a unique personality and I am the Beast of Belsen." See Tom Wood, *The Bright Side of Billy Wilder, Primarily* (Garden City, NY: Doubleday, 1970), 160.

2. "A Foreign Affair: Treatment," dated May 31, 1947 (48-page story treatment by Wilder, Charles Brackett, and Robert Harari), Paramount Pictures, Margaret Herrick Library, 9–10, 4, 5, 9, 38, 4 and 6; the pajama dialogue is in *Operation Candybar* (*A Foreign Affair*) (incomplete precensorship version of script authored by Wilder, Brackett, and Richard Breen, and dated November 20, 1947), Rauner Special Collections Library, Dartmouth College Library, 20.

3. *A Foreign Affair* (Release Dialogue Script, dated May 20, 1947), New York Public Library for the Performing Arts, Lincoln Center reel 2A, 2; Eisen-

hower quoted in United States Forces European Theater (USFET), *Occupa-tion* (n.p.: 1946), 10.

4. Billy Wilder to Davidson Taylor, Headquarters USFET, reproduced in Ralph Willett, "Billy Wilder's *A Foreign Affair* (1945–1948): The Trials and Tribulations of Berlin," *Historical Journal of Film, Radio and Television* 7, no. 1 (1987): 3–14, here 13. Also at http://www.dartmouth.edu/~germ43/pdfs/wilder_memorandum.pdf, accessed March 1, 2013.

5. Billy Wilder to Davidson Taylor, in Ralph Willett, "Billy Wilder's *A Foreign Affair,*" 13–14.

6. Ed Sikov, *On Sunset Boulevard: The Life and Times of Billy Wilder* (New York: Hyperion, 1998), 271.

7. See Wolfgang Schivelbusch, *In a Cold Crater: Cultural and Intellectual Life in Berlin, 1945–1948*, trans. Kelly Barry (Berkeley: University of California Press, 1998), 142. Schivelbusch's account of the German postwar film indus-try here draws on letters and reports in John Pommer's private archive.

8. For Best Picture, Best Director, and Best Screenplay (together with Charles Brackett); Ray Milland received an Oscar as Best Actor in a Leading Role.

9. Sikov, *On Sunset Boulevard*, 243. The Yad Vashem database of Holocaust vic-tims lists her as having died in Plaszów, Poland, in 1943, without giving any more details, on the basis of a testimony by her brother Mikhail Baldinger, a Holocaust survivor. See http://db.yadvashem.org/names/nameDetails.html?itemId=427105&language=en, accessed March 1, 2013.

10. Sikov, *On Sunset Boulevard*, 239.

11. Ibid., 241–43. *Death Mills* is available at http://archive.org/details/Death Mills, accessed March 1, 2013. As he explained in *Billy How Did You Do It?* (1992), his interview with Volker Schlöndorff, Billy Wilder reacted very strongly to one sequence of the film in which a barely alive person waves weakly at the viewer.

12. Sikov, *On Sunset Boulevard*, 244.

13. *Love in the Air* (An Original Story for the Screen) by Irwin Shaw and David Shaw, undated ms., Paramount Pictures, Special Collections, Margaret Herrick Library.

14. The 1948 film states in its credits that it is "based" on this "original story by David Shaw."

15. *A Foreign Affair: Treatment*, SF 88788, Story Department, Paramount Pic-tures, Special Collections, Margaret Herrick Library.

16. In the film, a residue of this aspect of Erika's personality can still be felt in her comment that in politics "women pick out whatever is in fashion and change it like a spring hat," prompting John's complaint, "Yeah, last year it was a little number with a swastika on it. This year it's ostrich feathers, red, white and blue. Next year, it's going to be a hammer, maybe, and a sickle" (4B, 8, 3). Of course, Erika does not only sing the English, German, and French, but also the Russian lines of the concluding song about "The Ruins of Berlin" and she tempts John with some vodka that she got "at the Russian sector" (4B, 16, 5).

17. Gerd Gemünden, *A Foreign Affair: Billy Wilder's American Films* (New York: Berghahn Books, 2008), 60, argues that in the film "the moral ambiguity of

[Wilder's] characters has been dramatically increased, an indication that in the two-year span Wilder had become doubtful about the mission of the Allied occupation." I am indebted to Gemünden's findings throughout this chapter.

18. Graham Greene, *The Third Man* (1973; London: Faber & Faber, 1988), 7. Carol Reed, *The Third Man* (Rialto Pictures, 1949; Criterion Collection, DVD 64, 1999).

19. Charlotte Chandler, *Nobody's Perfect: Billy Wilder. A Personal Biography* (2002; repr. London: Pocket Books, 2003), 137: "He wanted only Dietrich herself, but thought she would say no to playing the part of a Nazi collaborator. Instead, he showed her some tests he had made with June Havoc, and asked Dietrich what she thought, not telling her that the part had been written for her. Neither did he mention that Frederick Holländer had written songs with her in mind. He planned to tell her that after her initial no. 'She kept making criticisms and suggestions, and finally I said, like I had thought of it just at that moment, 'Marlene, only *you* can play this part.' And she agreed with me.'"

20. *Nehmt nur mein Leben . . . : Reflexionen* (München: C. Bertelsmann, 1979), 194.

21. Chandler, *Nobody's Perfect*, 137. Marlene Dietrich may also have been reluctant to star as a Nazi entertainer because her older sister Elisabeth Will had stayed in Germany during the Nazi years and was, as the *Boston Globe* and the *Washington Post* reported in 1945, involved in entertaining German troops right outside of the Belsen military compound, not far from the infamous concentration camp. See "Marlene Dietrich finds Sister in Belsen, Seeks Mother in Berlin," *Boston Globe*, May 21, 1945, 3; "Dietrich Trying to Learn Fate of Mother in Occupied Berlin," *Washington Post*, May 21, 1945, 3. Based on a British source, the *New York Times* had earlier reported that the sister had been found living "in the Nazi concentration camp at Belsen." See "Dietrich's Sister at Belsen," *New York Times*, May 18, 1945, 6. According to *Spiegel*, Elisabeth and her husband Georg had been operating a canteen next to the movie theater for soldiers and SS personnel that was in close vicinity of the concentration camp. See Axel Frohn and Fritjof Meyer, "Die verleugnete Schwester," *Der Spiegel* 25 (2000), http://www.spiegel.de/spiegel/print/d-16694736.html, accessed March 1, 2013.

22. *Operation Candybar (A Foreign Affair)*, incomplete ms., 106 pp., with two reviews, Rauner Special Collections Library, Dartmouth College Library.

23. The script arrived at the PCA on November 25, and within a week Paramount had the critical response. The script preserved in the Dartmouth Library, which appears to be the one that Jackson of the PCA read, has handwritten markings and critical comments exactly next to those passages that the letter to the studio specifies as most problematic.

24. One request was to change a German woman's exclamation, "Du lieber Gott"—for reasons of religious piety, perhaps?

25. For example, in *Operation Candybar*, Erika von Schlütow still receives John in her bedroom, wearing mismatched pajamas, and Stephen Jackson made

the following demand: "It will be clearly indicated that John brings the mattress to Erika's apartment for some reason other than making the bed more comfortable. Several possibilities were suggested yesterday, such as, that the mattress would be used to cover a gaping hole in the wall, etc. We believe that it is absolutely imperative that the present objectionable inference be eliminated. Furthermore, in all these scenes in her apartment, the action should be played not in the bedroom but in the living room." In accommodating the request to change the pajama scene, Wilder actually contributed to the denazifying and humanizing of Erika by omitting her repartee. See Dietrich, *Nehmt nur mein Leben*, 195.

Most of the other changes are cosmetic at best. "Du lieber Gott!" becomes "Du lieber!"; Mike's line, "So what's Congress? A bunch of boobs that flunked out of law school," is modified to "So what's Congress? A bunch of salesmen that's got their foot in the right door"; Mike's comment on Erika, "Yes, sir! There's the kind of dish makes you wish you had two spoons. Boy, would you like to be married to her, huh? Not me. I'm too young to die" is toned down to, "Boy, that's a strudel! That's strudel a la mode! That's the kind of pastry makes you drool in your bib"—which echoes the reference to Phoebe (posing as "Gretchen Gesundheit" and passing for German) as a "strudel" (changed from the objectionable "pig"). Wilder kept Joe's line about Phoebe, "She must be tetched in the wool. All she can say is Jawohl," but replaced Mike's response "Is that bad?" by a giggle of all three of them. He did not change congressman Pennecott's line, "Anything I can do for you?" when Phoebe enters his room at night by mistake. Nor did he omit the following dialogue:

> *John:* What's so funny?
> *Erika:* You hold hands?
> *John:* Sure. Nice people do it, you know.
> *Erika:* You're so naïve, you Americans.

And pretty much all the other requests were simply ignored, so that the final film must still have appeared "overly sex suggestive" in the PCA's eyes—though the censors did permit the film to be shown.

26. Gene D. Phillips, *Some Like It Wilder: The Life and Controversial Films of Billy Wilder* (Lexington: University Press of Kentucky, 2010), 99.

27. Compare "*Operation Candybar (A Foreign Affair)*, Final White," November 20, 1947, Dartmouth Library, 29 (shot C-15 and C-16) and "*A Foreign Affair* (Censorship Dialogue Script)," April 24, 1948, Princeton University, Special Collections, Reel 2A, shots 22 and 23, 5. An unidentified clipping in the Filmarchiv Berlin highlights this scene. Ernie Schier, "Marlene Loses Tough Battle to Girl From Iowa" writes: "Director Wilder, or maybe it was his partner Brackett, has a number of hilarious touches in the film, including one shot of a fraulein wheeling a baby carriage up the remains of [Unter den Linden]. *Two tiny American flags, whipped by a strong breeze, fly proudly from the top of the carriage.*"

28. Wilder credited the actor John Lund for this addition. See Cameron Crowe, *Conversations with Wilder* (London: Faber & Faber, 1999), 76. Wilder added: "It

was a great line! It was not even Mother's Day." Without prompting from the PCA, the script kept Erika's wish unchanged, "I want to go with you to America," but altered "I want to see" to "I want to climb up the Statue of Liberty"; and instead of John replying that she wants to see the Stork Club and Bergdorf-Goodman, he finally says, "You want to get down in that basement at Fort Knox"—a line that casts Erika as a gold digger and makes a better contrast with the suggestion of climbing up the Statue for love of liberty.

29. Crowe, *Conversations*, 75.

30. When Erika is about to be taken away at the end and claims that she is on the white list, one of the M.P.s responds, "Yeah, and we know how you got it . . . and it wasn't . . . if you'll pardon the non-Aryan expression . . . kosher."

31. Far from refusing cigarettes, she takes one John has lit right out of his mouth.

32. Reel 2B, shot 25.

33. The paradoxical phrase "cure them of blind obedience" is eerily reminiscent of Gertrude Stein's 1945 comment that "Germans should learn to be disobedient." "'Off We All Went to See Germany': Germans Should Learn to Be Disobedient and GIs Should Not Like Them No They Shouldn't," *Life*, August 6, 1945, 54–58. See the "Coda" of this book.

34. Phoebe's compulsive ordering of pens in zippered pen cases may have been inspired by Byelikov in Chekhov's "The Man in the Case" (1898).

35. "Billy Wilder aurait pu, dans sa *Scandaleuse*, par fidélité à *Ninotchka*, soutenir qu'une catin nazie vaut mieux qu'une puritaine de l'Iowa" (review of *La Scandaleuse de Berlin*), *Les Lettres françaises* 259 (May 12, 1949). Billy Wilder and Charles Brackett had collaborated with Walter Reisch on the screenplay for Lubitsch's *Ninotchka*.

36. Colonel Plummer's original order to John, "You're to go straight back to Miss von Schluetow and pick up where you left off," was rewritten at the censors' request as "You're to go pick up that torch for Fraulein von Schluetow, light it again and carry it in public"—which hardly avoided the "flavor that he is sending John back to renew his sex relationship with Erika," as the censor had criticized.

37. Phillips, *Some Like It Wilder*, 100, quoting Maria Riva.

38. Ibid., 105–6. Phillips writes that "the filmgoer infers that the incorrigible Erika will most likely slip away from the two bedazzled soldiers and never see the inside of the prison camp." Phillips seconds Stephen Farber's view that "Wilder cannot quite abandon such a bewitching character to her fate without a hint of possible reprieve." "Films of Billy Wilder," *Film Comment* 7 (winter 1971): 14.

39. This argument has been developed in full by Joseph Loewenstein and Lynne Tatlock, "The Marshall Plan at the Movies: Marlene Dietrich and Her Incarnations," *German Quarterly* 65, no. 3–4 (summer–fall, 1992), 429–42, and by Barton Byg, "*Nazism* as Femme Fatale," in *Gender and Germanness: Cultural Productions of Nation*, eds. Patricia Herminghouse and Magda Mueller (Providence: Berghahn Books, 1997), 185.

40. Gemünden, *A Foreign Affair*, 69.

41. Marlene Dietrich Papers, Filmmuseum Berlin.

42. Ralph Willett, who invited readers to supply him with an appropriate source, reported in an e-mail of April 16, 2008, that no one ever contacted him to substantiate the claim. Rosemary C. Hanes at the Library of Congress "found several books and articles that make statements similar to Willett's," yet no "specific references to support the claims." The earliest reference Hanes found is in Axel Madsen's book, *Billy Wilder* (Bloomington: Indiana University Press, 1969), 74, but the assertion is not footnoted; Ed Sikov references Anthony Heilbut's *Exiled in Paradise: German Refugee Artists and Intellectuals in America from the 1930s to the Present* (Boston: Beacon Press, 1984), but that book gives no source either. David Culbert's article, "Hollywood in Berlin, 1945: A Note on Billy Wilder and the Origins of 'A Foreign Affair,'" *Historical Journal of Film, Radio and Television* 8, no. 3 (1988): 311–16, also gives no source. Neither does Tony Thomas, *Films of the Forties* (Secaucus, NJ: Citadel, 1975), 234.

43. Bosley Crowther found the film "a dandy entertainment which has some shrewd and realistic things to say" in the *New York Times* of July 1, 1948, and went on to praise plot, acting, and music. Edwin Schallert deemed it the "best topical film show that has arrived in months" in the *Los Angeles Times* on July 23, 1948, and argued that because of Holländer's songs "and the psychology conveyed through action and situation, 'A Foreign Affair' probes exceptional depths, in addition to being a thoroughgoing comedy. More serious pictures have often fallen short of a similar goal. The bitterness of 'A Foreign Affair' is thus likely to linger after its laughs have passed." The *Wall Street Journal* reviewer thought the film provided "wonderful entertainment all around" even though the writers "have taken many sharp shots at various pompous subjects in the course of the tale, Congress, the army, the lady folk at home, the Russians, and the world in general." The review ended with an allusion to the Berlin airlift (which marked the full-fledged arrival of the Cold War): "At last report U.S. planes were flying planeloads of food into Berlin. It is a pity they couldn't bring this film in at the same time because there is a planeload of laughs in it—especially for the soldier boys" (July 2, 1948). Richard L. Coe called *A Foreign Affair* a "wry, lively comedy that will keep you chuckling from takeoff to its final destination" in the *Washington Post* (September 3, 1948) and went on to praise the "running parade of wisecracks," the acting, predicted that the archive scene in which Phoebe filibusters with Longfellow was "likely to become a movie classic," compared Wilder's film with Lubitsch's *To Be or Not to Be*, and concluded emphatically: "Yes, 'A Foreign Affair' is one of the comedies of the year and you'll want to see it." The *Christian Science Monitor* (July 23, 1948) applauded the film for its realism, for giving "an impression of conditions in Berlin which many people have not had so vividly presented before. Interesting, too, is the handling of Russian soldiers, with humor and without rancor." These excerpts may read like blurbs from an advertisement, but they do reflect the unanimity of critical responses.

44. "Two Views of a Director—Billy Wilder": Herbert G. Luft, "I. A Matter of Decadence" and Charles Brackett, "II. A Matter of Humor," *Quarterly of Film Radio and Television*, 7, no. 1 (autumn 1952): 58–69; here 63 and 68.

45. "A Communication: A Letter about Billy Wilder," *Quarterly of Film Radio and Television* 7, no. 4 (summer 1953): 434–36; here 435. Available at http://www.jstor.org/stable/1210015, accessed March 1, 2013. Schulberg continues: "Don't get us wrong: we did not (to use Mr. Brackett's phrase) 'detest a joke.' We did detest a picture which treated a most crucial issue—the rehabilitation of Germany—as *nothing but a joke*. In the case of *A Foreign Affair*, we considered Wilder not decadent, Mr. Luft, nor humorous, Mr. Brackett, but simply irresponsible. At a time when sober American understanding of German problems seemed essential to our foreign policy, Wilder's slap-stick version of Berlin affairs struck us as an international disservice." I am grateful to Sandra Schulberg for alerting me to this communication. Schivelbusch, *In a Cold Crater*, 146, also reports that Pommer failed to appreciate Wolfgang Staudte's serious 1946 film *Die Mörder sind unter uns* (The Murderers Are among Us).

46. Ernst Jäger, "Marlene singt den Trümmersong," *Der Abend*, August 7, 1948: "Neither Germans nor Nazis are let off the hook, but what is unspoken, the basic attitude, honors these ex-Berliners. Even the ruins of Berlin would start to laugh. . . . Americanism in film has never been as free, and a film from the land of the conquerors never as brave. Hollywood has sent Germany a spiritual Care package that is priceless." *Kasseler Zeitung* (September 24, 1948) writes that Marlene Dietrich "stars in her most recent film, *A Foreign Affair*, that has now also opened in Germany to great success." Horst Schnarre, "Ort der Handlung: Berlin" (undated and unidentified clipping), writes: "What solid German citizen would dare to show his own weaknesses, to present them as givens for discussion?" Only the leftist paper *Vorwärts* (August 1, 1948) grumbled, under the headline "Marlene Dietrich als Pg": "That is how the American reeducators solve the Nazi question. The small-time followers are chased from their positions, but everything that is still usable comes under American protection, from the Generals to the Erikas." (My translations.) Marlene Dietrich Collection, Stiftung Deutsche Kinemathek, Museum für Film und Fernsehen, Berlin. On Schulberg's role, see also Phillips, *Some Like It Wilder*, 106.

47. Hemingway to Dietrich, July 1, 1950. Hemingway Archives, John F. Kennedy-Library, Boston.

48. Leftover footage was used by Stephen Soderbergh in his disappointing film *The Good German* (2006).

49. Hal Erickson, *All Movie Guide*, http://movies.nytimes.com/person/88679/Farciot-Edouart/biography, accessed March 1, 2013. The fact that the movie begins with Congressman Kraus photographing ruined Berlin from the plane "with a motion picture camera" adds further self-reflexivity to the film.

50. According to Paramount News, "seventy-nine pre-war newsreels were studied in order to accurately recreate the newsreel," http://www.tcm.com/tcmdb/title/75395/A-Foreign-Affair/notes.html, accessed March 1, 2013.

51. Alain Masson, "Contre philinte: *La Scandaleuse de Berlin*," *Positif* 248 (November 1981): 68–71: "Le Hitler qui baise la main d'Erika est plus chaplinesque que nature. . . . Le sens est clair: courtisane aérienne et splendide, Erika reste toujours supérieure aux régimes que sa presence semble cautioner; elle échappe à l'histoire" (70). In *Sunset Boulevard*, Billy Wilder would insert an overt Chaplin parody.

52. See Loewenstein and Tatlock, "The Marshall Plan at the Movies," 434.

53. Gemünden, *A Foreign Affair*, 63.

54. According to *Life* magazine, Mickey Mouse watches, which cost $3.95 in the United States, went for $500 at the black market near Brandenburg Gate. See Richard Whelan, *Robert Capa: A Biography* (New York: Alfred A. Knopf, 1985), 241.

55. It is worth mentioning that James Agee in his very brief film review praised Wilder's "sharp, nasty, funny stuff at the expense of the investigatory Americans," but deplored that later on "the picture indorses everything it has been kidding, and worse. A good bit of it is in rotten taste, and the perfection of that is in Dietrich's song 'Black Market.'" "Films," *The Nation* 167, no. 4 (July 24, 1948): 109.

56. In Ute Lemper's cover of the song, "compassion" was turned into "my passion" in these lines: "I give you for your ration my passion—and maybe." Lemper thus made explicit what was already implicit in Holländer's lyrics.

57. The motif of the German picking up cigarette butt that an American drops that was present in Wilder's 1945 ICD proposal is also incorporated into a film sequence just outside the entrance to the Lorelei. As John is following Erika's movements during the black market song, he discovers Phoebe in the audience and tries to conceal himself behind a pillar—thus creating a sense of another visual triangle.

58. This also extends to objects associated with them, like the nylon stocking hanging out of John's pocket while he receives the cake from Phoebe, the telephone with Erika on the line that John holds in his hand in Phoebe's presence, or the focus on John's photograph in Erika's closet when Phoebe is in Erika's apartment.

59. Robert Dassanowsky-Harris, "Billy Wilder's Germany," *Films in Review* (May 1990): 292–97 and 352–55, notes subtle but important difference in the German and English lyrics to "The Ruins of Berlin": "Both Erika's political sympathies and the warning of Birgel's return are garnered from the German lyrics" (353).

60. Willett, "Billy Wilder's *A Foreign Affair*," 14.

61. Friedrich Holländer, *Von Kopf bis Fuß: Mein Leben mit Text und Musik* (München: Kindler, 1965), 395–96. Phillips, *Some Like It Wilder*, 100, reports that Holländer had actually composed the songs for the Berlin-style Tingeltangel Club he opened in Hollywood and that Wilder had Paramount purchase the screen rights.

62. The repeated honking of John's jeep and the metallic sound of Erika's key dropping on the street seem Pavlov-like sound effects that signal their

sexual attraction; the sound appropriately interrupts, first the "Isn't It Romantic" music, and later on, the conversation between John and Phoebe.

63. Willoughby, "Sexual Behavior," 171, mentions the expression "frau bait" for chocolate and cigarettes during the occupation.

64. This whole sequence was deleted, as one of the drastic "Irish Cuts" in the "Release Dialogue Script" of May 20, 1948, to accommodate the more stringent censorship laws in Ireland. See "*A Foreign Affair:* Release dialogue shooting script," New York Public Library for the Performing Arts, Lincoln Center.

65. Mamoulian's sequence at http://maxzook.wordpress.com/2007/02/14/isnt-it -romantic/, accessed March 1, 2013, ties together many different people, including the composer and an army unit, who sing apparently improvised lines of the same song sequentially while the scene moves from Maurice Chevalier in a men's shop through many stages to Jeanette MacDonald's château; Wilder shows only John whose enamored elation at going to Erika's ruin with a mattress makes even the most horrifying ruin scenes "romantic." The musical backdrop spans the whole scene, with John whistling the "Isn't It Romantic" theme when he sees Erika brushing her teeth and the musical score also returns to the theme. I am grateful to William Paul for suggesting this connection.

66. See http://www.nytimes.com/books/98/12/27/specials/wilder-brackett .html, accessed March 1, 2013.

67. *Operation Candybar* of November 20, 1947 describes Berlin as "the biggest rubble heap on earth" (1), and in the aerial shot of the city's buildings they look "like thousands of decayed molars on the tray of some Gargantuan dentist" (3). In the set description of Erika's apartment building, "only about forty percent destroyed," a "bathtub hangs nonchalantly from the third floor, one burned-out apartment on the fourth floor is wide open to the street" (17). In her apartment "exactly one room . . . is habitable," and "one wall has been shaken out of true and tilts drunkenly as the wall in the cabinet of that Dr. Caligari" (18). Rauner Special Collections Library, Dartmouth College Library.

68. Phoebe shares her politically motivated obliviousness to the human toll in the story she tells with Ninotchka who cheerily comments when asked for news about the Soviet Union: "The last mass trials were a great success. There are going to be fewer but better Russians."

69. See Mae Tinee, "In This Film It's Granny Dietrich vs. Jean Arthur," *Chicago Daily Tribune*, September 14, 1948, 24. The cover of *Life*, August 9, 1948, also promised "In this issue: Russia's Strength: An economic and military report," suggestive of the intensifying Cold War. Dietrich turned forty-seven, Mitchell forty-five, Jean Arthur forty, and John Lund thirty-five the year *A Foreign Affair* was released. *Kasseler Zeitung*, September 24, 1948, reported Dietrich laughing during the shooting of that scene: "Zu komisch! Sie wollen Großvater sein, und ich bin gestern wirklich Großmutter geworden!" (Too funny! You want to be a grandfather and I really became a

grandmother yesterday!) Stiftung Deutsche Kinemathek, Museum für Film und Fernsehen, Berlin.

70. See, for example, Drew Middleton, "Failure in Germany," *Colliers*, February 9, 1946, 12ff.

71. Phillips, *Some Like It Wilder*, 100.

72. Interestingly, Plummer speaks these lines off, while the camera focuses on the delegation and ultimately the skeptical Phoebe, who *humphs* when Plummer concedes: "Some of us get out of line occasionally."

73. The chalk mark on the back of the father's coat is reminiscent of the "M" for "murderer" on Peter Lorre's overcoat in Fritz Lang's *M*. I am grateful to Johannes Türk at Indiana University for calling attention to this possible connection, which would add another German cinematic allusion to the obvious links with von Sternberg's *The Blue Angel* and Riefenstahl's *Triumph of the Will*.

74. The frame shows an ironic parallel between Erika's Hitler salute and the stretched-out hands of the baroque putti that decorate her ruined wall.

75. In Cameron Crowe, *Conversations*, 76, Wilder quotes these lines as evidence of John's "crackling relationship with Erika," describes them as "great soldier's talk," and comments: "You had to be laughing behind the camera, hearing him do this stuff."

76. It is in such contexts that John in the earlier version called Erika "Beast of Belsen."

Coda

1. Edward Twentyman from Cassell's publishing house told me this story at the Frankfurt Book Fair in 1962; he had heard it from a friend who was stationed in the British zone soon after World War II.

2. I am following Atina Grossmann, *Jews, Germans, and Allies: Close Encounters in Occupied Germany* (Princeton, NJ: Princeton University Press, 2007), 264, who also paraphrases the following joke and cites the story's source. I am grateful to Atina Grossman for leading me to further sources.

3. Leo W. Schwarz, *The Redeemers: A Saga of the Years 1945–1952*, with a preface by Lucius D. Clay (New York: Farrar, Straus and Young, 1953), 198. Schwarz mentions that the story had been told by a Mr. Segalson.

4. Perhaps even the vulgar "Ukrainian" joke that *A Woman in Berlin* inserted into her account of the Russian rapes could be reconsidered in these contexts.

5. Richard Whelan, *Robert Capa: A Biography* (New York: Alfred A. Knopf, 1985), has almost nothing to say about the image.

6. Margaret Bourke-White, *"Dear Fatherland, Rest Quietly": A Report on the Collapse of Hitler's "Thousand Years"* (New York: Simon and Schuster, 1946), 54–55.

7. *Life*, May 14, 1945, 22.

8. Dagmar Barnouw, *Germany 1945: Views of War and Violence* (1996; Bloomington: Indiana University Press, 2008), 83–85, called attention to the fact that the photograph was dramatically cropped—the original is not as effective. It was also rotated a bit counterclockwise and touched up: the burlap-like material on the left, probably camouflage, was whitened and the few pieces of rubble on the ledge on which Strickland is standing were erased, rubble that Bourke-White had mentioned in her account of the image. Peter Heigl, *Die US-Armee in Nürnberg auf Hitlers "Reichsparteitagsgelände"/ The U.S. Army in Nuremberg on Hitler's Nazi Party Rally Grounds* (Nürnberg: Dokumentationszentrum Reichsparteitagsgelände, 2005), 22–23, 48–49. Heigl also shows that the rally grounds later served as the site of a Polish D.P. camp (62–63).

9. Carolyn Burke, *Lee Miller: A Life* (New York: Alfred A. Knopf, 2005), 262–63.

10. Bourke-White, *"Dear Fatherland, Rest Quietly,"* 81. In a letter to his wife from August 25, 1947, Thomas Dodd gives a detailed description of the apartment, finds "Hitlers's furniture and furnishings" intact, and mentions that an Army colonel is now living in the apartment. Christopher J. Dodd, with Lary Bloom, eds. *Letters from Nuremberg: My Father's Narrative of a Quest for Justice* (New York: Crown Publishing, 2007), 105.

11. Gertrude Stein, "Off We All Went to See Germany," *Life*, August 6, 1945, 54–58, here 57.

12. Stein's essay solicited several readers' comments in *Life*, August 27, 1945, 4, ranging from one reader begging the editors to "spare us from any more of Gertrude Stein's inanities" to another requesting more articles by her: "That was excellent." George McCurrach ironically endorsed Stein's proposal to confuse Germans and recommended: "Take away all their textbooks and give them a new set written by Gertrude Stein, which should certainly confuse their little warlike minds no end alas!" Dean Modricker sent in their five-year-old child Barbara's talk to demonstrate its similarity with Stein's writing—to which the editors expressed their agreement. NBC Press Department manager Sidney H. Eiges submitted a photograph by Ray Lee Jackson of the *back* of Stein's head with the photographer's explanation: "She writes backwards so I thought we ought to photograph her backwards." Stein's joking thus provoked more gags and ironic comments among readers. The image is available at http://emuseum.icp.org/media/view/Objects /30375/60292?t:state:flow=ae5382b0-a95f-4276-b561-aec1607732f8.

13. Julia Faisst, *Cultures of Emancipation: Photography, Race, and Modern American Literature* (Heidelberg: Universitätsverlag Winter, 2012), 169. Her comments on Stein's "infantile insistence on obtaining flowerpots" and expressing "the human need for re-staging history" are also apt.

14. See *A Woman in Berlin*, trans. James Stern, intro. C. W. Ceram (1954; repr. New York: Ballantine Books, 1957), entry for June 2, 188/252.

15. See Bourke-White,*"Dear Fatherland Rest Quietly,"* picture insert between 166 and 167.

16. *A Woman in Berlin*, entry of May 10, 132/175–176, describes red flags in Schöneberg "apparently made out of former swastika flags; . . . These little

flags—how could it be otherwise in our country?—are neatly hemmed by female hands." Early versions of the map of the occupation zones displayed a Russian flag that was clearly made out of a Nazi banner in which the swastika at the center had simply been replaced by hammer and sickle.

Recycling went on with many other Nazi relics: for example, the marble of Hitler's Reichskanzlei was used to build the Russian war memorial in Treptow, the typesetter of the *Völkischer Beobachter* served for the production of *Die Neue Zeitung*, and young Zionists took over Julius Streicher's estate and turned it into a Kibbutz Nili for agricultural training.

17. Stig Dagerman, *German Autumn*, trans. Robin Fulton Macpherson, intro. Mark Kurlansky (Brit. ed. 1988; repr. Minneapolis: University of Minnesota Press, 2011), 27.

Afterword

1. Lucius D. Clay, *Decision in Germany* (Garden City, NY: Doubleday, 1950), 440.
2. Klaus L. Berghahn, "German Misery—1945: A Revision," *Monatshefte* 91, no. 3 (fall 1999): 414–23, here 420, finds that including both "unbelievable crimes committed by Germans in the concentration camps" as well as "the suffering of the defeated Germans" in a book he reviews "could be interpreted as a balancing of accounts or, even worse, as a blurring of the difference between perpetrators and victims."
3. See Karina Berger, "Expulsion Novels of the 1950s: More Than Meets the Eye?" in Stuart Taberner and Karina Berger, eds., *Germans as Victims in the Literary Fiction of the Berlin Republic* (Rochester, NY: Camden House, 2009), 42–55.
4. I am thinking of the longstanding debate about "German suffering." See, for example, Randall Hansen, "War, Suffering, and Modern German History," *German History* 29, no. 3 (September 2011): 365–79, for a good recent survey of the pitfalls in that debate and for suggestions "how that suffering can be narrated and understood without running into the intellectual dead ends of either self-pity or collective guilt."
5. United States Forces European Theater, *Occupation* (n.p., 1946), 15, 19, 7.
6. See, for example, Larry Rue, "Fail to Harden Troops against German People: GIs Bitter on Army's Hate Propaganda," *Chicago Daily Tribune*, September 30, 1945, 7.
7. Bertram Schaffner, *Father Land: A Study of Authoritarianism in the German Family* (New York: Columbia University Press, 1948), 98–99, as cited in George Blaustein, "To the Heart of Europe: War, Occupation, American Studies" (unpublished ms., 2013).
8. See Maria Höhn and Martin Klimke, *A Breath of Freedom: The Civil Rights Struggle, African American GIs, and Germany* (New York: Palgrave Macmillan, 2010).

Acknowledgments

Though it may not show it, this book has been long in the making, and the list of readers and listeners along the way is extraordinarily long. It includes generations of excellent research assistants; students in several classes I taught and participants in a symposium I organized on the subject of the 1940s; the resourceful Harvard University research librarians, media production assistants, speedy "scan-and-deliver" creators, and faculty aide program directors; archivists and librarians at numerous institutions in the United States and in Europe; translators of sources in languages I do not read; members of the audience at numerous institutions at which I was kindly invited to deliver versions of this project and of the chapters into which it was ultimately divided; and, finally, readers of individual chapters. George Blaustein, Maggie Gram, Jennifer Kurdyla, and Kevin Stone read drafts of the whole manuscript and made numerous corrections and suggestions for improvements, as did Glenda R. Carpio, Gaston Salvatore, and Sara Sollors. Two anonymous readers made excellent, detailed, and helpful comments and corrections. Lindsay Waters, my editor at Harvard University Press, has been supportive of this project from the very beginning and encouraged me to include personal asides. Shan Wang helped at every stage of the editorial process. As always, Alide Cagidemetrio has been my most careful listener, critic, and questioner along the way.

Since I have expressed my gratitude to a few specific persons in the notes accompanying individual chapters, I shall here merely list the names of those who have been most helpful to me in a single alphabetical order (with apologies in case I have inadvertently omitted anyone): Daniel Aaron, Anna Acosta, Amin Ahmad, Frederick Aldama, Dagmar Barnouw, Klaus Benesch, Laura Blake, George Blaustein, Suzanna Bobadilla, Alyssa Boyd, Ursula Breymayer, Matthew Briones, Vincent Brown, Barbara Buchenau, Barbara Burg, Christa Buschendorf, Stella Calvert-Smith, Norma E. Cantú, Bill Chapman, Herrick Chapman, Emma Cheshire, Holly Ciavattone, Judith Cohen, Sheila Coutts, Eileen Crosby-Ballou, David Brion Davis, Thomas Dichter, Morris Dickstein,

Marc Dolan, Bridget Drinka, Holger Drössler, Gerald Early, Julia Faisst, Aaron Fallon, Michael Fauser, Heide Fehrenbach, Dominika Ferens, Jeffrey Ferguson, Allyson Field, Philip Fisher, Moira Fitzgerald, Jennifer Fleissner, David K. Frasier, Herwig Friedl, Maarten van Gageldonk, Francesca Petrosino Gamber, Júlia Garraio, Leah Garrett, Marty Gecek, Brian Goodman, Maggie Gram, Andrew Gray, Tilly T. de Groot, Atina Grossmann, Janet Halley, Rosemary C. Hanes, Udo Hebel, Lisa Hellmann, Sebastian Hierl, Brian Hochman, Andreas Höfele, Ari Hoffman, Regina Hoffmann, Ruth Hoffmann, Maren Horn, Alfred Hornung, Ann L. Hudak, Rainer Huhle, Ronald Hussey, Kate Hutchens, George Hutchinson, Jonathan Hyams, Malgorzata Irek, Christoph Irmscher, Peter D. James, Gish Jen, Margot Kaiser, Jennifer Kapczynski, Frank Kelleter, Steven Kellman, Robin Kelsey, Adrienne Kennedy, Liam Kennedy, Margaret Keyes, Martin Klimke, Arthur Knight, Wolfgang Knöbl, Martina Kohl, René Kok, Karoline Krasuska, Jennifer Kurdyla, Pascale LaFountain, Anne Langendorfer, David Lawton, Kelsey LeBuffe, Julia Lee, Joe Loewenstein, Paul Michael Lützeler, Karen Maandag, Manfred Mardinskij, Alane Mason, Pamela Matz, Richard McCoy, Martin H. Meyer, Erica Michelstein, Robert G. Moeller, Herman Hennink Monkan, Nicole Morreale, Mohsen Mostafavi, Jerry Z. Muller, Matthew Murphy, Martha Nadell, Nicholas Nardini, Jennifer Nash, Peter Nelson, Helmut Nordmeyer, Victoria Northridge, Nicola Nowak, Rita O'Donoghue, Berndt Ostendorf, Brian Ostrander, Karin Palmkvist, Avinoam Patt, Heike Paul, William Paul, Donald Pease, Amanda Peery, Christina Peters, Kimberley L. Phillips, Angelika Pirkl, Jeff Pirtle, Laura Plummer, Johann Pörnbacher, Khory Polk, Henk Poncin, Jesse Raber, Holly Reed, Klaus Rheinfurth, Eric Rentschler, Sally Richards, Sven Riepe, Nicholas Rinehart, Sally Richards, Cambridge Ridley, Laurie Rizzo, Carolyn Roberts, Kathryn Roberts, Jinx Rodger, Laura Ronchi, Lisa Roth, Jack Rummel, Gaston Salvatore, Lisa Sanchez, Oliver Sander, Oliver Simons, Stefanie Schäfer, Wolfgang Schivelbusch, Christine Schmidt, Bernd Schnarr, Sandra Schulberg, Dagmar Schultz, Elfriede Schulz, Joelle Sedlmeyer, Stefan Seidl, Cheryl Sherrod, Michael Shulman, Ed Sikov, James Simpson, David Sollors, Adena Spingarn, Silvia Springer, Zoe Stanselle, Laura Stapane, Kevin Stone, Jon-Christian Suggs, Susan Suleiman, Wendy Sutherland, Lynne Tatlock, Laurie Thompson, Alan Trachtenberg, Adele Tuchler, Johannes Türk, Lutz Unterseher, Aleksandra Urakova, Tony Vaccaro, Joanne van der Woude, Tatyana Venediktova, Heather Vermeulen, Hans de Vries, Britta Waldschmidt-Nelson, Michaela Wasenegger, Nicholas Watson, M. Lynn Weiss, Sorrel Westbrook-Nielsen, Laura Wexler, Claudia Wieland, Ralph Willett, Marek Wilczynski, Ruth Wisse, Sarah Withers, Sabine Wolf, Cary Wolfe, Henry Wonham, Magdalena Zaborowska, Rafia Zafar, and Meike Zwingenberger.

Excerpt from "Little Gidding" from *Four Quartets* by T. S. Eliot. Copyright 1942 by Houghton Mifflin Harcourt Publishing Company. Copyright renewed 1970 by estate of T. S. Eliot. Reprinted by permission of Houghton Mifflin Harcourt Publishing Company. All rights reserved. Reprinted by permission of Faber & Faber Limited.

Excerpt from "Epilogue" from *Collected Poems* by Robert Lowell. Copyright © 2003 by Harriet Lowell and Sheridan Lowell. Reprinted by permission of Farrar, Straus and Giroux, LLC.

I am grateful to the Clark and Cooke Fund at Harvard University for permitting me to begin this project and for the Hyder E. Rollins Fund, Department of English, Harvard University, for covering the permission expenses that made possible the publication of this book with illustrations.

Every effort has been made to trace all copyright holders, but if any have been inadvertently overlooked the author and the publisher will be pleased to make the necessary arrangement at the first opportunity.

Index